CHINESE SYMBOLISM
AND
ART MOTIFS

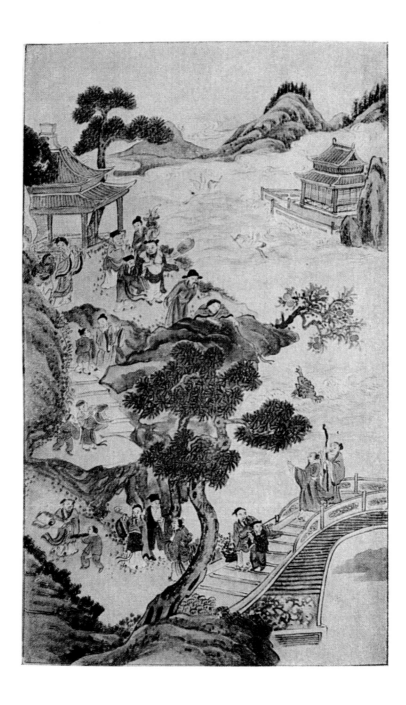

KEY TO COLOUR-PLATE

"SHOU SHAN, THE TAOIST PARADISE."

1. Han Chung-li　(漢 鍾 離) ⎫
2. Chang Kuo-lao　(張 果 老) ⎪
3. Lü Tun-yang　(呂 純 陽) ⎪
4. Ts'ao Kuo-chiu　(曹 國 舅) ⎪　The Eight
5. T'ieh-kuai Li　(鐵 拐 李) ⎬　Immortals
6. Han Hsiang-tzŭ　(韓 湘 子) ⎪　(q.v.)
7. Lan Ts'ai-ho　(藍 采 和) ⎪
8. Ho Hsien-ku　(何 仙 姑) ⎭
9. Liu Hai (劉 海), with
10. The Toad (三 脚 蟾) (q.v.)
11. Shuang Hsien (雙 仙), the Twin Genii of Union and Harmony.
12. Nan Chi Lao Jên (南 極 老 人), the Spirit of the South Pole.
13. The magicians Chang Ch'ien (張 騫) and
14. Liu Ch'ên (劉 晨),
15. Fu Hsing (福 星),
16. Lu Hsing (祿 星), and
17. Shou Hsing (壽 星), the three Star-Gods of Happiness, Affluence, and Longevity.
18. The philosopher Ch'ên Hsi-i (陳 希 夷)
19 and 20. Pai Hao (白 鶴), the White Cranes, Messengers and Coursers of the Gods.

CHINESE SYMBOLISM AND ART MOTIFS

An alphabetical compendium of antique legends
and beliefs, as reflected in the manners
and customs of the Chinese

by

C. A. S. WILLIAMS

with an introduction to the new edition by

TERENCE BARROW, Ph.D.

THIRD REVISED EDITION

ILLUSTRATED

CHARLES E. TUTTLE COMPANY
Rutland, Vermont & Tokyo, Japan

Published by the Charles E. Tuttle Company, Inc.
of Rutland, Vermont & Tokyo, Japan
with editorial offices at
2-6 Suido 1-chome, Bunkyo-ku, Tokyo 112

Copyright in Japan, 1974 by Charles E. Tuttle Company, Inc.

Reprint of Outlines of Chinese Symbolism and Art Motives
Third revised edition, copyright 1941 by
Kelly and Walsh, Limited, Shanghai

First Tuttle edition, 1974
First Tuttle paperback edition, 1988
Third printing, 1993

LCC Card No. 73-90237
ISBN 0-8048-1586-0
Printed in Japan

"WHAT ARE THE FOUR INTELLIGENT CREATURES?

They are:

the Unicorn, the Phoenix, the Tortoise
and the Dragon."

何 謂 四 靈。 麟 鳳 龜 龍。 謂 之 四 靈。

LEGGE: *Li Ki* (禮 記), Bk. VII, Sect. III, § 10, p. 384.

CONTENTS

ix

CONTENTS

x

CONTENTS

CONTENTS

ILLUSTRATIONS

xiii

ILLUSTRATIONS

xiv

ILLUSTRATIONS

ILLUSTRATIONS

INTRODUCTION TO THE
NEW EDITION

The surge of American interest in Chinese culture following the visit of President Nixon to China in 1972 has highlighted the healthy trend of recent years to look at China in a realistic way. Since the thirteenth-century visit of Marco Polo to China, the country has been regarded by the West as an exotic Flowery Land—a Celestial Kingdom, remote and forbidding. Until the sixteenth century it was a land that did not come under strong foreign, then Western, influence. The Japanese occupation of Manchuria in the 1930's, followed by the emergence of Chinese communism after World War II, gave the world a sober picture of a vast country intent on asserting its own destiny. The explosion of a Chinese atomic bomb, followed by recognition as a nation in the United Nations Organization, obliged the United States to recognize the Chinese nation of 800,000,000 people.

For ordinary people in Western countries an easy way to comprehend Chinese culture and history is through books on traditional arts, literature, and folklore. American tourists may now visit China in organized groups, yet for most of us China and the Chinese will remain something only to read about or to watch on a television screen. For those interested in ancient Chinese culture, books must remain the principal reference source, supplemented by visits to museum collections.

Outlines of Chinese Symbolism and Art Motives, in the words of the author, C. A. S. Williams, is "a practical handbook of the science of Chinese symbolism as based on the early folklore."

At the root of Chinese life, art, and literature are certain

basic ideas that can and should be grasped by anyone studying China. To achieve a sound knowledge of Chinese art symbolism and primary concepts, there is no better book than this. It is easy to use. Subjects are arranged alphabetically, described in concise essays, and illustrated with crisp line drawings by Chinese artists. All pertinent terms are accompanied by their Chinese writings.

The edition of Williams' book chosen for this reprint is the third revised edition, printed in Shanghai in 1941. Mr. Williams, a life member of the Royal Asiatic Society, Examiner in Mandarin at Hong Kong University, Professor of Customs College, and Acting Commissioner in charge of Maritime Customs in Peiping, wrote a number of books on Chinese language and culture. He was one of the band of versatile English scholars who gave the world pioneering works on the Far East.

Through thousands of years of continuous history China produced superb painters, poets, philosophers, potters, bronze-smiths, architects, and gardeners. Many of the artists and literary men were also priests who applied their religion in practical ways and developed such viable sects as Ch'an (Zen) Buddhism. Williams is remarkably perceptive on the subject of Buddhism, although he does not define Ch'an specifically. He is, however, far ahead of his time in pointing out the profound influence of imported Indian Buddhism on the ideals and art of China. Buddhist thought pervades Chinese culture in all its classic phases and was transmitted from China to Japan and Korea in an assimulated form to be modified in the creative local adaptations with which most of us are familiar. Almost everything in Williams, whether folklore or art symbolism, is applicable to Korea and Japan as well. For example, the symbolic "year" animals are the same in those countries. If India is the native mother culture of Far Eastern ideals, China is the dynamic intermediary between India and Japan, Korea, and Tibet. Williams's book is in reality a general guide to Far Eastern art symbolism and folk belief.

Westerners who study China should keep in mind the antiquity of this great country's civilization, which was already three thousand years old when Titus sacked Jerusalem and Roman legions occupied Britain.

Williams, writing as a scholar and linguist in the China of fifty years ago, could not conceive the vast changes that lay in the immediate future. He lived among Chinese who believed in their folklore and religions. Today we must take a

look at the contemporary scene. The simple fact is that China has adopted a system that has required the ousting of old-style Chinese landlords and administrators, who were primarily Confucian-trained. Changes unparalleled in 5,000 years of Chinese history have had disintegrating effects on Chinese art.

Chinese folkways and art symbols survived the perennial ravages of feudal wars and stultifying bureaucracies over a dozen dynasties. Can traditional custom and viable ancient art survive the mass-education programs of modern Chinese communism, which rejects belief in the ancient superstitions of folklore and the teachings of the three classic religions of Taoism, Confucianism, and Buddhism?

Twentieth-century communism is a Western invention of the nineteenth-century philosopher Karl Marx, who wrote away in the library of the British Museum in London. China has its traditional communism and the common sense to adapt and reform. From the *wu*, the formless, the Chinese forever strive for *yu*, the formful. From the nonlogical emerges the logical—a mode of thinking alien to the scientific West that thousands of Westerners are now adopting.

Before World War II the majority of Chinese had great faith in the protective power of amulets or magical symbols and implicit trust in the benevolent influence of ancestor spirits. Social and economic reforms have swept away the old bases of Chinese culture: religions and folklore. Respect for the past remains. Temples have become museums. Archaeological recovery is intense. But communist art employs techniques of Western realism as a medium of instilling political ideals, as in the Soviet Union. Whether such innovations are right or wrong is not the concern of this book. *Outlines of Chinese Symbolism and Art Motives* is a handbook of traditional modes and art that predate Chinese communism, although common sense suggests that much must survive in modern China.

Let us then turn to the basis of Chinese art symbolism. What is the foundation of Chinese thought that gave existence to these fascinating forms? The answer is best found in the evolution of human thought in the ancient Asian and Pacific world. We know that animism prevailed for thousands of years in Asia, that all natural things whether organic or inorganic were believed to possess an independent spirit. Often these spirits inhabited rocks, trees, or animals and were regarded as the souls of dead ancestors who actively cared for their living descendants. Some of the spirits were fabulous

creatures, but all supernatural entities influenced the affairs of living mortals. Natural phenomena such as rainbows or mists also acted as vehicles for ancestral spirits or the gods themselves. These concepts engendered a great respect for nature that has survived intact in some Oriental religions, such as Japanese Shintoism.

Reverence for birds is a special characteristic of Oriental animism, for birds suggest the free soul. Supernatural creatures, such as the dragon, were as real in the imaginations of the ancient Chinese as were the living creatures before their eyes.

The sophisticated religions modified ancient animisms. Five hundred years before Christ the teachings of Lao Tzu, Confucius, and latterly the Indian doctrine of Buddha gave to the East its enduring ideals of life and death. Oriental art is thus both philosophical and religious, founded on a primitive animism that became submerged. And thus Chinese art has two distinct phases—that of animism in the ages of stone or bronze, followed by that of the historical dynasties based on the classic religions. The transitional dynasty is conventionally the T'ang (A.D. 618–906), but overlaps are many. The pre-T'ang period is especially characterized by motifs that are strongly animistic, employing dragons and "demon" ancestral masks in abundance.

The second phase is richer in religious symbols of a complicated kind that are mostly inspired by the concepts of Buddhism: Bodhisattvas, angels, gate guardians, devils, and saints. In this second era, classic art reached its highest point in the achievements of the Sung dynasty (A.D. 960–1279), notably in painting and ceramics. Sung painting abounds in naturalistic birds, fish, flowers, plants, and mountains. Man is seen contemplating nature as an inconspicuous yet unique part of nature.

As a general rule the symbols of Chinese art become less ritualistic or magical as the dynasties proceed in time; yet, as we see in Williams, the basic animistic motifs such as the dragon persist through all epochs of Chinese art. In fact there is a persistent unity in Chinese art. The fabulous dragon seen in Shang art one or two thousand years before Christ still looks out at us from the walls of Chinese restaurants in Hong Kong, Honolulu, London, New York, and San Francisco.

The fashionable European taste for "Chinoiserie" has a history of at least three hundred years, over which time the Chinese, ever good businessmen, exploited the market by

producing the exotic curiosities the Western barbarians wanted. Some of the Chinese exports are beautiful yet far from typical. In the latter half of the nineteenth century, scholars got to the principles of real Chinese art. Private collectors and museums then acquired the vast collections now to be seen in America and Europe. America has superb collections of Chinese art in institutions from Boston and Washington in the East to San Francisco and Honolulu in the West.

Archaeological finds in China are now protected by the Chinese communist government, a happy change from the times prior to World War II, when tomb robbing was a profession made lucrative by Western demand for Chinese art objects. Such thievery today would bring swift retribution in the form of a prison sentence.

When and where did Chinese art have its beginning? The answer is far from simple. Environmental changes over thousands of years as well as racial and ethnic complexities in what we now call China, from its frigid north to its subtropical south, gave rise to many Chinese cultures. Before the rise of the Shang and Chou dynasties, which mark the "modern" beginning of Chinese art, with their *ku'ei* or fabulous dragons and the *t'ao t'ieh* ancestral mask, there is a lengthy prehistoric art. Half a million years before the dynastic eras in the Lower Paleolithic or Old Stone Age, Peking man roamed the plains and hills of Chinese Asia. About 40,000 B.C., at the onset of the Upper Paleolithic Age, modern man emerged. Distinctive Chinese art symbols first made their appearance in the Chinese Neolithic (polished stone tool age) in the Yang Shao culture, which emerged about 2,500 B.C. to endure a thousand years. The pottery of the early Yang Shao exhibits patterns in red pigments that proceed in time through simple linear motifs to "primitive" conventionalized renderings of men and animals. From these early pictographic symbols, Chinese written characters evolved to highly abstract ideographic writing.

An astonishing fact of Chinese art is the sudden appearance in the Shang dynasty (c. 1766–1121 B.C.) of sophisticated bronze vessels bearing art motifs that are typically "Chinese" and are the progenitors of certain Chinese art symbols that have persisted for three or four thousand years. The Chou dynasty (c. 1122–256 B.C.) developed the superb bronze art of the Shang in such forms as time and circumstances required. These vessels were made for use in rituals performed to gain the favor of ancestral or other spirits. The archaic written Chinese characters inscribed on them provide

information both on the development of writing and on their use as ritual offering vessels.

Diversity is characteristic of all Chinese art, both dynastic and predynastic. Stylistic changes emerge from technical inventions or cultural preference. Basic media included stone, bronze, jade, shell, ceramics, silver, gold, silk, wood, and lacquer. The Han dynasty (202 B.C. to A.D. 221) exhibited many of the cultural refinements of life that we regard today as typical of classic Chinese life. Silk, lacquer, and the writing brush appeared. We know much about the Han Chinese because of their custom of burying with their dead an abundance of personal goods, domestic articles, and little ceramic models portraying daily life. Han decoration is rich in geometric motifs, such as the zigzag, bands, and lozenges. Bronze mirrors of the period have luxuriant designs on their reverse sides. Also in Han times the tiger, the tortoise, and other animals not used as art motifs in earlier periods make their appearance. It is the Han dragon that takes on all the features of the "typical" Chinese dragon with horns, a long tail, wings, a jagged spine, and plate-like scales. The phoenix also assumes its well-known form in the Han dynasty.

Indian Buddhist teachings were known in Han times, yet it was not until the T'ang dynasty that Buddhism became well established in China. Buddhist teachings were opposed by the rulers, an opposition peacefully overcome as Buddhism merged with native Taoism and Chinese folk culture. The result was the emergence of one of the finest regional cultures the world has ever seen.

The greatest single achievement of Buddhism was the formation of the Dhyana meditation school, or Ch'an Buddhism, which was founded by the Indian "blue-eyed Brahmin" Budhidharma (Japanese: Daruma), who is described by Williams under the subject of "tea." Bodhidharma is said to have arrived in China in 527. His mystical teachings mingled Chinese practicality with Indian mysticism to produce Ch'an. Ch'an, or Zen, to use the Japanese word, permeates the best Chinese art, and, along with paper, is China's special gift to world civilization.

Ch'an influence reached its height in the Sung dynasty and thereafter declined in China. Hui-neng (Japanese: Eno), who lived from 638 to 713 in the T'ang period, was one of Zen's greatest exponents. The tea ceremony, flower arrangement, architecture, painting, and calligraphy owe much to Ch'an. The traditions withered in China but survived in Japan even

into modern times in art and scholarship. Dr. Daisetz Suzuki (1870–1966), prophet of Zen to the West, has written much on the Chinese masters and their Japanese successors.

The ancient philosophical basis of Chinese lore and art symbolism is that the world and the heavens have polarity, namely a positive or male *yang* and a negative or female *yin*. This principle is one sugesting counterbalancing parts, one side giving energy to the other. When *yang* and *yin* work in society, the outcome is egalitarian and democratic, while in art the work is dynamic and creative. Symbolically *yang* and *yin* are depicted as a swirling S set in an "egg" or circle, each division having within itself a small circle or dot. It is usual to see one half of the design blocked in with a color while the opposing side is either left plain or colored, red and black being a favorite contrast.

Another feature of Chinese artistic culture is the use of jade as a material believed to possess supernatural power. In neolithic times, copies of tools and weapons cut in jade were used ritually and are among the most beautiful products of Chinese culture. The *pi*, or disc of jade, and the bronze tripod, or three-footed, vessel represent the essence of traditional Chinese culture.

It is generally agreed among scholars and connoisseurs that the high point of Chinese civilization was reached in the Sung dynasty. Sung painting and ceramic art reached a perfection never surpassed in any subsequent dynasty. A strong yet refined delicacy marks the age. Beautiful images of fishes, rocks, trees, and flowers pervade Sung paintings. Man emerges into the natural world as a poetic creature content with his lot.

Certain flowers, fruits, and plants assumed persuasive symbolic power in Sung times. The pine inspired thoughts of longevity, the bamboo of supple bending before life's troubles, the mulberry of calm filial piety. Depicting seasons, the tree peony indicated the delights of spring, the chrysanthemum the charm of autumn, and the wild plum austere winter. Of all flowers the lotus is symbolically supreme, being the symbol of friendly summer, spiritual purity, creative power, and the blessing of immortal gods. Lotus leaves at the base of an image in Far Eastern iconography indicate that the figure depicted is of divine character.

There have been many developments in the study of Chinese art and culture since Williams wrote *Outlines of Chinese Symbols and Art Motives,* yet his book is still useful because of his uncluttered treatment of the timeless subject

matter he presents. It remains a unique reference work. There are aspects of Chinese studies pursued today that Williams probably never dreamed of, such as the body of evidence linking the decorative arts of South Sea Island cultures of Polynesia and Melanesia to the Asian mainland, and notably to Shang and Chou China. Yet that is of little relevance. Williams gives basic information in his book, making it a treasure house where layman and expert can find the facts of folklore and the art symbols of China.

TERENCE BARROW, Ph.D.

INTRODUCTION

All the inhabitants of oriental countries, and especially those of the Flowery Land, are gifted with a vivid imagination —a quality of important constructive value. This high development of the imaginative powers is very largely due to the reaction created by the complicated symbolism of the ancient folklore. In a civilization which has a longer recorded history than that of any other nation, it is not to be wondered at that in China many interesting old classical legends have been handed down from generation to generation, and the manners and customs of the people have naturally been influenced thereby to a very considerable degree. From the earliest ages the Chinese have had a firm credence in the prevalence of occult influences, and a general trust in amulets and charms and other similar preservatives against the spirits of evil, although nowadays the Government is making efforts to dissuade the people from these superstitious beliefs. The ancient world, however, to the Chinese mind, was crowded with heroes, fairies, and devils, who played their respective parts in the colourful drama, and left an undying name and fame in the legendary history of the country.

The symbolism which has gradually developed in China is a subject as yet imperfectly treated in any European tongue, and there is no doubt that a careful study of the popular emblems, and their evolution, will be found to shed an interesting light on the literature, fine arts, industry, and daily life of the inhabitants.

A close examination of the symbolism will show that it is founded on legendary matter which has been transmitted,

both verbally and in writing, from very distant ages, and in the process the nature of this legendary material has undergone certain variations, *i.e.*, a legend may lose certain elements, gain more elements, or some of its elements may be substituted for others. The Grecian philosopher Euhemerus advanced the theory that the gods of mythology were merely deified mortals; this theory, known as euhemerism, is quite obviously applicable to much of the Chinese mythology, and helps in the derivation of the fundamental origin of many otherwise inexplicable ideas. Other variations occur owing to the Chinese love of playing on words, organic or inorganic objects being often represented by others of similar sounding names; these might be called tautological variations. Different versions of the same legend will be found in different localities; these are geographical variations. Attempts have been made to compare the Chinese symbolism with that of other countries, but, apart from the motives imported with Indian Buddhism, most of the other fancied resemblances are probably due to mere coincidences on account of similar manners and customs, chiefly owing to the nature worship which forms the basis of most religions, and to the fact that the first necessity of all primitive peoples is to draw up a general code of behaviour, which is calculated to ensure the essential health and happiness of the tribe, i.e., the early folklore was animistic and therapeutic in its application to the human requirements of the times. The mere fact that corresponding legends exist in countries so far apart as China, Africa, and Iceland, is in itself no conclusive argument of early communication or connection between their respective inhabitants.

"The Chinese pantheon has gradually become so multitudinous that there is scarcely a being or thing which is not, or has not been at some time or other, propitiated and worshipped."[1] Their religious observances at present are chiefly a blend of Confucianism (儒), Taoism (道), Buddhism (釋), and Lamaism (喇嘛教)—a modified form of Buddhism. "This is borne out by the fact that in every Chinese funeral procession, such as is so frequently seen in a large town of China, no matter how long or short the procession may be, there are always bands of Buddhist and Taoist priests employed to say prayers on behalf of the deceased, and these priests are employed, not by Buddhists or Taoists, but by Confucianists."[2] The Chinese themselves admit that the three religions are but one religion (三教一教). Mahommedanism (回回教) also occurs, but is confined to the south-western and north-western

provinces. In this faith, also, the process of absorption into the national *potpourri* of beliefs is making way, and, since the suppression of the Panthay rebellion in 1837, when 30,000 Mahommedans were massacred, there has been a gradual decline in the number of the followers of the Prophet.

The underlying idea of Confucianism is essentially a reverence for the ruler, the family, and the social relationships, the cult observed by the "superior man." It is quite distinct, strictly speaking, from the mythology of Taoism with its numerous divinities to health, wealth, stars, rivers mountains, etc. "All Chinese life is permeated with Taoist fancy; the symbolism of the Chinese depends upon it; Chinese poetry is full of it; all Chinese legend and folklore teems with it. . . . The Buddhist religion had already become a complicated system of ritual and idol worship before it reached China. It was already a mixture of many things, and in China it had little difficulty in mingling into its structure many more." [3] It is difficult to say to what degree the mentality of the Chinese has been saturated and fertilized by Buddhist idealism, but there are everywhere signs of what Buddhism has been to China in the past. The careful observer may discern Buddhist thoughts in the ornamental stonework of an archway, the etchings on a metal tobacco pipe, in the countless ideographs of the long vistas of shop-signs, in the reliefs and designs on bronze utensils and chinaware, in the conventional patterns employed for the decoration of silk embroideries and carpets, in pictures and paper charms on house-doors, etc. There are reflections or echoes of Buddhist teachings in the composition of a garden, or the names of certain fruits and flowers. The life and character of the people show signs of Buddhist influences, the speech of the Chinese is interspersed with Buddhist utterances, while their literature and drama abound with Buddhist ideas and expressions.

It has therefore been considered necessary to introduce descriptions of many objects of religious worship into this work, and notices have been given of the principal Buddhist and Taoist deities, together with articles on Confucius and other celebrities. Birth, marriage, and death have also been treated to show the symbolic nature of Chinese ceremonial and its inseparable connection with religious elements. Animals and birds, both mythical and natural, trees, flowers, coins, weapons, etc., have also been examined from an emblematic point of view. The collected material has been arranged alphabetically, with cross references to other relevant articles.

The illustrations have all been drawn for me by various Chinese artists. I have to acknowledge my indebtedness to the following designs, which have been copied or adapted for the purposes of this publication:

From *Peking,* by ALPH. FAVIER. "Toy Pedlar," "Lama Priest Attired for Worship," "Swords" (adapted), "Lama Devil-dancers' Masks," "Dice and Playing-cards," "House in Process of Construction," "Chinese House."

From *History of Chinese Pictorial Art,* by PROFESSOR H. A. GILES. "A Hundred Colts" (two plates).

From *The Middle Kingdom,* by S. WELLS WILLIAMS. "Ancient Anatomical Chart," "P'an Ku Chi Selling Out the Universe" (adapted).

From *Chinese Music,* by J. A. VAN AALST. "Sonorous Stone," etc. (adapted).

From *Lamaism,* by L. A. WADDELL. "Insignia and Weapons of the Lama Gods" (adapted).

From *Myths and Legends of China,* by E. T. C. WERNER. "The Money Tree."

From *Chinese Porcelain,* by W. G. GULLAND. "Diaper Patterns" (adapted), "The Eight Ordinary Symbols," "The Eight Buddhist Symbols."

From *The Mentor,* 1st March, 1916. "Old Chinese Temple Rug," "A Plate of Willow Ware."

A certain portion of literature, especially books of reference, must always resemble the rambler rose, which has to climb up some protecting wall, rather than the fruit tree, which is supported only by its own firm trunk. Without relying considerably on the recognised authorities and specialists of sinology it would be impossible for any one individual to produce a sufficiently comprehensive record in the brief space of his own life-time. I have accordingly consulted a number of Chinese classical productions, together with the volumes on the shelves of the Chinese Customs Reference Library, and the Libraries of the Peking, Shanghai, Tientsin, and Hong Kong Clubs, as well as the Royal Asiatic Society, etc., in my attempts to bring together the necessary material relative to the subject in hand. I have been very careful to acknowledge all references to authors from whose works I have actually quoted, and I am deeply indebted to these valuable sources of information. It is possible, however, that I may have inadvertently omitted to specify chapter and verse in a few isolated cases, and, where this is so, I take the opportunity to offer my apologies.

The main object I have kept in view has been to collect,

amplify, and arrange some authentic information con-
cerning the fundamental symbolism, in the hope that it may
aid in the development of a finer appreciation of the workings
of the Chinese mentality and understanding of the people.
Moreover, it should also provide artists, designers of costumes
and upholsteries, etc., collectors of oriental curios (chinaware,
bronzes, rugs, ivory, pictures, and other objets d'art), as well
as advertisers of imports and exports, with suggestive ideas of
some assistance in the furtherance of their respective interests,
while students of Chinese will also be enabled to trace out the
significant influence of symbolism on the language and
literature of the country.

In conclusion I may say that I do not claim that this
volume is an exhaustive encyclopædia. It is merely to be
regarded as a practical handbook of the science of Chinese
symbolism as based on the early folklore, with illustrations of
typical forms; and, if it serves to any extent as a useful guide,
I shall be amply compensated for the labour involved.

C. A. S. WILLIAMS.

Customs College,
 Peiping, 1st October, 1932.

Authorities.

[1] Werner: *Myths and Legends of China*, Ch. IV, p. 93.
[2] Li Ung Bing: *Geography of China*, 1915, pp. 15-16.
[3] Clennell: *The Historical Development of Religion in China*,
 pp. 78, 106-7.

CHINESE SYMBOLISM
AND
ART MOTIFS

AGRICULTURE
(耕 種)

The Chinese have pushed agriculture to a high pitch of perfection with very simple instruments of husbandry. The natural fertility of the soil, combined with the industry of the farmer, are productive of abundant crops of cereals under favourable conditions of weather. The Ministry of Agriculture and Commerce has established experimental stations where efforts are being made to improve the culture of the various food products of the soil, and the Nanking Agricultural College has done much to advance modern methods of scientific farming.

The primitive Chinese plough is as ancient as the country, and is without colter or wheel, being merely a share point set in a very rude piece of bent wood, yet it answers the purpose remarkably well. It is generally harnessed to the yellow ox (黃 牛), or to the water-buffalo (水 牛).

Grain culture is of such importance in the national life that the Emperor used to set the example to the people every spring by means of a ceremonial ploughing (躬 耕) of "a sacred field with a highly ornamental plough kept for the purpose, the Emperor holding it while turning over three furrows, the princes five, and the high ministers nine. . . . A monstrous clay image of a cow is carried to the spot, containing or accompanied by hundreds of little similar images. After the field is ploughed it is broken up, and the pieces and small images are carried off by the crowd to scatter the powder on their own fields, in the hope of thereby insuring a good crop."[1] This ceremony, also known as "meeting the spring" (迎 春),

1

or "beating the spring ox" (鞭 春 牛), though no longer carried out by the government officials, is still kept up in some of the country districts, where it is believed that its omission would result in disaster to the crops, and it is held at the period known as *Li Ch'un* (立 春), which occurs about the 5th February, when the farmers have a holiday.

"A part of the iron of an old ploughshare is sometimes suspended on the outside of the clothing. At other times it is in a silver covering, having only a small part of the iron point projecting, or it is folded up neatly in a paper, and having been put into a small red bag, it is worn about the person." [2] The object is to keep away evil spirits, to whom the sharp metal is objectionable.

Good harvests being essential to the well being of the people, the rain-bringing dragon, the sun-producing phoenix, the spirits of land and grain (社 稷), the god of the soil (土 神), etc., are duly propitiated by means of shrines erected in the fields. In fact a good deal of the mythology and super-stition of the Chinese is bound up with the art of agriculture, which is said to have been originally taught to the people by the legendary Emperor Shên Nung (神 農), 2838-2698 B.C.

The Chinese *Materia Medica* (本 草 綱 目), or Herbal, deals with 1,892 botanical and natural history species, and contains 8,160 prescriptions for medicinal use. It was the work of Li Shih-chên (李 時 珍), who completed his task in 1578 after 26 years' labour. There are also many other books on agriculture and botany, in which a wealth of detail and abundance of illustration have been recorded and transmitted from very ancient times.

Among the principle agricultural products of the country are rice, wheat, maize, kao-liang, millet, barley, oats, buck-wheat, beans, peas, sesamum, rape, hemp, jute, ramie, taros, yams, sweet potatoes, marrows, and fruit of many kinds.

"The great defect in Chinese agriculture—ignorance of methods of improving the seed by selection and crossing— is a particularly serious drawback in the cultivation of rice." [3]

"A Chinese family consisting of three generations could live comfortably on a piece of ground scarcely large enough to place the implements of many an American farm. There may or may not be a horse to help to till the ground; probably there will be a cow, a buffalo or a donkey. Human labour is the main source of energy, and the farmer, his wife and children all work unremittingly, bestowing individual attention to each

2

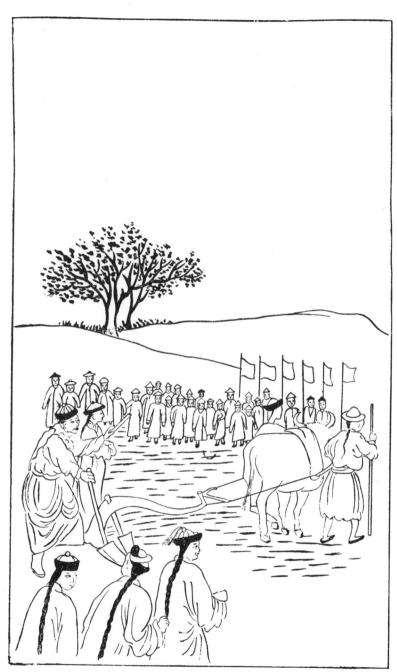

SACRIFICIAL PLOUGHING

root, almost to each stalk that grows. The ubiquitous pig, a great factor in Chinese agricultural economy, is often an inmate of house as well as of shed. . . . The water-wheel is used in farming for raising water from a running stream or pond to irrigate fields. It is made entirely of bamboo and wood, no metal being employed. It is supported by a framework of bamboo poles placed close to the bank on to which the water is to be raised. When this is taken from a stream the wheel is driven by the pressure of the water against flat pieces of wood attached to the periphery to which are also fastened bamboo tubes. These tubes fill with the water as they pass through it and as the revolution of the wheel carries them to the top they discharge into a trough from which the irrigating canals radiate. In places where the water is stationary the wheel is turned by men treading on it. Wheels of this kind are sometimes over 30 feet in diameter."[4]

The Chinese symbol for "well," *ching* (井), is an agricultural key-word denoting fields anciently laid out along the lines of this character. Each *ching* was divided into nine plots. To eight families were assigned the eight exterior plots, the one in the centre, containing a well with four roads leading to it, being reserved to be worked in common on behalf of the State. Thus China began with an equalized system of land tenure and taxation. The word for "earth" is denoted by the symbol (土), of which the upper line is the surface soil, and the lower the sub-soil or rocky substratum, while the central stroke represents the vegetation; the word "field" (田), unmistakably portrays the dykes of the rice or "paddy" fields; while the character for "man" or "male" is a combination of "power" and "field" (男), literally "labour in the fields"; the sign for "rice" (米), is a figure depicting four grains divided by the form +, expressing the separation by threshing. These derivations illustrate the vital importance of agriculture to the Chinese from time immemorial.

AUTHORITIES.

[1] Williams: *Middle Kingdom*, Vol. II, p. 108.
[2] Doolittle: *Social Life of the Chinese*, p. 561.
[3] Dingle and Pratt: *Far Eastern Products Manual*, No. 181.
[4] *Catalogue of the Collection of Chinese Exhibits at the Louisiana Purchase Exhibition, St. Louis*, 1904, published by order of the Inspector General of Customs, China, pp. 86, 354-5.

ALARM-STAFF
(警 杖)

Sanskrit, *Hikile* or *Khakhara.* A staff with a leaf-like loop at the top, with jingling rings, carried by the mendicant

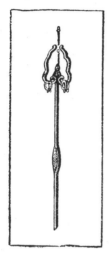

monk to drown by its jingling all worldly sounds from the ears of the holder and to warn off small animals lest they be trod upon and killed. Buddha is said to have possessed a "pewter staff" (錫 杖), the shaft of which was made of sandalwood, and the head and rings of pewter. Sometimes a priest wears clogs with only one cross-piece instead of two to make the least possible sacrifice of creeping life.

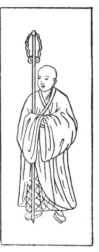

The primary laws of Buddhism forbid the taking of animal life under any circumstances whatever.

ALARM-STAFF

BUDDHIST PRIEST
WITH ALARM-STAFF

Were these laws rigidly observed, the lives of obnoxious insects, reptiles, etc., would be inviolate. They are, however, practically disregarded, except in relation to some of the larger animals, though birds are generally kindly treated by the Chinese, and considerable merit is believed to accrue to those who purchase fish, tortoises, etc., at religious festivals, and return them to their natural element.

AMBER
(琥 珀)

Amber, which is a fossilized resin exuded in ages past by certain extinct species of pine-trees, is found in China in the Province of Yunnan, embedded in the earth. It was first mentioned in the first century A.D.

Ordinary amber is known to the Chinese by the name of 琥 珀 (*hu-p'o*) a term which is derived from 虎 魄 (*hu-p'o*),

5

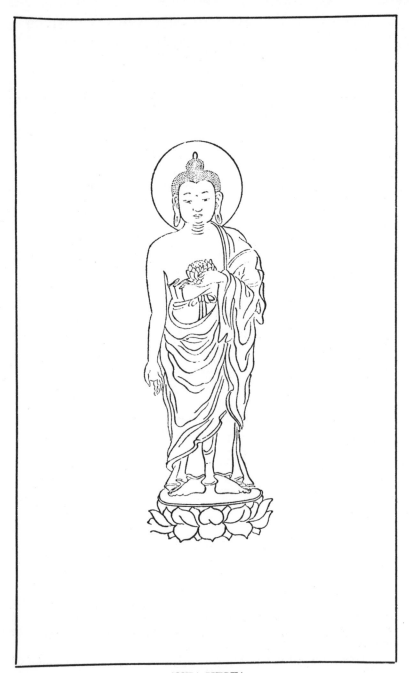

AMIDA BUDDHA

6

meaning "the soul of a tiger," the latter term originating in the old Chinese tradition that when a tiger dies its spirit enters into the ground and becomes transformed into a mineral. Hence this substance is popularly regarded as symbolic of courage, being supposed to be imbued with the qualities of that fierce animal. The variety known as "blood amber" (血 珀) is chiefly used in Chinese medicine as an aphrodisiac, but here again its power is chiefly emblematic of its supposed origin.

The value of true amber depends upon the size, form, colour, and transparency of the product. There are numerous imitations made of sheep's horn, copal, shellac, resin, celluloid and glass.

AMITABHA
(阿 彌 陀 佛)

Lit: Boundless Light. Amida Buddha. The abbreviated form of *Namah Amitabha* (南 無 阿 彌 陀 佛), "Hear us, O Amida Buddha!" His image is often seen in the second court of the Buddhist monastery by the side of the figure of SHAKYAMUNI BUDDHA (*q.v.*).

This popular Buddha came to the front early in the 5th century A.D. There are various traditions as to his origin. He is said by some to be an incarnation of the ninth son of the ancient Buddha *Maha bhidjna bhibhu*, by others the second son of a certain Indian of the lunar race, or again, the celestial reflex of SHAKYAMUNI BUDDHA.

Amitabha is also known as the Impersonal Buddha. He is an object of popular devotion, and is believed to preside over the Paradise of the West, the Pure Land, into which the souls of the pious may be born, there to rest in bliss for a long age.

AMUSEMENTS
(玩 耍)

The principle amusements of the Chinese are of a very simple nature, and although football, tennis, and other athletic games are gradually becoming popular among the younger generation, the average individual does not usually indulge

7

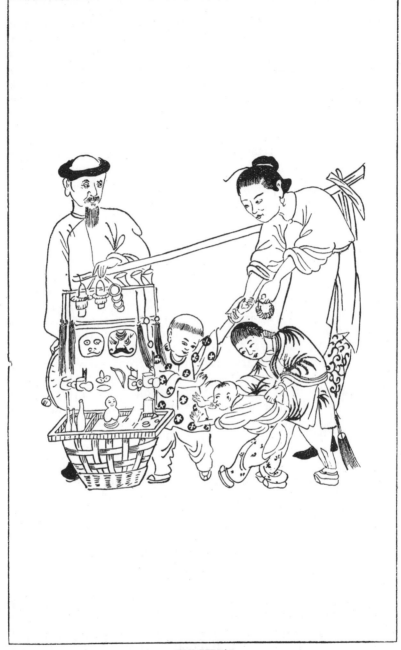

TOY PEDLAR

8

in sports which entail any considerable amount of physical exertion.

Young children may often be seen pitching coppers, fighting quails or crickets, or guessing the number of seeds in an orange. "Among their out-of-door amusements, a very common one is to play at shuttlecock with the feet. A circle of some half a dozen keep up in this manner the game between them with considerable dexterity, the thick soles of their shoes serving them in lieu of battledores, and the hand being allowed occasionally to assist." [1]

There is scarcely any one vice to which the Chinese are so generally addicted as gambling; it prevails among rich and poor, young and old, and to the injury of all. There are various games of cards (紙 牌); an ordinary pack of cards

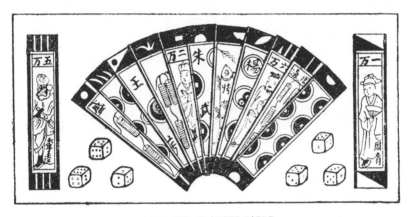

DICE AND PLAYING-CARDS

consists of 160, about 2½ by ¾ inches in size, with black backs; throwing dice (骰 子), and playing dominoes (牙 牌), are also extensively practised; *Fan-tan* (番 攤), a gambling game played with brass cash, is common in South China; *Mah-jong* (麻 雀), is played with 136 dominoes called "tiles," which take the place of playing-cards. The tiles have numbers and also suits—the winds, dragons, Chinese characters, bamboos and circles. At the beginning of the game the "tiles" are arranged in a square "court," which has four walls, each 17 tiles long and two tiles high. The walls are built indiscriminately. The player taking the last wall breaks the square by extracting two tiles. Each player then takes 13 tiles in turn. From this point the players start making sets and sequences of tiles, as in poker. Fresh tiles are taken in

9

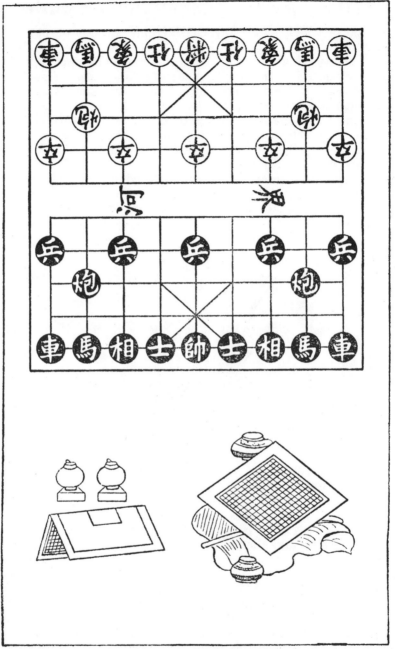

TOP: HSIANG-CH'I, OR ELEPHANT CHECKERS, WITH BOARD. BOTTOM WEI-CH'I, OR SURROUNDING CHECKERS. BOARDS, WITH WOODEN RECEPTACLES FOR CHECKERS (CONVENTIONALLY TREATED)

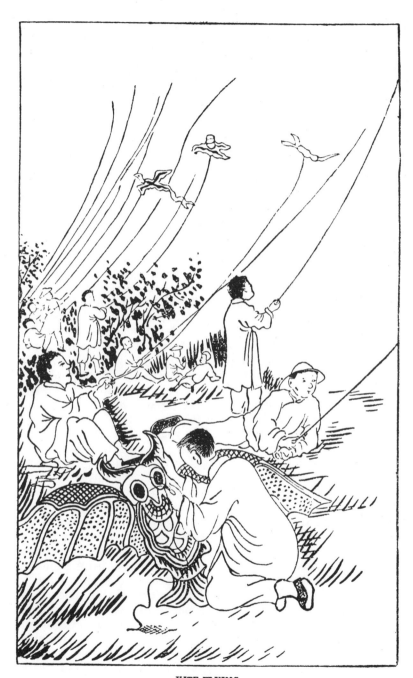

KITE-FLYING

11

turn and discarded tiles thrown into the court. Points are awarded according to the values of the tiles and the various sets and sequences made. *Chai-mui* (猜枚), or Guess-fingers, is a regular amusement at dinner-parties. The Game of Promotion (陞官圖), is a favourite with the Chinese. It is played on a board or plan representing an official career from the lowest to the highest grade, according to the imperial system. It is a kind of ludo played with four dice, the object of each player being to secure promotion over the others. *Wei-ch'i* (圍棋), or "surrounding checkers," is played with black and white counters on a board of 324 squares, while *Hsiang-ch'i* (象棋), or "elephant checkers," is a game distinctly analagous to Western chess.

"A favourite amusement is the flying of kites. They are made of paper and silk, in imitation of birds, bats, butterflies, lizards, spectacles, fish, men, and other objects; but the skill shown in flying them is more remarkable than the ingenuity displayed in their construction."[2] Not only boys, but grown men, take part in this amusement, and the sport sometimes consists in trying to bring down each other's kites by dividing the strings, which are rubbed together. The ninth day of the ninth moon is a festival devoted to kite-flying all over the land. On this day the people repair to the highest piece of ground or the loftiest roofs available, and employ their time in flying kites and drinking wine in which chrysanthemum petals have been soaked. The origin of this custom has to be sought for nearly a thousand years ago. Legend has it that during the later Han dynasty a certain Huan Ching (桓景), of Joo-nan (汝南), pupil of the magician Fei Ch'ang-fang (費長房), was suddenly warned by the latter to betake himself with his family to a high mountain, to escape a calamity which was destined to overtake the district in which he lived. On the mountain-top he was bidden to wear a bag containing fragments of dog-wood (*Evodia rutaecarpa*), and to drink wine in which the petals of chrysanthemums had been soaked, to ward off evil influences. These injunctions he obeyed to the letter, and was rewarded by escaping from an overwhelming catastrophe which destroyed his flocks and herds in the plain below. In memory of this signal deliverance, people on this day go up annually to the mountains and hills in imitation of Huan Ching. The kite-flying, which is now invariably associated with these expeditions, finds no foundation in the original fable, and was very likely suggested by the combination of circumstances, a high elevation, and a

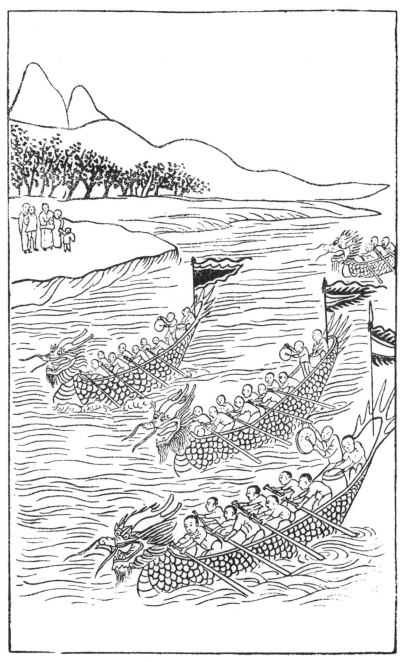

THE DRAGON BOAT FESTIVAL

13

fresh autumn breeze. It is also said that kites are flown in honour of Mêng Chia (孟嘉), 4th century, A.D., of whom it is recorded that, when his hat was blown off by the wind at a picnic, he remained quite unconscious of his loss. Kites (風箏), were used as early as the 2nd century B.C. for purposes of military signalling. To some kites a kind of Aeolian harp is attached. Bamboo frames, with fire-crackers attached, are sometimes sent up the string, the crackers being timed to explode on reaching the top.

Theatrical entertainments constitute a common amusement, and are often arranged by the priests for the ostensible purpose of repairing their temples (*vide* DRAMA).

"The general and local festivals of the Chinese are numerous, among which the first three days of the year, one or two about the middle of April to worship at the tombs, the two solstices, and the festival of dragon-boats, are common days of relaxation and merry-making; only on the first, however, are the shops shut and business suspended."[3] (*Vide* ANCESTRAL WORSHIP, DRAGON, FIRE).

AUTHORITIES.

[1] Davis: *The Chinese*, London, 1836, Vol. 1, p. 318.
[2] Williams: *The Middle Kingdom*, Vol. 1, p. 826.
[3] Williams: *The Middle Kingdom*, Vol. 1, p. 809.

ÂNANDA

(阿難)

"A first cousin of SHÂKYAMUNI (*q.v.*), and born at the moment when he attained to Buddhaship. Under Buddha's teaching, Ânanda became an Arhat, and is famous for his strong and accurate memory; and he played an important part at the first council for the formation of the Buddhist canon. The friendship between Shâkyamuni and Ânanda was very close and tender; and it is impossible to read much of what the dying Buddha said to him and of him, as related in the Mahâpari-nirvâna Sûtra, without being moved almost to tears. Ânanda is to reappear on earth as Buddha in another Kalpa."[1]

AUTHORITY.

[1] Legge: *Travels of Fa-hien*, p. 33, note 2.

ANANDA, THE FAVOURITE DISCIPLE OF BUDDHA, AND COMPILER
OF THE BUDDHIST SCRIPTURES

15

ANCESTRAL WORSHIP
(祭 祖)

A very ancient cult of the Chinese, consisting in the honours paid to the *manes* or departed spirits, either at the grave-side, or before the ancestral tablets set up in the house. The tablet is generally about twelve inches long and three inches wide, bearing the name and date of birth, and having a receptacle at the back, containing a paper setting forth the names of the more remote family ancestors. Incense is burnt and ceremonial offerings of food are made in honour of the dead; the worship on the hills (拜 山), or at the tomb, takes place in spring and autumn.

The filial piety, which is so great a moral asset of the people, has its origin in ancestral worship. If the departed souls are not reverenced, it is believed that they will work evil upon their living kindred. "Filial piety," said Confucius, "consists in obedience; in serving one's parents when alive according to propriety; in burying them when dead according to propriety; and in sacrificing to them according to propriety." The reviling of a person's ancestors is regarded as the worst form of abusive language.

All Souls' Day, or the Buddhist Festival of Departed Spirits, is called in Chinese *Yü Lan P'ên Hui* (孟蘭盆會), Sanskrit, *Ullambana, lit.*: "the vessel to hold offerings." It is celebrated on the 15th day of the 7th moon, chiefly for the purpose of saying masses for the solitary souls (孤 魂), of those who died away from home, and have nobody to perpetuate their memories by ancestral worship. During the Festival of Tombs, *Ch'ing Ming* (清 明), at the end of the 2nd moon, occasion is also taken for the worship of departed spirits. This festival is also for the purpose of celebrating the spring, and was originally the time for the rekindling of the cooking fires, which were supposed to be put out for three days, when cold food (寒 食), was eaten by all the people.

ANT
(螞 蟻)

The composition of the written symbol for the ant denotes that it is the *righteous* (義), *insect* (虫), in reference to its orderly marching and subordination.

The internal arrangements of the chambered nest of

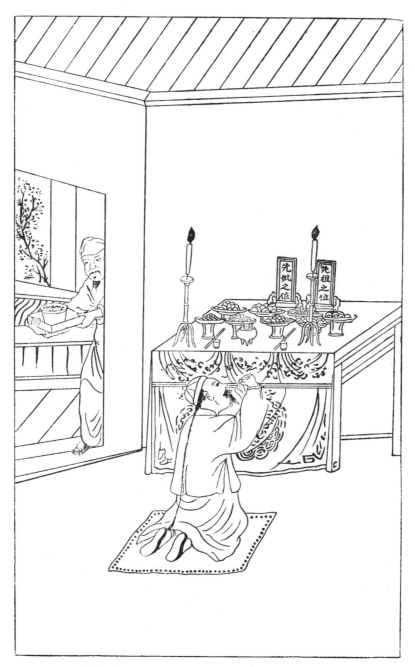

WORSHIPPING BEFORE THE ANCESTRAL TABLETS

17

earth, in which the ants maintain a perfect system of order, store their provisions, and nurture their young on the milk of the aphis, have been described by Chinese writers with considerable accuracy.

The white ant (白蟻), or termite, in its larval stage, commits great depredations upon the woodwork of buildings in South China. It is sometimes attacked and destroyed by a species of small black ant. A variety of pine-wood (眞杉木), is said to resist the ravages of white ants, and is therefore employed for the construction of the beams and joists of Chinese houses.

The ant is the emblem of virtue and patriotism, but at the same time it symbolises self-interest, and striving for filthy lucre, as evidenced in the metaphorical expression: "Ants cling to what is rank smelling" (羣蟻附羶), which has this significance. The Chinese people have been compared to ants, on account of the manner in which they overcome difficulties by dint of mere numbers; while they resemble these minute animals no less in their persevering and untiring industry.

APPLE
(蘋 果)

The true apple, *Malus sylvestris*, is not cultivated in China; the varieties found are more akin to *M. prunifolia*, being handsome in appearance but of poor flavour.

The wild crab-apple *M. baccata* (山荆), is very abundant in the North. The small cherry-apple, *Pyrus spectabilis* (海棠), is also common.

Apple blossom is sometimes employed as a decorative motive, and is regarded as an emblem of feminine beauty. On account of the similarity in the sound of the Chinese word for "apple," *p'ing* (蘋), and "peace," *p'ing* (平), the gift of a few apples suggests the idea of perpetual concord, and is equivalent to the greeting, "Peace be with you."

APRICOT
(杏)

Prunus armeniaca. Many varieties of apricot are grown in terraces on the hill-sides in North China. The edible

18

kernels （杏核）, take the place of almonds, which they resemble.

The fruit is an emblem of the fair sex, and the slanting eyes of Chinese beauties are often compared to the ovoid kernels.

The following lines are ascribed to Sung Tzŭ-ching （宋子京）, A.D. 998-1061, President of the Board of Works and a celebrated author:

"The scholar has reaped the reward that is due,
 And homeward returns on his wearying steed;
When the blossoming apricots come into view,
 He urges his charger to bear him with speed."

（一 色 杏 花 紅 十 里 狀 元 歸 去 馬 上 飛）

ARCHITECTURE
（建 築）

"It is generally supposed that the remote ancestors of this nation, in their migration eastward, dwelt in tents: their circumstances would require such habitations; and when they became stationary, their wants would prompt them to seek some more substantial covering from the heat and the storm. But the tent was the only model before them; and that they imitated it, their houses and pagodas, built at the present day, afford abundant proof. The roof, concave on the upper side, and the verandah with its slender columns, show most distinctly the original features of the tent."[1]

The fact that the Chinese roof is curved in its pitch, and also at the corners, is also explained by the *Chou Li* （周禮）, or "Ritual of the Chou Dynasty," in the chapter on building rules, which states that the angle or pitch of the roof near the ridge should be greater than the pitch near the eaves, because the greater incline at the top enables the rain-water to flow with greater velocity, while the gentle upward slope at the bottom throws it out some distance from the wall of the house.

The first brick houses are said to have been built by the tyrant Emperor Chieh Kuei （桀 癸）, 1818 B.C. The earliest type of brick used by the Chinese, and still used to a large extent in making houses throughout the country districts in the smaller towns, was moulded by hand between boards and sun-dried. The curved roof is constructed on wooden pillars, the spaces between which are filled in with stone or brickwork.

The original style of Chinese architecture is altogether

EMPEROR SHIH OF THE CH'IN DYNASTY DESIGNING THE GREAT WALL OF
CHINA. THE GRAND SECRETARY OF STATE IS LAYING OUT A SAND MODEL
UNDER THE IMPERIAL DIRECTIONS

different to that of the West. In building an ordinary house, the foundation is made by digging a shallow trench, wherein are placed a few rough-hewn stones, not laid as wedges, but filling in angles, and thus mutually supporting each other; four or more pillars of wood are then set upon, not into the mud of which the floor is to be made, standing each on a small slab of stone, thicker or thinner, if any dissimilarity in the length of the several pillars must be made up; four crossbeams make the framework on which the roof is to be laid, being of rafters and loose tiles; lastly rise walls of mud or bricks. The walls having little or no connection with the roof or the pillars, do not always follow the same line but may incline outward or inward. The roof, if a little top-heavy, as it generally is, gives a jaunty air to the pillars, and, to lend the additional support which seems so much needed, large sloping beams or buttresses are driven into the earth at each side of the house. The pillars, ceiling, and roof are then daubed with red paint, the walls plastered, and, if the purse and taste of the proprietor permit, gilded tablets inscribed with the old Chinese character, gay flowers, and grotesque monsters in paint or relief, cover the walls and cornices; altars and niches for idols being added if space will allow.

"Houses are frequently built against some hill, if there be any. Where wood is abundant, they are constructed of it, being supported by posts, between which is a kind of coarsely woven mat-work, covered with mud and then whitened with lime. The pieces of timber-work perfectly joined and exposed to view, are, so to speak, like a frame that may be taken to pieces, and transported from place to place at pleasure. When there is a scarcity of wood, the walls are constructed of bricks, mud, or stone, and the roof of gutter tiles or thatch. In the province of Kwangtung, the houses are almost all of bricks, having scarcely anything but a ground floor. In cities, many have an upper story, or more properly a garret. They must not equal the temples in height, a thing which would expose him, who might be so daring as to attempt it, to a lawsuit, and his house to demolition. As to the interior, the apartments are badly distributed, and badly ventilated. Instead of glass there are latticed windows prettily carved and covered with silk paper. The first apartment entered is the hall for the reception of strangers, which is likewise the dining-room, and extends through the house, or the main building, if there are several edifices united. From this hall we pass on to the other apartments, which no person, not even a kinsman, can

21

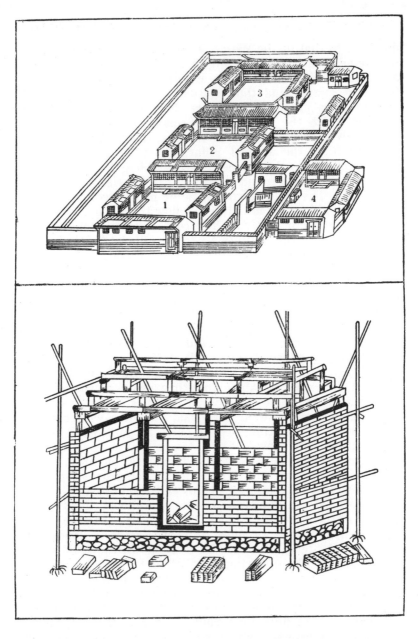

TOP: CHINESE HOUSE. 1, COURT WHERE VISITORS ARE RECEIVED. 2, OWNER'S
QUARTERS. 3, COURT RESERVED FOR WOMEN. 4, SERVANTS AND DEPENDENTS.
BOTTOM: HOUSE IN PROCESS OF CONSTRUCTION

22

enter, unless he be a very near relative. There is no floor except in the houses of the wealthy, and no ceiling unless there be an upper storey. Seen at a distance, the better Chinese houses present a pretty appearance but the interior by no means corresponds to the outside. As they are generally of only one storey, an individual sometimes occupies as many as three contiguous buildings, and hence it is not surprising that their towns should occupy a great space. In front of the house there is always a pretty yard or court, which serves for drying rice, threshing, and divers other purposes; the rear and sides are environed with trees or bamboos, and if there are several main buildings, they are separated by inner courts.

"The temples, much higher than dwelling houses, have usually a beautiful front, supporting a stage for actors. The corners of the roof, which is sharper than that of a private edifice, are turned up in the manner of a cornice, and on the right and left of the entrance, are placed huge lions in stone, of inferior sculpture. After passing the portal, we enter a spacious court surrounded by long galleries resting upon columns. At the further extremity of this is the proper temple, where are figures in wood or stone of various colours, which, though varnished and gilded, are for the most part very hideous. Before these are set open dishes, and large vases, bearing lights and incense burnt in honour of the gods. At the side are one or two iron bells and a large drum. Besides the principal edifice, which is properly the sanctuary, there are lateral apartments where the priests lodge. A temple built against a rock, upon a hill, or in the midst of a grove, presents to the eye a very picturesque view. The Chinese erect upon certain eminences towers of many stories in height. These are of a hexagonal or octagonal shape, and much overtop the temples. Each storey supports a jutting roof, which does not so much serve to shade the gallery under it, as to contribute to the beauty of the structure. Such towers are built in the neighbourhood of cities, not at all for their defence, but to secure prosperity to the inhabitants, and to avert calamities." [2]

Superstition accounts for the prejudice against two-storied buildings, or of any building dwarfing its immediate neighbours, as this deprives the humbler dwelling of Heaven's guardianship. Height is also limited by the belief that good spirits soar through the air at a height of 100 feet, a restriction of moment only in gate temples and other buildings on city walls. Climate and the belief that good

spirits blow from the south have decided the orientation of buildings with a southern aspect and windowless north walls. The abhorrence of a tortuous path, which is a characteristic of evil spirits, has given us the spirit walls which defend so many gateways. For the same reason we have the upcurved roof ridge with its dragon finials.

The most striking features in the best native buildings are the roofs and gables, with their ridges and fantastic gargoyles (龍頭), of plaster or porcelain. These gargoyles represent various creatures perched in single file on the angles of the roof, each one cast in a single piece with the tile on which it is resting. The origin of the figures is as follows:—

"In the year 283 B.C. the cruel tyrant, Prince Min, of the State of Ch'i, after being defeated by a combination of other states, was strung up to the end of a roof ridge and left hanging there without food or water, exposed to the burning rays of the sun until he died. In order to stigmatize his evil deeds the people of the State of Ch'i placed his effigy, riding a hen, on the roof of their houses. With the weight of the prince on its back, the hen could not fly down to the ground, and in order to prevent it escaping over the roof, a *ch'i wên*, a kind of dragon, was placed at the other end of the ridge. This is the fierce beast you see, with horns and bushy tail and its mouth wide open, as if to swallow Prince Min and the hen, if they venture near him. It was not until the time of the Ming Emperor Yung Lo that the other figures were added. A correct set was put together in the following order: hen, dragon, phoenix, lion, unicorn, celestial horse, *ch'ih wên*. If more were required, any of the figures could be repeated, with the exception of the hen and the *ch'ih wên*, but always so as to form an odd number up to eleven. The reason for this was that odd numbers come under the influence of *Yang* or Male Principle. However, in later times both the principle of odd numbers and the conventional arrangement of the set were departed from. In most cases the only figures that were used, between the hen and the *ch'ih wên*, were those that foreigners call dogs, but which are really lions. Moreover, since the latter days of the Republic, even the hen with Prince Min was removed from the roofs of public buildings, so as to prevent, it is said, any possible unpleasant political comparisons." [3] It is a custom of the Chinese builders, on fixing the upper beam of the roof of a building, to let off fireworks and worship it, or the spirits that preside over the ground on which the house stands. To

suspend a piece of red cloth, and a corn-sieve, from the upper beam, is supposed to promote felicity—the latter to cause an abundant harvest of grain during the year. Placing money beneath the base of a wall or below the threshold of a door is also done for the promotion of happiness and felicity on the building. Pine branches are affixed at the top of the scaffolding poles on which the builders stand, so that wandering spirits of the air will be deceived into the belief that they are passing over a forest, and will not adversely affect the success of the construction work, or bring bad luck on the house.

"Engraved rocks are seen in China, though the practice is not carried to the same extent as in Persia, India, and other eastern countries, to commemorate remarkable events, for the literature of the people obviates the necessity. The smoothed surface of rocks *in situ* are, however, engraved with characters under the direction of geomancers, when they lie in spots esteemed lucky; such characters are supposed to have some cabalistic influence upon the fortunes of the surrounding country. The pillars and door-posts of temples, and the entablatures of honorary portals are often inscribed with sentences and names; sometimes to commemorate distinguished or worthy individuals, and sometimes merely for ornament's sake; the skill displayed in cutting these inscriptions is at times almost inimitable. The government also employs this mode of publishing their laws and regulations, just as the Romans anciently published their Twelve Tables, which are, as the officers say, to be kept in everlasting remembrance; the characters are plainly and deeply engraved upon marble, and the slab is afterwards set up in a conspicuous spot in such a manner as to preserve it from the effects of the weather."[4]

"Memorial arches (牌樓), are scattered in great numbers over the provinces, and are erected in honour of distinguished persons, or by officers to commemorate their parents (formerly), by special favour from the Emperor. Some are put up in honour of women who have distinguished themselves for their chastity and filial duty. Permission to erect them is considered a high honour. They are placed in conspicuous places in the outskirts of towns, and in the streets before temples or near government edifices. Some of these arches are elaborately ornamented with carved work and

25

inscriptions. Those built of stone are fastened by mortises and tenons in the same manner as the wooden ones; they seldom exceed twenty or twenty-five feet in height. The skill and taste displayed in the symmetry and carving upon some of them are very creditable."[5]

The architecture of old Peking is full of symbolism (*vide* No CHA). It has a beautiful appearance as viewed from the surrounding wall, from which can be seen an entrancing vista of temples and palaces, their curving roofs glittering with blue, green

" THE FORBIDDEN CITY," PEIPING

and yellow tiles, among the groves of trees with which the city abounds. The ancient capital presents a rather unique aspect from an aeroplane, from which we can observe that it is not only one city, but a veritable conglomeration or nest of cities, one packed within the other—like a Chinese puzzle. The shape of the whole collection is that of a square imposed upon a parallelogram. This square figure, in the north, consists of the Tartar or Inner City, while the adjoining parallelogram in the south contains the Chinese or Outer City. In the centre of the Tartar City is the Forbidden City, surrounded by the Imperial Palaces, which are open to the public on payment of a small fee. At one time they held many valuable treasures, most of which have since been removed by the Government. The main city and all its internal cities are each surrounded with separate battlemented walls of earth, concrete and brick.

Among the noted achievements of the Chinese are their great roads, numerous canals, and immense single-arched bridges; but above all the "Ten Thousand Li Rampart" (萬里長城), or Great Wall, which traverses high mountains, crosses deep valleys, spans broad rivers, and extends to a length of 1,500 miles.

In modern times there is a tendency among the Government Officials and the wealthy classes to conform more

or less to the styles of western architecture, and factories have now been built which are turning out firebricks, stoneware piping, glazed tiles, flint line tiles, roofing tiles, drain-pipes, foundation bricks, and ordinary building bricks.

AUTHORITIES.

[1] *The Chinese Repository*, Vol. II, 1833, p. 194.
[2] *Loc. cit.*, Vol. IX, Nov. 1840, Art. III, pp. 483-4.
[3] Arlington and Lewisohn: *In Search of Old Peking*, 1935, pp. 29-30.
[4] *The Chinese Repository*, Vol. VIII, April 1840, Art. V, p. 644.
[5] *Catalogue of the Collection of Chinese Exhibits at the Louisiana Purchase Exposition*, St. Louis, 1904, p. 190.

ASTROLOGY

(星 命)

There is an intimate connection between geomancy, horoscopy, astronomy, and astrology, and it is difficult to determine precisely where the one begins and the other ends.

Climatic changes (風 水), are said to be produced by the moral conduct of the people through the agency of the sun, moon, and stars.

The YIN and YANG (*q.v.*), and the FIVE ELEMENTS (*q.v.*), together with the EIGHT DIAGRAMS (*q.v.*), enter largely into Chinese astrological calculations.

The planets are classed as: *Shao Yin* (少 陰), or Lesser Negative Influence; the fixed stars as *Shao Yang* (少 陽), or Lesser Positive Influence; the sun, *T'ai Yang* (太 陽), Major Positive Influence; and the moon, *T'ai Yin* (太 陰), Major Negative Influence; their potency varying according to their positions in the zodiac (黃 道), and the twelve divisions of the ecliptic (十 二 宮). These twelve divisions or mansions mark the twelve places at which the sun and moon come into conjunction, and each has its distinguishing name as follows:— (1) 降 婁; (2) 大 梁; (3) 實 沉; (4) 鶉 首; (5) 鶉 火; (6) 鶉 尾; (7) 壽 星; (8) 大 火; (9) 析 木; (10) 星 紀; (11) 元 枵; (12) 娵 訾. They are in some degree analagous to our signs of the zodiac, and also correspond to the animals and hours of the TWELVE TERRESTRIAL BRANCHES (*q.v.*). The zodiac is divided into 28 constellations (*vide* STARS).

In the computation of a fortunate time to undertake any given enterprise, a favourable combination of the eight horos-

ASTROLOGER CASTING A HOROSCOPE

28

copic characters is arrived at. These eight characters are the four pairs of characters representing the year, month, day, and hour. The characters denoting the year are those of the Twelve Branches and Celestial Stems in the Chinese cycle (*vide* CYCLE OF SIXTY). Those denoting the month are the combinations of Branches and Stems assigned to that month (*vide* Table of Months under MOON), being the epoch in the annual cycle. Those denoting the day are the combinations of Branches and Stems assigned in the lunar calendar to that day, being the epoch in the lunar monthly cycle. Those denoting the hour are the combinations of Branches and Stems representing that hour (*vide* TWELVE TERRESTRIAL BRANCHES and TEN CELESTIAL STEMS), being the epoch in the daily solar cycle. By considering the mutual affinities of these eight characters as referred to the Yin and Yang, Five Elements, etc., the good or bad auspices of any undertaking may be determined. The same system applies to birth, death, and marriage, and in fortune-telling. The eighty cyclical characters (八字), pertaining to the time of birth, are communicated between betrothed persons and occasionally between bosom friends or sworn brothers. Chinese calendars are often made up in the style of *Old Moore's Almanac*, with full directions as to omens and portents, and what undertakings can best be carried out on each particular day, all worked out by the rules of astrology.

The appearances of comets, and eclipses of the sun and moon, are believed to have a malign influence over the affairs of men. "In an astrological sense Mars symbolises fire, and rules the summer season. It is the author of punishments, and is the producer of sudden confusion. Saturn represents earth, and, when it meets Jupiter in the same 'house,' it portends good fortune to the empire. If, however, Saturn, with the four other planets, should appear white and round, mourning and drought are in store for the country; if red, disturbances are to be expected, and troops will take the field; if green, floods are to be looked for; if black, sickness and death will spread over the land; and if yellow, a time of prosperity is at hand. Venus represents gold, and is deemed a complacent planet, but, while in many of its phases it foretells peace and plenty, it at other times presages the movements of troops, and the disruption of the empire. If it at first looms large, and afterwards small, the national forces will be weak, and if contrariwise, they will be strong. If it appears large and extended, trouble will fall upon princes

and nobles, and military expeditions, then undertaken, will begin fortunately and end with disaster; but, if it should appear compact and small, campaigns which begin in misfortune will end successfully. Mercury symbolises water, and, when seemingly of a white colour, it forecasts drought; when yellow, the crops will be scorched up; when red, soldiers will arise; and when black, floods are at hand. If it appears large and white in the East, troops beyond the frontier will disperse; if red, the Middle Kingdom will be victorious; in certain conjunctions with Venus, it portends great battles in which strangers will be victorious; and if it approaches Venus, several tens of thousands of men will meet in strife, and the men and ministers of the ruler will die." [1] (*Vide* also ASTRONOMY, FENG SHUI, MOON, STARS, SUN.)

AUTHORITY.
[1] Douglas: *China*, 1882, pp. 275-6.

ASTRONOMY
(天 文)

Astronomy has from time immemorial been a favourite study with the Chinese, and the literature on the subject is extensive. Their knowledge of this science is considerable though not profound. "It has enabled them to calculate eclipses and to recognise the precession of the equinoxes, but it has left them with confused notions on subjects which are matters of common knowledge among western peoples. The earth, according to their notions, is flat, immovable, and square, measuring about 1,500 miles each way. The sun, the diameter of which is 333 miles, stands at a distance of 4,000 miles above it, but considerably below the sideral heaven, the distance of which from the earth has been found, by 'the method of right-angled triangles, to be 81,394 *li* (3 *li*=1 mile), 30 paces, 5 feet, 3 inches, and six-tenths of an inch! The months and seasons are determined by the revolution of Ursa Major. The tail of the constellation pointing to the east at nightfall announces the arrival of spring, pointing to the south the arrival of summer, pointing to the west the arrival of autumn, and pointing to the north the arrival of winter." [1]

The Imperial Board of Astronomy (欽天監), was founded in the 13th century and joined to the Ministry of Public Instruction in 1913. Its chief function was the preparation, printing, and distribution of the calendar, which was

a government monopoly. The Jesuit missionaries have done much in the development of the science of astronomy and regulation of the lunar calendar in China. The old Peking Observatory (觀星台) contains a number of bronze astronomical instruments, many of which date from the 13th century; some of these were removed by the Germans after the Boxer outbreak of 1900, and returned in 1921. (*Vide* also ASTROLOGY, MOON, SUN.)

AUTHORITY.

1 Douglas: *China*, 1882, p. 385.

AXE
(斧)

Sanskrit, *Parasu*. The character *Fu* (斧), axe, is said

ANCIENT
BATTLE-AXE

BUDDHIST
AXE

to be analogous to *Fu* (甫), to begin, because to make any wooden article it is necessary to begin by cutting down a tree. In fashioning an axe-handle it is necessary to have another as a model; in contracting a marriage it is necessary to have a go-between; hence the axe has become symbolic of the marriage go-between.

It is one of the weapons or insignia pertaining to some of the Buddhist deities, and it is also the emblem of Lu Pan (魯班), a famous mechanic, who lived in the State of Lu about 500 B.C., and is now worshipped as the God of Carpenters.

AZALEA
(杜鵑花)

"The Chinese botanists having observed that several Ericaceous and Solanaceous plants, having stamens whose anthers open by pores at the apex, are strongly narcotic, have lumped together species of Azalea, Andromeda, Rhododend-

31

ron and Hyoscyamus under this heading." [1] The principal varieties are the *Nao yang hua* (鬧羊花), or *Yang chih ch'u* (羊躑躅), lit.: "goat-stupefying flower," a species of Hyoscyamus; the *Azalea procumbens* or "tiger flower" (老虎花), and the *Azalea pontica* (黃杜鵑).

In the north-eastern provinces the hills are adorned with azaleas of gorgeous hue, especially in the neighbourhood of Ningpo and Wenchow. It is difficult to convey any idea of the charming aspect of these azalea-clad mountains, where on every side the eye rests on masses of flowers of dazzling brightness and surpassing beauty.

Prophylactic properties are attributed to the dried flowers of these handsome but poisonous plants, which are prescribed in rheumatism, paralysis, bronchitis, toothache, abscess, etc., on the Chinese principle that one poison must be counteracted by another.

The azalea is a great favourite, and provides a brilliant *motif* in painting and artistic decoration. It is an emblem of the fair sex.

AUTHORITY.

[1] Smith: *Contributions towards the Materia Medica and Natural History of China*, 1871, p. 29.

BAMBOO
(竹)

The bamboo, *Bambusa arundinacea*, commonly known as "the friend of China," grows throughout the greater part of the country. By long cultivation and care, it has become sufficiently hardy to grow as far north as Peking. There are about ten species, but many variations of each. Some specimens attain a diameter of two or three feet and a height of some thirty or forty feet. The Spotted Bamboo (斑竹), is said to be marked with the tears of the two consorts of the Emperor Shun as they wept over his tomb in the land of Ts'ang-wu. The Spiny Bamboo (棘竹), attains a large size. The Coir Bamboo (棕竹) is solid-stemmed and used in the manufacture of fans. The *Chu P'u* (竹譜), or Bamboo Treatise, published in the 3rd or 4th century, gives a detailed account of the bamboo, and its uses in ancient times. The young shoots (竹筍) serve as food, the pulp in the manufacture of paper, the stems for pipes, buckets, masts, furniture, etc., the leaves for rain-coats, thatch, packing, etc., and decoctions of the seeds, leaves, sap, and roots are employed for medicinal purposes. In ancient times bamboo tablets were used instead of books.

The Chinese are exceedingly fond of borrowing figures and illustrations from the bamboo, and the character *chu*, by which the tree is represented, enters into the composition of many characters expressing some action or object connected with the use of the bamboo. The foliage is often conventionally treated in Chinese designs. The bamboo is an emblem of longevity owing probably to its durability, and to the fact

33

that it is evergreen and flourishes throughout the winter.

One of the twenty-four classical examples of filial piety, had a sick mother, who longed for soup made from bamboo shoots in winter, and he wept so copiously on her account in a bamboo plantation that his tears, like the warm rains of Spring, softened the hard wintry ground and caused the tender shoots to burst forth, in reward for his pious affection.

BAT

(蝙 蝠)

The *pien fu* (蝙 蝠)—under which term is included all the numerous kinds of bats—has several names. It is called *fu i* (附 翼), or "embracing wings," referring to the manner in which it spreads out and hangs by its wings. Other names are *t'ien shu* (天 鼠), "heavenly rat"; *hsien shu* (仙 鼠), "fairy rat"; *fei shu* (飛 鼠), "flying rat"; and *yeh yen* (夜 燕), "night swallow," etc.

CONVENTIONAL
BATS

Bats play an important part in Chinese legendary lore. According to the *Pên Ts'ao* (本 草), or *Chinese Herbal,* in the caverns of the hills are found bats a thousand years old, and white as silver, which are believed to feed on stalactites, and if eaten will ensure longevity and good sight. The blood, gall, wings, etc., are therefore prescribed as ingredients in certain medicines. The *Pên Ts'ao* also states that "the bat is in form like a mouse; its body is of an ashy black colour, and it has thin fleshy wings, which join the four legs and tail into one. It appears in the summer, but becomes torpid in the winter; on which account, as it eats nothing during that season, and because it has a habit of swallowing its breath, it attains a great age. It has the character of, a night rover, not on account of any lack of ability to fly in the day, but it dares not go abroad at that time because it fears a kind of hawk. It subsists on mosquitoes and gnats. It flies with its head downward, because the brain is heavy."

Some of the Chinese bats are very large, the wings measuring two feet across. There are about twenty species belonging to nine genera, most of which are found in Southern China.

The bat is by no means regarded with aversion as in other countries. On the contrary it is emblematic of happiness and longevity. The conventional bat is frequently employed for decorative purposes, and is often so ornate that it bears a strong resemblance to the butterfly. Its wings are sometimes curved in the shape of the head of the Joo-I (*q.v.*), and it is generally painted red—the colour of joy. The design of the Five Bats is a pictorial rebus standing for the Five Blessings (五福), viz., old age (壽), wealth (富), health (康寧), love of virtue (攸好德); and natural death (考終命); this is owing to the similarity in the sound of the characters for "bat" and "happiness"—both pronounced *Fu.*

BEAR
(熊)

Bears were very common in China in early times and may be found even now, though in smaller numbers. *Ursus tibetanus,* a black variety, and *Aeluropus melanoleucus*—the Great Panda—a beast with a white body and black ears, eyes, legs, and tail (formerly embroidered on the court robes of officials of the sixth grade), occur in Kansu, Szechuan, and Tibet; *U. ussuricus*—a black bear, and *U. (Melanarctos) cavrifrons*—a grizzly, appear in Manchuria and Corea. *U. (Selenarctos) leuconyx* is seen in Shensi.

There is a legend to the effect that one of the Chou Emperors dreamed that a bear entered his room through the window, and seating himself on a chair by the bed, foretold several important affairs of State. A model or picture of a bear was regarded as a potent charm against robbers.

The bear is a symbol of bravery and strength, and its paws are regarded as a delicacy, though not often found at the table in modern times.

BEAST OF GREED
(饕餮)

The *T'ao t'ieh,* or Beast of Greed, does not now represent any specific animal, but merely stands for an embodiment of and a warning against the vices of sensuality and avarice. It is shown in relief on the inner side of the isolated "shield wall" (影壁), erected before the main entrance of official builings. The object of the "shield wall" is to prevent the noxious vapours emanating from evil spirits (which always travel in straight lines) from entering the house.

BRONZE CAULDRON OF THE SHANG DYNASTY, ORNAMENTED WITH THE "CLOUD AND THUNDER PATTERN" AND THE "BEAST OF GREED." DESIGN FROM THE PO KU T'U

36

The *T'ao t'ieh* is designated by *T'an* (貪), the same character as that for "avarice," and standing as it does for the embodiment of this vice, it cannot fail by reason of its hideous aspect, to convey a salutary warning to the official, who must encounter it every time he enters or leaves his *yamen*. In many cases these *T'ao t'ieh* have been obliterated, and are nowadays replaced by the crossed flags of the Republic in token of patriotism, though occasionally a large red sun, the symbol of brightness and purity, is substituted.

The Beast of Greed is generally represented with two enormous eyes and powerful mandibles armed with curved tusks, and is said to have actually existed at the time of the Emperor Yao, being banished from the realm by his successor Shun. The term *T'ao t'ieh* is now generally used for a glutton, and an ogre with this name, having a huge belly and a thin face, is often seen on ancient bronze vessels and food utensils as a warning against self-indulgence.

BEE

(蜂)

Apis mellifica or the domestic bee (家蜜蜂), is chiefly found in the hill districts, and commonly kept by the monks of the mountain temples. The honey is employed for making sweetmeats and preserves, and the wax, coloured with vermilion, is used to enclose the tallow core or centre of the common candle. The Chinese bee is of a very gentle disposition.

"In China honey-bees are not cultivated to anything like the extent they are in other countries. . . . In the wilds of Shansi, Shensi, Kansu, and Szechuan, many of the villagers keep bees somewhat extensively, while in the Manchurian forest areas the settlers have learnt their value, and set out specially hollowed tree trunks, stood on end, to attract the wild bees when they swarm. But nowhere is apiculture reduced to an art or looked upon as much more than a profitable hobby." [1]

The composition of the written symbol for the bee denotes that it is the *awl* (夆), *insect* (虫), in reference to its sting. This creature is an emblem of industry and thrift, and a crowd of people is metaphorically compared to a swarm of bees, while honey mixed with oil is a euphemism for false friendship.

The Chinese bee is smaller than the foreign varieties. "Wild bees are also found. The natives smoke them, and thus capture them, wrapping them up in a cloth, and take them home to rear. The hives are curious-looking objects: some are like hour-glasses about two feet long, while others are not so willow-waisted, but more cylindrical in shape; both sorts are fastened high up horizontally against walls of buildings, or over the front door. The entrance to the hour-glass ones are at the ends, and to the cylindrical ones at the side in the middle. These apertures, of which there are several, are very small, being only large enough for the tiny insects to push through one at a time."[2] Beehives and apparatus in foreign style are also employed in apiculture in China to some extent, the hives being moved about from place to place during the summer where suitable flowers are blooming, at other times being fed with syrup.

AUTHORITIES.

[1] Sowerby: *A Naturalist's Note-book in China*, p. 265.
[2] Dyer Ball: *Things Chinese*, 5th Ed.: BEES.

BEGGING-BOWL
(鉢多羅)

Sanskrit, *Patra*. Carried by priests and mendicants. The alms-bowl of Buddha is said to have been made of stone, and possessed of miraculous powers, but those in modern use are generally of wood. Buddhist priests, on their initiation, are presented with a gown, staff, water-pot, and begging-bowl for food.

BELL
(鐘)

Bells have been known in China from the highest antiquity, and heralds, commissioned by the sovereign, used them to convene assemblies of the people to hear the imperial will and receive instruction.

The large hanging bell without a clapper (鐘) is struck to mark the periods of Buddhist or Confucian worship. A set of 16 smaller bells (編鐘), hung on a frame, was used at

CHOU CHIA ÊRH CHUNG (周挾耳鐘). EARED BRONZE BELL OF THE CHOU
DYNASTY. CONTAINS 36 MAMMAE, WHICH EMIT DIFFERENT NOTES WHEN
STRUCK WITH A MALLET.

39

Confucian services. The hand-bell (鈴), Sanskrit, *Ghanta*, with clapper, is generally of brass and is used in ritualistic observances by Buddhist, Lama, and Taoist priests. Wind-bells (風鈴) are fixed to the corners of the eaves of temples, etc., and ring when the wind blows. The sound of the sacred bells is believed to disperse the evil spirits. "The *To* (鐸), or tocsin, is an ordinary bell having either a metal or wooden tongue, and a handle at the apex. Formerly there were four different kinds of tongued bells in use in the army. The ringing of the *To* conveyed to the soldiers the injunction to stand still and be quiet in the ranks. Hence, this bell came to be associated with the idea of respect and veneration; and when music was performed to illustrate the meritorious actions of warriors, faithful ministers, etc., the *To* was employed to symbolize obedience; each military dancer had a bell with a wooden tongue; it was used at the end of the dance. At present the *To* is used only by the Bonzes to mark the rhythm of their prayers."[1]

The bronze bells of the Shang and Shou dynasties, 1766-249 B.C. were decorated with many emblematic devices, chiefly of a religious nature (*vide* MUSICAL INSTRUMENTS).

AUTHORITY.

[1] *Catalogue of the Collection of Chinese Exhibits at the Louisiana Purchase Exposition*, St. Louis, 1904, p. 198.

BIRDS AND BEASTS
(禽 獸)

Chinese naturalists make five grand divisions of animated nature, the feathered, hairy, naked, shelly, and scaly animals; at the head of the feathered race they class the *Fêng-huang* (鳳 凰), or Phoenix; among hairy animals, the *Ch'i-lin* (麒 麟), or Unicorn, stands pre-eminent; man is the chief of all naked animals; while the Tortoise and the Dragon rate respectively as leaders of the shelly and scaly tribes. The six domestic animals of China (六畜) are the Horse, Ox, Goat, Pig, Dog, and Fowl, and these, with the exception of the Horse, constitute the five sacrificial beasts (五牲). Each of the TWELVE TERRESTRIAL BRANCHES (*q.v.*) has its corresponding animal or bird.

About three or four thousand years ago China is said to have been suddenly invaded by numbers of wild beasts, and

the Yellow Emperor (黃 帝), 2698 B.C. is credited with having organised them into an army by which he routed his opponent Yen Ti (炎 帝). (Vide *Wang Chang*, Bk. II, Ch. 4.)

The skins of many animals are converted into wearing apparel for the winter. The lower orders use those of sheep, cats, dogs, goats, squirrels, and even rats and mice. The expensive fur dresses of the higher orders descend from father to son, and sometimes form no inconsiderable portion of the family inheritance. It is the custom for both rich and poor to pawn their furs in the summer, as they are well looked after in the pawnshops, which are generally strong, substantial buildings immune from the attacks of thieves, and, moreover, the better kinds are properly licensed by the government. The civil and military official grades were formerly distinguished by the insignia of different birds and animals embroidered upon the *p'u tzŭ* (補 子) or badges on the back and front of the robes worn on ceremonial occasions.

"Chinese proverb-makers have not overlooked the many apt illustrations of human life and conduct which are to be gathered from the habits and instincts of the animated beings around them; and some of their comparisons are strikingly characteristic of the modes of thinking so prominent in the popular mind. Thus, for example, the practice of filial duty is enforced by a reference to the lamb and kid: 'Look,' say they, 'at the lamb; it always kneels when it is suckled by the dam'."

Many creatures are supposed to have the power of changing their shape, and of coming and going in a mysterious way. Some are said to have been once men, and will, after many years, be permitted to regain, permanently, their human form. If they come in contact with mankind, sickness and death will result to the latter. It is therefore considered necessary to propitiate them with shrines and offerings in the countryside. The denizens of the zoological kingdom have a share in the communistic theory of Buddhism; the stories of past existence in animal form is said to form the basis of Aesop's fables, and the animals are said to have wept bitterly on the death of their master and protector. To liberate a captured animal or bird is regarded by the Buddhists as a good deed that will not be unrewarded in the next world.

Birds and animals figure largely in Chinese symbolism, and many representations of them are to be seen in pictures, on chinaware, in bronze or stone, and as architectural reliefs,

etc. (*Vide* separate notices on individual species, and also the Author's *Chinese Metaphorical Zoology, Journal,* N.C.B. Royal Asiatic Society, 1919, p. 26.)

AUTHORITY.

[1] *Chinese Repository,* Notices in Natural History, Vol. VII, 1838-9, p. 321.

BIRTH

(生 子)

The birth of a child, particularly a son, is regarded by the Chinese as a highly fortunate event (喜 事.), on which great importance is placed owing to the necessity for the continuity of the worship of the family ancestors, which is the underlying principle of the system of Chinese ethics (*vide* ANCESTRAL WORSHIP). The youthful scion of the race is therefore regarded as the apple of the eye, and protected by all manner of talismans and safeguards against the spirits of evil everywhere said to be intent on encompassing the death of unsuspecting infants (*vide* CHARMS).

In early ages it was the custom to announce the birth of a son by hanging a bow at the door; and the emblem of male supremacy, a valuable malachite ornament (璋), like a marshal's *bâton,* was given to him to play with. The arrival of a daughter into this vale of tears was regarded as of secondary importance, and a curved tile, used as a weight for the spindle, and constituting the emblem of the female, was considered suitable as a plaything in her case. It is probable that these emblems are connected with an ancient form of phallic worship, which forms the basis of so many religions.

On the hundredth day after the birth of a male infant, a tray containing various small articles of apparel, toilet, etc., used by males and females, is placed before him, and, whatever article the child grasps is considered to indicate his character in after life.

The following customs connected with the birth of children are prevalent in Foochow. When a family has a daughter married since the fifteenth day of the previous year, who has not yet given birth to a male infant, a present of several articles is sent to her by her relatives on a lucky day between the fifth and fourteenth of the first month. The articles sent are as follows: a paper lantern bearing a picture of the

THE TEST OF THE YEAR-OLD BABY TO INDICATE HIS FUTURE TASTES

小孩一週

Goddess of Mercy, KUAN YIN (*q.v.*), with a child in her arms, and the inscription, "May Kuan Yin present you with a son" (觀音送子); oysters in an earthenware vessel; rice-cakes; oranges; and garlic. The oysters (蠣), having the same sound, *tieh*, in the local dialect, as "younger brother" (俤) signify "May a younger brother come." The earthen vessel *kou* (磜), stands for "to come" in the *patois*. The cakes, *kao* (糕), represent "elder brother" (哥), and imply "May you have more than one son." The oranges, *chi* (桔), stand for the word "speedily" (急); and the garlic, *saung kiang* (蒜根), for "grandchildren and children" (孫兒). In the second year, if there are still no children in spite of all these auspicious arrangements, a lantern is presented bearing a device and the inscription, "The child seated in the tub" (孩兒坐盆), a reference to the wooden tub which generally receives the Chinese baby at the time of birth. In the third year an orange-shaped lantern (桔燈) is sent. An offering of sugar-cane, which is long and in many sections (節節高), signifies "many elder brothers" (as many as the sections); flowers of the rape (油菜花), having "many seeds" (多子) imply "many sons"; beancurd, *taiu hou* (豆腐), has the same sound as "sure to have" in the local parlance, and infers that a son is certain to arrive eventually. From such origins many of the common Chinese emblems are derived. A piece of porcelain, scroll, or silk bed-spread, decorated in various colours with the pleasing design of the hundred infants (百子圖), will also express the hope for the blessing of numerous offspring, and at the same time there is an allusion to the golden age of Yao and Shun, when the people of China lived in such prosperity that scholars, farmers, and merchants alike felt as light-hearted as little children. There are actually only 99 children in the design, in reference to Wên Wang (文王), Duke of Chou, 1231-1135 B.C., who had 99 children of his own, and adopted one more, whom he found in a field after a thunderstorm.

BODHI TREE
(菩提樹)

The Bôdhi or Bo Tree, Sanskrit, *Bôdhidruma*, the Tree of Intelligence, was a pippala or peepul-tree (*Ficus religiosa,* Willd.), and is so called because under it SHÂKYAMUNI BUDDHA (*q.v.*), the Indian prince, seeking to be emancipated from the sorrows and agonies of life and the evanescence of

worldly pleasures, first attained *Bôdhi* (Enlightenment). Shâkyamuni spent a penance of seven years under its shade before he became a Buddha. Hence it is also known as the Tree of Meditation (思惟樹). The original tree grew near Gaya in Bengal, and "a slip of it was taken and planted in the sacred city of Amarapoora in Burmah, 288 B.C. This is said to be still in existence." [1]

As the founder of Buddhism sat and reflected under the spreading boughs, "peace came to his mind with the conviction that man is tormented by greed for gain or by sorrow for loss simply because he is held captive within the narrow limits of self-interest, and that beyond this captivity stretches out a vast expanse of universal life. But life itself never dies, since it persists in the lives of those who have grasped the truth and found the real life in that which is common to all." [2]

Buddhism is said to have been introduced into China from India in the reign of the Emperor Ming Ti (明帝), A.D. 58-76 of the Eastern Han dynasty. It is fundamentally a religion of meditative training, charity, gentle words, benevolence, and common benefit, though in China it has undergone considerable modifications (*vide* SHÂKYAMUNI BUDDHA).

AUTHORITIES.

[1] Giles: *Glossary of Reference*: BO TREE.
[2] Anesaki: *Buddhist Art*, 1916, pp. 3 seq.

BOOKS
(書)

Professor F. Huberty James, of the Imperial University of Peking, wrote of Chinese literature in 1899: "It is the legitimate offspring of the ultra-oriental mind, the expression of the Chinese heart, the story of the home-life, school-life and national life of half the population of Asia. It is the precious, though fragmentary, record of the hopes and fears, the doubts and convictions, the struggles and labours, the victories and defeats, the songs and laments, the dreams and visions, the feasts and fasts, the vanities and realities, alternately blessing and cursing, musing or deluding, inspiring or depressing the souls of countless millions of pilgrims on their passage through this world to the vast and wondrous future."

Scholastic acquirements have always been deeply venerated in China, and the written character is regarded as sacred;

it is therefore considered in accordance with propriety that all waste paper containing print or writing should be respectfully burnt, "Some of the Chinese classics, as the 'Book of Changes' (易 經), or the ' Great Instructor ' (大 學), are regarded as able to keep off evil spirits when put under the pillow of the sleeper, or kept near by in the library. He who is able to repeat *memoriter* passages from these books when walking alone need not fear the spirits." [1]

Bamboo tablets were commonly used before the invention of paper. It is asserted that block-printing can be traced to the Sui dynasty A.D. 581-618. Movable types originated at the beginning of the eleventh century. Books were first bound up in leaves about A.D. 745, before which time they were in rolls. The self-styled "First Emperor" (始 皇 帝) of the Ch'in dynasty, with the object of blotting out the claims

SETS OF BOOKS IN COVERS, CONVENTIONALLY
TREATED FOR DECORATIVE PURPOSES

of antiquity, gave orders for all books to be burnt in 213 B.C., and many valuable works perished. Printing was invented in Europe in 1474.

A book often runs to an extraordinary number of volumes or sections (卷). According to an old distich, "If one wishes to be acquainted with the Past and the Present he must read *five cartloads* of books!" (要通今古事須讀五車書). There is a general work of reference (類 書) known as *Ku Chin T'u Shu Chi Ch'êng* (古今圖書集成), first published in 1726, in 10,000 books, arranged under 6,109 categories, and containing about four times as much matter as the *Encyclopaedia Britannica*. A copy of this wonderful production is to be

seen in the British Museum. Notices of some of the principal
Chinese literary works will be found in the Appendix to the
Author's *Manual of Chinese Metaphor.*

A common conventional design of good augury consists
of two books placed together and decorated with a fillet, when
it is classed as one of the various categories of EIGHT TREA-
SURES (*q.v.*).

AUTHORITY.

1 Doolittle: *Social Life of the Chinese*, p. 561.

BRAHMA
(梵 王)

Brahma, according to Indian mythology, is the creator or
first person in the trinity of the Hindoos, the other two being
Vishnu, the preserver, and Siva, the destroyer, of the creation.
He is generally represented with three faces and four arms.

This deity has been made by the Buddhists into an
attendant or vassal of Buddha, and the Taoists have in turn
borrowed him from the Buddhists as their supreme god. He
is also identified with Indra, and the Jade Ruler (*vide* THREE
PURE ONES). He is sometimes represented as a woman.

The "Brahma Sutra" (梵王經) is used as a sacred
classic in the Buddhist monasteries. It is described by De
Groot in his *Le Code du Mahâyâna en Chine,* as "the centre of
gravity of the Church, the marrow, the heart, the axis on
which turns the whole existence of the monks."

BRONZE
(古 銅)

The Chinese use the same denomination *t'ung* (銅) for
copper, brass, and bronze. It is made up of the character
chin (金), "gold," and *t'ung* (同), "similar," indicating,
according to Chinese commentators, sound, harmony, and
assembling, possibly because employed in the manufacture of
musical instruments.

In order to study the symbolism of China from its
fundamental origin, it is necessary to devote some attention

47

SHANG FU I CHUEH (商父乙爵). BRONZE SACRIFICIAL WINE VESSEL OF THE
SHANG DYNASTY, 1766-1154 B.C. USED FOR ANCESTRAL WORSHIP

CHOU FU TSUN (周憑尊). BRONZE WINE-POT OF THE CHOU DYNASTY, 1122-255 B.C. SHAPED LIKE A WATER-FOWL, WHICH AS IT SWIMS SKILFULLY ON THE WATER WITHOUT BEING IMMERSED, IS A WARNING TO TIPPLERS NOT TO DRINK TO EXCESS AT OFFICIAL BANQUETS.

to the early bronzes, of which a detailed description, together with the significance of their ornamentation, is given in the Po Ku T'u (*q.v.*) a work published during the Sung dynasty.

According to the *Shu Ching* (書經), nine tripods were made in the Hsia dynasty, 2205-1818 B.C., of metal sent as tribute from the nine provinces, and each had a map of a province engraved thereon, though some say they were decorated with representations of spirits and demons; the earliest specimens now extant are engraved with provincial maps and date from the Shang and Chou dynasties, 1766-255 B.C.

The ancient religion of the Chinese was undoubtedly a primitive nature worship in propitiation of the elements productive of rain and sunshine for the benefit of the crops. A belief in numerous gods and spirits of mountains, rivers, clouds, etc., the deification of the luminaries of the firmament, and also of various imaginary powers, became gradually evolved, and, though no images were anciently made, certain symbols were devised to suggest the various deities, and they were engraved or moulded on the ancient bronze, food, wine and sacrificial vessels. These symbols, with variations, have survived to the present day.

The earliest forms of the Chinese written character are to be found on the antique bronzes, of which a fine collection is on view at the Peking Museum (1930).

The age of a bronze article may be determined from the colour and brilliance of its patina, which depends partly on the composition of the alloy, and partly on the nature of the soil in which the object was buried.

Vide also DIAPER PATTERNS, DRAGON, PHOENIX, WRITTEN CHARACTERS.

BROOM
(箒)

The emblem of Shih Tê (拾得), a poet of the 7th century. It typifies insight, wisdom, and power to brush away all the dusts of worry and trouble. To read the book of nature (*vide* SCROLL), and sweep away all mundane difficulties, is the ideal and motto of the naturalistic theory of the ancient Chinese.

The manifold evil spirits are supposed to be afraid of a

broom. "Many families are in the habit of performing a kind of pretence sweeping with a broom on the last day of the year, rather intending the removal of evil than that of filth."[1]

AUTHORITY.

[1] de Groot: *Religious System of China*, Vol. VI, p. 972.

BUDDHA'S HAND

(佛 手)

A peculiar kind of inedible citron, *Citrus medica* (香 櫞) running almost entirely into rind, and terminating at the head in long narrow processes like fingers, is known to the Chinese as Fo Shou or Buddha's Hand. It has a very powerful and fragrant odour, and is offered up in porcelain bowls before the shrine of the household gods at the New Year Festival and other religious sacrifices. It is also used for scenting rooms.

This fruit connotes Buddhism because its form resembles a classic position of Buddha's hand with the index and little finger pointing upward.

It is also a symbol of wealth as it illustrates the gesture of grasping money.

BUTTERFLY

(蝴 蝶)

There are in China many different species of the order *Lepidoptera*, of which the family *Papilio*, or the butterflies, form an important part. Some of the latter are of a gigantic size and variegated colouring, and it is therefore not astonishing that this insect should be a favourite theme for the poet and the painter.

The philosopher Chuang Tzŭ (莊 子) once dreamt that he was transformed into a butterfly and found great happiness in flitting hither and thither sipping nectar from innumerable flowers. Hence the insect is an emblem of joy. It is also a symbol of summer. "The butterfly is a sign of conjugal felicity; in fact it might almost be called the Chinese Cupid. The origin of this is to be found in the story told by the Taoist philosopher Chuang Tzŭ, of a young student who, running

after a beautiful butterfly, unknowingly intruded into the private garden of a retired magistrate, whose daughter he thus saw, and was so struck with her charms, that he determined to work hard and try to obtain her for his wife. In this he was successful, and rose to high rank." [1]

The butterfly is often conventionally depicted with great skill, and is a common decoration for embroidery and chinaware.

AUTHORITY.

[1] Gulland: *Chinese Porcelain*, Vol. I, p. 99.

CANGUE
(枷)

From the Portuguese *Canga*—yoke. Also called the "wooden necktie" (木風領). The heavy square wooden collar worn by criminals for such offences as petty larceny, etc. It is taken off at night, but during the day the wearer must be fed by others, as he cannot reach his mouth.

The infliction of this instrument of punishment is not now stipulated in the Chinese penal code, but it is still employed to a certain extent in remote districts.

CANOPY
(蓋)

One of the EIGHT TREASURES (*q.v.*) or auspicious signs on the sole of Buddha's foot, sometimes symbolically representing the sacred LUNGS (*q.v.*) of that divinity. It is of similar import as the UMBRELLA (*q.v.*). According to some authorities it was originally a flag.

CARPETS
(地 毯)

The weaving of carpets and rugs is believed to have been introduced from Persia and India in ancient times.

As in the case of CHINAWARE (*q.v.*), a free use of symbolic devices is made for purposes of decoration. The DIAPER PATTERNS (*q.v.*) are employed as border designs, while numerous birds and animals, both natural and mythical, together with many conventional floral arrangements and

THE CANGUE

54

religious emblems, which can be found treated in this volume, are commonly woven in coloured wools into the fabric of the Chinese floor coverings, which are composed of the wool of the sheep, goat, or camel and are usually reversible. A design or key-note is often repeated many times on the same carpet. "Recently foreign importers have supplied designs for some of the rugs shipped to them, and the Chinese weaver is very skilful in making exact copies of any designs furnished to him. In general, rugs with the native designs, especially the older ones, are far more beautiful and harmonious than the rugs made on foreign designs. In many cases, the designs furnished by the foreign importers are merely copies of old Chinese rugs found in private collections and museums. Modern Chinese designs are painted by native artists, who make this work a profession. They turn out from six to ten designs per month, in colour. These designs are turned over to another designer or copier, who makes an enlarged design in black on tissue paper. This large design is made in the actual size of the rug. The tissue paper drawing is then pasted on to the warp strings in the same position that the rug is to occupy, and the design is traced on to the strings as a guide to the weavers. A miniature design in black and white is supplied to the weavers, with notations indicating the colours which are to go on the various lines." [1]

The Chinese loom is of very simple construction, and the weaver sits before it on a long bench. His coloured balls of woollen yarn swing and bob merrily, keeping time to the movement of his nimble fingers as they tie the knots of wool into the warp, clip them off with a razor-edged knife, and pound them into place with an iron fork. The cotton warp is stretched on heavy beams, whose weight keeps it taut. Several weavers work on large carpets at the same time. The method of weaving is as follows:

SENNA KNOT

The woollen yarn is fastened to two threads of the warp either by a Senna knot, or a Giordes knot. After being securely fastened, the thread is cut to the depth of pile required. The longer the pile the softer is the carpet, and therefore the length varies between 3/8 to 5/8 of an inch. The

GIORDES KNOT

55

OLD CHINESE TEMPLE RUG

closeness of the warp gives the number of threads to the square foot, which vary from 60 to 120, 90 being the usual number for the market.

The colouring of many of the antique varieties is impossible to reproduce at the present day. The blues have an unequalled depth and luminosity, the warm imperial yellows are of an unrivalled delicacy increasing with age, and the soft reds are unsurpassed by modern dyers.

In the weaving a heavy weft or cross-thread is used, sometimes four heavy strands after each transverse row of knots. The texture is coarser than that of Persian or Turkish carpets, but the pile is flatter or less perpendicular. Sometimes the pattern is accentuated by cutting away part of the pile, leaving the design standing in relief. The wool is generally yarn-dyed. Occasionally carpets are woven in two or three sections which are knitted together by the warp threads.

The old temple rugs are the most beautiful and valuable. The late J. P. Morgan is said to have paid as much as $25,000 for one specimen. In the temple rug illustrated on Page 56 appear the imperial five-clawed Ming dragons contesting for the flaming jewel, which is one of the Buddhist emblems. At the lower end are the sacred mountains and the PLANT OF LONG LIFE (q.v.), beyond which are the waves of the sea, conventionally treated. Throughout the field are distributed cloud-forms, BATS (q.v.), and the EIGHT TREASURES (q.v.), of Buddhism, thus emphasizing the *horror vacui* of the primitive artist. At the top is a continuous festoon, made up of conventionalized buds and flowers of the sacred LOTUS (q.v.). The length is ten feet, width eight feet, and it contains forty-two hand-tied knots to the square inch.

Few genuine old rugs can now be obtained at any price, but the modern article is not to be despised, and Peiping, Tientsin and Soochow are the chief centres of production at the present time.

AUTHORITY.

[1] Dingle and Pratt: *Far-Eastern Products Manual*, No. 32.

CASTANETS
(鈸)

Two round brass plates struck together and used on the stage and in temples. The single brass oblong slab is called

the "sounding plate" (響板), and is struck with a brass rod. The latter is used by pedlars and priests, and is the emblem of Ts'ao Kuo-chiu (曹國舅), one of the EIGHT IMMORTALS (*q.v.*) of Taoism.

CAT

(貓)

It is curious that so common an animal as the cat was not selected for inclusion among the animals of the duodenary cycle (*vide* TWELVE TERRESTRIAL BRANCHES) and the twenty-eight constellations (vide STARS). It has therefore been suggested that the animal is not indigenous to China and did not abound in the country in former times. Cats are, however, referred to in the "Book of Odes" (詩經), a collection of lyrics in vogue among the people many centuries before the Christian era.

There are both domesticated and wild varieties, and their skins are used for clothing by the lower classes. They are fattened for food in some parts of China.

"'The cat,' says one Chinese author, 'is called the domestic fox; the name *mao* (貓), is given to it in imitation of its mewing, but the composition of this name is intended to express an *animal* which catches rats in *grain*. The cat is a small animal, and is everywhere domesticated; it catches rats; there are those of a white, black, piebald, and yellow colour; it has the body of a fox, and the face of a tiger, soft hair, and sharp teeth; the tail is long, and the loins short. Those which have yellow eyes, and the roof of the mouth marked with many *rugae*, are the best. Someone has said that the pupil of the cat's eye marks the time; at midnight, noon, sunrise, and sunset, it is like a thread; at 4 o'clock and 10 o'clock, morning and evening, it is round like a full moon; while at 2 o'clock and 8 o'clock, morning and evening, it is elliptical like the kernel of a *tsao* (棗) or date. The end of the nose is always cold, but for one day during summer (the summer solstice, which falls about 21st June) it becomes warm; the cat naturally dreads cold, but not heat. It can mark on the ground and divine for its prey, and it eats what it catches according to the decades, in the same manner as

the tiger does; and by these tests, both are known to belong to the same class."[1]

"Rats destroy silkworms, but cats keep the rats away; hence the superstition that cats are protectors of silkworms, the picture of a cat (蠶貓, *ts'an mao*, silkworm cat), stuck on a wall, being powerful enough to ward off harm from the worms. Cats are also credited with a general power to put evil spirits to flight perhaps because of their being able to see in the dark. It is said that in some parts worship is paid to the cat spirit."[2]

"The coming of a cat to a household is an omen of approaching poverty. The coming of a strange cat, and its staying in a house, are believed to foreshadow an unfavourable change in the pecuniary condition of the family. It is supposed that a cat can foresee where it will find plenty of rats and mice in consequence of approaching dilapidation of a house, following the ruin or poverty of its inhabitants."[3] It is considered to be very unlucky when a cat is stolen from a house. A cat washing its face portends the arrival of a stranger. Dead cats are not buried but hung on trees.

AUTHORITIES.

[1] *The Chinese Repository*, Vol. VII, March, 1839, Art. IV, p. 598.
[2] Couling: *Encyclopaedia Sinica*: CATS.
[3] Doolittle: *Social Life of the Chinese*, p. 571.

CEDRELA

(椿 樹)

The *Hsiang ch'un* (香椿), or *Cedrela odorata*, is mentioned by the philosopher Chuang Tzŭ (莊子) as being a long-lived tree, symbolical of the father of a family.

The wood resembles mahogany and is used in cabinet work. A decoction of the bark is employed as medicine for fever and dysentery. The leaves are eaten in the spring and the silkworm is also fed upon them; they are also used to make a lotion for baldness. The fruit of the tree is said to be astringent, and is employed in the treatment of affections of the eye. (*Vide* also HEMEROCALLIS.)

CHAIN
(鐵 練)

"Buddha formulated his view of life into a twelve-linked closed chain called 'the Wheel of Life' or of 'Becoming' (*Bhavacakra*), or the Causal Nexus (*Pratitya Samutpāda*); which he is represented, in the Vinaya scripture itself, to have thought out under the Tree of Wisdom."[1] (*Vide* WHEEL OF THE LAW, BODHI TREE.) This chain, which is of iron, is one of the insignia of some of the Buddhist deities.

AUTHORITY.
[1] Waddell: *Lamaism*, p. 105.

CHARMS
(符)

Charms carried on the person are made up of all kinds of materials, and worn on the shoulder, back, or breast, to protect from disease, demons, and evil influence. The *Shao hui t'un fu* (燒灰吞符), the swallow-ashes charm, consists of incantations against demons, written on yellow paper, which is burned, the ashes mixed with water and swallowed. Charms are used in almost every phase of life, for the protection of houses (五方鎮宅符), graves (五方奠墓符), for the collection of wealth (招財聚符), etc. The illuminate-demon mirror, *Chao yao ching* (照妖鏡) is worn by brides. Amulets, which are generally suspended from the neck by a cord to protect the wearer against evil spirits, sickness, accidents, etc., are found in great variety; stone, metal, paper, animal and vegetable substances, with or without characters or designs engraved or written thereon being but a few of the materials employed. Religious texts are used as charms or talismans. They are usually written or printed on narrow strips of red or yellow paper, and pasted on the lintels of doors, walls of rooms, etc. Some kinds are worn on the person, others made into pellets or reduced to ashes and swallowed as spiritual medicine. The larger variety of paper charms is often accompanied by curious pictures or symbolic illustrations.

A number of old brass or copper cash are sometimes strung together in the form of a sword, and kept straight by a piece of iron running up the middle. They are hung at the heads

of beds so that the supposed presence of the monarchs, under whose reigns the cash were coined, may have the effect of keeping away ghosts and evil spirits. They are used chiefly in houses or rooms where persons have committed suicide or suffered a violent death. Sick persons use them, also, in order to hasten their recovery.

Another charm is the *Pai chia so* (百家鎖), or "Hundred Family Lock." To obtain this a man goes round among his friends, and having obtained from one hundred different persons three or four cash each, he himself adds whatever money is required, and has a lock made, which he hangs on his child's neck, for the purpose of locking him, as it were, to life, and making the one hundred persons sureties for his attaining old age. A similar article is the *Ching ch'üan so* (頸圈鎖), or the "Neck Ring Lock," worn by grown females as well as by children for the same purpose as the preceding.

The *Ku t'ung ching* (古銅鏡), or the "Old Brass Mirror," is supposed to possess the virtue of immediately healing any who have become mad by the sight of a spirit or demon, by their merely taking a glance at themselves in it. By the rich it is kept in their chief apartments, for the purpose of keeping away spirits.

The *Hu chao* (虎爪), or the "Tiger's Claw," is a charm against sudden fright, and is said to infuse the wearer with the courage of the animal.

An amulet of peach-wood or peach-stones (桃符) is regarded as a powerful antidote against evil spirits. A string of carved peachstones is often hung about the necks of children to prevent them from being stolen by demons for the purpose of burying them under the foundations of buildings or bridges to give solidarity to the structure. "A kind of padlock is made by cutting the kernels of the flat peach (蟠桃). The mother fixes one of these padlocks on each of her child's feet. . . . The common people believe that peach-stone padlocks confer longevity, bind children to life, and have a mysterious power for warding off evil influences."[1] In this connection it may be interesting to note that the peasant of Exmoor who is liable to fits of any kind wears suspended from his neck a little bag containing small pieces or twigs of the ash-tree, which is supposed to possess healing virtue. Many Chinese children wear a brass or silver padlock attached to the neck by a chain. This is to chain them to existence, and prevent them being ravished by death from their affectionate parents. These padlocks may be

found in all silversmith's shops and many street stalls, and vary in size and shape.

"A person goes round begging a bit of thread from door to door. With these various coloured threads, a kind of tassel is made, and hung on to the dress of the child. This tassel is called the Hundred Family Tassel (百家線)." [2]

The good fortune of a child is said to be assured if he wears suspended from his neck a metal plate engraved with the eight characters of his horoscope (八字), or the animals representing the corresponding signs of the zodiac. The Twelve Branches of Earth (十二地支), in various combinations with the Ten Celestial Stems (十天干), provide terms for the sixty years of the Chinese cycle. When baby girls are discarded and exposed in the open, the eight characters of their horoscope are sometimes pinned to their garments, so that they may not be married to one whose horoscope does not agree with theirs.

An ear-ring (耳朵) is sometimes attached to a child's ear to delude the evil spirits—always on the look-out to injure male children—into the belief that the boy is really a girl. "Persons give to this ear-ring the form of a weight of a clock, as this represents, according to their idea, something heavy and hard to raise. The evil spirits would thus be unable to snatch from this world a beloved child, the weight attaching to the ground and riveting him to existence." [3]

The Heavenly Dog (天狗), otherwise called the Child-stealing Devil (偷生鬼), is said to be the soul of a young girl who has died unmarried, and hopes, by killing a child who will take her own place as a spirit, that she will gain the privilege of reincarnation as a mortal. It is therefore considered necessary to protect a newborn infant—*similia similibus curantur*—by means of the "hair of the dog," or a Dog's Hair Talisman (狗毛符), *i.e.*, a lock of the child's hair is mixed with a dog's hair, rolled into a ball, and sewn on to his clothes, after which he may be taken out for an airing with impunity.

Children are often given the name of an animal, and provided with a silver dog-collar (狗圈) or ring, which is pressed over the head in order to induce evil spirits to imagine that the child is really an animal, and therefore not worth their attention.

Spells are formed by a fanciful union of several characters, to which astrology is sometimes added; and, in those of the Buddhist variety, Sanscrit or Thibetan words may be

employed. These spells are sometimes kept about the person, and sometimes pasted on walls or over doors. Some, also, are used as cures for sick persons, by being written on leaves and then transferred into some liquid, or by being written on paper, burnt, and thrown into the liquid, after which the patient has to drink off the liquid and the spell together. There are spells for almost every deity. Among the most common are the *Yin fu* (印符), or "Sealed Spells." These are either of the Taoist or Buddhist variety, written on yellow paper with red ink, and then stamped with a seal kept in the temples before the idols. The *San chiao fu* (三角符), or "Triangular Spell," is a paper with a spell written on it, and folded up in a triangular shape. It is fastened to the dress of children, to preserve them from evil spirits and from sickness. Besides these there are many others of various kinds, such as the different forms of the characters *fu* (福), prosperity or happiness; and *shou* (壽), longevity. There are also numerous figures of deified heroes, etc., which, though not properly speaking charms, are considered felicitous, and therefore hung up in houses and honoured, some constantly, others on particular occasions.

"The Chinese are superstitiously strict in observing the new year. Labour, even by the lower classes, is put a full stop to on the preceding and following day of the new year; and by the better orders of society, a fortnight or a month is generally kept. On New Year's Day, the old paper charms are removed, and new ones, with some scalloped paper, are pasted up in their stead; five slips of paper, to represent the five happy things, are suspended from the lintels of the front door, and pieces of the same are pasted on trees, farming implements, furniture, carts, boats; in short, on everything which the hopes or fears of the worshipper induce him to preserve or defend in this manner. The shopmen paste, or put in their drawers, the word *lucky* or *fortunate;* and mechanics, on commencing any employment, either place before them the last mentioned character, or write it on the work on which they are about to be employed, hoping that the new year will prove a propitious one." [4]

"Iron nails which have been used in sealing up a coffin, are considered quite efficacious in keeping away evil influences. . . . Sometimes such a nail is beaten out into a long rod or wire, and encased in silver. A large ring is then made of it, to be worn on the ankles or the wrists of a boy until he is sixteen years old. Such a ring is often prepared for the

TAOIST NOSTRUM CURING ALL DISEASES

use of a boy, if he is an only son. Daughters wear such wristlets or anklets only a few years, or even a shorter time." [5]

AUTHORITIES.
[1] Doré: *Researches into Chinese Superstitions*, Vol. I, p. 24.
[2] *Loc. cit.*, p. 21.
[3] *Loc. cit.*, p. 15.
[4] *The Chinese Repository*, Vol. XX, Feb., 1851, Art. III, p. 87.
[5] Doolittle: *Social Life of the Chinese*, p. 561.

CHERRY
(櫻 桃)

The Chinese cherry is smaller than the Western varieties. The commonest is the Hill Cherry, *Prunus tomentosa* (山 櫻 桃), which is grafted on the wild peach. It is found in Shensi, Kansu, Hupeh, and Hunan. *P. pseudocerasus, P. pauciflora,* and *P. humilis* are also to be seen, the last mentoned being a dwarf species, of which the fruit is too sour to be eaten raw.

Astringent and cosmetic properties are ascribed to the tree, the leaves, root, branches, flowers, and pips being prescribed in various ailments by Chinese medical practitioners. The fruit is sometimes preserved as a sweetmeat with honey.

The colour of the cherry is much appreciated by poets and artists, who consider that it vies in richness with the ruby and sapphire. From the poetical comparison of the lips of the famous beauty Fan Su (樊 素)—one of the two beautiful concubines of the famous poet Po Chü-i (白 居 易)—to the brilliant red of the cherry, this fruit has become a common emblem of the fair sex.

CHINAWARE
(磁 器)

Chinaware or porcelain, together with pottery (陶 器), and earthenware (窰 貨) have been manufactured from early ages by the Chinese, who, no doubt, were actuated by the desire to fashion suitable vessels for holding foods and liquids, and eventually to create a synthetic jade, or some substance of similar hardness and brilliancy, capable of being employed for useful and ornamental purposes. Plates, cups, bowls,

LARGE MING POLYCHROME VASE. DESIGN: COW-HERD AND SPINNING-MAID

(*vide* STARS)

jars, vases, tiles, etc., are chiefly produced in Kiangsi, Kuang-tung, and Fukien. The oldest and largest porcelain manu-facturing city is Chingtêchên (景德鎮) near Kiukiang. The materials used are: (1) *petuntse* (白墩子), a hard, white, fusible quartz; (2) *kaolin* (高嶺), or decomposed felspar of granite; (3) sand and other ingredients. The Chinese claim for themselves the invention of the potter's wheel.

It is beyond the scope of this work to enter into all the different classes of porcelain, and the reader is referred to such specialists as W. G. Gulland (*Chinese Porcelain*), S. W. Bushell (*Chinese Art*), etc., where all the fine distinctions are carefully explained, while the modern industry is fully des-cribed in the *Far Eastern Products Manual* (Nos. 38 and 173), edited by E. J. Dingle and F. L. Pratt.

Porcelain is, however, interesting from the symbolic standpoint, being commonly decorated with numerous con-ventional and emblematic designs of great antiquity, which may be found treated in this volume under separate articles, *e.g.*, DIAPER PATTERNS, COLOURS, EIGHT IMMORTALS, DRAGON, PHOENIX, PLUM, UNICORN, etc., etc. The emblematic nature of the shapes of Chinese porcelain articles is also worthy of passing notice. The ordinary bottle-shaped vase is probably derived from the female form, and other shapes refer not only to Chinese but also to European usages. Plates were originally made for foreign markets, and the Chinese tea-cup proper has no handle. The shapes of some of the china vessels have been designed from objects of nature, such as the gourd, peach, pomegranate, etc. Many forms have been originally intended for utilitarian purposes, and have gradually become more elaborately ornamented and varied until they could no longer be employed for their primary uses, and, owing to their enhanced beauty and intrinsic value, they are now regarded as objects of art.

There is a God of Porcelain who owes his divinity to his self-immolation in one of the furnaces in utter despair of being able to accomplish the Emperor's orders for the produc-tion of some vases of particular fineness. The pieces which came out of the furnace, after the unfortunate potter was burned, pleased his Majesty so much that he honoured him with deification.

A perfect piece of porcelain is judged by the fineness of the material, the whiteness, the glaze, the painting, and the shape. The colours are required to be of good quality, and should not carelessly overlap the outlines of the design, which

K'ANG HSI "THREE COLOUR" WINE POT IN THE FORM OF THE CHARACTER *shou* (壽), LONGEVITY. (GRANDIDIER COLLECTION, MUSÉE DU LOUVRE)

must be well-drawn, clear, and distinct. The glaze should be brilliant and free of flaws, and the shape must be uniformly proportioned. A specimen conforming to all these requirements usually commands a high price.

CHISEL-KNIFE

(鏨 刀)

Sanskrit, *Kartrikā*. One of the weapons or insignia of the deities of Lamaism.

LAMA
CHISEL-KNIFE

CHRYSANTHEMUM

(菊 花)

The *Chrysanthemum indicum,* or China aster, is much cultivated in all parts of the country and is greatly esteemed for the variety and richness of its colouring. "There are innumerable varieties of the chrysanthemum in China, of which at least thirty-five are said to be indigenous in Honan. Four distinct treatises have been written on the cultivation of this composite flower. . . . The dried fragrant flowers are said to be tonic, sedative and cosmetic. They are principally used as a wash for sore eyes. A tincture is said to be useful in debility. The ashes of the flower are said to be insecticide. The flower is taken in the form of powder to recover the drunkard."[1] A kind of tea is made from the dried petals, which are sometimes soaked in wine.

The 9th moon is known as the Chrysanthemum Month (菊月), when it is customary to make a special point of going out and feasting the eyes upon the beautiful blossoms (賞菊), after which a refection of crabs and samshu is consumed. In Peking, chrysanthemum cuttings of different kinds are grafted on a sturdy, wild variety, which grows in profusion on the city wall, thus producing a grotesque plant with blooms of many colours.

The flower is an emblem of mid-autumn and symbol of joviality. Since the republican era it has been employed as a decorative *motif* on collars, badges, buckles, sword-hilts, etc.,

69

used by the Chinese army, in contra-distinction to the sheaves of rice, which are similarly employed in the naval uniforms. It may be regarded as the national flower. In this connection it is to be noted that the chrysanthemum-like emblem of Japan is really the rising sun in conventional form.

The chrysanthemum is generally associated with a life of ease, and retirement from public office. The poet T'ao Ch'ien (陶 潛), A.D. 365-427, in spite of poverty refused to occupy an official post, but preferred to devote his life to poetry, music, wine, and chrysanthemum growing.

"Chrysanthemums are given very charming and refined names. The yellow button, similar to the wild form, is called, 'Heaven full of Stars'; the white quill, 'Goose-feathers Tube'; the yellow quill, 'Carrot-threads'; the large ragged mauve, 'Drunk with Wine made from Peaches of the Immortals'; the big single white with a yellow centre, 'Jade Saucer Gold Cup'! the varieties with very fine petals, 'Pine Needles,' or 'Dragon's Beard'; red ground and white dots, 'Maple-leaves and Reed Flowers'; white streaked with red, 'Snow on the Ground Rouge,' the idea suggested being either that of a young girl admiring the snow, or the journey of the lovely Wang Chao-chün to the snowy wastes of Central Asia." [2]

AUTHORITIES.

[1] Smith: *Contributions towards the Materia Medica and Natural History of China*, p. 62.

[2] Ayscough: *The Chinese Idea of a Garden*. The China Journal of Science and Arts, March, 1923, p. 137.

CICADA

(蟬)

The cicada or katydid—sometimes called the "scissor-grinder"—is very common in China, the most frequent being the large variety known as *Cicada atrata* of the order *Hemiptera*. The male sings throughout the summer to attract the female. The music emitted—much admired by the Chinese—is produced by the vibration of two flaps or *lamellae* situated in the thorax of the male insect. It may be noted that the ancient Greeks also highly appreciated the love-song of the cicada. According to an ancient Grecian legend, a certain lute-player of Locri, who was engaged in a musical contest with a rival, broke two of the strings of his instrument. This

would have cost him the victory, but for the fact that a cicada settled upon his instrument and began singing with such power and sweetness that the victory was given to the man of Locri. So grateful were the Locrians to the cicada that they erected a statue representing the player with the insect upon his instrument in token thereof. It is often improperly called a locust—an insect which is far more injurious to the crops. "The cicada, or broad locust, is abundant about Canton in summer, and its stridulous sound is heard from the trees and groves with deafening loudness. Boys often capture the male, tie a straw round the abdomen, so as to irritate the sounding apparatus, and carry it through the streets in this predicament, to the great annoyance of every one." [1]

The insect has five eyes, which enable it to detect the approach of its enemies, it being chiefly liable to the attacks of the PRAYING MANTIS (*q.v.*), a small though very voracious creature; besides the two compound eyes, there are three simple ones, situated cyclopean-wise in the middle of the forehead. The young larva passes the first four years of its life under ground, and then comes out in the form of a mobile pupa, splits down the back, and emerges a perfect insect. This rising, as it were, from the grave, was noticed by the ancient Chinese, who saw in the cicada an emblem of immortality, and resurrection. It was probably for this reason that in former days a piece of jade, carved in the shape of a cicada, was placed in the mouth of a corpse before burial. The insect is also the symbol of happiness and eternal youth, as it lives longer than any other insect, its life-cycle being said to extend over seventeen years. The PO KU T'U says of the cicada that "tiny creature though it be, it may nevertheless serve to illustrate great ideas, signifying as it does the restraint of cupidity and vice."

AUTHORITY.

[1] Williams: *The Middle Kingdom*, Vol. I, p. 273.

CLUB

(棒)

Sanskrit, *Cadā.* One of the weapons or insignia of some of the Buddhist and Taoist deities. It has a round knob at the end.

COINS

(錢)

The Chinese cash, being the symbol of prosperity, is very popular, both as an amulet and an ornament. The name *huan fa* (圜 法) or "round coins," was applied to metal currency by T'ai Kung in the 11th century B.C. The coins were of copper and described as "square within (referring to the hole to string the coin) and round without" (內方外圓). This represents the internal rectitude of the persons who constitute the government and their external suavity and accommodation; they present no rugged corners to annoy those with whom they come in contact.

The *wu chu* (五 銖), or 5/24th tael coin of the Han dynasty (206 B.C.–A.D. 25) is considered to be both lucky and decorative. It is reproduced in gold, silver, bronze, or jade, and suspended from the neck on a chain or cord. The genuine *wu chu* coin is, however, rather rare.

WU CHU COIN

COIN OF THE T'ANG DYNASTY

Coins of the T'ang (唐) or Sung (宋) dynasties are much in demand as amulets and can be purchased at the street stalls, but the unwary numismatist is often taken in by imitations.

K'ANG HSI COIN, OBVERSE

K'ANG HSI COIN, REVERSE

The provincial coins of the K'ang Hsi (康 熙) and Shun Chih (順 治) periods, produced at various mints, bearing

corresponding characters on the reverse, are believed to have talismanic powers when strung together in such an order that the characters form a rhyme. Ch'ien Lung (乾隆) and Chia Ch'ing (嘉慶) coins, which have a particularly good well-finished appearance, are also much esteemed.

Sometimes a few cash on a red string are hung for a time round the neck of the city God (城隍), so that they may acquire virtue, after which they are worn by children to repel the evil influences. Sometimes the number of cash hung on the child's neck is equal to the number of years the child has lived, a fresh coin being added every year, until the age of 15 years, by which time he is supposed to have passed the thirty dangerous barriers (關), which, according to Chinese belief, occur along the path of life. According to the *Wan Pao Ch'üan Shu* (萬寶全書) these barriers are as follows:

1.	Barrier of the four seasons, guarded by a maleficent demon	四	季	關
2.	Barrier of the four pillars	四	柱	關
3.	„ „ „ demon *Niu Wang*—the Cow King	牛	王	關
4.	Barrier styled the Devil's Gate, guarded by a maleficent demon	鬼	門	關
5.	Barrier where life is exposed	撞	命	關
6.	„ of insurmountable difficulty	直	難	關
7.	„ „ the golden hen falling into a well	金雞落井		關
8.	Barrier of the private parts	下	情	關
9.	„ „ „ hundred days	百	日	關
10.	„ „ „ broken bridge	斷	橋	關
11.	„ „ „ nimble foot	急	脚	關
12.	„ „ „ five genii	五	鬼	關
13.	„ „ „ golden padlock	金	鎖	關
14.	„ „ „ iron snake	鐵	蛇	關
15.	„ „ „ bathing tub	浴	盆	關
16.	„ „ „ white tiger	白	虎	關
17.	„ „ „ Buddhist monks	和	尙	關
18.	„ „ „ heavenly dog	天	狗	關
19.	„ exciting Heaven's pity	天	弔	關
20.	„ of the lock and key	開	關鎖	關
21.	„ where the bowels are sundered	斷	腸	關
22.	„ „ „ head is broken	打	膯	關
23.	„ of the thousand days	千	日	關
24.	„ „ „ nocturnal weeping	夜	啼	關
25.	„ „ „ burning broth	湯	火	關
26.	„ where children are buried	埋	兒	關
27.	„ „ life is shortened	短	命	關
28.	„ of the General's dagger	將	軍劍	關
29.	„ „ „ deep-running water	深	水	關
30.	„ „ fire and water	水	火	關

Like all Eastern nations, the Chinese are excessively superstitious, placing much reliance in amulets, talismans, etc.,

of which there are no end. A very singular one is made of old cash, in the shape of a small sword, decorated with a cord and tassel. This they consider one of their principal charms against the attempts of the evil spirits to gain possession of them.

A certain form of coin-shaped amulet known as "coins for throwing into the bed-curtains," *Sa chang ch'ien* (撒帳錢) is explained by the *Imperial Record of Chinese Coins* (錢欽定錄) as being originally coins of gold and silver made by order of the Emperor Jui (睿宗), of the T'ang dynasty, to be cast into the awning of the bed of his daughter on her marriage. These coins were engraved with various auspicious phrases, the custom being derived from the occasion when, on the wedding night of the Emperor Wu of the Han dynasty (漢武帝) and his consort (李夫人), the maids of honour threw flowers and fruit into the awning of the royal couch, for their majesties to catch in their robes, believing that they would be blessed with a corresponding number of children according to the amount received.

Coins for warding off evil are known to the Chinese as *Pi hsieh ch'ien* (避邪錢). A conventional coin, ornamented with a fillet, is employed for decorative purposes, and is one of the EIGHT TREASURES (*q.v.*). A coin-shaped object of jade, a disc with a round hole in the middle, was anciently a badge of rank, and named *Pi* (璧). An emblem consisting of two coins is often hung over shop doors, instead of the figure or written name of the God of Riches, to attract wealth to the establishment.

Many different materials are recorded as having served as currency at one time or another; amongst these may be mentioned inscribed skins, tortoise shells, cowries, axes, spades, amulets, rings, silk rolls, paper, gold, silver, copper, brass, zinc and iron. A copper coinage has existed in China for twenty-five centuries. In 1032 B.C. currency regulations were established which enacted that metallic pieces should henceforth be exchangeable according to their weight. The early spade and knife coins represented for purposes of barter the implements which constituted the wealth of the people. The later issues of knife tokens, ascribed to the first century A.D., were highly conventionalized, the blade being shortened, and the ring having become a thickened copy of the round coin with square hole which had by that time become the common coinage. The cash with a round hole was no doubt a reminiscence of the amulets and rings, but it soon gave place to the square hole

74

DIAGRAM SHOWING PRINCIPAL SHAPES OF CHINESE COINS

variety, symbolic of Heaven—formerly believed to be round and Earth—believed to be square. Copper cash had been made and used in China since the time of Confucius, but paper currency really dates from the T'ang dynasty. The written symbol for cash or money, *ch'ien* (錢), consists of the radical *chin* (金), metal, and the phonetic *chien* (戔), small, and was so styled from its being thin. The mace, or 100 cash, was probably represented in ancient times by a single coin called *ch'ien* (錢), which now only exists on paper. The word "cash" is derived from the Sanskrit *Karsha*, or *Karshapana*, Copper. Cash are strung on string in rolls of 100, of which 10 nominally go to the string, known as *tiao* (吊) or *ch'uan* (串), formerly called *kuan* (貫). The basis of the currency system of China was the copper cash, which was originally 1/1,000 of a tael of silver, worth only a generation ago the third of a pound sterling; and of this copper cash, at the exchange ruling in 1905, it took approximately 10,000 to equal a pound sterling.

The following table gives the approximate date for each of the regular shapes of Chinese coins from earliest ages to the present day, as illustrated by the diagram on the previous page:

A, B.—Hollow headed spade coins (空 首 布), from 600-350 B.C.
C.—Round legged spade coins (圓 足 布), „ 475-221 „
D.—Square „ „ „ (方 足 布), „ 475-221 „
E.—Pointed „ „ „ (尖 足 布), „ 670-221 „
F. G. H.—Long sword coins (長 刀 錢), „ 475-221 „
I.—Devil's head coins (鬼 頭 錢), „ 612-589 „
J.—Round cash with round holes (圓 空 圜 法), „ 660-336 „
K.— „ „ „ square „ (方 空 圜 法), „ 221. „
L.—Short sword coins (短 刀 錢), „ A.D. 7-10.
M.—Small thick spade coins (莽 布), „ „ 10-14.
N.—Round unpierced money in modern use. The Mexican and Spanish dollars were the first in use, after which Chinese dollars were minted at Tientsin, under the Emperor Kuang Hsü, together with silver subsidiary coins and copper cents.

COLOURS
(五 色)

Colour has its appropriate meaning and purpose in Chinese symbolism and may be emblematic of rank, authority, virtues and vices, joys and sorrows, etc. The five primary colours, according to the Chinese gradation, are red, yellow, blue (including green), white, and black (*vide* FLAGS). Red is the emblem of joy and is employed for all festive occasions; yellow,

the national colour, was sacred to the Emperor and assumed only by his Majesty and his sons, or the lineal descendants of his family, purple being prescribed by the Board of Rites for grandsons; the higher officials use blue sedan chairs, and the lower green; white is the colour of mourning; black—the colour of bruising—is the sign of evil and therefore unpopular. The Emperor wrote his special Edicts in vermilion. The colour of visiting cards, when in mourning, is light brown. After some time has elapsed a small piece of paper of that colour, with the name inscribed thereon, may be pasted in the middle of the usual red card. The red visiting card, however, is gradually going out of fashion, and is being replaced by the white foreign-style card. Mauve is used for the seals of the highest authorities.

As regards the Buddhist images, "white and yellow complexions usually typify mild moods, while the red, blue, and black belong to fierce forms, though sometimes light blue, as indicating the sky, means merely celestial. Generally the gods are pictured white, goblins red, and the devils black, like their European relative." [1] It may be noted that, with the ancient Egyptians, white was the emblem of purity, black of vice, and gold of eternal light.

A love of exaggeration in any and every form appears to sway the modern Chinese. The sound that pleases them must be loud and explosive. A colour must be brilliant, an outline striking or grotesque. The more we examine examples of their decorative art, the more we realize their over-emphasis of the dominant lines.

The former nine grades of officials were distinguished by a button or ball of stone, glass, or metal, and of a particular colour, worn on the top of the cap. Thus for the first rank, the button was of red coral, the third of blue stone, the fourth of purple stone, the fifth of crystal, the sixth of white jade, and the seventh, eight, and ninth of gold.

Yellow is used for sere garments for burying the dead in and by Buddhist priests. The literati or educated persons generally wear deep purple, but the most universal colour for clothing is indigo blue. Respectable people invariably dress in sober colour, such as blue, grey, or brown; flaring hues being used almost exclusively by children. No silks nor satins nor red garments should be worn for twenty-seven months after the death of a parent. The demand for foreign clothes is not now so strong as it was at the beginning of the republican era (1912), though the frock-coat and top-hat are still used on

ceremonial occasions, especially in the capital (*vide* COSTUME).

"Very old and curious is the origin of the *chih-ma*," or rough portraits of the gods, and the *tui tzŭ* or red paper scrolls generally used in pairs for home protection. So long ago as the time of the Five Rulers a New Year sacrifice was made to Heaven—a double sacrifice of thanksgiving and repentance. As a symbol of the latter the people smeared the posts and lintels of their doorways with the blood of a sacrificed lamb, just as the Jews did at the season of the Passover. Ages passed and paper was invented. Then, instead of blood, red paper was used on doors and gates. A curious survival in certain Southern provinces is the mixture of sheep's blood and plaster still popular for colouring wooden doorposts and window frames. The first *tui tzŭ* were made of plain paper. It was only much later that characters were inscribed on them from purely decorative motives. The first couplets expressed thanks, those of modern days ask blessings, wealth, happiness, and good fortune." [2]

Charms against evil spirits are written on yellow paper. "Sometimes a picture of an idol is painted or written upon this paper, or some Chinese characters are drawn on the paper with red or black ink. It is then pasted up over a door or on a bed-curtain, or it is worn in the hair, or put into a *red* bag, and suspended from the button-hole, or is burnt, and the ashes are mingled with tea or hot water, and drunk as a specific against bad influences or spirits. . . . A small yellow paper, having four characters upon it, meaning that the charm protects the house and expels pernicious influences, is also often put upon the ridge-pole and other high parts of the house." [3] Articles of a red colour are also believed to be serviceable in keeping away pernicious influences. Antithetical couplets, written on red paper, are pasted on Chinese house-doors for luck at China New Year (*vide* PAINTING).

The old man of the moon (月老), also known as Chieh Lin (結璘), the God of Marriage, is said to decide the nuptial unions of mortals, and record them in a book; he is also believed to connect their feet with an invisible red silk thread. Hence it has been the custom for the bride and bridegroom to pledge each other from two cups of wine and honey tied together with a red cord at the wedding ceremony.

The first colour to be satisfactorily employed in the decoration of porcelain was jade-green, after which the Chinese attempted to reproduce "the blue of the sky after rain." White, purple, yellow, brown, black, red and gilt were

in use during the Ming dynasty. The colours were much improved in quality by the Jesuit missionaries early in the Ch'ing period.

The gorgeous colouring of the buildings of the Purple Forbidden City, in the heart of Peking, is of a symbolic nature. The walls are red—symbol of the south, the Yang principle—the sun, happiness; while the palace roofs are of the bright yellow, which is the emblem of Earth—the Yin principle.

The royal colours were brown for the Sung dynasty (A.D. 960-1127); green for the Ming (A.D. 1368-1644); and yellow for the Ch'ing (A.D. 1644-1911). When the Emperor worshipped Heaven, he wore robes of an azure hue in allusion to the sky; when the earth, then his robes were yellow; when the Sun, he wore red; when the Moon, his dress was white.

There is a further colour symbolism to indicate the points of the compass. The east, according to classic rule, should be blue; the west, white; the north, black; and the south, red. The FIVE ELEMENTS (*q.v.*) are represented respectively by green, red, black, yellow and white. A system of symbolism also attaches to the colour of the sky. Green clouds are said to indicate a plague of insects; red, calamity or warfare; black, floods; and yellow, prosperity.

Green is the colour of the painted board carried before a criminal going to be executed, on which the authority for his punishment is inscribed. Red is a symbol of virtue, especially of truth and sincerity; hence, to say a person has a red heart, means that he is without guile. Black denotes guilt and vice; hence to say that a man has a black heart, is a contumelious expression for depravity. White is the indication of moral purity.

On the Chinese stage, a red face usually denotes a sacred person; a black face a rough but honest man; a white face a treacherous, cunning, but dignified person; while a mean fellow or low comedian is given a white nose. All the fine shades of character are represented by various combinations of colour.

AUTHORITIES.

[1] Waddell: *Lamaism*, pp. 337-8.

[2] Bredon: *Chinese New Year Festivals*, pp. 8-9.

[3] Doolittle: *Social Life of the Chinese*, pp. 560-1.

COMPASS

(指 南 針)

"The priority of the Chinese in the use of the magnetic compass is now so generally acknowledged that any argument adduced to prove or illustrate it would be altogether superfluous.

THE CHINESE ASTROLOGICAL COMPASS

There is a clear statement of the use of the instrument, given in the *Shih Chi* (史 記), written about the commencement of the Christian era."[1] The Duke of Chou (周 公) is credited with the invention of a contrivance somewhat similar to the compass, under the form of a "south-pointing chariot" (指南車), in order to guide on their return journey certain tribute-bearing envoys who had come to China from Tonking in 1110 B.C.; this apparatus was said to consist of "a vehicle

80

THE DUKE OF CHOU (周公), THE REPUTED INVENTOR OF THE COMPASS.
DIED 1105 B.C.

81

surmounted by the figure of a man with outstretched hand which, by a mechanical device in connexion with the wheels, always pointed south." [2] It would appear, however, from this description, that this mechanical pointing, being due to the action of the wheels, could hardly be relied upon to point continually in one direction.

It is believed that the five directions, east, west, south, north, and centre, each have their particular evil influences. China was considered by the ancients to be the centre of the world (中 國), with the remaining countries situated on its borders. The application of the square and compasses, as symbols of morality, was known to the Chinese from early ages (*vide* the Author's *Manual of Chinese Metaphor*: Compass).

The "reticulated plate" (羅 盤), or astrological compass, is largely employed by professors of FENG SHUI (*q.v.*) and ASTROLOGY (*q.v.*). It consists of a baked clay disc, six or more inches in diameter, with a magnetic compass about one inch in diameter in the centre. The disc is covered with yellow lacquer and is inscribed with sixteen or more concentric circles, subdivided by radial divisions, with appropriate lettering. It synthesizes all the accepted Chinese theories as to the cosmic harmonies between the quasi-living energies of nature (*see* YIN and YANG and FIVE ELEMENTS), time-relations as indicated by the sun and moon and the directions in space from any point on the earth.

The arrangement of the circles varies slightly, but the following system is common:

1. The *Pa Kua*—EIGHT DIAGRAMS (*q.v.*)
2. The eight numbers of the magic square (not including 5, which is understood to be in the centre).
3. Twelve sectors, named after the *Pa Kua* and by four pairs of "sexagenary cycle" characters (*vide* CYCLE OF SIXTY).
4. The twenty-four celestial mansions or "heavens" (*vide* STARS).
5. The twenty-four characters: *i.e.*, four of the *Pa Kua*, eight of the "stems" (*vide* TEN CELESTIAL STEMS) and the twelve of the "branches" (*vide* TWELVE TERRESTRIAL BRANCHES).
6. The twenty-four fortnightly climatic periods of the solar cycle (*vide* SUN).
7. Seventy-two sectors, of which sixty are named by pairs of sexagenary cycle characters.
8. One hundred and twenty sectors, of which forty-eight are named by pairs of cyclic characters.
9. The twenty-four characters as in 5 but shifted 7½ degrees anti-clockwise.
10. Similar to 8 but with different pairs of cyclic characters.
11. Sixty sectors with pairs of cyclic characters.
12. Same as 9 but with the radii shifted 7½ degrees clockwise from those in 5.

13. Similar to 8 but with different characters.
14. Sixty unequal sectors with cyclic characters.
15. Allocation of the Five Elements to 14.
16. Three hundred and sixty divisions alternately numbered with odd numbers corresponding to the extent of the Lunar Asterisms.
17. Same as 16 with marks referring to significance.
18. The names of the twenty-eight (unequal) lunar asterisms.
19. The planets (with sun and moon) corresponding to the asterisms.[3]

AUTHORITIES.
[1] Wylie: *Chinese Researches*: MAGNETIC COMPASS IN CHINA, p. 155.
[2] Giles: *Chinese-English Dictionary*, 8128.
[3] Couling: *Encyclopaedia Sinica*: LO P‘AN.

CONCH-SHELL

（法 螺）

A marine shell, of the genus *Strombus*, much appreciated by the Chinese for its beautiful appearance, and often richly mounted on a stand as an ornament. It is one of the insignia of royalty, and the symbol of a prosperous voyage, while it is also regarded as an emblem of the voice of Buddha preaching the laws of his doctrine, and occurs as one of the auspicious signs on the FOOTPRINTS OF BUDDHA (*q.v.*).

"Like Buddha's spiral curls (*vide* SHAKYAMUNI BUDDHA), these shells through ages innumerable, and over many lands, were holy things because of the whorls moving from left to right, some mysterious sympathy with the Sun in his daily course through Heaven."[1] (*Vide* CONCH-SHELL TRUMPET.)

AUTHORITY.
[1] Ruskin: *St. Mark's Rest*, p. 237.

CONCH-SHELL TRUMPET

（螺 號 筒）

Sanskrit, *Sankha*. A trumpet formed from a conch-shell and used in Buddhist worship. Often mounted with bronze or silver. Conch-shells are also used as fog-horns by fishing-boats, and, when a number are blown at the same time, they produce eerie and far-reaching notes of great depth (*vide* CONCH-SHELL).

CONFUCIUS
(孔 丘)

A native of Ch'üeh-li (闕里), a hamlet of Ch'ang-p'ing in Shantung. He lived 551-479 B.C. His style was Chung-ni (仲 尼) and he is known as Confucius—the Latinised form of K'ung Fu Tzu (孔 夫 子), the Philosopher K'ung. His father's name was K'ung Shu-liang Ho (孔叔梁紇), and on the latter's death, his mother married again and removed to a place called Ch'ü-fu (曲 阜). He is China's greatest sage, who has been revered throughout the ages, and is chiefly noted as a teacher, and for editing the national lyrics, known as the *Odes*; he also edited the *Canon of History,* and wrote, under the title of the *Spring and Autumn Annals,* the history of his native State from 722-484 B.C. His Discourses, or Analects, were recorded by his disciples. He taught that the nature of man is pure at birth, and that it becomes vitiated only by the impurity of its surroundings. His daily texts were charity of heart and duty towards one's neighbour, and the virtues on which he laid most stress were justice and truth. He died at the age of 73, leaving a single descendant, his grandson Tzŭ Szŭ (子 思) through whom the succession has been transmitted to the present day; his family is undoubtedly one of the oldest in the world. During his life the return of the Jews from Babylon, the invasion of Greece by Xerxes, and the conquest of Egypt by the Persians, were contemporaneous.

Confucian temples (文 廟) are found in every town in the land. "The plan is always the same, three courts in a south to north direction, except that the third court in some cases may be placed east of the second. The main building, the temple proper, is on the north side of the second court. The whole enclosure was left without a south gate until some student of the district had gained the high place of *chuang yuan* (Senior Scholar); this gate when made (and some other parts of the temple) were only used by the Emperor or a *chuang yuan.* The temple walls are red; this, and many other things and names about the place, recall the Chou dynasty, in which Confucius lived." [1] In the temple stands an altar to the sage, and his tablet on which is inscribed "Seat of the Spirit of the Most Excellent Master Confucius." The official worship of the sage was carried out at the spring and autumn equinoxes. On the day before, everything was prepared as for the worship of ancestors; the next day the candles were lighted, incense burnt, the blood and skin of sacrificed animals offered up, and the

CONFUCIUS IN COURT COSTUME

officials participating in the ceremony walked in procession to the tablet, where they made obeisance. Then the chief official poured out a libation of wine, and placed the tablet on the altar; finally they bowed down and worshipped and burnt an offering of silk, and submitted the flesh of the victims while reciting a prayer to Confucius, during which a dance was performed to slow music by a number of youths. Though sacrifices were thus offered up in memory of the Master, there is no idolatry in Confucianism, which is a cult appealing to the innate chivalry and lofty principles which distinguish the character of the highly moral person. The ethics of Confucianism are based on the following theories:

1. The Universe is regulated by an Order which is moral in its essence.
2. Man is morally good by nature, and it rests with him to remain so.
3. Man errs from ignorance and the force of bad example.
4. The remedies are education of the official classes and good example set by them.
5. The individual must rectify himself before he can rectify others. He must study the teachings of the Ancients and be well versed in modern ritualistic rules and social observances.
6. Above all it is essential to cultivate the Five Virtues (五 常) viz., benevolence, justice, propriety, wisdom, and sincerity.

It is to be noted that Confucius also has a place assigned to him among the deities of the Taoist religion, and he is addressed as honoured one of Heaven who causes literature to flourish and the world to prosper."

AUTHORITY.
[1] Couling: *Encyclopaedia Sinica*: CONFUCIAN TEMPLE.

CONVOLVULUS

(旋 花)

There are many different species of Convolvulaceous plants in China.

The *Convolvulus reptans* (菠稜) is largely cultivated in the central provinces, being planted round the edges of tanks and pools, and appreciated for its succulent leaves, which resemble spinach in flavour.

The *Convolvulus major* (牽牛花), or Morning Glory, is much prized for its beautiful flowers, and also for its roots, which are used for medicinal purposes.

The *Ipomoea quamoclit* (蔦蘿), or bindweed, which frequently grows on pine-trees, is a common emblem of love and marriage.

CORAL
(珊 瑚)

Coral was known to the Chinese from early ages, and was chiefly imported from Persia and Ceylon. It was anciently supposed to represent a tree called the *T'ieh shu* (鐵 樹), which grows at the bottom of the sea, and flowers only once in a century. It is an emblem of longevity and official promotion. The button of the second of the former nine grades of officials was of red coral.

Carved coral figures, snuff-bottles, etc., became popular during the reign of the Emperor K'ang Hsi (1662-1723), and they first came from Japan, with which country China had trade relations by means of junks which visited Nagasaki from time to time.

COSTUME
(服 制)

The fashion or style of the personal apparel of the Chinese has undergone but gradual change throughout the ages until comparatively recent times, when, with the dawn of the republican era, the beautiful and elaborate ceremonial costumes passed into desuetude, and the long plaited queue began to be discarded. From the loose flowing robes of early times were evolved the simpler, though still voluminous garments of the later dynasties. Official dress was formerly subject to special restrictions laid down by the Board of Ceremonies at Peiping, but in modern days the rules are not so rigorous, the ceremonial wear for civilians is now similar to that of other countries, and the military and naval officials appear in uniform. There is a strong tendency among the masses for the wearing of foreign shoes and hats, but the high price of foreign clothing, as compared with the cheaper cotton articles of Chinese style, acts as a deterrent against the universal use of western garb.

The most ancient insignia formerly embroidered on ceremonial garments are the symbols comprising the TWELVE ORNAMENTS (*q.v.*). The official insignia under the Manchu dynasty were as follows:

First Grade. Cap, with a button of worked gold, ornamented with a bead, and surmounted by an oblong button of plain red coral. Violet coat, with a square plaque (補 子) on

EMPEROR AND EMPRESS OF THE THIRD DYNASTY IN SACRIFICIAL COSTUME.
NOTE THE EMPEROR'S HEADDRESS, TO WHICH 288 GEMS WERE ATTACHED.
THE SOVEREIGN, BY LOWERING HIS HEAD, WAS ABLE TO INTERPOSE A CURTAIN
OF JEWELS BEFORE HIS FACE TO AVOID LOOKING UPON ANY UNPLEASANT
SIGHT

YANG KUEI FEI (楊貴妃) DANCING BEFORE THE EMPEROR
YUAN TSUNG (玄宗) OF THE T'ANG DYNASTY

ANCIENT WARRIORS
90

the breast, and another on the back, embroidered with the figure of a white crane, *Grus viridirostris* (仙鶴). Belt decorated with four pieces of agate, encrusted with rubies. Military officers of the same order, plaques embroidered with the unicorn of Chinese fable (麒麟).

Second Grade. Cap, with button of worked gold, ornamented with a small ruby, and surmounted by a button of chased red coral. Plaques embroidered with a golden pheasant, *Thaumalia picta* (錦鷄). Gilt belt ornamented with four plates of worked gold, enriched with rubies. Military officers, plaques with a lion, *Felis leo* (獅子).

Third Grade. Cap, with button of worked gold, surmounted with a clear blue sapphire button. Peacock's plume with one eye. Plaques with peacock, *Pavo muticus* (孔雀). Belt with four plates of worked gold. Military officers, plaques with panther, *Felis Fontanierii* (豹).

Fourth Grade. Cap, with button of worked gold, ornamented with a small sapphire, surmounted by a button of opaque blue *lapis lazuli*. Plaques bearing a wild goose, *Anser ferus* (雲鴈). Belt with four plates of worked gold, with a silver button. Military officers, plaques with a tiger, *Felis tigris* (虎).

Fifth Grade. Cap, with gold button, ornamented with a small sapphire, surmounted by a button of clear white rock crystal. Plaques with a silver pheasant, *Gallophasis nycthemerus* (白鷴). Belt with four plates of plain gold, with a silver button. Military officers, plaques with a black bear, *Ursus tibetanus* (熊).

Sixth Grade. Cap, with button of white opaque marine shell, *Adularia*. Blue plume. Plaques with an egret, *Egretta modesta* (鷺鷥). Belt with four round tortoise-shell plates with a silver button. Military officers, plaques with a mottled bear, *Ailuropus melanoleucus* (羆).

Seventh Grade. · Cap, with button of worked gold, ornamented with a small crystal, surmounted by a button of plain gold. Plaques with a mandarin duck, *Aix galericulata* (鸂鶒). Belt with four round silver plates. Military officers, plaques with a tiger cat, *Leopardus macroseloides* (彪).

Eighth Grade. Cap, with button of worked gold, surmounted by another button also of worked gold. Plaques with a quail, *Coturnix communis* (鵪鶉). Belt with four ram's-horn plates with a silver button. Military officers, plaques with a seal, *Phoca equestris* (海馬).

Ninth Grade. Cap, with gold button, surmounted by

OFFICIAL OF THE FIRST GRADE UNDER THE MANCHU REGIME

TZ'U HSI (慈禧), EMPRESS DOWAGER. DIED 1908

another of chased gold. Plaques with a paradise flycatcher, *Tchitrea Incei* (練 鵲). Belt with four plates of black horn with a silver button. Military officers, plaques with a rhinoceros (犀 牛).

The plaques of the unclassed officials were embroidered with an oriole, *Oriolus chinensis* (黃 鸝). Each grade was divided into two classes, principal (正) and subordinate (從). The character for "longevity" (壽) was engraved on the button of the 2nd grade to distinguish it from that of the 1st.

Imperial and official costumes have been characterised in the past by their elaborate nature and high value. The Imperial head-dress or crown was first made by Huang Ti (黃 帝), the Yellow Emperor, 2698 B.C. The sides of the crown covered the ears; the gems hanging before were intended to remind the weaver not to look at what was base, and the covering of the ears intimated that he should not listen to slanderers. The Emperor Ming Huang (明 皇 帝), A.D. 713, of the T'ang dynasty, issued a sumptuary decree, in the second year of his reign, prohibiting the extravagant costliness of the apparel which was then in fashion, and set an example by causing a bonfire to be made in his palace of a vast heap of embroidered garments and jewellery, but he relapsed later on to a love of magnificent attire and a craving for sensual enjoyment eventually abdicating the throne in favour of his son.

As the historical play is the most popular form of dramatic entertainment, the theatrical wardrobes always contain a supply of costumes in the antique style, some of which, owing to the richness of their embroidery, are of great beauty and value.

Chain-mail and copper-plated armour, and helmets made of raw hide overlaid with metal, were formerly used by the Chinese army. A thick wadded military jacket, consisting of thirty to sixty layers of tough bark-pulp paper (皮 紙), was worn by the common soldier. The modern military uniforms are light blue and khaki for the army, and dark blue for the navy.

Blue cotton cloth, dyed with indigo, is worn by the majority of the people, silk outer garments being added by the well-to-do, The summer costume of the better classes is a long gown of light silk, gauze or grass-cloth, folded over to the right breast, and fastened from top to bottom, at intervals of a few inches, by buttons of cloth, gilt, crystal, etc., the nether garment consisting of loose trousers. Stockings of silk or cotton, and shoes of cloth, satin, etc., with a thick white sole, and silk or cotton

MEN'S CLOTHING (MODERN)

1, JACKET; 2, CAP; 3, WAISTCOAT; 4, LONG ROBE

MEN'S CLOTHING (MODERN)

1, FUR JACKET; 2, INNER JACKET; 3, COTTON SOCK; 4, PURSE;

5, FELT SHOE; 6, COTTON TROUSERS

WOMEN'S CLOTHING (MODERN)

1, SHORT COAT; 2, WAISTCOAT; 3, TROUSERS; 4, PLEATED SKIRT;

5, COTTON SOCK; 6, SHOE

97

WOMEN'S ADORNMENTS

1, METHOD OF DRESSING THE HAIR; 2, ROUGE; 3, FACE POWDER; 4, EAR-RINGS;
5, RING; 6, HAIR ORNAMENT; 7, HAIR-PIN AND EAR-PICK; 8, BANGLES

caps, are also worn. The designs on Chinese boots and shoes all have recognised names, though sometimes the fantastic figures owe their existence to individual caprice. The principal designs are the "cumulus cloud"—the layers which ornament the toe; the "old age character"—the embroidered symbol which is the word for "longevity," and is in the seal character; and the "butterfly pattern." In the winter, over a long dress of silk or crape, is worn a short jacket of fur, silk or broadcloth, with a narrow collar, and over the lower extremities in addition to the trousers, are drawn a pair of tight leggings fastened to each side of the waist. The winter garments are generally wadded with cotton. The dress of the women is usually a large-sleeved robe of silk or cotton, over a long garment, under which are loose trousers sometimes fastened round the ankle. The fashion of cramping the feet is gradually disappearing. It is the custom of both men and women, if the nature of their avocations permit, to allow the nails of one or more fingers of the left hand to grow to an inordinate length, when they are sometimes protected by cases made of bamboo, etc. The colour of mourning is white and dull grey, whereas red is the sign of joy and festivity. Purple, dark blue, or black, are the most popular shades affected by men, pink and green being reserved almost exclusively to women, who, however, also favour pale blue and other colours, according to the dictates of the prevailing fashions. Children are frequently dressed in gaudy colours.

It is customary to shave the heads of young children, leaving a tuft above one or each ear in the case of girls, and on the top of the head in the case of boys. The queue is still affected by men in the country districts, though it is quickly passing out of fashion. It is not the custom for men to wear moustaches before the age of forty, nor beards before sixty. Unmarried women wear their hair hanging down in long plaits, but on marriage they twist it up towards the back of the head, and ornament it with flowers, jewels, and bodkins. Their eyebrows are often shaved to the form of thin crescents, and their faces are sometimes painted and powdered.

The Chinese people being so fond of elaborate ornamentation it is natural that they should pay some attention to the matter of personal jewellery, which is also much employed as a convenient means of investing their savings in the shape of heavy gold rings, bangles, etc. Antique Chinese jewellery is of a highly decorative and emblematic nature, and even in modern times many examples of beautiful repoussé and filigree

work are to be found, sometimes decorated with kingfisher feathers (*vide* KINGFISHER). Precious stones are uncut and merely polished and set *en cabochon*. Children often wear a silver necklet and a locket to symbolically fasten them to life. To a man's belt or girdle are often attached various appendages, such as a fan-case, tobacco-pouch, money-bag, etc., which are often of the finest silk embroidery. (For derivation of Chinese sleeve and queue *vide* HORSE.)

COTTON
（棉花）

It will be out of place in this volume, which treats primarily of the symbolism of the country, to go into the cultivation and manufacture of Chinese cotton, which is the seed hair of various species of plants of the genus *Gossypium*, but as this textile product is of such paramount importance to the people, who dress in cotton from head to foot, it may be worthy of passing mention.

The earliest name for cotton is *po* (帛), which is of Turki origin. The later term, Treasure of the Ancients, *ku pei* (古貝), is from the Malay *kapas*, and bales of cloth were used in former times as currency for purposes of barter. The present name of the cotton-plant, *mien* (棉), was coined from the original term *po* (帛) by the addition of the symbol "tree" (木), while the seed-pods and their fibrous covering are called "flowers" (花).

Cotton was originally introduced from Burma and Turkestan, and Huang Tao P'o (黄道婆), a woman who lived in the 14th century A.D., is said to have invented the flocking-bow and the loom, and taught the people the art of spinning and weaving; so highly were her services appreciated that after her death a temple was erected to her memory, and the people worshipped before her image.

The plant is chiefly grown in the Yangtze and Yellow River basins, and in Chekiang, Shansi, Shensi, and Shantung, the best being the Shensi variety, which is derived from American seed. Cotton is used for making clothing, bed curtains and coverlets, mattresses, awnings, sails, etc. There are now upwards of seventy modern cotton mills in China, and the production of yarn and cloth is rapidly increasing. Over a million piculs of raw cotton were exported abroad in the year 1928.

CRANE
(鶴)

Grus montignesia, or the Manchurian crane. "Next to the *Fêng* (vide PHOENIX), this bird is the most celebrated in Chinese legends, in which it is endowed with many mythical attributes. It is reputed as the patriarch of the feathered tribe and the aerial courser of the immortals. There are said to be four kinds of *ho,* viz., the black, the yellow, the white, and the blue, of which the black is the longest-lived. It reaches a fabulous age. When 600 years old it drinks, but no longer takes food. Human beings have repeatedly been changed into its shape, and it constantly manifests a peculiar interest in human affairs." [1]

The figure of a crane, with outspread wings and uplifted foot, is sometimes

CRANES AND PINE TREE

placed on the centre of a coffin in a funeral procession, being supplied to convey the soul of the departed to the "Western Heaven" riding on its back. This bird is one of the commonest emblems of longevity, being generally depicted under a pine-tree—also a symbol of age. A white crane was formerly embroidered upon the court robes of civil officials of the fourth grade.

According to the *Sou Shên Chi* (搜神記), Ting Ling-wei (丁令威), 2nd century A.D., a native of Shengking (盛京) went to the Ling-hsü mountain (靈虛) to study the black art. After 1,000 years he changed himself into a crane, perched on a tombstone near the gate of his native town, and sang:

"A bird there is and that is Ting Ling-wei,
His home he left a thousand years ago;
Its walls unchanged, its folk now turned to clay:
Far better be a *hsien* than moulder so."

有鳥有鳥丁令威　　去家千載今來歸
城郭是人民非　　何不學仙塚纍纍

101

After giving vent to these sentiments he rose in the air and soared away up to Heaven.

AUTHORITY.

[1] Mayers: *Chinese Reader's Manual*, 168.

CRICKET

(蟋蟀)

"The common cricket is caught and sold in the markets for gambling; persons of high rank, as well as the vulgar, amuse themselves irritating two of these insects in a bowl, and betting upon the prowess of their favourites."[1] "Combats between crickets are contested with great spirit, and tubfuls of them are caught in the autumn, and sold in the streets to supply gamesters. Two well-chosen combatants are put into a basin, and irritated with a straw, until they rush upon each other with the utmost fury, chirruping as they make the onset, and the battle seldom ends without a tragical result in loss of life or limb."[2]

This insect is the emblem of courage and the symbol of summer.

AUTHORITIES.

[1] Williams: *The Middle Kingdom*, Vol. I, p. 273.
[2] *Loc. cit.*, Vol. II, p. 90.

CROSS-THUNDERBOLT

(雙箭石)

Sanskrit, *Visra-vajra.* A sacred emblem, representing two thunderbolts crossed, held in the hand of Buddhist idols (*vide* THUNDERBOLT).

CROSS-THUNDERBOLT

CROW

(烏鵶)

Corvus macrorhynchus or the black crow, and *C. torquatus* or the white-necked crow, are found in China in large numbers.

The various Chinese names for this bird are mostly onomatopoetic or representative of its raucous voice.

The crow is used as a symbol of the SUN (*q.v.*), a red or golden crow with three feet being the tenant of that luminary. It is held up as an example of filial piety, as it is said to take care of its parents when disabled or in their old age, and to disgorge food for their sustenance.

"The Chinese crow, sometimes called the white-winged raven, on the other hand, is an omen of evil. Its cry is harsh and unpleasant; its voice is regarded as unlucky—perhaps, as some suggest, *because* it sounds much like *ka* (咬), the common Chinese word for 'bite.' While prosecuting any business or planning any affair, if the person unexpectedly hears the crow crying out *ka, ka, ka* (Fukienese), 'bite, bite, bite,' he is often impressed thereby with the idea that he shall not be successful. The proverb says: 'this bird's voice is bad, but its heart is good'"[1] The cawing of a crow heard to the south between 3 and 7 a.m., however, denotes that one will receive presents. Between 7 and 11 a.m. it portends wind and rain. At other times and from other points of the compass it has different interpretations.

AUTHORITY.
[1] Doolittle: *Social Life of the Chinese*, p. 571.

CROWN OF BRAHMA

(寶 冠)

Also called the Treasure Crown. One of the auspicious signs on the FOOTPRINTS OF BUDDHA (*q.v.*). It is the imprint of Buddha's heel, and is a symbol of his supremacy over the other gods of the Indian pantheon.

CURIOS

(古 玩)

The term "Curio" is a much abused one, and covers a "multitude of sins." Strictly speaking, of course, it should only apply to the genuine antique, apart from the modern bric-a-brac, and adaptations of Chinese articles for foreign consumption, which are also loosely described as curios by dealers when retailing to the unsuspecting tourist. It is fairly safe

to say that very few genuine pieces are to be found except in the hands of collectors and dealers, for the country has been all but combed clean of unattached *articles de vertu*, and imitations are all the more plentiful in consequence.

Some of the spurious antiques, mostly porcelains, are extremely cleverly manufactured, and much ingenuity is exercised in their reproduction. Bronzes are notoriously faked and seasoned, and to distinguish between the spurious and the genuine is usually very difficult. The effect of the application of a little water is a rough test which often reveals many imperfections. New chisel marks are to be regarded with suspicion, and the bottom of the article should generally be worn smooth. Marks on the bottom are often deceptive, the wrong period being frequently given in order to mislead the unwary purchaser. Gilt horses of the Ming dynasty are reproduced with the gilding and the corrosion intact. Patina is painted liberally on modern brass, to produce the effect of extreme age. Equestrian and other figures of the T'ang period, in brown earthenware, are very abundantly imitated and sold for high prices.

The value of a genuine antique generally depends on its history, and on the amount realised in previous sales. There is no real intrinsic value. It is therefore important to study the nature and examine into the antecedents of the article in question, before including it in a collection of museum pieces. (*Vide* BRONZE, CHINAWARE, JADE, etc.)

CYCLE OF SIXTY
(花甲子)

The Chinese Cycle of Sixty, or the Cycle of Cathay, is a combination of various characters or signs called the *Shih t'ien kan* (十天干), or TEN CELESTIAL STEMS (*q.v.*), with the *Shih êrh ti chih* (十二地支) or TWELVE TERRESTRIAL BRANCHES (*q.v.*), in such a manner that a complete cycle of sixty years is formed by a single revolution. When a repetition of the first combination becomes necessary another cycle is commenced, and may be continued exactly in the same manner as the first, thus answering much the same purpose as our ten decades for a century of years, five complete cycles being the exact equivalent of three centuries of our time.

"According to the *Yüeh ling chang chü* (月令章句)

forming part of the Record of Rites, the invention of this system is due to Ta Nao (大 撓), 27th century B.C., who studied the properties of the five elements and calculated the revolving motions of the Tou (斗) constellation, Ursa major, and thereupon devised the combination above named for the purpose of giving names to days. By joining the first of the twelve to the first of the ten signs, the combination *Chia-tzŭ* (甲 子) is formed, and so on in succession until the tenth sign is reached, when a fresh commencement is made; the eleventh of the series of twelve 'branches' being next appended to the sign *Chia* (甲). The sixty combinations which are thus formed receive the name *Chia-tzŭ* (甲 子), or *Hua Chia-tzŭ* (花 甲 子) a list of the *Chia-tzŭ* characters from the initial combination of the series, and are commonly known as the Cycle of Sixty. It was not until the period of the Han dynasty that this invention was made applicable to the numbering of *years*, and Chinese authors have attributed the commencement of such a practice to the period of Wang Mang (王 莽)—*vide* Mayers: *Chinese Reader's Manual*, Pt. I, No. 804—but traces of its employment at a somewhat earlier date have been discovered (Cf. Legge's *Classics*, III, proleg, p. 96). The cyclical signs play a great part in Chinese divination, owing to their supposed connection with the elements or essences which are believed to exercise influence over them in accordance with the order of succession represented above."[1]

The Horary Characters are twelve in number, and the Celestial Stems ten, and as the least common multiple of 10 and 12 is 60, the cycle recommences after 60 years.

According to Chinese chronologists, time is divided into three great periods (三 元), embracing 24,192,000 years. They are designated 上 元, 中 元, and 下 元, terms which are also applied to the three periods of the year, viz. the 5th of the first, seventh, and tenth moons.

Buddhism has introduced twelve deities or rulers of the cycle, who are known as *Yüan Chia* (元 甲) or *Yüan Ch'ên* (元 辰).

In the appended table of five complete cycles from A.D. 1744, it will be noted that 1924 is the first year of the 77th cycle of Chia Tzŭ, being under the influence of the element Wood, and subject to the symbol of the Rat. This system of recording dates has the disadvantage that the same combinations occur every sixty years, and for this reason the cycles have been numbered. Sometimes the reigning title of the Emperor and the year of his reign are quoted, as K'ang Hsi, 20th year. Since

No. of year in Cycle	Name of year in Cycle (combined Stems and Branches)		Corresponding Elements			Symbolic Animals			74th	75th	76th	77th	78th
1	Chia Tzŭ	甲子	Mu	木	Wood	Shu	鼠	Rat	1744	1804	1864	1924	1984
2	I Chou	乙丑	,,	,,	,,	Niu	牛	Ox	1745	1805	1865	1925	1985
3	Ping Yin	丙寅	Ho	火	Fire	Hu	虎	Tiger	1746	1806	1866	1926	1986
4	Ting Mao	丁卯	,,	,,	,,	T'u	兎	Hare	1747	1807	1867	1927	1987
5	Wu Ch'ên	戊辰	T'u	土	Earth	Lung	龍	Dragon	1748	1808	1868	1928	1988
6	Chi Ssŭ	己巳	,,	,,	,,	Shê	蛇	Snake	1749	1809	1869	1929	1989
7	Kêng Wu	庚午	Chin	金	Metal	Ma	馬	Horse	1750	1810	1870	1930	1990
8	Hsin Wei	辛未	,,	,,	,,	Yang	羊	Ram	1751	1811	1871	1931	1991
9	Jên Shên	壬申	Shui	水	Water	Hou	猴	Monkey	1752	1812	1872	1932	1992
10	Kuei Yu	癸酉	,,	,,	,,	Chi	鷄	Cock	1753	1813	1873	1933	1993
11	Chia Hsü	甲戌	Mu	木	Wood	Ch'üan	犬	Dog	1754	1814	1874	1934	1994
12	I Hai	乙亥	,,	,,	,,	Chu	猪	Boar	1755	1815	1875	1935	1995
13	Ping Tzŭ	丙子	Ho	火	Fire	Shu	鼠	Rat	1756	1816	1876	1936	1996
14	Ting Chou	丁丑	,,	,,	,,	Niu	牛	Ox	1757	1817	1877	1937	1997
15	Wu Yin	戊寅	T'u	土	Earth	Hu	虎	Tiger	1758	1818	1878	1938	1998
16	Chi Mao	己卯	,,	,,	,,	T'u	兎	Hare	1759	1819	1879	1939	1999
17	Kêng Ch'ên	庚辰	Chin	金	Metal	Lung	龍	Dragon	1760	1820	1880	1940	2000
18	Hsin Ssŭ	辛巳	,,	,,	,,	Shê	蛇	Snake	1761	1821	1881	1941	2001
19	Jên Wu	壬午	Shui	水	Water	Ma	馬	Horse	1762	1822	1882	1942	2002
20	Kuei Wei	癸未	,,	,,	,,	Yang	羊	Ram	1763	1823	1883	1943	2003
21	Chia Shên	甲申	Mu	木	Wood	Hou	猴	Monkey	1764	1824	1884	1944	2004
22	I Yu	乙酉	,,	,,	,,	Chi	鷄	Cock	1765	1825	1885	1945	2005
23	Ping Hsü	丙戌	Ho	火	Fire	Ch'üan	犬	Dog	1766	1826	1886	1946	2006
24	Ting Hai	丁亥	,,	,,	,,	Chu	猪	Boar	1767	1827	1887	1947	2007
25	Wu Tzŭ	戊子	T'u	土	Earth	Shu	鼠	Rat	1768	1828	1888	1948	2008
26	Chi Chou	己丑	,,	,,	,,	Niu	牛	Ox	1769	1829	1889	1949	2009
27	Kêng Yin	庚寅	Chin	金	Metal	Hu	虎	Tiger	1770	1830	1890	1950	2010
28	Hsin Mao	辛卯	,,	,,	,,	T'u	兎	Hare	1771	1831	1891	1951	2011
29	Jên Shên	壬辰	Shui	水	Water	Lung	龍	Dragon	1772	1832	1892	1952	2012
30	Kuei Ssŭ	癸巳	,,	,,	,,	Shê	蛇	Snake	1773	1833	1893	1953	2013
31	Chia Wu	甲午	Mu	木	Wood	Ma	馬	Horse	1774	1834	1894	1954	2014
32	I Wei	乙未	,,	,,	,,	Yang	羊	Ram	1775	1835	1895	1955	2015
33	Ping Shên	丙申	Ho	火	Fire	Hou	猴	Monkey	1776	1836	1896	1956	2016
34	Ting Yu	丁酉	,,	,,	,,	Chi	鷄	Cock	1777	1837	1897	1957	2017
35	Wu Hsü	戊戌	T'u	土	Earth	Ch'üan	犬	Dog	1778	1838	1898	1958	2018
36	Chi Hai	己亥	,,	,,	,,	Chu	猪	Boar	1779	1839	1899	1959	2019
37	Kêng Tzŭ	庚子	Chin	金	Metal	Shu	鼠	Rat	1780	1840	1900	1960	2020
38	Hsin Chou	辛丑	,,	,,	,,	Niu	牛	Ox	1781	1841	1901	1961	2021
39	Jên Yin	壬寅	Shui	水	Water	Hu	虎	Tiger	1782	1842	1902	1962	2022
40	Kuei Mao	癸卯	,,	,,	,,	T'u	兎	Hare	1783	1843	1903	1963	2023
41	Chia Ch'ên	甲辰	Mu	木	Wood	Lung	龍	Dragon	1784	1844	1904	1964	2024
42	I Ssŭ	乙巳	,,	,,	,,	Shê	蛇	Snake	1785	1845	1905	1965	2025
43	Ping Wu	丙午	Ho	火	Fire	Ma	馬	Horse	1786	1846	1906	1966	2026
44	Ting Wei	丁未	,,	,,	,,	Yang	羊	Ram	1787	1847	1907	1967	2027
45	Wu Shên	戊申	T'u	土	Earth	Hou	猴	Monkey	1788	1848	1908	1968	2028
46	Chi Yu	己酉	,,	,,	,,	Chi	鷄	Cock	1789	1849	1909	1969	2029
47	Kêng Hsü	庚戌	Chin	金	Metal	Ch'üan	犬	Dog	1790	1850	1910	1970	2030
48	Hsin Hai	辛亥	,,	,,	,,	Chu	猪	Boar	1791	1851	1911	1971	2031
49	Jên Tzŭ	壬子	Shui	水	Water	Shu	鼠	Rat	1792	1852	1912	1972	2032
50	Kuei Chou	癸丑	,,	,,	,,	Niu	牛	Ox	1793	1853	1913	1973	2033
51	Chia Yin	甲寅	Mu	木	Wood	Hu	虎	Tiger	1794	1854	1914	1974	2034
52	I Mao	乙卯	,,	,,	,,	T'u	兎	Hare	1795	1855	1915	1975	2035
53	Ping Ch'ên	丙辰	Ho	火	Fire	Lung	龍	Dragon	1796	1856	1916	1976	2036
54	Ting Ssŭ	丁巳	,,	,,	,,	Shê	蛇	Snake	1697	1857	1917	1977	2037
55	Wu Wu	戊午	T'u	土	Earth	Ma	馬	Horse	1798	1858	1918	1978	2038
56	Chi Wei	己未	,,	,,	,,	Yang	羊	Ram	1799	1859	1919	1979	2039
57	Kêng Shên	庚申	Chin	金	Metal	Hou	猴	Monkey	1800	1860	1920	1980	2040
58	Hsin Yu	辛酉	,,	,,	,,	Chi	鷄	Cock	1801	1861	1921	1981	2041
59	Jên Hsü	壬戌	Shui	水	Water	Ch'üan	犬	Dog	1802	1862	1922	1982	2042
60	Kuei Hai	癸亥	,,	,,	,,	Chu	猪	Boar	1803	1863	1923	1983	2043

FIVE COMPLETE CYCLES, OR 300 YEARS, FROM A.D. 1744-2043.

the inauguration of the Republic the year of the Republic is mentioned. It is common for a Chinese to give his age by stating the animal appertaining to the year of his birth.

AUTHORITY.
[1] Mayers: *Chinese Reader's Manual,* II, 296.

DAGGER

(刀)

A dagger, or short knife, is often seen in the hands of some of the Buddhist and Taoist deities; it usually has a curved blade.

DEATH

(喪 事)

The various ceremonies connected with death and burial, have, as their underlying motives, the prevailing reverence for ancestors, which forms the basis of the Chinese system of ethics. On the death of the Wu Kung (武 公) of the Ch'in State (秦), sixty-six persons were put to death in order to be buried with him, and attend on him in the next world. Mu Kung (穆公), had 177 common persons and three persons of note put to death to be interred with him. About 150 years B.C. Shih Huang Ti (始皇帝) ordered that, at his death, his household, women and domestics, should all be killed and buried with him. Until comparatively recent times it has been the custom to inter valuable clothing and jewels with the dead, and in former ages the deceased was provided with a complete set of household utensils, of pottery, bronze, etc., which were placed in or near the coffin. The Chinese believe in a future state somewhat similar to that existing on earth, and therefore treat their dead with a view to preparing them for the exigencies of the next

world and supplying them with the various articles of luxury and necessity which they trust will be translated in the spirit land for the use of the *manes*—or ghost of the deceased—by the modern process of burning paper effigies of such articles.

When a man is at the point of death, it is considered honourable to have his bed taken into the rear hall, and placed in the middle of the room, his head lying eastward; when others beside the master of the house are sick, they may be carried into a side appartment. After this, if the sick man wishes to make a will, it can be taken down. As soon as the breath has departed, the body is laid out upon a mat on the floor and covered with a shroud; a little cotton wool is sometimes put in the mouth or nose, to see if the breath moves it. The eldest son now puts two cash in a bowl, which he covers with a cloth, and goes to the river-side or to the nearest water, and after burning candles and crackers, throws them into the water, and dips up the bowl full, with which he washes the corpse; this custom, called "buying water," is common in Canton. Immediately after death, the whole household joins in wailing, both men and women casting off their ornaments, dishevelling their hair, and baring their feet, in token of grief. The eldest son or grandson then offers the food, and pours out the libations at the feet of his parent; if a wife, or child, or concubine dies, the master himself manages the ceremonies; and the nearest relatives according as they may be present, except married daughters or sons adopted by others.

The customs about visiting the bereaved family vary; friends come in mourning apparel, and enter the chamber of the dead, where they are received by the eldest son, and join their lamentations with his; he himself remains near the dead. When the day for placing the body in the coffin arrives, the relatives assemble; it is dressed in its best robes, according to the rank the departed bore in his lifetime; a piece of money or a pearl is put in the mouth, a willow twig placed in the right hand, to sweep away demons from his path; a fan and handkerchief in the left hand; the bracelets, bangles, earrings, etc., of females, are also all put on. This is done under the impression that the spirit appears before the judge of Hades in these habiliments.

The next thing is to put up the *ling wei* (靈 位) or ancestral tablet, which is a slip of blue paper containing the name, surname and titles of the defunct.

While the corpse remains in the house, the rich call in the assistance of priests, and sometimes expend large sums of

money in hiring them to say prayers, in erecting altars in the house, paying musicians, and burning paper models of various kinds in honour and for the use of the dead. Most classes engage the services of the priests, and think that their friends are the easier for them, or are quite released from suffering. When engaging them, the family also announces the death by pasting a notice on the outer door, and writing letters to the relatives, the nephews or younger brothers doing it for the chief mourner, who is too much swallowed up with grief to attend to it.

A day having been selected for the funeral within the forty-nine days of deepest mourning, the cortege is made ready.

The selection of a family sepulchre is supposed to be a matter of great importance to the prosperity of the family, and is entrusted to the skill and science of a professor of the FENG SHUI (*q.v.*) or geomantic art, whose directions are implicitly followed.

The funeral procession is generally made as showy and diversified as the means of the family will allow, by hiring musicians to play, engaging coolies and pavilions, to carry and enshrine the tablet, sacrifices, and effigies, with banners, tablets and other articles, most of which are hired for the occasion.

As the funeral procession proceeds through the street, the musicians play dirges at short intervals, and the chief mourners, completely dressed in sackcloth, and the friends wearing white caps follow them. A man precedes the coffin to scatter round pieces of paper along the road; this is called *fang lu ch'ien* (放 路 錢) *i.e.,* scattering road money, each of these slips of paper being regarded as current money in Hades, and now used to buy the goodwill of malicious, wandering elves, that they may not molest the wraith of the deceased on its way to the grave—many persons supposing the spirit accompanies the coffin to the grave, and the chief mourner frequently carries a banner with the epitaph of the spirit written on it to show it the way to its long home.

The order of a large procession is somewhat as follows: First, the person who scatters the paper money; then come those bearing large white paper lanterns on poles, having the titles borne by the deceased written thereon in blue-characters; these are followed by the principal band of musicians, between which are carried ornamental banners and flags bearing inscriptions of a general nature, notices to people to retire aside, official tablets, etc. In front of the tablets are two persons

with gongs, who beat the same number of strokes the deceased would be entitled to if he still held office. An incense pavilion or *hsiang t'ing* (香亭), and a second, bearing a roasted pig, accompanied by mourners, the two separated by an embroidered banner and followed by musicians, come after the tablets; a third pavilion, containing fruits, cakes, comfits, etc., and perhaps others, succeed, each containing portions of the sacrifice. These *t'ing* (亭) or pavilions, are square stands of wood, covered by a light roof or cupola, and when new look very rich from the carving, gilding, and gay colours put upon them; they are borne on light thills like a sedan. After the sacrifice come the retinue of priests, preceded by lanterns showing the name of their monastery, and an altar containing their implements; then follow some of the relatives and servants, the latter bearing trays of betel-nuts, pipes, etc., as refreshment for the mourners, succeeded by more banners and muscians. A splendid shrine containing the picture or tablet of the dead, and supported by the nephews or grandchildren, as bearers, follow the priest; between this and the coffin, a number of children attend carrying baskets of flowers or little banners, with the chief mourner, who totters along by himself, supported under the arms by servants, exhibiting the greatest sorrow, as if he was just ready to drop down with grief. His head has not been shaved since his father's death, and perhaps his face has not been often washed; his clothes are awry, and his gait and aspect altogether are negligent and slovenly. The pall or *kuan chao* (棺罩) is frequently a rich piece of silk embroidery, of many colours, and covers the coffin completely, the fringe reaching nearly to the ground. The crowd of mourners, among whom servants bearing the younger children or grandchildren on their backs, and other attendants, bring up the rear. The length of a procession is sometimes half a mile, and even more, especially in the country, where the villagers are attracted by respect or curiosity to attend it.

The forms of graves vary in different parts of the country, and their locations are unlike. In the south, an elevated, dry, location is chosen, one that commands a good prospect, and if possible a view of the water; in the northern provinces, cultivated and low land is frequently taken, and the graves occupy less space. There are no grave-yards in Chinese cities, but the people prefer lonely and waste spots, where the sighing trees can wave over the dead, and the melody of nature refresh the departed spirit. In the south, the grave is usually constructed somewhat after the shape of a large arm-chair, in

FUNERAL BANNER

(長旛)

112

which the spirit can recline at its ease. The masonry in the back of the supposed chair is built up with the tombstone in it, and the coffins are deposited in the seat. In large graves, behind and above the back are two small stones with two characters cut on each to define the limits of the grave, or as it is in Chinese, of the *tsê* (宅) or home of the dead. Some of the family sepulchres around Canton are further ornamented with sculptured lions to guard this *dwelling;* but at the north, images of various animals are sometimes placed in a line, making an avenue leading up to the tomb. There too, the grave is shaped like a pyramid, or a box, and occasionally a stone supported on posts covers the naked coffin. The poor are often merely thrown on the ground there to lie till their remains moulder to dust. The coffins are made of planks half a foot thick, called *shou pan* (壽板) or longevity boards, and are rounded on one side, so that when put together the coffin resembles a section of the trunk of a tree. The rich frequently provide their own coffins before death, spending scores of dollars in buying fragrant and durable woods; these are kept in the house or near the door, ready for use.

In some cases a matshed is erected over the grave, in which the priests perform a variety of ceremonies for the repose of the departed, similar to those observed at the house; but usually the coffin is merely buried with the burning of crackers and papers, and the repetition of prayers and wailings.

The great festival in the ancestral ritual is on the first day of the term of *Ch'ing ming* (清明), which commences during the first half of the month of April. The ceremonies of sweeping the grave can be performed during any of the thirty days following, but the first day is the luckiest. Early on this day, the men and servants of the family repair to the grave to *pai shan* (拜山), *i.e.*, worship the tumuli, or *pai fên* (拜墳), *i.e.*, worship the grave, carrying with them a sacrifice of meats, vegetables and spirits arranged on a tray, a quantity of incense-sticks, fire-crackers, and gold and silver paper, with a broom and hoe. These last mentioned are first used; the weeds that have sprung up during the year around the grave are pulled up, and the filth or rubbish is swept away; the offering is then spread out, and the gold and silver papers burned, to supply the spirit with food and money during the coming year. Slips of red and white paper, two or three feet long, are secured to the corners of the grave as evidence of the rites having been performed; the appearance of a hill-side, with thousands of

113

FUNERAL PROCESSION AT PEKING. BY CHOU P'EI-CH'UN (周培春).

these testimonials fluttering in the breeze, is singular. The eldest worshipper then reads a prayer, after which it is burned, amidst the explosion of crackers.

The world of spirits, according to the Chinese, is like the world of men: and as in this life, it is impossible to live without eating, or to obtain comforts without money; so, in the life to come, the same state of things prevails. Hence, those who wish to benefit the departed, must not only feed them once in the year, but supply them with cash for unavoidable expenses. In order to remit money into the invisible world, they procure small pieces of paper, about four inches square, in the middle of which are affixed patches of tin-foil or gold-leaf, which represent gold and silver money; these they set fire to, and believe that they are thus transformed into real bullion, passing through the smoke into the invisible world. Large quantities of this material are provided, and sacrificial paper constitutes a great article of trade and manufacture, affording employment to many myriads of people. The basis of this "joss-paper" is chiefly pewter beaten into thin tissue, and backed with paper made from bamboo wood pulp. It is often made up in the shape of sycee ingots.

The Chinese like to have their coffins ready in advance, and sometimes store them in their own premises. A present of a coffin is much appreciated. It is the general usage to keep the dead bodies of parents, especially until they can obtain an auspicious place to inter them, or until a favourable time is appointed by the geomancer. Meanwhile the coffin is lodged in a special building appropriated for that purpose. The poor often leave the remains unburied in the fields or on the hills, not in all cases very well coffined. There are charity organisations for the interment of paupers.

DEER

(鹿)

The hog-deer (麏) abounds in the Yangtze valley, the antelope (羚羊) is found in Szechuan, Hupeh, Shensi, and Kansu; while the yak, or *Elaphurus Davidianus* (麈), ranges over the mountains of Tibet. The yak was formerly common in China, and was called *ssŭ-pu-hsiang* (四不像), as like, and yet not like, the four animals from which it is supposed to have borrowed the plan of its body, namely, the horns from

the stag, feet from the ox, neck from the camel, and tail from the ass. The herds of deer were said to follow this animal as their leader, and were guided by the movements of its tail. The yak's tail or chowry (彈箒) features as part of the paraphernalia of the ancient sages, and is now employed by Buddhist and Taoist monks to keep their persons free from the dust and contamination of the world (*vide* FLY-WHISK).

The deer is believed by the Chinese to live to a very great age, and has therefore become an emblem of long life (*vide* GOD OF LONGEVITY). It is said to be the only animal which is able to find the sacred fungus of immortality (*vide* PLANT OF LONG LIFE). The people eat hartshorn in large quantities, and at much expense, in the hope of prolonging their mundane existence. The horns of the deer hold the same important place in the Chinese Materia Medica as they did formerly in all European Pharmacopœias. They are sorted as "old" (老鹿茸) and "young" (嫩鹿茸). The soft internal part of the horns is dried, pulverised, and made up into pills. The inferior parts are boiled into jelly (白膠) or tincture. Stimulant, tonic, astringent, and many other doubtful properties are assigned to this substance, which is only available to the wealthy. It contains a large proportion of phosphate of lime, and may have some good effect in rickets and other infantile diseases.

A picture of a deer often represents official emolument (祿), as a *jeu de mot* on the similar pronunciation—*lu*—of the two words.

DIAMOND MACE

(金 剛 杵)

THE CH'U OR DIAMOND MACE

Sanskrit: *Vadjra*. One of the auspicious signs on the FOOTPRINTS OF BUDDHA (*q.v.*). Explained as signifying the divine force that strikes and breaks all the lusts of the world, also said to represent a thunderbolt and to be the symbol of resolution and indefatigable action (*vide* THUNDERBOLT).

The thunderbolt, on account of the fusion caused by friction in falling, is reduced to its hardest metallic constituents, and it was therefore regarded as synonymous with that hardest

116

of gems, the diamond, and hence the name for the thunderbolt of the gods, *i.e.*, diamond mace, originally carried by Indra, the warrior deity of India, who figures in Chinese Buddhism as subsidiary to Shakyamuni, and is styled Ti-shih (帝釋), or Yintolo (因陀羅).

DIAPER PATTERNS

(花 紋)

The Chinese have a *horror vacui* or dislike for bland undecorated spaces in their works of art, and the native craftsman does not look upon an article as complete until by line or colour he has thoroughly broken up the plainness of its surface. There are numerous intricate and diversified designs, which are used profusely in the decoration of shop-fronts, temples, bridges, memorial arches, porcelain, bronzes, carpets, embroidery, stationery, etc. These adornments are often of a conventional and symbolic type, being arabesque or diaper patterns arranged in rows or borders and employed as ornamental panels; many of them are of very ancient origin and may be traced to the primitive nature worship of the people in distant ages.

"The simplest ornament and the one most frequently met with not only in ancient but also in modern art is that commonly known as the meander or key-pattern. The Chinese call it the 'thunder pattern' (雷 紋). As the author of the PO KU T'U (*q.v.*) points out, this design was evolved from archaic pictographs representing clouds and thunder. The meander in its primitive form, such as found on the bronzes attributed to the Shang period, consists of a non-continuous pattern formed by separate pairs of the simple spiral figure. Later the separate elements became joined together and elaborated, till in the course of time the 'thunder pattern' was often represented by a most intricate form of decoration. To an agricultural people such as the Chinese this emblem possessed a significance of supreme importance. Rain was essential to their very existence, and the symbol for thunder typified the downpour that brought the heaven-sent gift of abundance."[1] In the example of the bronze cauldron of the Chou dynasty illustrated

BRONZE CAULDRON OF THE CHOU PERIOD (FROM PO KU T'U) SHOWING
EXAMPLE OF KEY-PATTERN.

118

THE WU CHUAN TING OF THE CHOU DYNASTY (周 無 專 鼎), circa 800 B.C.,
PRESERVED ON SILVER ISLAND (焦 山) IN THE RIVER YANGTZE. HEIGHT
1⅓ FT., DEPTH 1½ FT.

on page 118, the lozenge-shaped spaces are occupied by the 'cloud and thunder pattern' surrounding a small nipple in the centre, for the nipple nourishes mankind, while clouds and thunder fertilize growing things; on the upper rim appears the *k'uei* (夔) dragon, who exerts a restraining influence against the sin of greed. The Shuo Wên dictionary gives 𝕻 as the archaic form (古文) for 'cloud' (雲), 🯀 for 'thunder' (雷), and 囘 for 'to revolve' (囘), and from the combination of the clouds and the rolling of the thunder is evolved the meander. It is to be noted, however, that the egg symbol ☯ of the dual influences of nature (*vide* YIN and YANG) is said by some authorities to be also a symbol of thunder rolling, and a significance is ascribed to the swastika (卐), so that these two emblems may be likewise connected with the meander, which may also be a variation of the EIGHT DIAGRAMS (*q.v.*).

The T-pattern or swastika-diaper, which corresponds to the *Potencé* division line of European heraldry, is said to be derived from the SWASTIKA (*q.v.*), or to be merely a variation of the meander or key-pattern. The 'recumbent silkworm' (臥蠶) is an antique ornamentation occurring on ancient bronzes. The heads of the JOO-I (*q.v.*) are reproduced in many forms, and much resemble the *Nebulé* division line of western heraldic devices; they are used to form bands or borders. The coin pattern is often employed in the decoration of blue and white china; a common arrangement of Chinese curved tiles on the tops of walls produces a similar effect. Many ornamental windows are worked out with tiles arranged after the fashion of the diaper patterns.

"An ornament as ancient yet not so common as those already described is that known as the 'fish' (魚紋) or 'fish-scale pattern' (鱗紋). It is well shown (on page 119) in the celebrated cauldron preserved in the monastery on Silver Island, near Chinkiang." [2]

"Recurrence in art expresses repose and is frequently used for border patterns, in which the Chinese are past masters. A border is required to give a sense of completeness. The elements used for border decoration are chiefly drawn from the key-pattern and the swastika with its numerous modificatons; from bats usually alternated with a written character such as *shou* (壽) or *hsi* (喜), floral scrolls, dragons, and birds." [3]

Amongst other diapers may be mentioned the Trellis-work, which sometimes appears as a band or border, but often covers

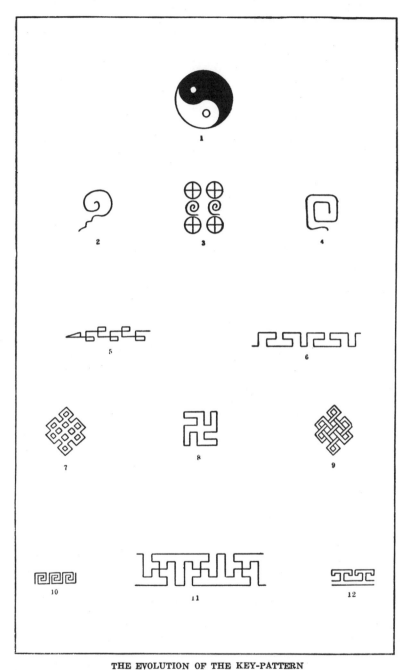

THE EVOLUTION OF THE KEY-PATTERN
1, THE EGG-SYMBOL OF THE YIN AND YANG. 2, 3, 4, ARCHAIC FORMS: CLOUDS,
THUNDER, TO REVOLVE. 5, 6, MEANDERS OR KEY-PATTERNS OF THE CHOU
DYNASTY. 7, MYSTIC KNOT (q.v.). 8, SWASTIKA. 9, MYSTIC KNOT.
10, 11, MODERN MEANDERS. 12, T-PATTERN.

DIAPER PATTERNS

1, RECUMBENT SILKWORM. 2, JOO-I HEADS. 3, COIN DESIGN. 4, TRELLIS-WORK. 5, HONEYCOMB. 6, RING. 7, PLAIN DIAMOND-WORK. 8, FLOWERED DIAMOND-WORK. 9, LOZENGE. 10, SCROLL-WORK.

DIAPER PATTERNS

1, FISH-ROE. 2, OCTAGONS AND SQUARES. 3, NETWORK. 4, SCALE-WORK.
5, SPECKLED WORK. 6, PETAL-WORK. 7, CURL-WORK. 8, Y-WORK. 9,
HERRING-BONE. 10, TRIANGLE-WORK.

the whole field; the Honeycomb design, which when filled in with conventional petals, is called "flowered," and when it contains a star it is designated "starred." The Ring pattern may also be flowered or starred. The Diamond-work design is either plain or flowered. The Lozenge of dark or light squares occurs as a band or border, in panels, or as a representation of stone flooring. Scroll-work is largely employed in the decoration of the later pieces of porcelain. The Fish-roe design is found in both early and the late chinaware. Octagons and Squares are often seen on egg-shell plates. Network is a kind of filigree design consisting of squares with beads suspended from their upper angles. Petal-work consists of the massed petals of flowers. Speckled-work comprises small dots and generally occurs on green enamel. Scale-work is a representation of fish-scales and is used in bordering and panels. Curl-work is frequently found in later examples of porcelain. Y-work often appears in mandarin china.

AUTHORITIES.
[1] Yetts: *Symbolism in Chinese Art*, p. 3.
[2] *Loc. cit.*, p. 7.
[3] Couling: *Encyclopaedia Sinica*: EMBROIDERY.

DOG

（犬）

The written symbol employed to denote the dog is derived from the ancient pictogram *ch'üan* (犬)—the graphic representation of which was much admired by Confucius—now rendered 犬 or 犭, and used as the 94th radical to form characters signifying other quadrupeds, etc. It is the 11th symbolic animal of the TWELVE TERRESTRIAL BRANCHES (*q.v.*), and is classed among the six domestic animals of China (*vide* BIRDS AND BEASTS). The dog is much valued for its fidelity, though despised for other reasons; it fulfills the dual rôle of guardian and scavenger. The chow-dog is fattened with rice for human consumption in south China, and there are thousands of dog farms in Manchuria and Mongolia, where the larger species are reared for the sake of their skins. Chinese dogs, commonly called "wonks" (黄狗), are generally either yellow or black, with coarse bristling hair, and tails curling up high over the back, ears sharp and erect, and head pointed.

"The coming of a dog indicates future prosperity. Many people believe that if a strange dog comes, and remains with one it is an omen of good to his family, indicating that he will become more wealthy." [1] "An image or representation of this animal is found in connection with several objects of worship. It occurs on a painting extensively used by married women as an object of worship in their sleeping apartments. It is called the 'heavenly dog,' or 'a dog of the heavens.' The picture represents a certain genius, surrounded by several children. He is in the act of shooting a dog with a bullet by means of a bow, the dog being in the air much above the level of the shooter and children. This dog in the heavens is believed to eat the children of mortals, and this genius is famed for his skill in shooting this bad dog. A literary man has furnished the following explanation of the use of this painting. Some women are born on days which are represented by the chronological or horary character, which means 'dog.' These women after marriage, and before they give birth to a child, must procure a picture of the genius shooting the 'heavenly dog,' and worship it by the burning of incense and candles. The child then may be expected to live." [2] (*Vide* description of Heavenly Dog Star under MOON.)

The oldest representation of dogs in China is engraved on a bronze vase of the Chou Dynasty, mentioned by Dr. Berthold Laufer of the Field Museum in Chinese Pottery of the Han Dynasty. Miniature hunting dogs were cut out of jade before the Christian era.

The Emperor Ling Ti, who reigned about A.D. 170, felt that nothing was too good for his favourite dog. The animal, undoubtedly born under a lucky dog star, was given the official hat of the Chin Hsien grade, the highest literary rank of the time. One wonders whether the dog appeared at imperial audiences in his hat, which was eight and three-quarter inches high in front, three and three-quarter inches high behind, and ten inches broad. Other dogs belonging to the Emperor were given lesser rank. Upon the consorts of these canine dignitaries were bestowed the ranks of wives of corresponding two-legged officials. The daintiest morsels of rice and meat were set aside for their use, and a special escort of soldiers accompanied them.

The origin and evolution of the Pekingese type are somewhat obscure. "Short dogs" are mentioned in the official record of the Chou Dynasty (about 1000 B.C.) as part of the annual tribute sent from the States now known as the province

of Shansi. In the time of Confucius, five centuries later, reference was made to "short-mouthed" dogs, which were carried in the carts after the chase. About the end of the first century of the Christian era, small dogs were for the first time labelled as a class apart. They were called "Pai," which was defined as a "short-legged, short-headed dog," belonging under the table. Until a thousand years ago, the Chinese used low tables; so an under-the-table-dog was, in fact, a toy dog. In the seventh century A.D. the "Emperor of the Turkoman country" presented the Emperor of China with a male and a female dog, which are described as twelve inches long and seven inches high. They were little trick dogs of remarkable intelligence; they could lead horses by the reins and hold torches in their mouths to light the way for their imperial master when he came home from a party enlivened by the fraternal cups of wine of which Li Po sings so happily in many of his odes. The dogs came from Fu Lin, as Constantinople was called.

The Buddhist lion is an ever recurring symbol in Chinese art and legend. More than any previous ruling family the Manchus capitalized in their own interests the lion-like characteristics that indirectly linked the palace dogs with Buddhism. For the Manchu Dynasty derived its name from the Manjusri Buddha, the Chinese Wen Shu, who rides through Chinese art and literature on a lion. In deference to Wen Shu, the lamas of Tibet sent lion-dogs as a symbolic tribute to the Manchus. The Pekingese lapdog rode on the high crest of imperial favour. The palace eunuchs vied with one another to develop specimens that would gain imperial recognition or win the heart of some spoiled lady of the court—for a handsome consideration.

Of all the Manchus, none bred Pekingese more enthusiastically than the late Empress Dowager, Tzu Hsi, one of the most picturesque and striking personalities of the nineteenth century. She loved the familiar and flattering title her subjects had bestowed on her—the "Old Buddha"—and she emphasized the comparison of her Pekingese to the Buddhist spirit-lion in order to keep alive the connection between her Manchu family and Lamaist Buddhism. She laid down the law for the palace dogs as rigidly as she did for her humblest subjects on the remote frontiers of Tibet.

"Let the Lion Dog be small, with the swelling cape of dignity round its neck and the billowing standard of pomp above its back.

"Let its face be black, its forefront shaggy, its forehead

126

straight and low. Eyes large and luminous. Ears like the sail of a war-junk. Nose like the monkey-god of the Hindus.

"Forelegs bent so that it shall not desire to wander far or to leave the Imperial precincts. Body like that of a hunting lion spying for its prey. Feet tufted with plenty of hair that its footfalls should be soundless. Lively and pompous. Timid to avoid danger.

"Colour golden sable (like a lion), to be carried in the sleeve of a yellow robe, or red bear, or black bear, or striped like a dragon—to suit costumes. It should wash its face like a cat—dainty."

If it falls ill, "anoint it with clarified fat of the leg of a snow-leopard and give it to drink from throstle egg-shells full of juice of custard-apples, in which are three pinches of shredded rhinoceros horns, and apply piebald leeches; and, if it dies, remember that man is not immortal and thou too must die."

"Khan Hsiang-tao says: 'The dog is a creature that keeps watch, and is skilful in its selection of men; it will keep away from anyone who is not what he should be. On this account the ancients at all their festive occasions of eating and drinking employed it.' " [3]

AUTHORITIES.

[1] Doolittle: *Social Life of the Chinese*, p. 571.
[2] *Loc. cit.*, p. 230.
[3] Legge: *Li Ki*, Bk. XLIV, p. 443, note.

DONKEY

(驢)

Donkeys are plentiful in all parts of China north of the Yangtze river, especially in Honan and Shantung provinces. Their flesh is used for food, and they are much in demand for dry ploughing and carrying grain. A kind of glue is made from the hide. The wild ass, *Equus hemionus,* is found in Chinese Turkestan (新疆).

It is to be noted that when familiar animals were selected to denote the years of the CYCLE OF SIXTY, the TWELVE TERRESTRIAL BRANCHES (*q.v.*), and the twenty-eight constellations (*vide* STARS), the donkey was omitted, which leads to the supposition that it was either uncommon or non-existent in China in ancient times. This creature to the Chinese, as to the

Westerner, is the common emblem of stupidity. The phrase, "The year of the donkey and the month of the horse" (驢牛馬月) corresponds to "the Greek Kalends," or "never," as there are no such designations of the years and months. No reference to the ass is found earlier than in the After Han History, in which we read of the Emperor Ling (靈帝), A.D. 168-189, driving four asses attached to his carriage—an action that immediately caused the price of the beast to rise to that of a horse.

DOOR GODS
(門 神)

Acccording to the legend, the Emperor T'ai Tsung of the T'ang dynasty (唐太宗) was once disturbed at night by the throwing of bricks and tiles outside his bedroom and the hooting of demons and spirits. His Majesty and all the inmates of the palace were much alarmed and the Ministers of State were informed. General Ch'in Shu-pao (秦叔寶) stepped forward, and addressing the Emperor said: "Your servant has during his whole life killed men as he would split open a gourd and piled up carcasses as he would heap up ants; why should he be afraid of ghosts? Let your servant, in company with Yü Ch'ih Ching-tê (尉遲敬德), arm ourselves, and keep watch standing." The Emperor granted his request, and during the night he experienced no further alarm, at which he was much pleased, but remarked: "These two men, watching all night had no sleep." He therefore commanded a painter to draw two pictures of men clad in full armour, holding in their hands a gemmed battle-axe, and having a whip, chain, bow and arrows girt on their loins, with their hair standing on end according to their usual manner. These were suspended on the right and left doors of the palace, and the evil spirits were said to be subdued. Subsequent ages imitated this precedent, and have ever since made the champions Ch'in and Yü the tutelary deities of the doorways, the former being depicted with a white face and the latter with a black face.

It is also recorded that Shên Shu (神荼) and Yü Lü (鬱壘), two brothers of remote antiquity, lived on Mount Tu So (度朔) under a peach-tree, and were said to have power

THE TWO DOOR GODS, CIVIL STYLE.

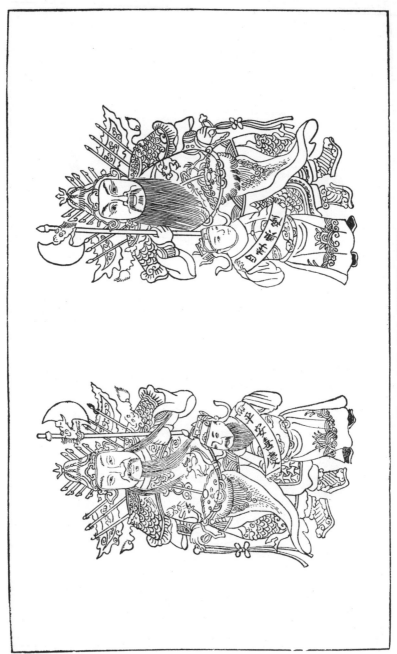

THE TWO DOOR GODS, MILITARY STYLE.

130

over all the disembodied spirits (鬼). They bound the wicked ones with reeds (葦) and fed the tigers with them. On New Year's Eve their coloured portraits or gaudy pictures of tigers are pasted on the doors of houses as a talisman against evil spirits.

When these painted effigies are not depicted in full, the characters 文 承 and 武 尉 are written instead upon squares of red paper, which are pasted upon the doors.

DOVE

(鴿)

Various species of *Columbæ*, or doves and pigeons, are found in China, but the commonest is the *Turtur orientalis*, or Eastern Turtle-dove, colloquially known as *Pan chiu* (班 鳩), which occurs in all parts of the country.

The dove, which was a symbol of innocence with the ancient Egyptians, is regarded by the Chinese as the emblem of long life. It was the custom, during the Han dynasty, to present old persons with a jadestone sceptre (王 杖), which was one foot long, and adorned with the figure of a pigeon at one end, implying the wish that the recipient might continually digest food as well as pigeons do. This "pigeon staff" (鳩 杖) was therefore a symbol of protracted longevity, and is metaphorically referred to in modern parlance in this sense.

Wooden whistles are sometimes attached to the tails of domesticated pigeons, thus producing a harmonious sound when flocks of these birds are circling about in the air. The eating of the eggs of doves and pigeons is said to prevent smallpox.

The Chinese believe the dove to be eminently stupid and lascivious, but grant it the qualities of faithfulness, impartiality and filial duty. The cock is said to send away its mate on the approach of rain, and let her return to the nest with fine weather. They have an idea that it undergoes periodic metamorphoses, but disagree as to the form it takes, though the sparrow-hawk has the preference. The bird is most famed, however, for its filial duty, arising very probably from imperfect observations of the custom of feeding its young with the macerated contents of its crop; the wood pigeon is said to feed her seven young ones in one order in the morning and reversing it in the evening. Its note tells the husbandman when to begin

his labours, and the decorum observed in the nests and cotes of all the species teach men how to govern a family and a State.

The following lines, in praise of virtuous conduct, occur in the "Book of Odes" (詩 經).

> "The turtle-dove is in the mulberry-tree,
> And her young ones are seven in number;
> The virtuous man, the princely one,
> Is uniformly correct in his deportment."
> (鳲鳩在桑。 其子七兮。 淑人君子。 其儀一兮。)

It is to be noted, however, that *ch'i*, seven, is said to be poetic license because it rhymes with *i*, one or uniform. The dove, in point of fact, unsually has only two young at a time.

DRAGON
（龍 ）

"The Eastern dragon is not the gruesome monster of mediæval imagination, but the genius of strength and goodness. He is the spirit of change, therefore of life itself. . . . Hidden in the caverns of inaccessible mountains, or coiled in the unfathomed depth of the sea, he awaits the time when he slowly rouses himself into activity. He unfolds himself in the storm clouds; he washes his mane in the blackness of the seething whirlpools. His claws are in the fork of the lightning, his scales begin to glisten in the bark of rain-swept pine trees. His voice is heard in the hurricane, which, scattering the withered leaves of the forest, quickens a new spring." [1]

DRAGON

The Shuo Wên dictionary (說 文)—A.D. 200—states that of the 369 species of scaly reptiles, such as fishes, snakes, and lizards, the dragon is the chief; it wields the power of transformation, and the gift of rendering itself visible or invisible at pleasure. In the spring it ascends to the skies, and in autumn it buries itself in the watery depths. It covers itself with mud in the autumnal equinox, and emerges in the spring; thus announcing by its awakening the return of nature's energies, it became naturally the symbol of the productive force of moisture, that is of spring, when by means of genial rains and storms all nature renewed itself. It may be noted that

the crocodile was worshipped by the ancient Egyptians, and the theory has been advanced that the Chinese dragon is merely a modified form of the alligator found occasionally to the present day in the Yangtze River, for the emergence of the latter from hibernation synchronises with the coming of spring, when the dragon is believed to be exerting its beneficient influence; it is, however, difficult to trace an analogy between this fabulous animal and any other natural species, for the body of the dragon seems to be distinctly serpentine, its head is made up of parts of those of various other animals, the teeth are those of a mammalian carnivore, while the legs and claws are those of a bird. Moreover, as it is a beneficent creature, it cannot be compared with the ferocious dragon of heraldry and mediæval mythology. "The dragon seems to perpetuate the tradition of primæval flying saurians of geologic times, now known only through their fossilized remains. The Lamas and Chinese Buddhists have assimilated them with the mythical serpents (Naga) of Indian myth."[2] Fossil remains of the Stegodon, Mastodon, Elephant, etc., are occasionally unearthed in various parts of North China. The bones are called Dragon's Bones (龍骨), and the fossil ivory is termed Dragon's Teeth (龍齒); they are powdered, levigated, and used medicinally in the treatment of various ailments such as chorea, spermatorrhæa ague, and hemorrhages.

"There are three chief species of dragons; the *lung* (龍), which is the most powerful and inhabits the sky; the *li* (螭), which is hornless and lives in the ocean; and the *chiao* (蛟), which is scaly and resides in marshes and dens in the mountains. The *lung* is however the only authentic species, and is thus described. 'It has nine resemblances, or forms, viz.: the head of a camel, the horns of a deer, eyes of a rabbit, ears of a cow, neck of a snake, belly of a frog, scales of a carp, claws of a hawk, and palm of a tiger. There is a ridge of scales along its back, eighty-one in number; the scales on its throat lie towards the head, and those on the head are disposed like the ridges in a chain of mountains. On each side of its mouth are whiskers, and a beard hangs under its chin, where also is placed a bright pearl; it cannot hear, which is the reason why deaf persons are called *lung* (聾). Its breath proceeds from the mouth like a cloud; being sometimes changed into water, at other times into fire; its voice is like the jingling of copper pans. There are several varieties; some are horned and others hornless, some are scaleless, and one kind has no wings. It is the common opinion that the dragon, being a divine animal,

ORDER OF THE DOUBLE DRAGON AS CONFERRED DURING THE MANCHU DYNASTY. 1, FIRST DIVISION, THIRD CLASS, FOR FOREIGN MINISTERS AND BOARD PRESIDENTS. 2, FIRST DIVISION, SECOND CLASS, FOR MEMBERS OF FOREIGN ROYAL FAMILIES. 3, FIRST DIVISION, FIRST CLASS, FOR FOREIGN RULERS. 4, SECOND DIVISION, THIRD CLASS, FOR FOREIGN ATTACHES, SENIOR MILITARY OFFICERS, CONSULS GENERAL, AND PRESIDENTS OF COLLEGES. 5, SECOND DIVISION, SECOND CLASS, FOR FOREIGN ACTING MINISTERS AND INSPECTOR GENERAL OF CUSTOMS. 6, SECOND DIVISION, FIRST CLASS, FOR FOREIGN VICE MINISTERS.

ORDER OF THE DOUBLE DRAGON AS CONFERRED DURING THE MANCHU DYNASTY.
1, THIRD DIVISION. THIRD CLASS, FOR INTERPRETERS, MAJORS AND CAPTAINS.
2, THIRD DIVISION, SECOND CLASS, FOR CONSULS, NAVAL COMMANDERS (2ND
CLASS) AND COLONELS. 3, THIRD DIVISION, FIRST CLASS, FOR 2ND & 3RD CLASS
ATTACHES, CONSULS, SECRETARIES OF LEGATIONS, NAVAL COMMANDERS (1ST
CLASS), GENERALS AND PROFESSORS OF COLLEGES. 4, FIFTH DIVISION, FOR
MERCHANTS, ETC. 5, FOURTH DIVISION, FOR SERGEANTS, ETC.

dies of its own accord. It eats swallows' flesh, for which reason, when people pray to the dragon for rain they throw swallows into the water.' The *chiao*, which inhabits the marshes and dens, differs but little from the dragon of the sky. It is described as having a small head and neck, without horns, a breast of a crimson colour, back striped green, and sides yellow; has four legs, but is otherwise like a snake, and about thirteen feet long." [3]

"Another Chinese authority informs us that the dragon becomes at will reduced to the size of a silkworm, or swollen till it fills the space of Heaven and Earth. It desires to mount —and it rises till it challenges the clouds; to sink—and it descends until hidden below the fountains of the deep. The Chinese most thoroughly believe in the existence of this mysterious and marvellous creature; it appears in their ancient history; the legends of Buddhism abound with it; Taoist tales contain circumstantial accounts of its doings; the whole country-side is filled with stories of its hidden abodes, its terrific appearances; it holds a prominent part in the pseudo-science of geomancy; its portrait appears in houses and temples, and serves even more than the grotesque lion as an ornament in architecture, art designs, and fabrics. It has, however, been less used for ornamental purposes since the overthrow of the Monarchy." [4]

A primitive form of dragon is known as *k'uei* (夔). It is a beneficent creature, said to exert a restraining influence against the sin of greed, and it generally occurs in conventional form on ancient Chinese bronzes. Other varieties are the Celestial Dragon (天龍), which protects and supports the mansions of the gods; the Spiritual Dragon (神龍), which produces wind and rain to benefit mankind; the Dragon of Hidden Treasures (伏藏龍), which mounts guard over the wealth concealed from mortal eye; the Winged Dragon (應龍); the Horned Dragon (虯龍); the Coiling Dragon (蟠龍), which inhabits the waters; and the Yellow Dragon (黃龍), which emerged from the River Lo (洛河) to present the elements of writing to the legendary Emperor Fu Hsi. "Modern superstition has further originated the idea of four Dragon Kings (龍王)—identified with the *Nāgas* or Serpent Spirits of the Hindoos—each bearing rule over one of the four seas which form the border of the habitable earth; and the subterranean palaces which form their respective abodes are named as follows: in the east sea, 清華宮; in the south sea, 丹陵宮; in the west sea, 素靈宮; in the north sea, 元冥宮." [5]

There are said to be nine distinct offshoots of the dragon, and they are respectively distinguished by special characteristics. These creatures, according to the *Ch'ien Chü'eh Lei Shu* (潛確類書), by Ch'ên Jen-hsi (陳仁錫), are as follows:

1. *P'u-lao* (蒲牢), carved on the tops of bells and gongs, in token of its habit of crying out loudly when attacked by its arch-enemy the whale;

2. *Ch'iu-niu* (囚牛), carved on the screws of fiddles, owing to its taste for music;

3. *Pi-hsi* (贔屓), carved on the top of stone tablets, since it was fond of literature; it is also said to represent a male and female tortoise bowed down by grief, and is largely used as a pedestal for tombstones, one head looking each way. It is a river god, and is believed to be endowed with supernatural strength;

4. *Pa-hsia* (霸下), carved at the bottom of stone monuments, as it was able to support heavy weights;

5. *Chao-fêng* (朝鳳), carved on the eaves of temples, owing to its liking for danger;

6. *Chih-wên* (螭吻), carved on the beams of bridges, because of its fondness for water. It is also placed on the roofs of buildings to keep off fire. It likes to gaze and look out, and is sometimes symbolised by the figure of a fish with uplifted tail;

7. *Suan-ni* (狻猊), carved on Buddha's throne, on account of its propensity for resting. It has also been identified with the *Shih-tzŭ* (獅子) or symbolic lion;

8. *Yai-tzŭ* (睚眦), carved on sword-hilts, and where the blade joins the handle, in memory of its lust for slaughter;

9. *Pi-kan* (狴犴), carved on prison gates, as it was addicted to litigation and quarrelling, and loved to use its energy and strength, being very fierce. It is a scaly beast with one horn.

On the shores of the North Lake at Peking there stands what is known as the "Nine Dragon Spirit Screen." This screen is of brick faced with a marvellous design of glazed coloured tiles set together in the form of nine coiling and writhing dragons. They are so beautifully fashioned that they actually seem to be alive and ready to fight in protection of the Emperor against all evil spirits and marauders in the sacred precincts. As there are nine main species of dragon, so this protective screen symbolises all the dragons in existence. It was originally erected before the Temple of Ten Thousand Buddhas—long since destroyed by fire. Another fine screen of a similar nature is also to be seen in the Forbidden City near the Hsi Ch'ing Mên (Gate of the Bestowal of Rewards).

Slightly different collections of dragon spawn are given in the *Shêng An Wai Chi* (升庵外集), and other publications, which also mention the *Chiao-t'u* (椒圖), carved on door-handles because it likes to close things; the *T'ao-t'ieh* (饕餮),

carved on covers and sides of food-vessels as a warning against its gluttonous nature; and the *Cha-yü* (猰貐), which has the head of a dragon, tail of a horse, and claws of a tiger; this monster is 4 *chang* (40 feet) long, and loves to eat men; it appears in the world if the ruling sovereign shows a lack of virtue; amongst other relatives of the dragon may be mentioned the *Lang-pei* (狼狽), said to be amphibious and supposed to have short hind legs unsuitable for locomotion, so that one animal rides upon another of the species, the latter making use of its long fore legs. This combination is a symbol of two persons joined together for evil purposes.

"The dragon is said to be the emblem of vigilance and safeguard. The ancients and the moderns have both spoken of this fabulous being. Consecrated by the religion of the earliest people, and particularly the Chinese nation; having become the object of their mythology, the minister of the will of their gods, the guardian of their treasures." [6] By the ancients a water-spout was thought to be a living dragon, and swelling waves—"enchanted." The monster is said to possess the power of raising great waves to injure men and boats.

The round red object which seems to be the constant appurtenance of the dragon is variously described as the sun, the moon, the symbol of thunder rolling, the egg emblem of the dual influences of nature, the pearl of potentiality—the loss of which betokens deficient power—or the "night-shining pearl" (夜明珠), which Professor Giles defines as a carbuncle or ruby. The Chinese imperial coat of arms from the Han to the Ch'ing dynasty consisted of a pair of dragons fighting for a pearl. "A Minister of State—Chi Liang, Marquis of Sui—walking abroad on a certain occasion, found a wounded snake, to which he gave medicine and saved its life. Afterwards, when he was again abroad in the evening, he saw the snake holding a brilliant pearl in its mouth, and as he approached it, the snake is said to have addressed him thus: 'I am the son of His Majesty the Dragon, and while recreating myself was wounded; to you, Sir, I am indebted for the preservation of my life, and have brought this pearl to recompense you for your kindness.' The Minister accepted the pearl and presented it to his Sovereign, who placed it in his hall, where by its influence the night became as day." [7]

The dragon is the fifth of the symbolic creatures corresponding to the TWELVE TERRESTRIAL BRANCHES (*q.v.*). "According to the *I Ching*, the symbol *chên* (震), corresponding to the third of the four primary developments of the

creative influence, is synonymous with *lung*, the dragon; and, in conformity with this dictum, the powers and functions of nature governed by the forces thus indicated, such as the East, Spring, etc., are ranked under the symbol 青 龍, the Azure Dragon, which also designates the eastern quadrant of the uranosphere." [8]

Since the reign of Kao Tsu (高 祖) of the Han dynasty, 206 B.C., the five-clawed dragon was the emblem of imperial power; the Emperor's throne, his robes, and articles of household use, etc., all bore the device of this scaly monster. It was also assigned to the use of the Emperor's sons, and princes of the first and second rank. Princes of the third and fourth rank were allowed the use of the four-clawed dragon, while princes of the fifth rank, and certain officials, were only entitled to employ a serpent-like creature with five claws as their emblem. The following description of court ceremonial, as practiced early in the seventeenth century, will serve as an illustration of the vanished splendour of the past: "When the Emperor of China takes his seat on the dragon throne, flags, chowries, and satin umbrellas are arranged on his right and left hand, and a band of music plays in a large building to the southward. On his right are the military officers, and on his left the civil officers; and they all, at a given signal, bow their heads nine times. The Emperor comes out of his palace in the following manner: He is seated in a sedan chair covered with yellow satin, with three rows of fringe, twelve chowries and twelve flags, upwards of twenty spears having the points sheathed, ten led horses with saddles and bridles complete, and upwards of twenty horses with the brothers and sons of the Emperor dressed in yellow satin jackets, and armed with bows and swords. Immediately in front of the Emperor is carried an umbrella of yellow satin with three rows of fringe, and having the figure of a dragon worked upon it in gold thread, and upwards of a hundred men in charge of the women (eunuchs) surround the Emperor's chair. The band of music which plays when the Emperor comes out or enters the palace, consists of a pipe with six stops, two trumpets, a lyre, and an alligator harp." [9]

The Dragon Boat Festival, known variously as 端 陽 節, 中 元 節, 解 糉 節, or 龍 舟 節, is held on the 5th day of the 5th moon, and presents a very animated scene. Long, narrow boats, holding sixty or more rowers, race up and down the river in pairs with much clamour, as if searching for someone who has been drowned. The festival is popularly believed to

have been instituted in memory of a statesman named Ch'ü Yüan (屈原), a native of Ying (郢), who drowned himself in the River *Mi-lo* (汨羅) in 295 B.C., after having been falsely accused by one of the petty princes of the State, and as a protest against the corrupt condition of the government. The people, who loved the unfortunate courtier for his virtue and fidelity, sent out boats in search of the body, but to no purpose. They then prepared a peculiar kind of rice-cake called *tsung* (糉), made of glutinous rice and wrapped in leaves, and, setting out

DRAGON OF THE CLOUDS DRAGON OF THE SEA

across the river in boats with flags and gongs, each strove to be first on the spot of the tragedy, and to sacrifice to the spirit of the loyal statesman. This mode of commemorating the event has been carried down to posterity as an annual holiday. A dragon boat generally measures 125 feet in length, 2½ feet in depth, and 5½ feet in width, and costs about $500. The bow of the boat is ornamented or carved with a dragon's head, and the stern with a dragon's tail, and carries men beating gongs and drums, and waving flags to inspire the rowers to renewed exertions. Accidents frequently occur during these races and the local authorities in some districts have accordingly restricted or forbidden the practice. It is quite probable that the festival had an earlier origin, and was possibly inaugurated with the object of propitiating the beneficent dragon in the hope that he would send down sufficient rain

for the crops (*vide* illustration of the Dragon Boat Festival under AMUSEMENTS, and the legend of the rebel Huang Ch'ao detailed under TREES).

AUTHORITIES.
[1] Okakura: *The Awakening of Japan*, pp. 77-78.
[2] Waddell: *Lamaism*, p. 395.
[3] *The Chinese Repository*, Notices of Natural History, Vol. VII, 1839, p. 252.
[4] Dyer Ball: *Things Chinese*, 5th Ed.: DRAGON.
[5] Mayers: *Chinese Reader's Manual*, Pt. I, No. 451.
[6] *Encyclopaedia Londinensis*: HERALDRY, Vol. IX, p. 421.
[7] *The Chinese Repository*, Vol. IV, 1835, p. 238.
[8] Mayers: *Chinese Reader's Manual*, Pt. I, No. 451.
[9] *The Chinese Repository*, Vol. IX, Nov., 1840, Art. II, p. 453.

DRAGON-FLY

(蜻 蜓)

The dragon-fly, an emblem of summer, and symbol of instability and weakness, provides a popular *motif* for the poets and painters of the Flowery Land.

It is sometimes known as the typhoon-fly, owing to the presence of the insect in large numbers before a storm. The Chinese believe that insects are excited and impregnated by the wind. Hence the written form for wind (風) contains the character *ch'ung* (虫), insect.

A slang term for the dragon-fly is "Old Glassy" (老琉璃), from the vitreous appearance of its large transparent and reticulated wings.

"There are a large number of different species of dragon-fly to be met with in China, of which the largest belong to the genus Aeschna. These magnificent insects are of a bright green colour, the wings transparent and colourless, the abdomen long and slender and thickened at the end. . . . A very common species throughout China has the whole of the body a brilliant crimson, while yet others are blue or yellow. . . . These beautiful insects may be seen flitting in great numbers over streams and along river banks of the interior. . . . Dragon-flies, being carnivorous in both their aquatic and adult stages, preying as they do upon other noxious insects, should always be encouraged. The larval stage feeds upon the larva of mosquitoes, while the perfect insect feeds upon the same insect in its mature stage. House flies also fall a prey to the dragon-fly."[1]

AUTHORITY.
[1] Sowerby: *A Naturalist's Note-book in China*, pp. 242-244.

DRAMA

（演 戲）

"Theatricals and the Drama, as at present in existence in China, owe their long-continued popularity to the patronage of the enlightened Emperor Ming Huang of the T'ang dynasty, who died in A.D. 762. This monarch, who thoroughly understood music and was a lover of the stage, is said to have founded a vast institution called the Li Yüan Chiao Fang (梨 園 教 坊), or Imperial Dramatic College, where several hundred boys and girls were trained to sing and play for the amusement and delectation of the Court, under the personal tuition of the sovereign, who designated his pupils as the 'Emperor's Pear Garden Pupils' from the fact that he gave them instruction in the Pear Garden of the Imperial Park at Ch'ang-an, then the Imperial Metropolis, now the provincial capital of Shensi, Sianfu. Subsequently actors, generally, became politely designated as the 'Young Folk of the Pear Garden,' a title which they have retained to this day. . . . The drama in China probably began as a religious festival, and became a vehicle of expression for some of the deepest solemnities of Chinese religious thought and then gradually was secularized and lost its vitality. That this is probably correct may be gauged from their Shên-hsi (神 戲) or 'Sacred plays,' which have been handed down from the Chou dynasty, whose long history began in the twelth century B.C. They had then a class of witch-dancers called Wu (武), who performed sacred dances; and subsequently these quasi-religious ceremonies naturally assumed a rôle that was essentially dramatic. . . . Chinese plays are broadly classified not as Tragedies and Comedies, but as Civil and Military. The latter include combats and violent deeds of all sorts. The former are quieter and deal with the more ordinary aspects of social life, often with a tendency to the comic."[1] The majority of plays acted in China were composed in the Yüan and Ming dynasties. They are divided into acts and scenes and are generally historic and highly moral in character. The dialogue is interspersed with poetry or blank verse, which is sung for the most part in a high-pitched recitative. The most striking feature is the Shakespearian absence of properties, and the fact that actors, musicians, and theatre attendants occupy the stage together. The Chinese theatres at the treaty ports are now beginning to show the influence of the foreign drama by the introduction

HUANG HO LOU or **THE YELLOW CRANE TOWER** 黃鶴樓

A CHINESE HISTORICAL DRAMA IN TWO ACTS. PERIOD OF THE THREE KINGDOMS OR RIVAL STATES, SHU (蜀), WEI (魏), AND WU (吳), A.D. 220-267. LEFT TO RIGHT: CHOU YÜ (周瑜), GENERAL OF WU; LIU PEI (劉備), EMPEROR OF SHU; CHINESE PERFORMERS IN STAGE DRESS. AND CHAO TZŬ-LUNG (趙子龍), GENERAL OF SHU.

143

of curtains, wings, and scenery. The revolving stage has been in China for many years.

The external part of a Chinese play is indicated by signs and makebelieve, by a few simple devices, and by the movements and dresses of the actors themselves. They are all fixed absolutely rigidly by convention and therefore well-known to every Chinese playgoer. But as they may not be so apparent to the uninitiated, we will give a few of them herewith:—

SYMBOLIC:

Two tables, one on top of the other covered with red cloth, and with a chair on top, indicate a throne or a judgment seat.

Two bamboo poles with some calico attached represent a city wall or gate.

A boat is generally represented by an old man and a girl with an oar, who move at a fixed distance from each other.

A snowstorm is represented by a man carrying a red umbrella, from the folds of which he shakes out a shower of white slips of paper.

A chariot is indicated by two yellow flags, with a wheel drawn on each, one held in each hand.

A whip held in the left hand shows that the actor is dismounting from, in his right hand is mounting, his steed.

ACTOR'S MOVEMENTS:

Lifting his foot high up indicates he is stepping over the threshold of a door.

Bringing the hands slowly together then closes the door.

A fan held close up to the face shows that he is walking bare-headed in the sun.

Walking slowly round the stage with both hands extended and feeling to both sides indicates walking in the dark.

Slowly moving the hands across the eyes denotes weeping.

Standing stiffly behind a pillar, he is in hiding.

Lifting the skirts, bending down at the waist, and walking with slow measured steps indicates the ascent of a ladder or stairs, or crossing a narrow plank on to a boat.

COLOUR AND DRESS:

A red painted face indicates a sacred, loyal personage, or a great Emperor.

A black face—an honest, but uncouth fellow.

A white face—a treacherous, cunning, but dignified person.

A white patch on the nose—a villain.

Devils have green, gods and goddesses gold or yellow faces.

An Emperor's robe is always yellow, embroidered with coiled dragons winding up and down.

High officials also wear yellow, but have dragons flying downwards.

A warrior's hat is bedecked with two long peacock feathers.

A beggar is indicated by a silk robe with gaudy patches.

A gay woman is covered with jewellery and gaudy silk and satins.

A virtuous one is always clad in a plain black gown with light blue trimmings on the sleeves.

A ghost is represented by an actor with a black cloth over head and face, or with a slip of white paper stuck on the cheek, or with a long curl of white paper suspended from the head.

Death is indicated by a red cloth thrown over the face.

Two men carrying black flags show that evil spirits are roaming about looking for victims.

SOUNDS:

Blowing of trumpets off stage heralds the approach of cavalry.

Fireworks indicate the appearance of a demon.

Two or three blasts of the trumpet indicate an execution taking place off stage." [2]

A good actor may receive a salary as high as two thousand dollars a month. According to the general rule it is improper for women to take part in stage plays, and the women's parts are usually taken by men, but this custom is not now so strictly adhered to. Romantic love is never disproportionately emphasised on the Chinese stage.

Temporary theatres are often erected of matting and posts. A shed large enough to accommodate two thousand persons can be put up in a day, and almost the only part of the materials which is wasted is the rattan which binds the mats and poles together (*vide* also AMUSEMENTS, COLOURS, COSTUME).

AUTHORITY.
[1] Arlington: *The Chinese Drama*, Introduction, p. xxiv *et seq.*
[2] Arlington and Lewisohn: *In Search of Old Peking*, 1935, pp. 275-7.

DRUM

（鼓）

From the remotest ages the Chinese have been acquainted with instruments of percussion, of which the tanned skin of animals was the vibrating medium. They would appear, in the first instance, to have been made of baked clay, filled with bran and covered with skin, and used principally to excite warriors in the battlefield to deeds of prowess. The Chinese possess about twenty different kinds of drums at the present day, varying from five inches to several feet in diameter.

The drums in use at Confucian temples are richly painted and ornamented with birds, dragons, flowers, etc., in gold and vermilion, while others are very simple and unadorned.

The fish Drum （魚鼓） is a bamboo pipe, one end of which is covered with snake-skin. It is tapped by blind fortune-tellers, and is the emblem of Chang Kuo-lao （張果老）, one of the EIGHT IMMORTALS (*q.v.*) of Taoism.

T'AO KU OR HAND-DRUM

The *T'ao Ku* （鞀鼓）, Sanskrit, *Damaru*, is used in ritual music, and a small variety is carried by street vendors. It is a rattle-drum with a handle passing through the body; two balls are suspended by strings from each side of the barrel, and when the drum is twirled they strike against the head.

The *Pang Ku* （梆鼓） is a small flat drum, with a body of wood; the top is covered with skin and the bottom is hollow. It is commonly used in orchestras (*vide* also MUSICAL INSTRUMENTS).

DUCK

（鴨）

The fenny margins of lakes and rivers, and the sea-coast marshes, afford sufficient food and shelter to many varieties of waterfowl. Geese, swans, mallard, teal, grebe, etc., are found in large quantities during the winter, after which they migrate to colder regions.

"Ducks are sometimes caught by persons who first cover their heads with a gourd pierced with holes, and then wade into the water where the birds are feeding; these, previously

146

accustomed to empty calabashes floating about on the water, allow the fowler to approach, and are pulled under without difficulty." [1] Wild fowl are sometimes snared by means of long strings supported by bamboos at a certain height above the water. At intervals along the strings are fastened powerful hooks, on which the birds, swooping in at dusk, are impaled. In some districts nets are used, which is a more humane method of capture. Quantities of wild fowl are also killed by the native sportsmen with blunderbusses, muzzle-loading guns, long-barrelled flint or fire-locks, etc., loaded with iron shot, which often break the teeth of the unwary consumer of Chinese game.

The duck is an emblem of felicity and is commonly depicted with the lotus. It is a common article of diet, and is often dried and salted; the tongues and liver are regarded as great dainties; the Peking duck is celebrated for its excellent flavour, and has been introduced into America.

The Mandarin Duck, *Aix galerculata,* or *Yüan yang* (鴛 鴦), also known as *Hsi ch'ih* (稀 翅), is a very beautiful species. It is called the Mandarin Duck an account of its alleged superiority over other ducks, and the extreme beauty of its plumage. These water-fowl manifest, when paired, a singular degree of attachment to each other, and are said to pine away and die when separated. Hence they have been elevated into an emblem of conjugal fidelity. (*Vide* GOOSE.)

AUTHORITY.
[1] Williams: *The Middle Kingdom,* Vol. I, p. 340.
[2] Arlington and Lewisohn: *In Search of Old Peking,* 1935, pp. 275-7.

EIGHT DIAGRAMS
(八 卦)

The *Pa Kua*, or Eight Diagrams, are represented by an arrangement of certain cabalistic signs consisting of various combinations of straight lines arranged in a circle, said to have been evolved from the markings on the shell of a tortoise by the legendary Emperor Fu Hsi (伏羲), 2852 B.C. They are also said to have been created from the two primary forms (兩儀), represented by a continuous straight line (———) called *Yang I* (陽儀), or the symbol of the male principle, and a broken line (—— ——) called *Yin I* (陰儀), or the symbol of the female principle (*vide* YIN AND YANG). Mathematics are said to have been derived from the Eight Diagrams, which figuratively denote the evolution of nature and its cyclic changes.

Wên Wang (文王), 1231-1135 B.C., the founder of the Chou dynasty, while undergoing imprisonment at the hands of the tyrant Emperor Chou Hsin (紂辛), devoted himself to a study of the Diagrams, and appended to each of them certain explanations entitled 彖, which, with further observations termed 象, attributed to his son Chon Kung (周公), constitute the abstruse work known as the "Canon of Changes" (易經), the most venerated and least understood of the Chinese classics, serving as a basis for the philosophy of divination and geomancy, and supposed to contain the elements of metaphysical knowledge and the clue to the secrets of creation.

The following table of the Eight Diagrams of Fu Hsi shows their names, the objects they represent, their attributes or virtues, their appropriate animals, and the points of the compass to which they refer:

	乾	兌	離	震	巽	坎	艮	坤
	Ch'ien	Tui	Li	Chên	Sun	Kan	Kên	K'un
	Heaven; the sky.	Water collected as in a marsh or lake.	Fire, as in lightning; the sun.	Thunder.	The wind; wood.	Water, as in rain, clouds, springs, streams, and defiles; the moon.	Hills, or mountains.	The earth.
	Untiring strength; power.	Pleasure; complacent satisfaction.	Brightness; elegance.	Moving, exciting power.	Flexibility; penetration.	Peril; difficulty.	Resting; the act of arresting.	Capaciousness; submission.
	Horse	Goat	Pheasant	Dragon	Fowl	Swine	Dog	Ox
	S.	S.E.	E.	N.E.	S.W.	W.	N.W.	N.

149

"In addition to the series of eight diagrams described, Fu Hsi, or some one of his successors, is held to have enlarged the basis of calculation by multiplying the original number eight-fold, thus creating the , Sixty-four Diagrams or Hexagrams. This is accomplished by duplicating each of the original diagrams with itself and the remaining seven, forming combinations such as the following:

and so on to the end. A six-fold multiplication of these again gives the 384 爻, completing the number to which the diagrams

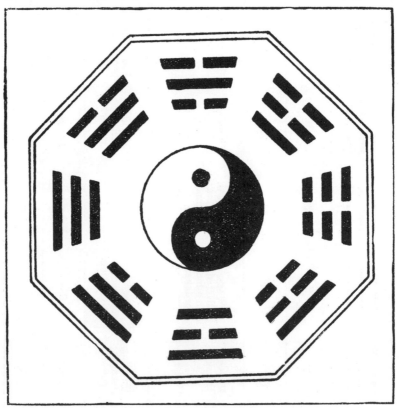

THE EIGHT DIAGRAMS WITH THE SYMBOL OF CREATION IN THE CENTRE

are practically carried, although it is maintained that by a further process of multiplication a series of 16,777,216 different forms may be produced." [1]

A plaque, such as the above, made of copper, silver, or jade, engraved with the Eight Diagrams, is considered to have the power of preserving the wearer from misfortune, and assuring his future prosperity. It may also be nailed over a house door as an emblem of felicity.

AUTHORITY.

[1] Mayers: *Chinese Reader's Manual*, Pt. II, No. 241.

EIGHT IMMORTALS

(八 仙)

"The character 仙, which signifies *genii*, is composed of 人 *a man and* 山 *a hill.* It represents the superior class of human spirits, who, having been deified, dwell in mountains and hills remote from human habitations; to whom no temples are consecrated, and who, even the most eminent of them, are not of very high antiquity; although supposed to have the power of being visible and invisible at pleasure, of raising the dead, of changing, by a species of stone which they have discovered, whatever they touch into gold, and of effecting at pleasure various other wonderful transmutations. Their eminent position has been attained by abstraction from the world, to which eight, including two females, have risen higher than any other. The same term 仙 is given to *heaven, gods, earth, water,* and the *human soul,* as the five *genii* by way of eminence." [1]

"The *Pa Hsien,* or eight immortals, are legendary beings of the Taoist sect, said to have lived at various times and attained immortality through their studies of Nature's secrets. They are not unfrequently depicted on porcelain. They are also to be found as separate figures, standing or seated. Sometimes they ornament the edges of plates, standing on various animals among the waves of the sea, and their symbols occasionally occur as devices." [2] They also figure in bronze, ivory, embroideries, rugs, etc. They correspond in some measure to the EIGHTEEN LOHAN (*q.v.*) of Buddhism, who are also distinguished by their respective symbols, with which they are always represented. The Hsien and the Lohan have the power of crossing rivers and seas standing or sitting on these symbolic appurtenances.

The Eight Immortals each represent a different condition

151

in life, *i.e.*, poverty, wealth, aristocracy, plebianism, age, youth, masculinity, and femininity. According to the "Kai Yü Yeh K'ao" (陔餘叢孝) by the noted scholar and critic Chao I (趙翼), A.D. 1727, "the legend relating to the above personages as constituting a defined assemblage of immortalized beings is traceable to no higher antiquity than the period of the Yüan dynasty, although some, if not all of the members of this group had been previously celebrated as immortals in the Taoist legends." [3]

The Eight Immortals of Taoism are described as follows:

1. Chung-li *Ch'üan* (鍾離權), the Chief of the Eight Immortals, is said to have lived under the Chou dynasty, 1122-249 B.C., and to have obtained the secrets of the elixir of life,

CHUNG-LI CH'UAN

CHANG KUO-LAO

and the powder of transmutation. He is generally depicted as a fat man with a bare belly, sometimes holding a peach in his hand, and always grasping his emblem, a fan, with which he is believed to revive the souls of the dead. "Fairylike stories say he married a young and beautiful wife, and retired to his native place to lead the life of a philosopher. One day walking in meditation in the country, he noticed a young woman in deep mourning, sitting near a grave and fanning the freshly upturned soil. When asked the reason, she said that her late husband implored her not to remarry until the soil on his grave dried. Having found an admirer, she wanted the grave to be

dry as soon as possible, and was assisting in carrying off the moisture by fanning it. Chung-li Ch'üan offered her his help. Taking her fan, he invoked spirits to his aid, struck the tomb with the fan, and it became absolutely dry. The widow thanked him gaily, and walked away, leaving her fan, which Chung-li Ch'üan kept. When his young wife saw the fan, she wanted to know whence it came. On hearing the story she became very indignant, protesting that she would never behave so and that the widow must be a monster of insensibility. These words gave the magician an idea to test her feelings. With the aid of powerful spells he pretended to be dead, at the same time assuming the shape of a handsome young man, and making love to the supposed widow, who in a few days agreed to marry him. The young man said to his betrothed that he needed the brain of her late husband to make a powerful potion, and the widow opened the coffin to comply with her lover's request. To her horror her former husband suddenly came to life, while her admirer disappeared into thin air. Unable to survive her shame, she hung herself, while Chung-li Ch'üan set the house on fire, taking out of it only the fan and the sacred book called Tao-teh King." [4]

2. Chang Kuo-lao (張果老), 7th and 8th century A.D., a recluse who had supernatural powers of magic, such as rendering himself invisible, etc. He used to be accompanied by a white mule, which carried him immense distances, and, when not required, was folded up and put away in his wallet; when he wished to resume his travels he squirted some water upon the wallet and the beast at once appeared; he generally rode the animal backwards. His emblem is the *Yü Ku* (魚 鼓), a kind of musical instrument in the shape of a bamboo tube or drum with two rods to beat it. The Emperor Ming Huang wished to attach him to his court, but Chang Kuo could not give up his wandering life. On the second summons from court he disappeared and entered on immortality without suffering bodily dissolution.

3. Lü Tung-pin (呂洞賓), *circa* A.D. 750, a scholar and recluse who learnt the secrets of Taoism from Chung-li Ch'üan, the Chief of the Eight Immortals, and attained to immortality at the age of 50. He is the patron saint of the barbers, and is also worshipped by the sick. In his right hand he holds a Taoist fly-brush, and his emblem, a sword, is generally slung across his back. He was exposed to a series of temptations, ten in number, and having overcome them, was invested with a sword of supernatural power, with which he traversed the

earth, slaying dragons, and ridding the world of various forms of evil for upwards of 400 years.

4. Ts'ao Kuo-chịu (曹國舅), said to be the son of Ts'ao Pin (曹彬), A.D. 930-999, a military commander, and brother of the Empress Ts'ao Hou (曹后) of the Sung dynasty. He

LU TUNG-PIN

TS'AO KUO-CHIU

wears a court head-dress and official robes, and his emblem is a pair of castanets, which he holds in one hand. He is a patron saint of the theatrical profession. The castanets are said to be derived from the court tablet, authorising free access to the palace, to which he was entitled owing to his birth.

5. Li T'ieh-kuai (李鐵拐) is represented as a beggar leaning on an iron staff, for the following reason. He attained so much proficiency in magic during his life on earth that he was frequently summoned to the presence of Laocius in the celestial regions. In such cases he went there in spirit, leaving his body, apparently dead, in charge of his disciple. Once, when he was absent longer than usual, his disciple, who was called away to his mother's bed of sickness, decided that his master was really dead this time; so he burned the body and went home. When Li T'ieh-kuai returned from the Hills of Longevity, he discovered that he had no body into which to enter. Hastily he cast around for somebody recently dead, but all he could find was the body of a lame beggar in a nearby wood.

154

He entered into it, and is always represented as a beggar with an iron crutch and a pilgrim's gourd from which a scroll is escaping, emblematic of his power to set his spirit free from the body. His emblem is the pilgrim's gourd, and he is sometimes represented standing on a crab or accompanied by a deer.

LI T'IEH-KUAI

HAN HSIANG-TZU

6. Han Hsiang-tzŭ (韓湘子), nephew of Han Yü (韓愈), a famous scholar who lived about A.D. 820. He is credited with the power of making flowers grow and blossom instantaneously. He was a favourite pupil of Lü Tung-pin (*vide* No. 3 above), who carried him to the supernatural peach-tree (*vide* PEACH), from which he fell and became immortal. His emblem is the flute, and he is the patron of musicians. He wandered in the country, playing his flute and attracting birds and even beasts of prey by the sweet sounds. He did not know the value of money, and, if given any, used to scatter it about on the ground.

7. Lan Ts'ai-ho (藍采和). "Generally regarded as a woman and represented as dressed in a blue gown, with one foot shod and the other bare, waving a wand as she wanders begging through the streets." [5] She continually chanted a doggerel verse denouncing this fleeting life and its delusive pleasures. Her emblem is the flower-basket which she carries, and she is the patron saint of the florists.

8. Ho Hsien-ku (何 仙 姑), 7th century A.D. Daughter of a shopkeeper of Lingling (零 陵), Hunan. Having eaten of the supernatural peach, she became a fairy. She used to wander alone in the hills, and lived on powdered mother-of-pearl and moonbeams, which diet produced immortality. Once she got

LAN TS'AI-HO HO HSIEN-KU

lost in the woods and was in great danger from a malignant demon; but Lü Tung-pin (*vide* No. 3 above) appeared at the critical moment and saved her, using his magic sword. She disappeared when summoned to the court of the Empress Wu (武 后), A.D. 625-705. Her emblem is the lotus, which she carries in her hand. Sometimes she is represented poised on a floating petal of the lotus, with a fly-whisk in her hand. She assists in house management.

AUTHORITIES.

1 Kidd: *China*, p. 288.

2 Franks: *Bethnal Green Museum Catalogue of Oriental Porcelain*, 2nd Ed., p. 241.

3 Mayers: *Chinese Reader's Manual*, Pt. II, No. 251.

4 *Peking*, August, 1931.

5 Giles: *Biographical Dictionary*, No. 1085.

EIGHT TREASURES
（八 寶）

The *Pa Pao,* or Eight Treasures, are represented by various categories or collections of antique symbols, depicted on porcelain, embroideries, etc., and generally entwined with ribbons or flllets. "These fillets are pieces of red cloth tied round anything believed to possess the efficacy of a charm and are supposed to represent the rays or aura of the charm. They are, in fact to the charm what the halo is to the gods or goddesses." [1]

The following arrangements of Eight Treasures are commonly met with:

1. The Eight Ordinary Symbols, viz., the PEARL, LOZENGE, STONE CHIME, RHINOCEROS' HORNS, COIN, MIRROR, BOOK, and LEAF (*q.q.v.*).

2. The Eight Precious Organs of Buddha's Body, viz., the HEART, GALL-BLADDER, SPLEEN, LUNGS. LIVER, STOMACH, KIDNEY, and INTESTINES (*q.q.v.*).

3. The Eight Auspicious Signs (八吉祥), on the Sole of Buddha's Foot, or a variation of the SEVEN APPEARANCES (*q.v.*). This combination comprises the WHEEL OF THE LAW, CONCH-SHELL, UMBRELLA, CANOPY (also said to be a flag), LOTUS, JAR, FISH, and MYSTIC KNOT (*q.q.v.*). They are made of wood or clay and stand on the altars of Buddhist temples, besides being utilised as architectual *motifs,* etc.

4. The various emblems of the EIGHT IMMORTALS (*q.v.*) of Taoism. They consist of the SWORD, FAN (*q.q.v.*), FLOWER-BASKET (*vide* FLOWERS), LOTUS, FLUTE, GOURD, CASTANETS (*q.q.v.*), and MUSICAL TUBE (*vide* DRUM).

AUTHORITY.
[1] Gulland: *Chinese Porcelain,* Vol. I, p. 32.

EIGHTEEN LOHAN
（十 八 羅 漢）

The Eighteen Lohan, also variously called Arhat, Arahat, Arhan, Arahan, Arhant, Arahant (Sanskrit), "Destroyers of the Enemy" (*i.e.* Passions), "Deserving and Worthy," or the "Worthies" (尊者), are the personal disciples of Buddha, the

THE EIGHT ORDINARY SYMBOLS

1, DRAGON PEARL; 2, GOLDEN COIN; 3, LOZENGE; 4, MIRROR; 5, STONE
CHIME; 6, BOOKS; 7, RHINOCEROS' HORNS; 8, ARTEMISIA LEAF.

THE EIGHT BUDDHIST SYMBOLS

1, JAR; 2, CONCH-SHELL; 3, UMBRELLA; 4, CANOPY; 5, LOTUS; 6, WHEEL
OF THE LAW; 7, FISH; 8, MYSTIC KNOT.

patrons and guardians of Shakamuni's system of religion and its adherents, both lay and clerical. Sixteen are of Hindoo origin, and two more have been added by the Chinese in comparatively recent times. Their images are arranged along the side walls of the second or main hall of the Buddhist monastery.

"Lohan, Arhat, Arahat, are all designations of the perfected Ârya, the disciple who has passed the different stages of the Noble Path, or eightfold excellent way, who has conquered all passions, and is not to be reborn again. Arhatship implies possession of certain supernatural powers, and is not to be succeeded by Buddhaship, but implies the fact of the saint having already attained Nirvâna. Popularly the Chinese designate by this name the wider circle of Buddha's disciples as well as the smaller ones of 500 and 18. No temple in Canton is better worthy of a visit than that of the 500 Lohan." [1]

Many extravagant stories are related of the supernatural powers of these guardians of Buddhism, who are appointed to certain stations in different parts of the world, and to each is assigned a retinue of 500—1,600 subordinate Arhats. The pictures and images of the Lohan are mainly derived from the works of one or two painters of the T'ang dynasty, and based on descriptions given in Buddhist records.

The Lohan are represented, each one posed in a fixed attitude with his distinctive symbol or badge, in the same way as the apostles of Christ—Mark with a lion, Luke with a calf, Peter with a key, etc. There is little or no variation in different localities in the names and serial numbers of the original sixteen, but there would appear to be considerable doubt as to who the remaining two actually are. In many temples the 17th and 18th places are given respectively to Nandimitra and a second Pindola. As one of the additional Lohan we sometimes find the well-known Imperial patron of Buddhism Wu Ti (武帝), A.D. 502, the first ruler of the Liang dynasty, or Kumarajiva, the great translator who flourished about A.D. 400. Other occasional incumbents are Dharmatrata (法救), a learned author who lived about the middle of the first century of our era, and the Pu Tai Ho Shang (布袋和尚), or Calico-Bag Monk, said to be a reincarnation of Maitreya (Ajita), or of Amita Buddha, represented as seated and holding the open end of the bag which is round his back, or sitting inside the bag, with three or six young "thieves"—symbolising the deadly sins—playing round him; this monk is said to have lived in the sixth century A.D., and is the special patron of tobacco sellers.

TOP LEFT: LOHAN NO. 1, PIN-TU-LO-PO-LO-TO-SHE, PINDOLA THE BHARADVAJA.
TOP RIGHT: LOHAN NO. 2, KA-NO-KA-FA-TSO, KANAKA THE VATSA. BOTTOM
LEFT: LOHAN NO. 3, PIN-T'OU-LU-O-LO-SUI-SHIH, A SECOND PINDOLA. BOTTOM
RIGHT: LOHAN NO. 4, NAN-T'I-MI-TO-LO-CH'ING-YU, NANDIMITRA.

TOP LEFT: LOHAN NO. 5, PA-NO-KA, VAKULA OR NAKULA. TOP RIGHT: LOHAN
NO. 6, TAN-MO-LO-PO-T'O, TAMRA BHADRA. BOTTOM LEFT: LOHAN NO. 7,
KA-LI-KA, KALIKA OR KALA. BOTTOM RIGHT: LOHAN NO. 8, FA-SHE-NA-FU-TO,
VAJRAPUTRA.

Lohanship is also occasionally assigned to Chi Kung (濟公), originally named Li Hsiu-yuan (李修元), a native of T'ient'ai (天台縣), Chekiang, born 1193. His father's name was Li Mou-ch'un (李茂春), and his mother was a member of the Wang (王) family. He was clever as a youth, and well versed in the doctrines of Buddhism. He cared little for official rank. His parents died when he was 18 years old. After the expiration of three years mourning he entered Lin Yin Monastery (靈隱寺), became a monk, and adopted the religious style Tao Chi (道濟). He was employed by Prime Minister Chin (秦) as his substitute in the Buddhist services. He was fond of wine, and broke the disciplinary rules of the priesthood. He posed as an eccentric person, and amused himself with worldly affairs, his supernatural powers in deciding law suits, curing sickness, vanquishing demons, etc., being so remarkable that he was known as the Mad Healer (濟顛).

When Maitreya the Messiah returns, the Lohan will collect all the relics of Shakamuni and build over them a magnificent pagoda. They will then enter an igneous ecstacy and vanish in remainderless Nirvâna.

The usual series of Lohan is as follows:

1. Pin-tu-lo-Po-lo-to-shê, Pindola the Bhāradvāja. His station is the Godhênga region in the West, and he has a retinue of 1,000 arhats. He was one of Buddha's great disciples, had a voice like a lion, and possessed superhuman powers which enabled him to rise in the air like a bird. In a remote existence he had been a bad son and a cruel man, and had to suffer in hell for a long period with nothing to eat but bricks and stones; hence his somewhat gaunt and haggard appearance. He has an open book on one knee and a mendicant's staff at his side.

2. Ka-no-ka-Fa-tso, Kanaka the Vatsa. Appointed to Kashmir with a retinue of 500 other arhats. He was originally a disciple of Buddha and it was said of him that he understood all systems good and bad.

3. Pin-t'ou-lu-O-lo-sui-shih, a second Pindola. Sometimes called Ko-no-ka-Po-li-to-shê (迦諾迦跋釐惰闍) or Kanaka the Bhāradvāja. His station is in the Purva-Videha region, and he has 600 arhats under his authority. Like Esau he was a hairy man.

4. Nan-t'i-mi-to-lo-Ch'ing-yu, Nandimitra. Sometimes known as Su-p'in-t'o (蘇頻陀) or Subhinda. He governs the Kuru country and had a retinue of 800 arhats. He sits with

an alms-bowl and an incense-vase beside him, holding a sacred book in the left hand, while, with the right he snaps his fingers as an indication of the rapidity with which he attained spiritual insight.

5. Pa-no-ka, Vakula or Nakula. Sometimes known as Pa-ku-la (巴古拉) or P'u-chu-lo (薄拘羅). His sphere of influence is Jambudvipa, or India, and he has a retinue of 800 arhats. He was one of Buddha's great disciples, and led a solitary life free from bodily ailments. He was converted to Buddhism at the age of 120, whereupon he became young and happy. His name means "mungoose-bearer" and he is said to have kept a mungoose as a pet. He is represented as meditating or teaching with a little boy by his side, and he holds a rosary of 108 beads.

6. Tan-mo-lo-Po-t'o, Tāmra Bhadra. Appointed to Tamradvipa or Ceylon and provided with a retinue of 900 other arhats. He was a cousin of the Buddha and one of his great disciples. Represented in an attitude of worship with his prayer-beads.

7. Ka-li-ha, Kālika or Kāla. He rules over Sêng-ka-ch'a (僧迦茶), or Sinha the Lion region, supposed to be Ceylon, but probably some other territory, and has a retinue of 1,000 arhats. He is identified with Lion King Kala (師子王迦羅), who attained arhatship and was honoured by King Bimbiasra. He sits in meditation and has extremely long eyebrows which he holds up from the ground.

8. Fa-shê-na-fu-to, Vajraputra. He rules over the Po-la-na (鉢剌拏) division of world, probably Parna-dvipa, and has a retinue of 1,100 arhats. He is represented as very hairy, lean, and ribbed.

9. Chieh-po-ka, Gobaka the Protector. Stationed on the Gandhamādana mountain with a retinue of 900 arhats. He is represented in contemplation with a fan in his hand.

10. Pan-t'o-ka, Panthaka or Pantha the Elder. His sphere is in the Trayastrimsat Heaven, and he is attended by 1,300 arhats. Elder brother of Chota Panthaka (Lohan No. 16, *q.v.*). His name signifies "born on the road" and was given to the two boys because their births occurred while their mother was making journeys. The name is also explained as meaning "continuing the way," *i.e.*, propagating the Buddhist doctrine. He was one of the greatest of Buddha's disciples, who "by thought aimed at excellence." He possessed magical power to

TOP LEFT: LOHAN NO. 9, CHIEH-PO-KA, GOBAKA, THE PROTECTOR. TOP RIGHT:
LOHAN NO. 10, PAN-T'O-KA, PANTHAKA OR PANTHA THE ELDER. BOTTOM
LEFT: LOHAN NO. 11, LO-HU-LO, RAHULA, THE SON OF BUDDHA. BOTTOM
RIGHT: LOHAN NO. 12, NA-KA-HSI-NA, NAGASENA.

165

TOP LEFT: LOHAN NO. 13, YIN-CHIEH-T'O, ANGIDA. TOP RIGHT: LOHAN NO. 14,
FA-NA-P'O-SSU, VANAVASA. BOTTOM LEFT: LOHAN NO. 15, A-SHIH-TO, ASITA
OR AJITA. BOTTOM RIGHT: LOHAN NO. 16, CHU-CH'A-PAN-T'O-KA, CHOTA-
PANTHAKA OR PANTHA THE YOUNGER.

pass through solids, to reproduce fire and water at will, and to reduce his dimensions little by little until he vanished entirely. He is represented sitting on a rock and reading from a scroll.

11. Lo-hu-lo, Rāhula, the son of Buddha. Assigned to the Priyangu-dvipa, a land of chestnuts and aromatic herbs, with a suite of 1,000 arhats. He was a diligent student of the canons and strict adherent to the laws of Buddhism. It is his fate to die and return to the world as Buddha's son several times. Represented with a large "umbrella-shaped" or domed head, bushy eyebrows, and a hooked nose.

12. Na-ka-hsi-na, Nāgasena. Appointed to the Pan-tu-p'o or Pandava Mountain in Magadha, with a retinue of 1,200 arhats. An expert in the propounding of the essentials of Buddhism. He had a commanding presence and a ready wit.

13. Yin-chieh-t'o, Angida. Stationed on the mountain called Kuang-hsieh or Broad-side, i.e., Vipulapārsva, with a retinue of 1,300 arhats. Represented as a lean old monk with a wooden staff and a book containing Indian writing.

14. Fa-na-p'o-ssŭ, Vanavāsa. Stationed on the K'o-chu (可 住) or Habitable Mountain, with a retinue of 1,400 arhats. He is represented sitting in a cave meditating with closed eyes and hands folded over his knees.

15. A-shih-to, Asita or Ajita. Appointed to reside on Gridhrakuta Mountain or Vulture Peak (q.v.), with a retinue of 1,509 arhats. Represented as an old seer with very long eyebrows, nursing his right knee and absorbed in meditation.

16. Chu-ch'a-Pan-t'o-ka, Chota-Panthaka or Pantha the Younger. Appointed to Ishadhara Mountain in the Sumeru range, with a retinue of 1,600 arhats. Younger brother of Pantha the Elder (Lohan No. 10, q.v.). Though dull and stupid at first, and despised by the other disciples, with the assistance of Buddha, he developed his intellectual faculties to an exceptional degree, and in course of time attained arhatship with the miraculous powers of flying through the air, and of assuming any form at will, etc. Represented as an old man sitting under and leaning against a dead tree, one hand holding a fan, and the other held up in an attitude of teaching.

17. A-tzŭ-ta, Ajita. Said to be an incarnation of Maitreya Buddha (q.v.), though this is not logical, as the Bodhisattva, according to all accounts, remains in the Tushita Paradise until the time comes for him to be reincarnated, and the Lohan, as guardians of Shakyamuni's religious system, are

LOHAN NO. 17,
A-TZU-TA, AJITA.

LOHAN NO. 18,
PO-LO-TʻO-SHE.

stationed on earth until Maitreya's coming again. Represented
as an old man seated on a rock and grasping a bamboo staff.

18. Po-lo-tʻo-shê. Probably another form of Pindola the
Bhāradvāja (*vide* Lohan No. 1). He rides upon a tiger, thus
showing his power over wild animals, and exemplifying his
strength to overcome evil.

AUTHORITY.
[1] Legge: *Travels of Fa-hien*, pp. 24-5, note 3.

ELEPHANT
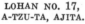
(象)

The written character which represents the elephant is
intended to combine the figures of its trunk, eyes, tusks, and
legs; and in the ancient seal character (illustrated under
WRITTEN CHARACTERS, *q.v.*) the resemblance is sufficiently
accurate to detect the animal; this character is sometimes
interchanged with Hsiang (相), Prime Minister.

Elephants are not now met with in China except in the
south of Yunnan, though they formerly abounded in Hunan,

Kuangsi, and Kuangtung; they were used in warfare by the Chinese in ancient times. During the reign of K'ang Hsi (1662-1723) the King of Siam sent a number of tribute elephants to Peking. According to the "Pên Ts'ao" (本草), the strength of the animal lies chiefly in the trunk, which, if injured, causes death; it is said to understand human speech,

THE WHITE ELEPHANT WITH THE SACRED ALMSBOWL OF BUDDHA ON ITS BACK. ONE OF THE SEVEN SACRED TREASURES OF BUDDHISM.

eats grass, and sugar cane, drinks wine, and dreads smoke, fire, lions, and serpents. The trunk of the elephant was formerly a great dainty with the Chinese. Plasters made of elephant hide were formerly used for the healing of severe wounds, and a decoction made by boiling the shavings of the tusks was employed as a tonic. Crude rubber, or crepe, is supposed by the Chinese to resemble the hide of the elephant in appearance

and thus *Hsiang-p'i* (象 皮) or "elephant's hide" is the term applied to indiarubber. Chop-sticks, inlaid ornaments for girdles, foot-measures, knife-handles, etc., are made of ivory in large quantities and great variety, especially at Canton.

The elephant is the symbol of strength, sagacity, and prudence, and is one of the four animals representing power or energy, the other three being the tiger, leopard, and lion. It is also one of the Seven Treasures of Buddhism (*vide* PEARL), and was sometimes called Chia Yeh (伽 耶). The animal is sacred to Buddhism and is sometimes depicted as offering flowers to Buddha. "Buddha is often represented as surrounded with his disciples, some of whom, strange to say, have blue beards. Whilst seated cross-legged, in a state of apathy, the monkey and elephant do homage to the saint, and acknowledge his power over the whole animal creation." [1] Buddha is said to have accomplished the miraculous feat of throwing an elephant over a wall, and he is occasionally represented as riding on an elephant. Samantabhadra, the All-good, one of the EIGHTEEN LOHAN (*q.v.*) is also sometimes depicted mounted on an elephant. Buddha is said to have entered the right side of his immaculate mother *Maya*, in the form of a white Elephant, the most holy beast of Buddhism, represented as *three-toed* (a mystic allusion to the Holy Trinity—Buddha, the Law, and the Priesthood). She died seven days after his birth, which was accomplished without pain and accompanied by amazing wonders. According to Hindoo mythology the world is supported on the back of an elephant standing on a tortoise. Ganesha is the elephant-headed god of the Indian pantheon. "The earth-shaking beast, who as a symbol of universal sovereignty, the Buddhist kings of Burma and Siam borrow from Buddhism. It seems to be Indra's elephant Airavata. This elephant is frequently represented as a miniature bronze ornament or flower-stand on the Lamaist altar. Mr. Baber records (*R.G. Soc. Suppl.*, paper, p. 33) a colossal elephant with six tusks, cast in silvery-bronze, in Western Szechuan. It is of artistic merit, and carries on its back, in place of a howdah, a lotus-flower, in which is enthroned an admirable image of Buddha." [2] The elephant is also the bearer of the WISH-GRANTING GEM (*q.v.*) and the sacred *Patra* or alms-bowl of Buddha. The Siamese have adopted the White Elephant as their national emblem, and they believe that this creature—an albino of a light mahogany colour—is the incarnation of some future Buddha. "When one is taken the capturer is rewarded and the animal brought to the King to be kept ever afterwards;

it cannot be bought or sold. It is baptized and fêted and mourned for like a human being at its death." [3]

Gigantic stone monoliths of elephants, standing and kneeling, are to be seen in the avenues of stone figures leading to the tombs of the Ming Emperors near the cities of Peking and Nanking. Childless women believe that, by lodging a stone on the back of one of these elephants, they will ensure the birth of a male infant.

AUTHORITIES.
[1] Gutzlaff: *China Opened*, Vol. II, p. 221.
[2] Waddell: *Lamaism*, p. 390.
[3] *Encyclopaedia Britannica*, 11th Ed.: ANIMAL WORSHIP.

ELIXIR OF LIFE

(金 丹)

"The Elixir of Gold, *Lapis philosophorum*, the mystical compound by means of which the Taoist alchemists professed themselves able to produce gold and to confer the gift of immortality." [1]

Among the mineral substances, which formed the basis of various magic mixtures for the prolongation of life, prepared by the ancient Taoist philosophers, are cinnabar or red sulphuret of mercury (硃 砂), realgar or red sulphuret of arsenic (雄 黃), sulphur (硫 黃), potash (硝 石), orpiment or yellow sulphuret of arsenic (雌 黃), and mother-o'-pearl (雲 母); among vegetable substances are the gum of the peach-tree, the charred ash of the mulberry, the dried root of the *Panax quinquifolia* or ginseng, and many other supposedly potent herbal extracts. There are also various fluids, *e.g.*, the Gold Essence (金 液), and the Jade Essence (玉 液), concocted by the mystics from gold and jade, and believed, to combine the virtues of the draught of immortality and the philosopher's stone. The symbolism of colour, and the emblematic significance of the materials employed in the fabrication of these elixirs, probably constituted powerful factors in their selection.

Cinnabar was subjected to close investigation by the Chinese alchemists as early as the beginning of the Christian era. "It was called by them *Hsien tan* (仙 丹) or 'Immortal Elixir,' and was the equivalent of the Philosopher's Stone of the alchemists of the west, who might have obtained their knowledge of this and other curious substances for the early

Chinese chemists, through the intercourse of Mohammedan traders from Arabia and the Persian Gulf, with the people of Southern and Eastern China. . . . Cinnabar is said to be connected with the south, and is believed to be at the head of all minerals and metals, being capable of transmutation, in equal periods of two hundred years, into each or any of the five principle metals, finishing with gold. . . . Stories of extraordinary longevity resulting from the drinking of the water of a well impregnated with cinnabar, situated in Ma-yang Hsien (麻陽縣), Hunan, led to the preparation of panaceas of all sorts from cinnabar, ginseng and other drugs."[2] Ginseng (人參), or the dried root of the *Panax quinquifolia,* is believed by the Chinese to possess magic potency for the extension of life owing chiefly to its fancied resemblance to the human form. "Popular superstition says that after three centuries the ginseng plant changes into a man with white blood, which is the veritable elixir of immortality, a few drops being sufficient to raise a dead man to life."[3] The age of the root is determined by the number of its rings, which are often artificially produced by means of fine ligatures of hair, as the value increases in proportion to the age of the plant. The roots are, moreover, often trimmed into the shape of the human body. The wild Manchurian ginseng is preferred to the cultivated variety. Fabulous stories are told of the discovery of special deposits of this herb, associated with guiding voices, stars, and other good and peaceful omens. Many of its reputed characteristics are strangely reminiscent of the mandrake of the Bible.

The quest of the PLANT OF LONG LIFE (*q.v.*) also exercised the energy of the Taoist hermits to a considerable degree. According to Taoist fable it is held that in the moon there is a supernatural hare, which is occupied in mixing drugs, on behalf of the gods, for the compounding of the elixir of life (*vide* HARE). The water of certain legendary streams, such as the *Tan Shui* (丹水), which flows at the foot of the K'un Lun mountains, and the invigorating fountain (玉醴泉), which springs from the jade-stone rock in the enchanted island of Ying-chou (瀛洲), etc., are also said to possess eternal life-giving qualities (*vide* ISLANDS OF THE BLEST). The Chinese Methuselah P'êng Tsu (彭祖) is said to have prolonged his life to the age of over 800 years by nourishing himself with powdered mother-o'-pearl and other substances. The philosopher Huai-nan Tzŭ (准南子) is reputed to have discovered the elixir of life in 122 B.C., and, after drinking thereof, he ascended into Heaven. As he rose he dropped the vessel containing the precious fluid, and

his dogs and poultry sipped up the dregs and mounted with him to the skies.

For the maturing and fructifying of the mystic compound which, when brought to perfection, constituted the *elixir vitae* or the "philosopher's stone," a period of nine months, as in the case of the gestation of the human *ova*, was considered necessary. The nine monthly revolutions or successive transformations of the magic substances were known in Taoist alchemy as *chiu chuan huan tan* (九 轉 還 丹).

AUTHORITIES.
1 Mayers: *Chinese Reader's Manual*, Pt. I, No. 663.
2 Smith: *Contributions towards the Materia Medica and Natural History of China*, p. 63.
3 Giles: *Glossary of Reference*: GINSENG.

EMBROIDERY

(繡 貨)

The art of embroidery probably originated in China with the introduction of sericulture some 4,000 years ago. The early religious and official costumes gave full scope for the decorative treatment of the elaborate costumes of the day, especially those intended for masculine adornment. The same art motives are reflected in the costumes of the modern theatre. where the historical drama is still chiefly in demand.

Textile ornamentation reached its zenith during the reign of the Emperor Ch'ien Lung, A.D. 1736 to 1795, but since that period the quality of all art products began to decline and the Chinese do not appear to have maintained that true perception of the harmonization of colours and delicacy of detail which characterized their early creations.

The designs used by the Chinese in embroidery work are chiefly of a conventional and symbolic nature, their treatment of plants, flowers, fruit, and birds being carried out with remarkably beautiful effect. The work for foreign export, however, often follows foreign lines, with Western designs, and is made up into articles appropriate for foreign requirements. Irish linen is occasionally imported to be worked up into embroidered handkerchiefs, etc. Innumerable household articles are worked in cotton *appliqué*, such as bedspreads and fancy towels, for which there is a steady demand. Old embroideries such as sleeve panels stripped from old garments

are made up into cushion pieces and tray centres, etc. The American market absorbs the bulk of this work, including the imitation antique embroidery, smoked and treated to resemble the genuine article.

"The stitches used are simple and few in number, namely: Satin stitch, and long and short stitch which is a development of it; French knots (*pointes de Pékin*); Stem stitch; Couching; Chain stitch, which is worked beforehand and applied to the material afterwards; and Split stitch. . . . Embroidery is mostly worked in a frame pivoted on two upright supports. The articles most frequently embroidered are costumes, temple hangings and shrine cloths, shoes, pipe-cases, purses, and fans."[1]

AUTHORITY.
[1] Couling: *Encyclopaedia Sinica*: EMBROIDERY.

ENAMELWARE

(珐 瑯 鐵)

The art of enamelling is said to have been introduced into China from Constantinople by the Arabs, and the Chinese term Fa lan t'ieh, "iron of Fa-lan," is said to be derived from Folin, a mediæval name for Stamboul, though others believe that *Fa lan* is equivalent to Frank or France.

Chinese enamels are divided into three classes: 1, cloisonné or cell enamels, made by soldering to the metal foundation narrow bands of copper, silver, or gold, and filling up the interstices of the decoration with enamel paste after which the piece is fired and polished; 2, champlevé, where the cells are fashioned in the ground of the bronze itself; and 3, painted enamels, where the pigment is applied with a brush and glazed.

Enamels, with their brilliant colouring, appeal strongly to the æsthetic sense of the people, and vases, boxes, cups, bowls, sacrificial vessels, etc., are manufactured by hand in all manner of conventional and symbolic designs.

The industry tends to improve and flourishes particularly in Peiping, where a fine collection of antique specimens may also be seen in the government museum.

FALCON
(鷹)

The Chinese designate eagles, falcons, and other raptorial birds by the term *Ying*, the written symbol for which on analysis is found to be a representation of one bird swooping down upon another.

"The Emperors of the Mongol dynasty were very fond of the chase, and famous for their love of the noble amusement of falconry, and Marco Polo says Kublai employed no less than seventy thousand attendants on his hawking excursions. Falcons, kites, and other birds of prey were taught to pursue their quarry, and the Venetian speaks of eagles trained to swoop at wolves, and of such size and strength that none could escape their talons." [1]

These predatory birds provide a popular ornamentation for screens, panels, etc., and are regarded as emblematic of boldness and keen vision.

The Chinese have a superstitious belief that medical benefit is derived from the feathers of the tail, with which they rub children suffering from smallpox as a curative charm.

In the feudal age of China falcon-banners styled *yü* (旟) were borne in the chariots of the higher chieftains, and in parts of Turkestan to this day a living hawk is carried as emblem of authority.

AUTHORITY.

[1] Williams: *The Middle Kingdom*, Vol. I, p. 258.

FAN

（扇）

Fans have been used in China from ancient times; the round variety was popular in the T'ang period, but the ordinary folding article (摺扇) was a Japanese invention introduced into China through Korea in the 11th century A.D. They are made in many different styles and form an excellent medium for the display of the artistic spirit of the Chinese. Circular fans are made of silk, paper, feathers, and from the leaves of the *P'u k'uei* (蒲 葵) or *Livistonia chinensis,* a palm-tree grown in the lowlands of South China. Folding fans have horn, bone, ivory, and sandalwood frames. Ornamental varieties of mother-o'-pearl, tortoiseshell, lacquer, etc., command the highest prices.

The fan is carried in the sleeve or waistband, and besides its ordinary use, is also employed to emphasize special points of a speech, or to trace out characters in the air when the spoken word is not understood. "As there is fashion in all things, so fashion has decreed that women are to use one sort of fan, and men another. It lies principally in the number of ribs in the fans. A man's fan may contain 9, 16, a very favourite number being 20 or 24 ribs, but a woman's fan must not contain less than 30 ribs. Feminine figures may be freely introduced in the decoration of fans for women, but it would be considered in bad taste for an adult male to be seen with a fan with such decoration."[1] Different kinds are used at different seasons by all who can afford to pay for this form of luxury; and it is considered ridiculous to be seen with a fan either too early or too late in the year. They are made to serve the same purpose as an album among friends of a literary turn, who paint flowers upon them for each other and inscribe verses in what is sometimes called the 'fan language.' "[2]

"Fans are used in decorative art: papers for fans are printed, mounted, and framed as pictures; open-work spaces are left in walls of the shape. Even the gods and genii are sometimes represented with these indispensables of a hot climate, some of them being capable of all sorts of magic."[2]

The fan is the emblem of Chungli Ch'üan (鍾 離 權), one of the EIGHT IMMORTALS (*q.v.*) of Taoism. A deserted wife is often metaphorically referred to as "an autumn fan" (秋 後 扇), since fans are laid aside at the end of summer.

176

EXAMPLES OF CHINESE FANS.

Many of the artists of the Sung and later dynasties were fond of painting miniature landscapes and floral studies on fans. The handles of fans, *i.e.*, the outer ribs, were also decorated with paintings and carvings. the wood for these handles was carefully selected. The hard surface of the bamboo made it a general favourite, but other rarer woods were also employed, especially those with a fine grain. Generally one surface of a fan and handle was embellished with painting, and the other with a specimen of fancy calligraphy. Thus a fan may display all the distinguishing characteristics of artistic production.

AUTHORITIES.
 [1] *Catalogue of the Collection of Chinese Exhibits at the Louisiana Purchase Exposition*, St. Louis, 1904, p. 226.
 [2] Giles: *Glossary of Reference*: FANS.
 [3] Dyer Ball: *Things Chinese*, 5th Ed.: FANS.

FENG SHUI

(風 水)

Feng-shui *lit.*, wind and water, *i.e.*, climatic changes said to be produced by the moral conduct of the people through the agency of the celestial bodies, is the term used to define the geomantic system by which the orientation of sites of houses, cities, graves, etc., are determined, and the good and bad luck of families and communities is fixed. The dousing-rod and the astrological compass are employed for this purpose. It is the art of adapting the abodes of the living and the graves of the dead so as to co-operate and harmonize with the local currents of the cosmic breath, the YIN and YANG (*q.v.*). By means of talismans and charms the unpropitious character of any particular topography may be satisfactorily counteracted. "It is belived that at every place there are special topographical features (natural or artificial) which indicate or modify the universal spiritual breath (氣 Ch'i). The *forms* of hills and the *directions* of watercourses, being the outcome of the moulding influences of wind and water, are the most important, but in addition the *heights* and *forms* of buildings and the *directions* of roads and bridges are potent factors. . . . Artificial alteration of natural forms has good or bad effect according to the new forms produced. Tortuous paths are preferred by beneficent

influences, so that straight works such as railways and tunnels favour the circulation of maleficent breath. The dead are in particular affected by and able to use the cosmic currents for the benefit of the living, so that it is to the interest of each family to secure and preserve the most auspicious environment for the grave, the ancestral temple, and the home." [1]

The Feng-shui system is said to have been first applied to graves by Kuo P'o (郭璞), a student who died in A.D. 324, and to house-building by Wang Chi (王伋), a scholar of the Sung dynasty. "For a grave, a wide river in front, a high cliff behind, with enclosing hills to the right and left, would constitute a first-class geomantic position. Houses and graves face the south, because the annual animation of the vegetable kingdom with the approach of summer comes from that quarter; the deadly influences of winter from the north." [2]

The symbolic figures, etc., on the roofs of buildings, the pictures of spirits on house doors, and the stone images erected before the tombs, are chiefly for the purpose of producing an auspicious aura in which the cosmic currents may generate for the creation of favourable Feng-shui for the benefit of the locality. (*Vide* also ASTROLOGY, CHARMS, DOOR GODS, DRAGON, etc.)

AUTHORITIES.

[1] Couling: *Encyclopaedia Sinica*: FENG-SHUI.
[2] Giles: *Glossary of Reference*: FENG-SHUI.

FIRE

(火)

The written symbol for fire is a pictogram (像形) representing a flame rising in the centre with sparks on either side. It is used as the 86th radical for the formation of characters connected with light and heat.

Fire is emblematic of danger, speed, anger, ferocity, lust, etc., and is the second of the FIVE ELEMENTS (*q.v.*). The planet Mars is called the Fire Star (火星). The fierce Buddhist deities have their halo bordered by flames.

At Chinese New Year (過年), and also at the Feast of Lanterns (燈節), many beautiful coloured lanterns are to

EXAMPLES OF CHINESE LANTERNS

1. HAND LANTERN. 2. FRONT DOOR LANTERN. 3. FANCY LANTERN.
4. WEDDING LANTERN. 5. TABLE LANTERN. 6. ESCORTING LANTERN.
7-10. FANCY LANTERNS. 11-12. HAND LANTERNS. 13. FESTIVAL
LANTERN. 14. WEDDING LANTERN.

be seen, and numerous fire-crackers are exploded. The latter festival is held on the 15th of the 1st moon and dates from the Han dynasty some two thousand years ago, being originally a ceremonial worship in the Temple of the First Cause (元始天尊).

Fire-crackers, Roman candles, Catherine wheels, rockets, etc., are made of crude gunpowder rolled up in coarse bamboo paper, with an outer covering of red—the colour of good omen. They are chiefly made in Hunan, Kiangsi, and Kuangtung. A *feu de joie* of squibs and cannon crackers is believed to disperse evil influences, especially when fired off in batches of three, one after the other; no doubt the three crackers are for the propitiation of the THREE PURE ONES (*q.v.*), or in honour of the Star-Gods of Health, Wealth, and Longevity. Fire-crackers are employed at all kinds of ceremonies, religious and otherwise, and are exploded as a farewell compliment on the departure from the locality of a popular person or a government official.

Crude gunpowder (火藥) has been manufactured by the Chinese since the seventh century, but was originally used only for fireworks. Guns, which were invented in Europe in A.D. 1354, were used in China from A.D. 1162. Cannon were employed by the Mongols in A.D. 1232. The Chinese hunter often fires from the hip, and generally uses a long muzzle-loading fowling-piece of antique pattern.

Effigies made of coloured paper are burnt at the grave-side in the hope that they will be translated into the spirit world for the assistance of the *manes* of the dead. These effigies replaced the original sacrifices of human beings and domestic animals formerly offered in connection with the honours paid to deceased celebrities.

The bride, on entering the house of her husband, is sometimes lifted over a pan of burning charcoal, or a red-hot ploughshare, laid on the threshold of the door by two women whose husbands and children are living. It is thereby intimated that she will pass successfully through the dangers of child-birth.

Fires are not generally used in Chinese houses except for cooking, but a brick stove-bed (炕), with a fire underneath, is used in the north. The source of illumination employed by the poorer classes is bean oil and candles made of white wax or vegetable tallow. The use of kerosene oil is now fairly general, and electric light has been installed in many places, though the plant is often very much overloaded and

the current correspondingly weak. When lamp-posts were first erected in Shanghai the innovation was regarded as a harbinger of evil to the dynasty. If a "flower" forms, on a burning lamp-wick, it may, according to its shape, imply that the wife is with child, that a guest is coming, or that someone is about to die. A couple of lanterns to hang at the gate or a pair of large red candles are considered to be auspicious gifts at a wedding, implying that the *Yang* (陽) or active principle of light will operate for the generation of plenteous offspring on behalf of the happy pair. "The candles in the bride's room are supposed to burn all night; if one or both goes out it is a bad omen, foretelling the untimely death of one or both; on the other hand, if the candles burn out about the same time, it indicates that the couple will have the same length of life, and the longer the candles burn, the longer will the couple live. The candles must not melt and trickle down the sides, or that would resemble tears and betoken sorrow." [1]

Lanterns play a prominent part in the social and religious life of the people. "Some of the lanterns are cubical, others round like a ball, or circular, square, flat and thin, or oblong, or in the shape of various animals, quadruped and biped. Some are so constructed to roll on the ground as a fire-ball, the light burning inside in the meanwhile; others as cocks and horses, are made to go on wheels; still others, when lighted up by a candle or oil, have a rotary or revolving motion of some of their fixtures within, the heated air, rising upward, being the motive power. Some of these, containing wheels and images, and made to revolve by heated air, are ingeniously and neatly made. Some are constructed prncipally of red paper, on which small holes are made in lines, so as to form a Chinese character of auspicious import, as happiness, longevity, gladness. These, when lighted up, show the form of the character very plainly. Other lanterns are made in a human shape, and intended to represent children, or some object of worship, as the Goddess of Mercy, with a child in her arms. Some are made to be carried in the hand by means of a handle, others to be placed on a wall or the side of a room. They are often gaudily painted with black, red, and yellow colours, the red usually predominating, as that is a symbol of joy and festivity. The most expensive and the prettiest are covered with white gauze or thin white silk, on which historical scenes, or individual characters or objects, dignified or ludicrous, have been

elaborately and neatly painted in various colours. Nearly every respectable family celebrates the feast of lanterns in some way, with greater or less expense and display. It is an occasion of great hilarity and gladness." [2] "It is the frequent practice for people to make specific vows in regard to burning a lamp before some particular god or goddess, in a temple dedicated to the divinity, for a month or a year, for the night time only, or both day and night, during the period specified. They usually employ the temple keeper to buy the oil and trim the lamp. Sometimes people prefer to vow to burn a lantern before the heavens. The lantern is usually suspended in front of the dwelling-house of the vower, In such a case, it is trimmed by himself or by some member of his family. Many also make vows to the 'twenty-four gods of heaven,' or to the 'Mother of the Measure,' writing the appropriate title upon the lantern they devote to carrying out their vows.

"On the occurrence of the birthday of the god or goddess, the family generally presents an offering of meats, fish, and vegetables. On the first and fifteenth of each month they regularly burn incense in honour of the divinity, whose title is on their lantern, before the heavens. The objects sought are various, as male children, recovery from disease, or success in trade." [3] (*Vide* also GOD OF FIRE, and THUNDERBOLT.)

AUTHORITIES.

[1] Gulland: *Chinese Porcelain*, Vol. II, pp. 414-5.

[2] Doolittle: *Social Life of the Chinese*, p. 385.

[3] *Loc. cit.*, p. 449.

FISH

(魚)

"Fish forms an important part in the domestic economy of the Chinese. Together with rice it constitutes the principal staple of their daily food, and fishing has for this reason formed a prominent occupation of the people from the most ancient times. The modes of fishing and implements used

at the present day vary very little from those of the remote past; the simplicity of the former and the ingenious construction of the latter are as remarkable now as in days gone by. That fishing should be engaged in so extensively is easily explained. The coast line is long and tortuous; groups of islands, forming convenient fishing stations, are spread all along the mainland; swift streams and large lakes intersect the country, and a net of canals water the vast plains in all directions. All these circumstances serve to direct the attention of the people to the exploration of the waters. On the part of the Government no restrictions are laid on fishing grounds. Fishing is carried on all the year round, and no regulations hamper the fishermen in the use of their nets or lines; but each fishing boat must be registered where it belongs, and at fixed periods must pay a fee for a licence. A tax is also required for the privilege of fishing in the rivers and canals, space being allotted to each party in proportion to the payment made. During the spawning season fishing is not interdicted in the inland waters, and even on the high sea fishermen continue their operations—but with this difference, that smaller nets are made use of during this intermediary period than during the regular fishing season." [1]

The commonest kinds of fish that serve as food in China are the carp, bream, perch, plaice, "white fish," "blue fish," mullet, pomfret, Sciaenidae fish, rock trout, scabbard fish, and eel. Crabs, shrimps, lobsters; oysters, clams, cockles, bêche-de-mer, cuttle fish, sea blubber, molluscs, turtles, etc., are also eaten. In fact, fishery products such as sharks' fins, compoy, awabi, dried shrimps, and other similar preparations, are among the chief delicacies of the Chinese table. Some interesting details of the Chinese fisheries and methods of fishing are given in the Bulletin of the Chinese Government Bureau of Economic Information (經濟討論處), No. 25, Series 2, March 23, 1923, and also in the Author's article "The Ningpo Fisheries," in the *New China Review*, 1919, Vol. IV, pp. 385 *seq*.

From the æsthetic point of view fish are also much appreciated by the Chinese. Many beautiful and fantastic varieties of gold fish are reared in ponds and jars, this ornamental species having been introduced into Europe towards the end of the seventeenth century. Carp and perch are frequently depicted on Chinese porcelain.

The legendary Emperor Fu Hsi (伏羲), 2953-2838 B.C.

is said to have been given his name, which means literally "Hidden Victims," on account of the fact that he made different kinds of nets and taught his people how to snare animals and secure the products of the sea.

The fish is symbolically employed as the emblem of wealth or abundance, on account of the similarity in the pronunciation of the words yü (魚), fish, and yü (餘), superfluity, and also because fish are extremely plentiful in Chinese waters. Owing to its reproductive powers it is a symbol of regeneration, and, as it is happy in its own element or sphere, so it has come to be the emblem of harmony and connubial bliss; a brace of fish is presented amongst other articles as a betrothal gift to the family of the bride-elect on account of its auspicious significance; as fish are reputed to swim in pairs, so a pair of fish is emblematic of the joys of union, especially of a sexual nature; it is also one of the charms to avert evil, and is included among the auspicious signs on the FOOTPRINTS OF BUDDHA (q.v.). "The fish signifies freedom from all restraints. As in the water a fish moves easily in any direction, so in the Buddha-state the fully-emancipated knows no restraints or obstruction." [2] The Buddhists consider great merit (福) accrues to those who release living creatures (放生), such as birds, tortoises, etc., bought for the purpose at religious festivals. A tank containing carp or gold-fish is generally to be found in the temple courtyard. "From the resemblance in structure between fish and birds, their oviparous birth, and their adaptation to elements differing from that of other created beings, the Chinese believe the nature of these creatures to be interchangeable. Many kinds of fish are reputed as being transformed at stated seasons into birds." [3] (Vide PENG NIAO).

The carp, with its scaly armour, which is regarded as a symbol of martial attributes, is admired because it struggles against the current, and it has therefore become the emblem of perseverance. The sturgeon of the Yellow River are said to make an ascent of the stream in the third moon of each year, when those which succeed in passing above the rapids of Lung-mên (龍門) become transformed into dragons; hence this fish is a symbol of literary eminence or passing examinations with distinction.

According to the Po Ku T'u (q.v.), fish are compared to a king's subjects, and the art of angling to that of ruling. Thus an unskilled angler will catch no fish, nor will a tactless prince win over his people.

185

On account of various legends that letters have been found in the bellies of carp, etc., the fish is also an emblem of epistolary correspondence.

AUTHORITIES.

[1] *Catalogue of the Collection of Chinese Exhibits at the Louisiana Purchase Exposition, St. Louis*, 1904, pp. 279-280.
[2] Lafcadio Hearn: *In Ghostly Japan*, p. 125.
[3] Mayers: *Chinese Reader's Manual*, No. 932.

FIVE ELEMENTS

（五行）

The Five Elements are Water (水), Fire (火), Wood (木), Metal (金), and Earth (土). They are first mentioned in the classic *Book of History* (*vide* Legge: Shu Ching, II, 320, note). They are mutually friendly or antagonistic to each other (相生相尅) as follows:—

Water produces Wood, but destroys Fire;

Fire produces Earth, but destroys Metal;

Metal produces Water, but destroys Wood;

Wood produces Fire, but destroys Earth;

Earth produces Metal, but destroys Water.

"Upon these five elements or perpetually active principles of Nature the whole scheme of Chinese philosophy, as originated in the 洪範, or Great Plan of the Shu Ching, is based. The latter speculations concerning their nature and mutual action are derived from the disquisitions of Chou Yen (騶衍) followed by the 五行志 of Liu Hsiang (劉向) and the 白虎通義 of Pan Ku (班固)."[1]

From the operation of the five elements, proceed the five atmospheric conditions (五氣), five kinds of grain (五穀), five planets (五星), five metals (五金), five colours (五色), five tastes (五味), etc., each of which is governed by its appropriate element, and should not be rashly mixed together or disaster will ensue. The TEN CELESTIAL STEMS (*q.v.*) are also influenced by the elements.

"According to Chu Hsi, the five elements are not identical with the five objects whose names they bear but are subtle essences whose nature is however best manifested by those five objects." [2]

The Spirits of the Five Elements are known as the Five Ancients (老五), who are also regarded as the Spirits of the Five Planets.

AUTHORITIES.

[1] Mayers: *Chinese Reader's Manual*, Pt. II, 127.

[2] Couling: *Encyclopaedia Sinica*: FIVE ELEMENTS.

FIVE POISONS

(五毒)

The five poisonous reptiles, *viz*, the viper, scorpion, centipede, toad, and spider, a powerful combination which has the power to counteract pernicious influences. "Sometimes images of these reptiles are procured, and worshipped by families which have an only son. Pictures of them are often made with black silk on new red cloth pockets, worn by children for the first time on one of the first five days of the fifth month. It is believed that such a charm will tend to keep the children from having the colic, and from pernicious influences generally. They are often found represented on the side of certain brass castings, about two inches in diameter, used as charms against evil spirits." [1]

A Tincture of the Five Poisons (五毒藥酒) is concocted by putting centipedes, scorpions, snakes, and at least two more kinds of venomous creatures into samshu. It is prescribed in catarrh, coughs, ague, and rheumatism. This potent spirit is placed in earthenware jars outside the shops of the well-to-do traders, to be taken by poor persons as a prophylactic remedy.

"The lizard (蠍虎) is sometimes included in the category of five poisonous insects. It is known as the Protector of the Palace for the following reason. If lizards are fed on vermilion and their tails cut off, and the blood of the latter rubbed on the wrists of the ladies of the harem, it can be proven whether they are virtuous or not. If they are virtuous the blood will not come off; if not, the blood will

PAPER CHARM KNOWN AS THE FIVE POISONS, AND ENDOWED WITH PROTECTIVE AND EXORCISING EFFICACY. IT IS SUSPENDED FROM THE CROSS-BEAMS OF THE ROOF ON THE 5TH DAY OF THE 5TH MOON (*vide* ALSO T'AI CHI AND EIGHT DIAGRAMS).

wash off! Perhaps this method was purposely devised by the eunuchs to frighten the ladies of the harem. In South China it is believed that if a lizard loses its tail—by casting —and the tail enters a person's ears, that person will become deaf. In the North it is believed that if one take a lizard's tail and rub it between the palms of the hands the latter will not perspire. And, worst of all, a lizard can crawl into the ear of a sleeping person and suck his brains! It is also believed that if a house-lizard comes into contact with food, it leaves a poisonous substance that will cause death." [2]

AUTHORITIES.

[1] Doolittle: *Social Life of the Chinese*, p. 566.
[2] Arlington: *The Story of the Peking Hutungs*, Peking, November, 1931, p. 19.

FIVE VISCERA

（五臟）

The Five Viscera are the HEART, LIVER, STOMACH, LUNGS, and KIDNEYS (*q.q.v.*) They represent the emotional feelings (*vide* IDOLS, MEDICINE), and are said to be governed by the FIVE ELEMENTS (*q.v.*), as follows:

FIVE VISCERA:	CORRESPONDING ELEMENTS:
Heart	Fire
Liver	Wood
Stomach	Earth
Lungs	Metal
Kidneys	Water

FLAGS

（旗）

Gay coloured standards, pennons, and streamers, have always been popular with the Chinese, who, like the Romans of old, were formerly accustomed to worship their military flags and banners.

According to the ancient "Book of Ceremonies" (禮 記), "On the march the banner with the Red Bird should be in front; that with the Dark Warrior behind; that with the

Azure Dragon on the left; and that with the White Tiger on the right; that with the Pointer of the Northern Bushell should be reared aloft in the centre of the host—all to excite and direct the fury of the troops" (行前朱鳥．後玄武，左青龍，而右白虎．招搖在上，急繕其怒).[1] *Vide* DRAGON, PHOENIX, TIGER, and TORTOISE.

ANCIENT IMPERIAL STANDARD

From the Han to the Ch'ing dynasty the Imperial coat of arms consisted of a pair of dragons fighting for a pearl, and the National Flag (國旗) was emblazoned with the device of the five-clawed dragon in variegated colours with the red sun or jewel on a yellow ground. At the inauguration of the Republic, however, the use of the imperial dragon as a national emblem was discontinued and the Republican Flag was devised. This was a five-coloured flag (五色旗), the different coloured bars being emblematic of the Five Clans (五族), viz.: *red* for Manchuria, *yellow* for the Chinese, *blue* for Mongolia, *white* for the Mohammedans, and *black* for Tibet. This flag was flown over government buildings, and two crossed Republican flags were depicted on official noticeboards (招牌) in place of, as formerly, the tiger's head design. The present national flag, introduced in 1928, consists of a red field with a white sun on a blue ground in the left top quarter. Long embroidered banners, Sanskrit, *Dvaja*, are employed in processions of a religious nature.

There was a movement for the independence of Manchuria early in 1932, and the flag designed for the use of the new state, Manchukuo (滿州國), has four stripes of red, blue, white, and black in a square at the upper right hand corner, signifying bravery, justice, purity, and determination respectively, while the yellow ground symbolises unification.

AUTHORITY.

[1] Leggs: *Li Ki*, Bk. I, Sect. I, Pt. V.

FLAGS OF CHINA

FORMER NATIONAL FLAG SUPERSEDING THE OLD TRIANGULAR FLAG. USED FROM 1889 TO 1912

PROVISIONAL FLAG OF THE REPUBLIC. USED FROM 1912 TO 1928

MILITARY FLAG

NATIONAL FLAG

CUSTOMS ENSIGN

FLAG OF INSPECTOR GENERAL OF CUSTOMS

POSTAL FLAG

FLAG OF SALT ADMINISTRATION

FLAGS OF CHINA (1931)

PRESIDENT

HIGH EXECUTIVE
OFFICIAL

MINISTER OF NAVY

ADMIRAL

CUSTOMS

SALT ADMINISTRATION

WATER POLICE

MERCHANT SHIPS

FLOWERS
（花）

An extraordinary devotion to flowers has prevailed from early ages among the Chinese, who are skilled horticulturists. The flowers of blossoming trees, appearing at the end of winter on the leafless branches, are particularly cultivated. Many flowering plants are said to have originated in China. The Emperor *Wu Ti* (武帝), of the Han dynasty, established a botanical garden at Ch'ang-an in 111 B.C. In planning a garden the Chinese is actuated by the desire to reproduce as closely as possible the innumerable natural scenes so dear to the heart of a refined scholar. Hills, streams, and bamboos are essential features. The best site is an uncrowded part of the city, near the wall, so that the garden will contain some rising ground on which winding paths may be constructed and pavilions erected at suitable points of vantage. Ornamental rocks of grotesque shape are much admired, and stunted trees are planted here and there, while shady pools containing lotus flowers and gold-fish, and spanned by miniature bridges with carved balustrades, are also desirable.

Artificial grottoes and rounded openings in walls, with suitable mottoes engraved or painted above them, are often to be seen. There are many historic gardens in China. Soochow, Hangchow, and Wusih are famous for gardens of great beauty. There is a celebrated garden in Shanghai known as the *Yü Yüan* (愚園), or Garden of Ease, in which are pavilions, terraces, rocks, and pools. A Chinese garden generally occupies a small space in comparison with western gardens, with their extensive lawns, wide herbaceous borders, and elaborate parterres. It is not considered correct to monopolise too much ground, as it might be more economically utilized for purposes of agriculture —the most important business of life.

Each flower in China has its appropriate meaning and purpose. The principal varieties are treated separately in this glossary, and their emblematic significance is also fully dealt with. "It is currently believed that every woman is represented in the other world by a tree or flower, and that consequently, just as grafting adds to the productiveness of trees, so adopting a child is likely to encourage a growth of olive branches." [1]

The Taoist Goodess of Flowers is known as Hua Hsien (花仙). She is generally represented accompanied by two

attendants carrying baskets of flowers (花籃). The flower-basket is the emblem of *Lan Ts'ai-ho* (藍采和), one of the EIGHT IMMORTALS (*q.v.*) of Taoism. A festival of flowers is held in certain parts of China on the 12th day of the 2nd moon. "The women and children prepare red papers, or silk favours of various colours, and on the appointed day suspend them on the flowers and the branches of flowering shrubs. The women and children then recite certain laudatory and congratulatory sentences, and prostrate themselves. By this worship it is supposed that a fruitful season can be assured." [2] "The head-dress of married females is becoming, and even elegant. In the front, a tube is often inserted, in which a sprig or bunch of flowers can be placed. The custom of wearing natural flowers in the hair is quite common in the southern provinces, especially when dressed for a visit. The women of Peking supply the want of natural by artificial flowers." [3] Ornamental pots containing artificial flowers made of paper, silk, or jewels of various colours with leaves of green jade are sometimes seen in Chinese houses.

A common term for China is the Flowery Land (花國). The floral kingdom supplies the Chinese with many of their finest designs in decorated textiles, porcelain, carpets, etc. Representations in flowers in architecture, painting, etc., are often so highly conventionalized, and the colouring so untrue to nature, that it is often difficult to determine the particular species intended. They are drawn as viewed from above, in accordance with the general rules of art. A particular flower is almost invariably drawn with a particular bird. Thus the longtailed birds such as the phœnix, peacock, fowl and pheasant have the peony; the duck, the lotus; the swallow, the willow; quails and partridges are generally depicted with millet; the stork and pine, as emblems of longevity, naturally go together. The bamboo, pine, and prunus are known as the three friends, because they keep green in cold weather, and are therefore frequently grouped together. Various flowers and fruit blossoms are often used to symbolize the twelve months of the year, *e.g.*, in the following order: prunus, peach, peony, cherry, magnolia, pomegranate, lotus, pear, mallow, chrysanthemum, gardenia and poppy. The following have been selected to represent the four seasons: the tree-peony for spring; the lotus for summer; the chrysanthemum for autumn; and the prunus for winter. (*Vide* also TREES, and separate notices of various flowers and trees.)

AUTHORITIES.

1 Douglas: *China*, p. 86.
2 Box: *Shanghai Folk Lore*, Journal Royal Asiatic Society, N.C.B., 1902, p. 177.
3 Williams: *Middle Kingdom*, Vol. II, p. 34.

FLUTE

(笛)

The *T'i* or transverse flute, is "a bamboo tube bound with waxed silk and pierced with eight holes, one to blow through, one covered with a thin reedy membrane, and six to be played upon by the fingers."[1] Another variety of flute, known as the *Hsiao* (簫), is of "dark brown bamboo, measuring about 1.8 foot in length, said to have been invented by *Yeh Chung* (耶 仲) of the Han dynasty. It has five holes above, one below, and another at one end, the other end being closed."[2]

The flute is the emblem of *Han Hsiang-tzŭ* (韓湘子), one of the EIGHT IMMORTALS (*q.v.*) of Taoism, and sometimes of *Lan Ts'ai-ho* (藍采和), another of that ilk. The marvellous skill with which *Hsiao Shih* (簫史)—6th century B.C.—performed upon this instrument, accompanied by his wife *Lung Yü* (弄玉), is said to have "drawn phœnixes from the skies." (*Vide* MUSICAL INSTRUMENTS.)

AUTHORITIES.

1 Giles: *Chinese English Dictionary*, 10,939.
2 *Loc. cit.*, 4,321.

FLY-WHISK

(塵尾)

Sanskrit, *Chauri*. Properly made of the tail of the yak, Tibetan ox (犛牛), but also composed of white horse hair or vegetable fibre, fixed to a short handle of plain or carved wood, and carried by the Buddhist priests as a symbol of their religious functions, and to wave away the flies which, according to the tenets of their creed, they may not kill. As the herd of deer was said to be guided by the movements of the yak's tail, so the sages of China are often depicted with this sign of leadership, and it is an item of the para-

FLY-WHISK OR CHAURI.

phernalia of Buddhism and Taoism. It is also called 塵土拂 or 拂蠅.

Buddha said: "Let every Bhikchu have a brush to drive away the mosquitoes." "In Buddhism it signifies obedience to the first commandment—not to kill. In Taoism it is regarded as an instrument of magic. Its origin is India. Many Buddhist images are represented holding it." [1]

AUTHORITY.

[1] Couling: *Encyclopaedia Sinica*: FLY-WHISK.

FOOTPRINTS OF BUDDHA
(佛 足 跡)

When Buddha felt, in 477 B.C., that the time of his Nirvana (涅槃)—the state of complete painlessness which was his highest goal—was approaching, he went to Kusinara and stood upon a stone with his face to the south. Upon this stone he is said to have left the impression of his feet, Sanskrit, *S'ripada*, as a souvenir to posterity. These impressions were subsequently reproduced in carved stone and religious paintings, and may be met with in temples in India, China, and Japan. A stone marked with Buddha's footprint is preserved in the T'ien-t'ai Monastery (天台寺), which is situated on the Western Hills near Peiping. On the footprints

TRACING FROM "BUDDHA-FOOT STONES."

are various emblematic and auspicious designs sacred to Buddhism; they are known as the SEVEN APPEARANCES (七相) (*q.v.*). The stone bearing the footprints, also known as the "Buddha-foot Stone," is not always cut out of a single block of stone, but is sometimes composed of fragments cemented together in an irregular shape and capped with a heavy slab of granite, on the polished surface of which the design is engraved.

In some cases, on the instep is a triple Lotus (*Tri-râtna,* or "Three Treasures"), which springs from a Triscula or Trident, which rests on a small mystic Wheel (*Châkra*) on the heel, and symbolizes the Three Buddhas of Past, Present, and Future, *i.e.,* AMITÂBHA, KUAN YIN and MAITREYA (*qq.v.*). The Vinâya-sutra says that the marks on the sole of Buddha's foot were made by the tears of the sinful woman, Amrapati and others, who wept at Buddha's feet, to the indignation of his disciples.

FOUR HEAVENLY KINGS

（四大天王）

The Heavenly Guardians or Deva Kings, Sanskrit, *Chaturmaharajas* or *Lokapalas,* the Kuvera of Brahamanism, were four Indian brothers. They are also called the Diamond Kings （四大金剛）. "These four celestial potentates are fabled in later Buddhist tradition as ruling the legions of supernatural beings who guard the slopes of Paradise (Mount Meru), and they are worshipped as the protecting deities of Buddhist sanctuaries. Pu K'ung （不空）—a Cingalese Buddhist, is said to have introduced their worship in the 8th century A.D." [1] They protect the world against the attacks of evil spirits, and their statues, gigantic in size, are to be seen at the entrance to Buddhist temples, two on each side.

"They stand each on the prostrate body of an evil demon—alert and ready to ward off all vices and wickedness which might threaten the men of faith and the countries where righteousness prevails; and in the powerful muscular tension of face, body, and limbs, the invincible will and tireless energy of each are vigorously portrayed." [2] Their names and characteristics are as follows:

1. The Land-Bearer （持國）, Skt. *Dhrtarāstra* （提頭賴吒）, Guardian of the East; also called *Mo-li Ch'ing* （魔禮青）. He has a white face, with a ferocious expression, and a beard the hairs of which are like copper wire. He carries a jade ring, and a spear. "He has also a magic sword, Blue Cloud, on the blade of which are engraved the characters *Ti, Shui, Huo, Feng* (Earth, Water, Fire, Wind). When brandished it causes a black wind which produces tens of thousands of spears, which pierce the bodies of men and turn

THE FOUR HEAVENLY KINGS

TOP LEFT, MO-LI CH'ING, GUARDIAN OF THE EAST. TOP RIGHT, MO-LI HAI,
GUARDIAN OF THE WEST. BOTTOM LEFT, MO-LI HUNG, GUARDIAN OF THE
SOUTH, BOTTOM RIGHT, MO-LI SHOU, GUARDIAN OF THE NORTH

them to dust. The wind is followed by a fire, which fills the air with tens of thousands of golden fiery serpents. A thick smoke also rises out of the ground, which blinds and burns men, none being able to escape."[3] He is the eldest of the four Kings.

2. The Far-Gazer (廣目), Skt. *Virûpaksha* (毗樓博乂), Guardian of the West; also called *Mo-li Hai* (魔禮海). He has a blue face and carries a four-stringed guitar, at the sound of which all the world listens and the camps of his enemies take fire.

3. The Lord of Growth (增長), Skt. *Virûdhaka* (毗樓博乂), Guardian of the South; also called Mo-li Hung (魔禮紅). He has a red face and holds an umbrella, called the Umbrella of Chaos, formed of pearls possessed of spiritual properties. At the elevation of this marvellous implement universal darkness ensues and when it is reversed violent thunder-storms and earthquakes are produced.

4. The Well-Famed (多聞), Skt. *Vaisravana* (毗沙門), Guardian of the North; also called Mo-li Shou (魔禮壽). He has a black face and "has two whips and a panther-skin bag, the home of a creature resembling a white rat, known as Hua-hu Tiao. When at large this creature assumes the form of a white-winged elephant, which devours men. He sometimes has also a snake or other man-eating creature, always ready to obey his behests."[4] He also carries a pearl in his hand.

There is a Taoist quartette of these deities named Li, Ma, Chao, and Wên, who are represented as holding a pagoda, sword, two swords, and a spiked club, respectively. They are said to have given military assistance to the Emperor at various times during the T'ang and Sung dynasties.

AUTHORITIES.
[1] Mayer: *Chinese Reader's Manual*, Pt. II, 110.
[2] Anasaki: *Buddhist Art*.
[3] Werner: *Myths and Legends of China*, Ch. IV, p. 121.
[4] *Loc. cit.*

FOUR TREASURES
(四 寶)

The four precious articles, or "Invaluable Gems" (無價之寶), of the literary apartment (文房), *i.e.*, ink (墨), paper (紙), brush-pen (筆), and ink-slab (硯).

Chinese ink in solid form—erroneously called Indian ink —decorated with all manner of symbolic devices, is chiefly made in Anhui of lampblack mixed with varnish, pork fat, musk (or camphor), and gold-leaf. Besides being used for writing the Chinese character, believed to be of mystic and sacred origin (*vide* WRITTEN CHARACTERS), if rubbed on the lips and tongue it is considered a good remedy for fits and convulsions.

Paper, which was originally fabricated from the bark of trees and the cordage of old fishing-nets, is now made from rice-straw, reeds, wood-pulp, rags, etc. It is said to have been originally invented by Ts'ai-lun (蔡倫), a native of Kuei-yang (桂陽). Chief Eunuch under the Emperor Ho Ti (和帝), of the Eastern Han dynasty; he died in A.D. 144, and was canonised as the god of the paper-makers, who worship him on his birthday. So useless did this strange invention seem to the people of that remote age that, use what means he might, Ts'ai-lun was unable to find a market for his discovery; he therefore eventually had recourse to a deception which proved so successful that not only did he establish a demand for his production, but also formed the precedent for a custom which has been universally observed throughout the country. Ts'ai-lun consented to feign death and, no doubt after the proper ceremonies had been carried out, was duly buried. Lest he should actually die and ruin his scheme, a hollow bamboo pole was struck in the ground over his mouth through which he could still breathe. When his friends and neighbours were all assembled they were told that if the "money" made of the despised paper was burnt at his grave they might buy back his life. When a sufficient amount was deemed to have been thus consumed he was exhumed and his living body shown to the astonished mourners. When, some years later, Ts'ai-lun actually died, he was counted a rich man, and the belief that imitation paper "money" burnt over the grave will buy back life, if not for another spell in this world, at least as a spirit in the next, of the departed, has been held throughout the land from his day to this. Paper images and charms are burnt to him on his birthday. Paper images and charms are burnt to the souls of the dead, and paper amulets against disease are often set on fire, and the ashes taken in wine or tea for curative or demon-expelling purposes (*vide* CHARMS).

Mêng T'ien (蒙恬) is credited with the introduction of the Chinese brush-pen, which is made of sable, fox, or rabbit hairs, set in a bamboo holder. He died in 209 B.C., and is

worshipped on his birthday by the pen-makers as their patron saint. The written paper is carefully burnt by devout persons.

The ink-slab is made of stone or paste, and is used for triturating the solid ink, and thus preparing it for writing purposes. It contains a well for the water, into which the ink is dipped before rubbing it on the stone to form a writing fluid. Ink-slabs are often beautifully carved, and some are made from ancient bricks stamped with the builder's date (*vide* WATER POT).

FOWL
(雞)

The fowl is the tenth symbolic animal of the TWELVE TERRESTRIAL BRANCHES (*q.v.*). Its various designations, 燭夜, 司晨, etc., mostly refer to its crowing, which is said to be regular all through the day as well as at dawn. The Chinese pay special and superstitious regard to the crowing of cocks, while the crowing of a hen is believed to indicate the subversion of a family and is an emblem of petticoat government.

The flesh of the male bird is said to be injurious, probably on account of the fact that the cock is used in oaths and sacrifices and is not to be slain on ordinary occasions. Blackboned fowls are called *Yao Chi* (藥雞) and are much prized for making soup for persons suffering from consumption and general debility. Cordial, tonic and many other fanciful properties are accorded by the Chinese to the yolk and albumen of the egg, which they compare to the sky and the soil of the universe, respectively. A kind of pepsine is prepared from the gizzard, called 雞內金, or 肫皮. Many distinctions are made between the colour and sex of the birds, as to their suitability, or otherwise, for particular kinds of diseases. Preparations of the male bird are prescribed for female patients, and *vice versa*.

The cock (公雞) is the chief embodiment of the element *Yang* (陽), which represents the warmth and life of the universe. It is supposed to have the power of changing itself into human form, to inflict good or evil upon mankind. The Chinese ascribe five virtues to the cock. He has a crown on his head, a mark of his literary spirit; and spurs on his feet, a token of his warlike disposition; he is courageous, for he

fights his enemies; and benevolent, always clucking for the hens when he scratches up a grain; and faithful, for he never loses the hour. The picture of a red cock is often pasted on the wall of a house in the belief that the bird is a protection against fire. As ghosts disappear at sunrise, the cock is supposed to drive them away by his crowing; hence a white cock is sometimes placed on the coffin in funeral processions to clear the road of demons. "The Chinese say that one of the three spirits of the dead comes into the cock at the time of meeting the corpse, and that the spirit is thus allured back to the residence of the family. Some explain the use of a purely white cock to the exclusion of any other coloured cock on such occasions, by saying that white is the badge of mourning; others, by saying that the white cock is a 'divine' or spiritual fowl." [1] No doubt, however, its white colour is emblematical of purity of heart. It was the custom for the bride and bridegroom to eat white sugar cocks at the wedding ceremony. "A white cock is said to be a protection against baneful astral influences and to be the only capable guide of transient spirits. In this connection one is reminded of a custom observed by modern Jews, *viz.*, the substitution of a cock for the scape-goat as a means of expiation. The sins of the offerer are said to be transferred to the entrails of the fowl, and these are exposed upon the house-top, to be carried away by birds of the air." [2] Cock-fighting (鬪 雞) was practised in China some five hundred years ago.

A cock and a hen standing amid artificial rock-work in a garden of peonies is common pictorial design symbolizing the pleasures of a country life. A fowl on the roof of a house is regarded as a bad omen, and it is very unlucky if it thunders while a hen is sitting on eggs.

AUTHORITIES.

[1] Doolittle: *Social Life of the Chinese*, p. 163.

[2] Walshe: *Some Chinese Funeral Customs*, Journal Royal Asiatic Society, N.C.B., Vol. XXXV, 1903-4, pp. 63-4.

FOX

(狐 狸)

The fox, especially *Vulpes tschiliensis,* is very common in North China. *Canis hoole* is found in South China, *Canis*

corsac in Mongolia and *Vulpes lineiveenter* in the mountains of Fukien. Foxes are sometimes seen emerging from old coffins or graves in the country, and are, therefore, regarded as the transmigrated souls of deceased mortals.

"The fox is a beast whose nature is highly tinged with supernatural qualities. He has the power of transformation at his command, and frequently assumes the human shape. At the age of 50 the fox can take the form of a woman, and at 100 can assume the appearance of a young and beautiful girl, or otherwise, if so minded, of a wizard, possessing all the power of magic. When 1,000 years old, he is admitted to the Heavens and becomes the 'Celestial Fox.' The celestial Fox is of a golden colour and possesses nine tails; he serves in the halls of the Sun and Moon, and is versed in all the secrets of nature. The *Shuo Wên Dictionary* states that the fox is the courser upon which ghostly beings ride; he has three peculiar attributes, *viz.*, in colour he partakes of that which is central and harmonising (*i.e.*, yellow); he is small before and large behind, and at the moment of death he lifts his head upwards. The 名 山 記 states that the fox was originally a lewd woman in times of old. Her name was Tzŭ (紫), and for her vices she was transformed into a fox." [1]

"The superstition about demons appearing in a form something like a fox (狐狸精) is very wide-spread. The creature has a man's ears, gets on roofs, and crawls along the beams of houses. It only appears after dark, and often not in its own shape but as a man or beautiful girl to tempt to ruin. Numberless stories of the foxes as girls are found in light literature. People live in great fear of them, and immense sums of money are expended to keep on good terms with them by offerings, incense, meats, tablets, etc. They often possess a man, who then commits all manner of extravagances and claims to be able to heal disease. Some wealthy people ascribe all their good fortune to their careful worship of the fox." [2] No doubt these magic powers were ascribed to the animal on account of its cunning and stratagem. The fox is regarded by the Chinese as an emblem of longevity and craftiness.

Wayside shrines, dedicated to the fox, are often found in the country, and as this creature is believed to be acquainted with all the secret processes of nature he is invoked both for the cure of disease, and also as god of wealth. The clay images of the fox-spirit in the shrines are generally in the shape of a richly-dressed official with a fox-like cast of eye, accompanied by his wife, a pleasant-looking elderly lady.

"Foxes are regarded as uncanny creatures by the Chinese, able to assume human shapes and work endless mischief (chiefly in love affairs) upon those who may be unfortunate enough to fall under their spell. In some parts of China, it is customary for mandarins to keep their seals of office in what is called a 'fox chamber' (狐仙樓); but the character for fox is never written, the sight of it being supposed to be very irritating to the live animal. A character 胡, which has the same sound, is substituted; and even that is divided into its component parts 古 and 月, so as to avoid even the slightest risk of offence. This device is often adopted for the inscriptions on shrines erected in honour of the fox."[3] "In the course of official business, a great number of documents are accumulated in the archives of the Yamen. Sometimes these are urgently required and the person in charge is unable to find them. He then lights some sticks of incense and prostrates himself beseeching the help of the fox god. Shutting up all the windows and doors, he leaves the room for a time. Returning after an interval he will find, it is said, thanks to the kindly help of the fox god, one volume or packet sticking out beyond the others; this will be the manuscript or volume he is in search of."[4]

Many interesting fox legends are to be found recorded in *Strange Stories from a Chinese Studio,* by Professor H. A. Giles, who obtained his material from the *Liao Chai Chih I,* written by P'u Sung-ling in the 7th century A.D.

AUTHORITIES.
 [1] Mayers: *Chinese Reader's Manual,* Pt. I, 183.
 [2] Couling: *Encyclopaedia Sinica:* FAIRY FOXES.
 [3] Giles: *Glossary of Reference:* FOXES.
 [4] Box: *Shanghai Folk-lore,* Journal Royal Asiatic Society, N.C.B., 1902, p. 114.

FU HSI

（伏羲）

2953-2838 B.C. The first of the Five Emperors of the legendary period, also known as 包羲氏 and 太昊.

FO HSI INVENTING THE EIGHT DIAGRAMS

He is said to have been miraculously conceived by his mother, who, after a gestation of twelve years, gave birth to him at Ch'eng-chi in Shensi. He taught his people to hunt, to fish, and to keep flocks. He showed them how to split the wood of the 桐 *t'ung* tree, and then how to twist silk threads and stretch them across so as to form rude musical instruments.

From the markings on the back of a tortoise he is said to have constructed the EIGHT DIAGRAMS (*q.v.*), or series of lines from which was developed a whole system of philosophy, embodied later on in the mysterious work known as the *Canon of Changes*. He also invented some kind of

203

calendar, placed the marriage contract upon a proper basis, and is even said to have taught mankind to cook their food."[1]

AUTHORITY.

[1] Giles: *Biographical Dictionary*, 585.

GALL-BLADDER

（膽）

The gall, according to the Chinese, has office of judge in the body; determination and decision proceed from it, and when people are angry it ascends or expands. It is symbolic of bravery. There is a belief that the gall of notorious criminals, who have been executed, has a great efficacy as a tonic, and that rice steeped therein and eaten will increase the courage of the consumer. "A hero should be brave," said Wei Shǔ-ch'ien (韋思謙) of the T'ang dynasty, "and even expose his gall-bladder in protection of the Emperor." A courageous man is referred to as possessing a gall "as large as a peck-measure," and a coward as merely having one "as small as a rat's." (*Vide* the Author's *Manual of Chinese Metaphor*, pp. 77-8.)

The gall-bladder is reverenced as one of the EIGHT TREASURES (*q.v.*) or Eight Precious Organs of Buddha, and is sometimes called *Lo* (螺), when it symbolises the sacred CONCH SHELL (*q.v.*) of the Buddhists.

GLOW-WORM

（螢 蛆）

The firefly proper, a click-beetle of the genus *Pyrophorus* and family *Elateridæ*, does not occur to any great extent in

China, but the beetle *Lampyris noctiluca,* generally known as the glow-worm, is very common. The female is wingless and emits light from certain cells in the ventral region of the hinder abdominal segments, for the purpose of attracting the flying male whose luminous organs are in a rudimentary condition. In certain genera of the family *Lampyridæ* the light-giving organs are present in both sexes.

"One of the most remarkable insects in China is the lanternfly, or *Fulgora candelaria.* A large insect, this species is of a pretty green colour, banded with yellow, its under-wings being yellow tipped with black, and abdomen yellow barred with black. It is remarkable in that it has the head drawn out into a long horn-like snout, the tip of which is luminous." [1]

According to a Chinese legend, Chü Yin (車胤), of the Chin dynasty, studied at night by the light of a bag full of glow-worms, as he could not afford a lamp, and he subsequently rose to a high position in the government. Hence this insect, besides being a symbol of beauty, is also regarded as an emblem of industry and perseverance, and, from the theory that rotting vegetation is transformed into glow-worms, presumably by a species of spontaneous combustion, it is also specified as a sign of regeneration and the light of the departed soul.

AUTHORITY.
[1] Sowerby: *Insect Denizens of a Chinese Garden,* N. C. Herald, 16th September, 1922, p. 828.

GOAD
(鐵 鈎)

The goad is one of the weapons or insignia of some of the Buddhist deities introduced from India. It resembles the elephant goad, and is finished off at the top with symbolic thunderbolts. It is an emblem of power and divine authority (*vide* Illustration under LAMAISM).

GOD OF FIRE
(祝 融)

The Spirit of Fire is said by some to have orginally been a Minister under the Yellow Emperor (黃帝), B.C. 2689;

by others to be identical with Ch'ung Li (重 黎), who is described as the deified son of the legendary Emperor Chuan Hsü (顓 頊), and also as a dual personality ruling over the elements of wood and fire, and entrusted with the administration of heaven and earth, while another account makes him contemporary with the mythical monarch Fu Hsi (伏羲), 2593-2838 B.C. He governs the South; hence he is sometimes called 南方君 and 南方赤帝. He is also known as 囘祿 and 赤精成子, and is represented as an animal with a human face, accompanied by two dragons as chargers. His face is red and fierce-looking, and he has three eyes, the odd one in the centre of his forehead protruding to enable him to see all round. His attendants in the temples hold various emblems such as a pair of birds, which are omens of fire; a fiery serpent; a fire-wheel or fire-ball by which conflagrations are kindled; a pencil and tablet to take note of the places to be scourged by fire. He is worshipped for three or four days, beginning on the 17th day of the 8th moon, when lanterns and lamps are hung in the streets. He is supposed to be able either to cause or prevent conflagrations, and is propitiated with the hope that fires may not break out. This is considered a necessary precaution on account of the almost universal lack of efficient fire-fighting apparatus in Chinese towns.

CHU JUNG, THE GOD OF FIRE

GOD OF LITERATURE
(文 昌)

A Taoist deity who is said to have lived as a man in Szechuan during the T'ang dynasty, was reincarnated several times, and was finally deified in the Yüan period, A.D. 1314.

He is reputed to reside in that part of the constellation *Ursa Major* known by the Chinese as K'uei (魁). He is also named *Wên Ch'ang Ti Chun* (文昌帝君), or briefly *Wên Ti* (文帝), and is worshipped on the 3rd moon, and on an auspicious day in the 8th moon, with sacrifices. Originally the constellation *K'uei* (奎) was regarded as the abode of Wên Ch'ang, but *Kuei* (魁) was substituted later, and this star is also regarded as a God of Literature.

"He is said to have transformed himself ninety-eight times, and to have wrought numerous wonderful effects. He has promoted all the three national religions. He equals in authority the three rulers of heaven, earth, and the sea, and assists those who are seeking office, or testing their abilities in the public examinations."[1]

This powerful divinity is generally represented holding a pen and a book on which is written four characters, meaning "Heaven decides literary success." As Wên Ch'ang he is figured as a handsome man in the sitting posture; as the star-god K'uei he is also represented as a man, but extremely ugly-looking, with a head having two long crooked horn-like projections. He sometimes stands with one foot on the head of a large fish, with the other foot lifted up. In one hand he holds an immense brush-pen, and in the other a cap such as was worn by the chief of a class of graduates. His image is always placed before the image of the other god of literature, though he is not regarded as his assistant. He stands upon the fish because the carp of the Yellow River is believed to make an ascent of the stream in the third moon of each year, and those which succeed in passing the rapids of Lung-mên (龍門) in Honan, become changed into dragons; this supposed transformation of fish to dragon (魚龍變化), has become an example and synonym for the literary success of the industrious student.

It appears that, owing to tautological variation, or similarity of names, Wên Ch'ang has been inextricably confused with (1) the star K'uei (魁), (2) an ugly individual known as Chung K'uei (鍾馗), who had power over the spirits of evil, and finally committed suicide by drowning himself in the river (hence the sea-dragon on which he stands).

AUTHORITY.

[1] Edkins: *Sketch of Taoist Mythology*, Journal Royal Asiatic Society, N.C.B., No. III, 1859, p. 312.

GOD OF LITERATURE GOD OF LONGEVITY

GOD OF LONGEVITY
(壽 老)

The star-god of longevity is Canopus, in the constellation Argo. He is often pictured as issuing from a peach, or in company with his three associates, the star-gods of happiness and wealth, a most auspicious combination.

"In every case he appears gentle and smiling, his venerable head, monstrously high on the upper part with white hair and eyebrows, mounted or leaning upon a stag. He will often hold in his hand the fruit of the fabulous tree, *P'an-t'ao* (蟠 桃), which blossoms every three thousand years, and only yields its peaches three thousand years after. If he is surrounded by mushrooms, *ling chih* (靈 芝)—*vide* PLANT OF LONG LIFE—which give immortality, and wears a yellow robe, he will be recognised as the supreme disposer of earthly things and the eternal ruler of the seasons." [1]

AUTHORITY.

[1] Jacquemart: *History of the Ceramic Art*, p. 25.

GOD OF THE KITCHEN
(竈 神)

The "Stove King," known as 竈神, 竈君, 竈王 or 司命灶君, is the patron god of the kitchen or family deity.

It would appear that the worship of this divinity dates from Wu Ti, a devotee of Taoism, and was in connection with alchemy, in 133 B.C. His picture is stuck up near the cooking-stove in every home; his chief duty is to apportion to each member of the family the length of their days; he also bestows wealth or poverty, and he notes the virtues and vices of the household, reporting the same to Almighty God (上帝) on the 23rd of the 12th moon of each year, on which day it is customary to propitiate him with offerings made of a sweet-meat which is so sticky that when he reaches heaven he is unable to open his lips. "Sacrificial meats, fruit, and wine are placed on a table in the kitchen before his picture, and offered up to him with prayer and thanksgiving. Each

GOD OF THE KITCHEN

KUAN TI READING THE ANCIENT CLASSICS

member of the family prostrates himself before the god, while crackers are exploded to frighten off all evilly-disposed spirits. The ceremony over, the picture which has done duty during the past year is torn down and burnt, together with the paper-money presented to the god, and the toy horse which is provided to carry him heavenwards."[1] He returns to the bosom of the family on the 30th of the month. A new picture is pasted up in the kitchen after the new year, and a congratulatory sacrifice of vegetables is offered up to him in order to secure his goodwill towards the household during the coming year.

AUTHORITY.

[1] Douglas: *China*, p. 268.

GOD OF WAR
（關 帝）

The Chinese Mars, or the military hero Kuan Yü （關羽）, was a native of Hsieh-chou （解州）, Shantung. He became a general under the Posterior Han dynasty over 2,000 years ago. He was one of the younger of the three sworn brothers, who raised an army and suppressed a rebellion, and whose exploits are so graphically recorded in the Annals of the Three Kingdoms. He was a supporter of Liu Pei, first Emperor of the lesser Han dynasty. Being taken prisoner by Hsün Ch'üan, he was executed in 220 B.C. at the age of 58. Even after his death he is supposed to have exerted a powerful influence for the good of the nation, and the protection of the country; and in recognition of his meritorious services he was ennobled early in the 12th century as a Duke; in 1128 he was raised to the rank of Prince; and in 1594 he was finally awarded the posthumous title of Emperor or God.

Emperor Kuan, also known as 武帝；神武關漢壽帝；關老爺；關公；美髯公；關聖帝君；協天大帝, is one of the most popular of the Chinese divinities. He is worshipped in every house, and temples dedicated to him—styled Wu Shêng Miao （武聖廟）—are found all over the country. His image is placed in the first hall of the Buddhist monastery. He is represented either alone or accompanied by two attendants, and is worshipped on the 15th day of the 2nd moon, and the 13th day of the 5th moon, by civil and military officials. He has also been accepted as patron saint of various trades

and professions. This has led to his being regarded as the tutelary deity of money-making enterprises in general, and so he has gradually developed into a kind of god of wealth, besides being also revered as a god of literature. "The sword of the public executioner used to be kept within the precincts of his temple, and, after an execution, the presiding magistrate would stop there to worship for fear the ghost of the criminal might follow him home. He knew that the spirit would not dare to enter Kuan T'i's presence." [1]

AUTHORITY.

[1] Werner: *Myths and Legends of China*, Ch. IV, pp. 117-118.

GOD OF WEALTH
(財 神)

"No idol in China is more universally worshipped than Ts'ai Shen Yeh, the God of Wealth. His shrine is to be found in nearly every home, his temples are very numerous, and high and low are always ready to burn a stick of incense before him. He is considered to be the deified spirit of Pi Kan (比干) a sage of the 12th century B.C., who was a relative of the infamous tyrant Chou Hsin (紂辛), the last ruler of the Shang dynasty. Pi Kan reproved him for his wickedness, whereupon the Emperor ordered that the sage's heart should be cut out in order to see if there were really seven orifices in the seat of the wise man's intelligence, as commonly believed to be the case (*vide* HEART)." [1]

This divinity is also known as 財帛星君 or 祿星, the Star-god of Affluence (*vide* STARS, and GOD OF LONGEVITY). He is usually accompanied by two attendants, and is worshipped on the 20th day of the 7th moon, mostly by poor people, but also by gamblers. There is a military as well as a civil form of the God of Wealth.

"Talismans, trees of which the branches are strings of cash, and the fruits ingots of gold, to be obtained merely by shaking them down, a magic inexhaustible casket full of gold and silver—these and other spiritual sources of wealth are associated with this much-adored deity." [2] (*Vide* GOLD.)

AUTHORITIES.

[1] *Catalogue of the Collection of Chinese Exhibits at the Louisiana Purchase Exposition*, St. Louis, 1904, p. 110.
[2] Werner: *Myths and Legends of China*, p. 171.

財
源
茂
盛

THE TWO GODS OF WEALTH, CIVIL AND MILITARY

213

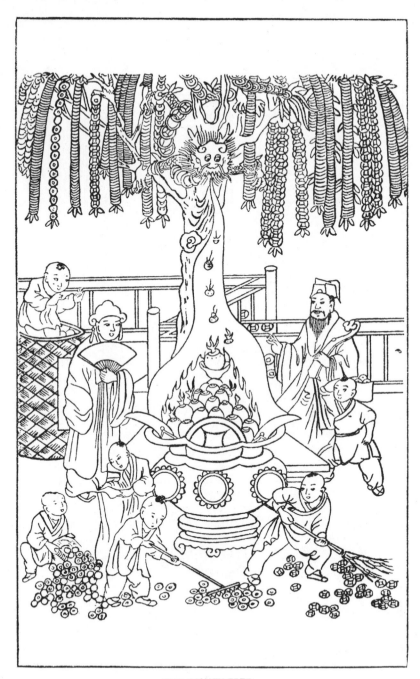

THE MONEY-TREE

214

GOLD

(金)

"The Chinese use the same character for metal and gold. It represents in the pseudo-science of *Fêng shui* or *Yin-yang* the chief of the sacred five-system of the elements which comprise also wind, fire, water and earth. . . . The character *chin* (金), gold or metal, is said by the *Shuo Wen* to be made up of the characters *chin* (今), 'now', indicating the sound and tone of the word, and *t'u* (土), 'earth', with two dots in earth. Classical scholars state that the two dots are supposed to represent the mode of occurrence of gold in the earth." [1]

Gold is found in many Chinese rivers, but in such small quantities that the washing does not pay. With the possible exception of Manchuria and the Yunnan-Szechuan region, the gold-mining industry in China has no prospects.

Cubes of gold weighing one catty were used as currency from the eleventh to the third century B.C. At one time gold and silver were the same in value; this anomaly was created by the absence of foreign intercourse. In the Han dynasty gold was cheap, because Buddhist image worship had not then created a demand for this metal. Gold is consumed in gilding, and exported to India as bullion, in the shape of small bars or coarse leaves. The Chinese often invest their savings in soft gold bracelets, rings, etc., and the goldsmith stamps the name of his shop inside any piece of gold he sells, it being understood that he will repurchase it at any time by weight, without questioning the quality of the metal. The ancient Taoist alchemists claimed to possess the secret of the Philosopher's Stone (金丹), by which common substances could be transmuted into gold (*vide* GOD OF WEALTH).

AUTHORITY.

[1] Couling: *Encyclopaedia Sinica*: MINING.

GONG

(鑼)

The Chinese brass gong is cast in the shape of a platter or a native straw hat with large brim; it is of various sizes, varying from 2 inches to 2 feet in diameter. It is suspended

by a string and struck with a mallet. The use of the gong is very general. In processions it drives away evil spirits; on board ship it announces departure; during eclipses it frightens the "Celestial Dog" when about to devour the moon; it is the signal on the outbreak of a fire; in songs it marks the tune; in the streets a small gong is the sign of the sweetmeat pedlar, and a large one may announce the approach of an official with his retinue; in Buddhist temples it is beaten to call the attention of the spirits.

The *Yün lo* (韻鑼) is a chime of ten small gongs suspended in a frame. It is used in religious ceremonies and in orchestras. The *Tien tzŭ* (點子) is a gong of brass or iron suspended at the city gates and in temples, varying from one to four feet in diameter, and of ornamental shape (*vide* MUSICAL INSTRUMENTS).

GOOSE, WILD
(雁)

"Said to be peculiarly the bird of the *yang* (陽鳥) or principle of light and masculinity in nature. It follows the sun in its wintry course toward the South, and shows an instinctive knowledge of the times and seasons in its migrations. It always flies in pairs, and hence is employed as an emblem of the married state. In the ritual of the Chou dynasty it was accordingly enumerated among betrothal presents." [1]

THE WILD GOOSE AS HARBINGER OF GOOD NEWS

The Chinese believe that geese never mate a second time, and a libation is poured out to the geese on the occasion of the bridegroom fetching his bride from her father's house. Memorial arches (牌樓) are sometimes erected in memory of widows who have not remarried, but have continued true to their husband's memory; a procedure which is regarded as highly meritorious.

The scholar Wang Hsi-chih (王羲之), A.D. 321-379, once made a copy of the Tao Tê Ching (道德經) for a Taoist priest, receiving in return the present of a flock of rare geese.

A wild goose is depicted on the Chinese postal flag in reference to Su Wu (蘇 武), of the 2nd century B.C., who, while under detention by the Hsiung-nu or Turkic tribes, contrived to inform the Emperor Han Wu Ti of his whereabouts by attaching a letter to the leg of a wild goose, which was subsequently shot in the Imperial pleasure grounds; whereupon steps were taken to effect his release. For the same reason geese are sometimes depicted on fancy note-paper. A wild goose was formerly embroidered on the court robes of civil officials of the third grade.

AUTHORITY.
[1] Mayers: *Chinese Reader's Manual*, Pt. I, 909.

GOURD
(葫 蘆)

The bottle-gourd is very durable when dried. It is often tied to the backs of the children of the boat people of Canton, to assist them in floating if they should fall overboard. Its shape renders it useful as a receptacle for medicine, and it is represented in the form of a sign-board by the drug-shops of the Chinese (*vide* SHOP-SIGNS). It is the symbol of mystery and necromancy and the emblem of Li T'ieh-kuai (李 鐵 拐), one of the EIGHT IMMORTALS (*q.v.*) of Taoism, who holds it in his hand while spirals of smoke ascend from it, denoting his power of setting his spirit free from his body.

Gourd-bottles being formerly carried by old men on their backs, figures of them, made either of copper or of the wood of old men's coffins, are worn as charms for longevity; the former round the neck, the latter round the wrist. "The gourd-shell, or a painting of the gourd on wood or paper, or a small wooden gourd, or a paper cut in shape like a perpendicular section of the gourd, or a paper lantern made in shape of a gourd, is in frequent use as a charm to dissipate or ward off pernicious influences." [1]

AUTHORITY.
[1] Doolittle: *Social Life of the Chinese*, p. 566.

GRAIN MEASURE
(斗)

The common peck measure holds ten catties of rice, and is generally made of willow-wood. It has also many symbolic

uses and takes a prominent part in the worship of the STARS (*q.v.*).

"The Grain Measure is a symbol of the full measure of justice, mercy, and virtue, which should be meted out to each being, irrespective of his station; the measure should be 'level' —filled to overflowing with benefits for the people. Being four-sided it represents the whole Empire; it is in fact in the form of the original character for 'kingdom.' which was a simple square." [1]

AUTHORITY.

[1] Ayscough: *Notes on the Symbolism of the Purple Forbidden City*, N.C.B.R.A.S. Journal, 1921, p. 65.

GRAPE

(葡 萄)

The grape, *Vitis vinifera,* was introduced into China in 126 B.C. by the famous Minister Chang Ch'ien (張 騫) on return from his mission to the Indo-Scythians.

There are various varieties, *e.g.,* the elongated white grape, the seedless white grape, the purple grape, and the wild grape. From some species a fairly good wine is made. In the northern regions the vines are coiled up and covered with earth to protect them from the severe cold of winter. The fruit is also preserved for several months by keeping it underground.

This fruit is sometimes used in art motives as a border pattern, and the design of the "sea-horses and grapers" (said to be derived from Greece) or the "squirrel and grape-vine," etc., are occasionally found on the backs of ancient bronze mirrors or in paintings.

HAMMER

(鎚)

Sanskrit, *Mudgara*. One of the weapons or insignia of some of the Buddhist and Taoist deities. P'AN KU (盤古) (*q.v.*), the Chinese Adam, is said to have fashioned the firmament with a hammer and chisel, and his image is to be seen in both Buddhist and Taoist temples (*vide* Illustrations under P'AN KU and LAMAISM).

HAND

(手)

The various gestures of the hand play an important part in Chinese symbolism. An acrobatic feat or a graceful posture on the stage will often elicit from the audience the approving gesture of the upturned thumb, as in Roman amphitheatres of old. The Chinese, like all orientals, are masters of gesticulation. They have many ways of counting on the fingers, each joint being separately reckoned, and these methods are employed in conversation and at auctions. Although they shake their own, and not their friends' hands it is a sign of affection to seize the hand of a parting or returning friend, and two friends are often seen walking hand in hand along the street. According to the "Book of Ceremonies" (禮記), a man should never touch a woman's hand in public. The western habit of shaking the hand of a person originated in the desire to prevent him using it to strike with, and the Chinese individual salutation with both hands joined together

219

implies that the hands are not employed in a hostile manner, but are held forward in token of allegiance of friendliness. The lowest form by which respect is shown in China at this day is known as *kung shou* (拱 手), that is, joining the hands and raising them before the breast. The next is *tso i* (作 揖), or bowing low with the hands joined. The third is *ta ch'ien* (打 千), bending the knee, as if about to kneel. The fourth is *kuei* (跪), to kneel. The fifth is *k'ou t'ou* (叩 頭), kneeling and striking the head against the ground. The sixth, *san k'ou* (三 叩), striking the head three times on the earth before rising from one's knees. The seventh, *liu k'ou*, (六 叩), that is, kneeling and striking the forehead three times, rising on one's feet, kneeling down again, and striking the head again three times against the earth. The climax is reached by the *san kuei chiu k'ou* (三 跪 九 叩), kneeling three separate times, and each time knocking the head thrice against the ground. Some of the gods of China are entitled only to the *san k'ou;* others to the *liu k'ou;* Heaven was worshipped with *san kuei chiu k'ou,* as was also the Emperor.

During the Sung dynasty the seat of honour was at the left hand side. In the time of the Yüan dynasty it was the right. The first Emperor of the Ming dynasty restored it to the left, which still continues to the present day. The left is the place of honour among the Japanese because their swords are worn on that side.

With regard to representations of Buddha, when the image has the palm of the hand directed towards the worshippers, it signifies unlimited giving. "When the left hand is laid palm upward on the knees, the right hand laid in the same way upon the left, and the thumbs joined at the tips, the combination is meant to express a fusion in contemplation of the five material elements symbolized by the fingers. Or when the fingers of the right hand clasp the fore-finger of the left according to a prescribed configuration, the gesture symbolizes the unity of the cosmic and the individual souls in the final spiritual enlightenment."[1] (*Vide* IDOLS).

AUTHORITY.

[1] Anesaki: *Buddhist Art,* pp. 34-5.

HARE
(兔)

The hare, *Lepus sinensis,* is common in the Yangtze valley and the northern regions. It is an emblem of longevity, often

depicted on porcelain, and represents the fourth of the TWELVE TERRESTRIAL BRANCHES (*q.v.*)

"This animal is reputed as deriving its origin from the vital essence of the MOON (*q.v.*), to the influence of which luminary it is consequently subject. Chang Hua (張 華), in the 'Po Wu Chih' (博 物 志), asserts that the hare conceives by gazing at the Moon, though earlier writers have alleged that the female hare becomes with young by licking the fur of the male. She is said to produce her young from the mouth. Like the FOX (*q.v.*), the hare attains the age of 1,000 years, and becomes white when half that period is completed. The red hare (赤 兔) is a supernatural beast of auspicious omen, which appears when virtuous rulers govern the Empire. Tradition earlier than the period of the Han dynasty asserted that a hare inhabited the surface of the Moon, and later Taoist fable depicted this animal, called 玉 兔, the Gemmeous Hare, as the servitor of the genii, who employ it in pounding the drugs which compose the elixir of life. . . . The connection established in Chinese legend between the hare and the Moon is probably traceable to an Indian original." [1] According to a Buddhist legend, the hare offered its body as a willing sacrifice, lying on a pile of dry grass, and was rewarded for its devotion by transmigration to the Moon.

AUTHORITY.

[1] Mayers: *Chinese Reader's Manual*, Pt. I, 724.

HEART

(心)

The heart, according to the Chinese, holds the office of prince or ruler in the body, and the spiritual intelligences (the thoughts) emanate therefrom. It is classed as one of the Five Viscera (五 藏), *viz.*; heart, liver, stomach, lungs, and kidneys, which represent the emotional feelings. The Chinese believe that the heart is the seat of the intellect, and is pierced by a number of "eyes," or apertures, which pass right through; in physical and mental health these passages are supposed to be clear (*vide* GOD OF WEALTH). It is reverenced as one of the EIGHT TREASURES (*q.v.*) or Eight Precious Organs of Buddha, and is sometimes called *Lun* (輪), when it symbolises the sacred WHEEL OF LIFE (*q.v.*) of the Buddhists.

HEMEROCALLIS

（萱草）

The *Hemerocallis graminea* is a species of Day-lily which has been known for ages as a drug or charm for dispelling grief (諼草), and is supposed to favour the birth of sons when worn in women's girdles, being therefore emblematic of the mother of a family. The young leaves are eaten, and appear to intoxicate or stimulate to some extent. The flowers are dried and mixed with the petals of the *Lilium bulbiferum* to form the medicament and relish known as Lily-flowers (金針菜). The root is diuretic, and is prescribed in dysuria, lithiasis, dropsy, jaundice, and hæmorrhoids, and the deer are said to feed upon it.

HORSE

（馬）

The horse, *Equus caballus,* is said to be originally a native of Central Asia, but the Mongolian pony is the species now commonly found in China.

The written symbol for this animal was anciently written 馬 and is now reduced to 馬. The horse is one of the Seven Treasures of Buddhism (*vide* PEARL), and represents the seventh of the TWELVE TERRESTRIAL BRANCHES (*q.v.*). It is classed under the element *fire,* and has its corresponding station in the *south.*

Information relative to the history and uses of the horse is contained in twenty-four sections of the "Pen Ts'ao" (本草), the great Chinese *Materia medica* published in 1596. "The first explains the character *ma,* which was originally intended to represent the outline of the animal. The second describes the varieties of horses, the best kinds for medical use, and gives brief descriptions of them, for the guidance of the practitioner. The pure white are the best for melicine. Those found in the south and east are small and weak. The age is known by the teeth. The eye reflects the full image of a man. If he eats rice his feet will become heavy; if rat's dung, his belly will grow long; if his teeth be rubbed with dead silk-worms, or black plums, he will not eat, nor if the skin of a rat or wolf be hung in his manger. He should not be allowed to eat from a hog's trough, lest he contract disease;

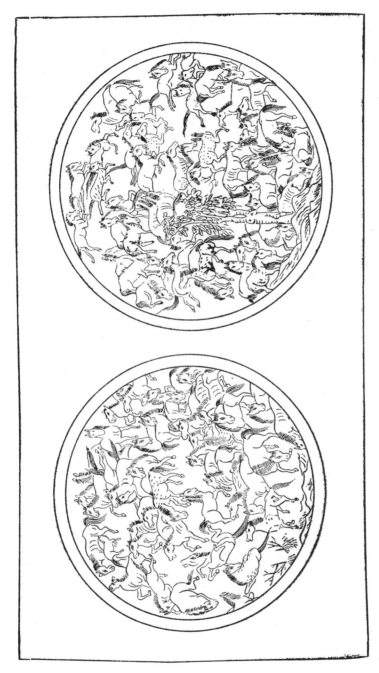

"A HUNDRED COLTS." FROM 16TH CENTURY WOODCUTS AFTER HAN KAN OF THE T'ANG DYNASTY, A CELEBRATED PAINTER OF HORSES. THERE ARE 50 ANIMALS ON EACH DISC, ALL IN VARIOUS POSITIONS, AND NO TWO ALIKE

223

and if a monkey is kept in the stable he will not fall sick.'
. . . The remaining sections treat of the various parts
of the horse's anatomy, which are used as food and medicine.
The liver is said to be poisonous. The heart, when dried,
powdered and taken with wine, is a certain cure for forget-
fulness. 'Above the knees the horse has *night-eyes* (warts),
which enable him to go in the night; they are useful in the
toothache. If a man be restless and hysterical when he
wishes to sleep, and it is requisite to put him to rest, let the
ashes of a skull be mingled with water and given him, and
let him have a skull for a pillow, and it will cure him.' The
same preservative virtues appear to be ascribed to a horse's
hoof hung in a house as are supposed, by some who should
know better, to belong to a horseshoe when nailed upon the
door." [1]

According to the "Ma Ching" (馬經), or *Horse Classic*,
written early in the 17th century, the points of the horse are
as follows: "There are thirty-two marks, of all which the
eye is the pearl; next you must see if the head and face are
proportionate, but he who wishes to know how to distinguish
a good horse, and does not examine the books of former ages,
is like a blind man going in a new road. The eye round as
a banner-bell, colour deep; pupil bean-shaped, well defined,
with white *striæ*; iris with five colours—he will be long-lived;
nose with lines like the characters *kung* (公) and *huo* (火)—
he will see forty springs; the forehead higher than the eyes;
mane soft with 10,000 delicate hairs; face and chops without
flesh; ears like a willow leaf; neck like a phoenix's, or cock's
when crowing; mouth large and deep, with lips like a box close
joining; incisors and molars far apart; tongue like a two-
edged sword and of good colour; the gums not black—he will
have a long life; lean as to flesh, fat as to bones; never
starting at sounds nor fearful of sights; the tail elevated is
reckoned a good sign; head inclined and neck crooked with
three prominences on the crown; sinews like a deer's; bones
of legs small, and hoofs light; fetlocks shape of a bow; breast
and shoulders broad, but little projecting forward; head long
and loins short; belly hanging, and the hair on it growing
upward; hoofs strong and solid; knees high and joints
uniform; flesh on the back thick, making it round as a wheel;
scapula like a guitar (琵琶), and femur inclined, and tail
like a flowing comet, hairs all soft." [2]

The horse is an emblem of speed and perseverance, and
a quick-witted youth is sometimes called a "thousand-li colt"

(千里駒). The eight steeds (八駿) of Mu Wang (穆王) 1001-746 B.C., the fifth sovereign of the Chou dynasty, are renowned in legend and story, and are often used as an art *motif*. With these eight steeds, each of which bore a distinguishing name, King Mu was driven by his charioteer Tsao Fu (造父) on his journeys through the Empire. Han Kan (韓幹), A.D. 750, and Chao Mêng-fu (趙孟頫), A.D. 1254, were the most celebrated Chinese painters of horses. The sleeve of the former Manchu official costume was shaped like the hoof of a horse, and the cue or tail of hair, the wearing of which by the people is now no longer *de rigueur,* is said to have

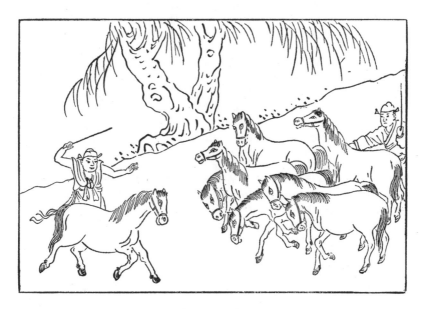

THE EIGHT FAMOUS HORSES OF MU WANG. AFTER HAN KAN

been adopted by the Manchus in imitation of a horse's tail, as a grateful tribute to the animal to which they owed so much.

The image of the King of Horses (馬王), an ugly ogre with three eyes and four hands, bearing various weapons of warfare, is occasionally found in wayside shrines. He is worshipped by horse-rearers, and is usually accompanied by a similar figure of the King of Cows (牛王), who is invoked by the cow-herders. These deities are supposed to be able to protect cattle from evil spirits and disease. The former

has by his side a small model of a horse, and the latter that of a cow.

AUTHORITIES.

[1] Williams: *Middle Kingdom*, Vol. I, pp. 375-6.
[2] *The Chinese Repository*, Vol. VII, Dec., 1838, Art. I, pp. 396-7.

HSI WANG MU
(西 王 母)

Hsi Wang Mu, or the Royal Lady of the West, is a legendary being supposed to dwell upon the K'un Lun mountains, in a large and beautiful palace, surrounded by extensive grounds, in which grew the fairy peaches (仙 桃), which ripen but once in 3,000 years and confer immortality upon those who eat them. Her mountain residence was remarkable for its beautiful gardens, marble and jasper buildings, nine-storeyed tower, and sparkling brooks.

In paintings she is usually depicted as a beautiful female in the attire of a Chinese princess, attended by two young girls, one of whom holds a large fan, the other a basket of the peaches of longevity. Her principal handmaidens, known as Gemmeous Lasses (玉 女) or Fairy Maids (神 女), were five in number, their designations corresponding to the colours attributed to the respective five points of the compass. She is said to have been at the head of the troops of genii, and to have held continual intercourse with imperial votaries. According to the "History of the Chou Dynasty" (周 書), the Emperor Mu (穆 王), 985 B.C., was entertained by her at the Lake of Gems (瑤 池) in the West. The Emperor Wu Ti of the Han dynasty (漢 武 帝), 140-86 B.C., is also said to have visited her mountain palace. She is generally accompanied by a crane, which she uses as a charger, and sometimes by the azure-winged birds (青 鳥), who serve (like the doves of Venus) as her messengers. Modern writers have drawn the conclusion that Wang Mu was the name either of a locality or of a sovereign in the ancient West. She was the subject of much research on the part of the Taoist writers. Later tradition has assigned to her a consort in the person of Tung Wang Kung (東 王 公), the Royal Lord of the East, whose name is designed in obvious imitation of her own, and who appears to owe many of his attributes to the Hindoo legends respecting the Vedic deity Indra. He is said to keep the register of all

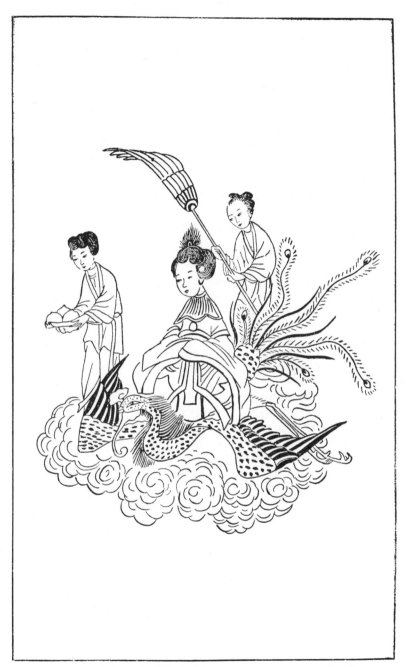

HSI WANG MU MOUNTED ON THE CRANE

the Taoist Immortals. The royal pair had nine sons and twenty-four daughters. The K'un Lun mountains (崐崘) are identified with the Hindu Kush in Central Asia, and also with Sumeru (須彌), the fabled abode of Indra and his consort. According to Taoist legends numerous trees of precious stones exist thereon.

The early Jesuit missionaries identified Hsi Wang Mu with the Queen of Sheba. Professor Giles has also connected her with the Roman Goddess Juno (Hera). The peaches of longevity may be compared to the golden apples, and Hsi Wang Mu's handmaidens to the Hesperides.

HUNDRED ANTIQUES

(百 古)

The group known as the hundred (*i.e.* sundry or various) antiques is a miscellaneous or general collection of emblematic forms comprising the EIGHT TREASURES (*q.v.*), the FOUR TREASURES (*q.v.*), the symbols of the four fine arts, music (*vide* MUSICAL INSTRUMENTS), chess (*vide* AMUSEMENTS), calligraphy (*vide* SCROLL, WRITTEN CHARACTERS), and painting (*vide* PAINTING), together with numerous conventional representations of sacrificial vessels, flowers, animals, etc.; or any small-decorative motives which do not fall under any particular classification.

HUNDRED ANTIQUES

IDOLS

（偶 像）

Idols are chiefly made of clay and wood, richly painted and gilded. Small images are made of brass or bronze. The gold plating on some of the metal figures is put on by hand with the aid of mercury as an amalgam, and polished by being rubbed with jade-stone. The bronze of the body sometimes contains gold offered by the faithful in the form of personal jewelry, which is melted down when making the casting. These "josses" are generally in a sitting position, and are usually dressed. Altars are placed before them, on which incense is burnt, and sacrificial food and wine are displayed. The enlarged ear-lobes of some of the images are a sign of divinity and superior knowledge. The expanded and somewhat boat-shaped gilded plaque placed behind the figure represents the halo or aureole (Jap. *funagoko*). A heart or internal organs of gold or precious stones may occasionally be inserted into the body.

According to Buddhistic records, there are Thirty-two signs (三 十 二 相), Skt., *Lakshana*, consisting of different marks or characteristic beauties displayed in the person of every Buddha, "commencing with a steady level in the sole of the foot, and ending with a lofty protuberance at the crown of the head." To these are added the Eighty Qualities (八 十 種 好), Skt., Pali *Anuwyanjana-lakshan*, "commencing with unrivalled length of nails and ending with the 萬 字 figure 'ten thousand,' or *svastika*, upon the breast." [1]

"A Bodhisattva is one whose essence has become intelligence; a Being who will in some future birth as a man (not

229

necessarily or usually the next) attain to Buddhahood. The name does not include those Buddhas who have not yet attained to *Parinirvana* (the condition of mind when the Buddhist has done with all the life of sense and society, and has no more exercise of thought). The symbol of the state is an elephant fording a river. Popularly, its abbreviated form *P'u-sa* (菩薩) is used in China for any idol or image." [2]

"As regards the *Postures* of the images, the chief sedent postures especially characteristic of the several forms of Buddha himself, and secondarily of the celestial Buddhas and Bodhisats are as follows:

1. 'The adamantine, unchangeable, or fixed pose' (Skt., *Vajra Palana*) sedent in the well-known cross-legged Buddha posture. The legs are locked firmly and the soles directed fully upwards. This is the pose of deepest meditation, hence it is also called, when the hands lie loosely in the lap, the 'Dhyāna or meditative *mudra.*'

2. 'The Bodhisat-pose' (Skt., *Satva Palana*) differs from No. 1 in having the legs loosed and unlocked. The soles are scarcely seen. This is the first pose of first emergence from meditation.

3. 'The sub-active pose' (Skt., *Niyampalana*) is emerged further from meditation. It has the legs unlocked, the left being quite under the right, and the soles invisible.

4. 'The Enchanter's pose' (Skt., *Lalita*), *i.e.*, after the manner of 'The Enchanter' Manjusri. Here the left leg hangs down with an inclination slightly inwards and the right is loosely bent.

5. 'Maitreya's pose.' Sedent in the European style with both legs pendent.

The chief attitudes of the hands and figures (*mudras*) are the following:

1. 'Earth-touching,' or the so-called 'Witness' attitude (Skt., *Bhūsparsa*), with reference to the episode under the Tree of Wisdom, when Sākya Muni called the Earth as his witness, in his temptation by Māra (*vide* VULTURE PEAK). It is the commonest of all the forms of the sedent Buddha. . . .

2. 'The Impartial' (Skt., *Samāhitan*), or so-called 'meditative posture' (Skt., *Samādhi*). Resting one hand over the other in the lap in the middle line of the body, with the palms upwards.

3. 'The best Perfection' (Skt., *Uttara-bodhi*). Index-finger and thumb of each hand are joined and held almost in contact with the breast at the level of the heart.

4. 'Turning the Wheel of the Law' (Skt., *Dharma-cakra*). Dogmatic attitude with right index-finger turning down fingers of left hand.

5. 'The best Bestowing' (Skt., *Varada*). It signifies charity. The arm is fully extended and the hand is directed downwards with the outstretched palm to the front.

6. 'The Protecting,' or 'Refuge-giving' (Skt., *Saran*). With arm bent and palm to front, and pendent with fingers directed downwards.

7. 'The blessing of Fearlessness' (Skt., *Abhaya*). The arm is elevated and slightly bent. The hand elevated with the palm to the front, and the fingers directed upwards.

8. 'The Preaching' differs from No. 7 in having the thumb bent, and when the thumb touches the ring-finger it is called 'The triangular pose.'

9. 'The pointing Finger,' A necromantic gesture in bewitching."[3] (*Vide* SHÂKYAMUNI BUDDHA.)

AUTHORITIES.

[1] Mayers: *Chinese Reader's Manual*, Pt. II, 314.
[2] Legge: *Travels of Fa-hien*, p. 19, note 2.
[3] Waddell: *Lamaism*, pp. 385-7.

INTESTINES

（腸）

Symbolic of compassion and affection. The Chinese believe that they connect with the lungs. They are reverenced as one of the EIGHT TREASURES (*q.v.*) of Buddhism, or Eight Precious Organs of Buddha, and are symbolically represented, in conventional designs, etc., as an endless knot (*vide* MYSTIC KNOT).

According to the Chinese, the intestines have the office of receiving and forwarding abundance.

IRON

（鐵）

"Iron is the second in importance of the China's mineral resources, and iron ore is found in every province, but is only worked by native methods where coal is also present, owing to the large quantity of coal used in iron smelting."[1]

It is one of the Chinese category of five metals (五金), corresponding to the five primary colours (五色), as follows:

METALS	COLOURS
Gold	Yellow
Silver	White
Copper	Red
Lead	Blue
Iron	Black

Iron is also a symbol of firmness, strength, determination, integrity, and justice. A government proclamation sometimes concludes with the words *t'ieh pi pu kai* (鐵筆不改), "the iron pen changes not," or the written law is unalterable—like that of the Medes and Persians. When lamp-posts were first erected in Shanghai, the innovation was regarded as a harbinger of evil to the government, and it was reported in the Chinese press under the graphic headline *t'ieh shu k'ai hua* (鐵樹開花), or "iron trees bursting into bloom," a common euphemism indicating an unusual occurrence. A variety of ornamental palm is known to the Chinese as the "iron tree"; it is supposed to flower only once in a century.

The iron pictures, or wall hangings, of the Chinese, consisting of sprays of flowers symbolizing the four seasons, or representing landscapes, etc., delicately executed in fine metalwork set in a wooden frame with no back, are said to have had their origin in the following manner. A poor artist of the T'ang dynasty was taken ill while on a journey, and fell exhausted by the roadside near a blacksmith's forge. The blacksmith left his work, and, taking pity on the afflicted man, he helped him into living quarters at the rear of his establishment, where, in course of time, and by dint of careful treatment, he gradually recovered. The artist had no money, so in order to show his gratitude he painted a picture for his benefactor. The latter thanked him and hung it up in his workshop. On that day the smith happened to be unoccupied and he amused himself by attempting to copy the work of art in beaten iron, eventually producing a fairly artistic design which he presented to the artist with his compliments, saying, "You work in your medium of colour, and I work in my good iron; shall I not have an equal chance with you of going down to posterity?" The artist was interested, and joined forces with

the blacksmith, and together they became famous as designers and fabricators of the new-fashioned "iron picture," which has been popular with lovers of artistic symbolism even up to the present day.

AUTHORITY.

1 Couling: *Encyclopaedia Sinica*: IRON.

ISLANDS OF THE BLEST

（三 仙 山）

The Three Isles of the Genii, or the Fortunate Islands, were supposed to be situated in the Eastern Sea, nearly opposite to the coast of Kiangsu. They were named *P'êng-lai Shan* (蓬萊山), *Fang-chang* (方丈), and *Ying-chou* (瀛洲). They were inhabited by fairies, who fed upon the gems scattered along their shores, and drank from the invigorating fountain of life (玉醴泉), which flows from a jade-stone rock 1,000 *chang* in height. The sacred fungus (芝) was found there in great abundance (*vide* PLANT OF LONG LIFE), and there were many glorious mansions occupied by the immortals.

The first Emperor of the Ch'in dynasty (秦始皇帝) despatched a troop of several thousand young men and women, under the guidance of the Taoist mystic Hsü Shih (徐市) 219 B.C., to search for these fabled abodes of bliss; but the expedition, though it sailed within sight of the magic islands, was driven back by contrary winds. It is conjectured that this legend has some reference to attempts at colonization of the islands of Japan.

JADE

（玉）

The English term for what in China is called *yü* is derived from the Spanish *piedra di hijada*, or 'stone of the loins,' pains in that region of the body being deemed amenable to treatment by the stone. The true jade, namely nephrite, is a hard, non-crystalline mineral composed of silicates of calcium and magnesium; it varies in colour according to the proportion of iron it contains, being either clear, *fên* (璺) ; indigo, *pi* (璋) ; green, *pi* (碧) ; kingfisher blue, *fu* (玞) ; yellow, *kan* (玕) ; cinnabar red, *chiung* (瑤) ; blood red *mên* (璊) ; black, *hsieh* (瑎) ; or white, *ch'a* (瑳). 'Jadeite,' a still harder silicate of alumina and sodium is regarded as an excellent substitute for jade; in fact about one hundred and seventy different varieties of stone of various colours are frequently included in the wide-embracing term 'jade.' The leading centre of the jade trade is the great open-air market held, at an early morning hour, near the temple of the Five Hundred Disciples at Canton. Jade was chiefly mined at Khotan (和闐州), in Chinese Turkestan, until the 11th century, but is now mostly imported from Burma. The New Zealand variety is not much appreciated by the Chinese..

The character *yü* (玉), jade, represents three (三) pieces of jade pierced through and connected with a string (|), the dot being added to distinguish it from *wang* (王), a prince. Jade pendants were formerly worn at the girdle, and in ancient times it was the custom for persons of high rank to place gold and gems in the tombs of their dead for the use of the *manes* or departed spirits, and the orifices of the body

234

were closed with pieces of jade. The jade-stone is the gem most valued by the Chinese and symbolises excellence and purity. The *Book of Rites* (禮記) states: "The Superior Man competes in virtue with Jade" (君子比德於玉).

Tracing the use of jade from ancient times it appears to have developed in the following order:—

 (1) Early weapons.
 (2) Mythological tokens.
 (3) Imperial emblems.
 (4) Ritual emblems.
 (5) Symbolic forms.
 (6) Utilitarian articles.
 (7) Decorative objects.

An interesting review of its characteristics, decoration, folklore and symbolism has been provided by Mr. S. C. Nott in his copiously-illustrated work "Chinese Jade Throughout the Ages."

Heaven was represented by the ancients in the tangible form of a perforated disk of jade (璧). It was believed that such a token embodied the qualities of solar effulgence, and was closely connected with the powers of Heaven by means of its magical properties, and therefore the Emperor, being the Son of Heaven, was able to commune and consult with Heaven through the medium of the jade disc. Many seals and other objects were carved with primitive tools in smooth "mutton-fat" jade during the Han dynasty. These are known as Han Yü (漢玉), or Jade from the Han dynasty.

From a period of high antiquity its rarity and costliness have caused it to be held symbolical of all that is supremely excellent and of the perfection of human virtue. Its nature was accordingly linked with that of the highest forms of matter. Thus in the commentary on the *I Ching* entitled 說卦, the authorship of which is attributed to Chou Kung, it is alleged that 乾爲玉爲金, *Ch'ien* or Heaven, is symbolized by the jadestone and gold, a combination of the highest strength with the purest effulgence. To this an ancient commentary adds that it is the 'most perfect development of the masculine principle in nature,' and the Taoist philosophers, enlarging upon these texts, attributed at an early period divers magical virtues to the gem. Pao P'u-tzu (抱朴子), a Taoist philosopher of the 4th century A.D., alleges that from the mountains producing jadestone a liquid flows which, ten thousand years after issuing from the rock, becomes coagulated into a substance clear as crystal. If to this be

added an appropriate herb, it again becomes liquid, and a draught of it confers the gift of living for a thousand years. . . . In the language of alchemy, moreover, 玉液 or beverage of jade was the name given to the supreme elixir which combines the virtues of the draught of immortality and the philosopher's stone (*vide* ELIXIR OF LIFE)." [1]

This celebrated mineral, the Yü, or gem *par excellence* of the Chinese, the *Yeshm* of the Persians, the *Sootash* of the Turks, is supposed by the Chinese to possess humane, just, intelligent, brave, and pure qualities, presumed to be conveyed to the wearer. Those who take it (internally) are said to be relieved from the claims of gravitation. . . . Its hardness, weight, sonoreity, and peculiar sombre tint, are the foundation of the Chinese taste for this precious stone. Philosophers and physicians have ascribed all sorts of properties to this substance, which can be no better than so much steatite or soapstone for any purpose in pharmacy." [2] A piece of jade, worn on the body, is said to prevent a person being thrown from his horse.

A variety of red jade or chrysophrase known as *Ch'iung* (瓊) was believed to grow upon a tree, 10,000 cubits in height and 300 arm-spans in circumference, which flourished in the palace gardens of the Taoist fairy Goddess HSI WANG MU (西王母), (*q.v.*) on the K'un Lun Mountains. Its leaves and blossoms, if eaten, were reputed to confer the boon of immortality.

The jade carvers in Canton work almost entirely in green jade, while those in Peking, Soochow, and Shanghai, confine themselves chiefly to white. "Jade objects have a large variety of uses. Sacrificial vases, incense-burners, pots and ewers, bowls and cups, thumb-rings, ear-rings, bracelets and hair-pins for personal adornment, linked chains as tokens of friendship, Joo-i, mirror-stands, and combs as betrothal gifts, locks for children's necks, pen-rests for students, statuettes, carved screens, sacred peaches, pomegranates, the eight Buddhist emblems for altars, are examples. A study of the objects made in this hard stone is of inestimable value for the comprehension of Chinese psychology." [3]

"The Chinese rank jade as the most precious of stones, and one who attempts to purchase a piece of the colour particularly prized by the Chinese will find it as expensive as a diamond of equal weight. The favourite colour is a fine apple green. Other shades, not so popular among the Chinese, satisfy foreign tastes at more moderate prices. Much arti-

ficial jade is made in Germany and chrysoprase from Siberia is sold as jade. Some of the carved ornaments offered as jade are made of a greenish white soapstone. This particular fraud may be easily detected, for real jade is too hard to be scratched with a knife, while soapstone is very soft. Defective pieces of jade are often filled with wax and thus made to pass muster as perfect specimens."[4]

"In ancient times," said Confucius, "men found the likeness of all excellent qualities in jade. Soft, smooth, and glossy, it appeared to them like benevolence; fine, compact and strong—like intelligence; angular, but not sharp and cutting—like righteousness; hanging down (in beads) as if it would fall to the ground—like (the humility of) propriety; when struck, yielding a note, clear and prolonged, yet terminating abruptly—like music; its flaws not concealing its beauty; nor its beauty concealing its flaws—like loyalty; with an internal radiance issuing from it on every side—like good faith; bright as a brilliant rainbow—like heaven; exquisite and mysterious, appearing in the hills and streams—like the earth; standing out conspicuously in the symbols of rank—like virtue; esteemed by all under the sky—like the path of truth and duty."[5]

AUTHORITIES.

[1] Mayers: *Chinese Reader's Manual*, Pt. I, pp. 303-4.
[2] Smith: *Contributions towards the Materia Medica and Natural History of China*: JADE.
[3] Couling: *Encyclopaedia Sinica*: JADE.
[4] Crow: *Handbook for China*, 4th Ed., Section on Art and Industries.
[5] Legge: *Li Ki*, Bk. XLV, § 13.

JAR

(罐)

This is a vase with a cover such as would be used as a reliquary or receptacle for sacred relics, of Buddhist saints, or as an incineray urn in which the ashes of cremated priests are deposited. It is one of the EIGHT TREASURES (*q.v.*) or auspicious signs on the sole of Buddha's foot, and it sometimes symbolically represents the sacred STOMACH (*q.v.*) of that divinity.

JASMINE
（茉 莉 花）

The *Jasminum grandiflorum*, with its white fragrant flowers is well known to all. It is commonly designated by the Chinese as *Mo li hua* (茉 莉 花), which Professor Giles suggests (*vide* his *Chi. Eng. Dict.* 8,006) may be connected with the Latin *moly*, "the magic plant with a white flower and a black root, given by Hermes to Ulysses as a charm against the sorceries of Circe." It is also called *Yeh hsi ming* (耶 悉 茗), which is no doubt a transliteration of the English jasmin, jasmine, or jessamine. The *Jasminum officinale* is known as *Su hsing* (素 馨).

The jasmines were originally brought to China from Persia and Central Asia. The petals are used to scent teas, and an oil is extracted from them, which is chiefly used in the preparation of toilet articles. The peculiarly sweet-smelling buds are run on wires and made into hair ornaments, or fashioned into hanging baskets for scenting rooms.

This flower is an emblem of the fair sex, and a symbol of sweetness.

JOO-I
（如 意）

"As you wish, in accordance with your heart's desire. The name of a kind of short sword, with sword-guard, originally made of iron, and used by the ancients for self-defence and also for purposes of gesti-culation. It is now often given as a present among the Chinese, signifying good wishes for the prosperity of the recipient. It is seen in the hands of idols, and is the setting of *Mani* (摩 尼), the round pearl—one of the *sapta ratna* (七 寶)—which is said to keep always clean and bright and to shed a brilliant light on all surrounding objects. Hence it is the symbol of Buddha and his doctrines. Used for the Sanskrit *riddhi* and *riddhi-pada,* in the sense of magical powers."[1] "Chao Hsi-ku (趙 希 鵠), an archæologist of the

SCEPTRE AND HEAD

13th century, tells us that the *ju-i* was used 'for pointing the way' and also for 'guarding against the unexpected,' *i.e.*, for self-defence. It was, in fact, a kind of blunt sword, and traces of basket work are still found inside what must have been the swordguard."[2] Its shape is said by some to have been derived from the sacred fungus or PLANT OF LONG LIFE (*q.v.*), and it is therefore regarded as an emblem of longevity, but in Buddhistic eyes it represents the mystic LOTUS (*q.v.*), which is generally carved on the superior end. The head of the Joo-i, conventionally treated, often figures as an ornament or border design on clothing, porcelain, carpets, buildings, etc., and bears a strong resemblance to the bat of good augury or to the top of the pomegranate. The Joo-i may also be compared to the Hindoo *vadjra* or DIAMOND MACE (*q.v.*), the symbol of destruction and conquering power of the Buddhists. It may also be connected with the sceptre of male supremacy anciently used for ceremonial purposes. The word *kuei* (圭) signifies a sceptre of authority, and its composition, 土 *earth*, repeated, denotes that it was originally made of some rude material dug from the earth. According to the "Book of Odes" (詩經), a sceptre (璋) was usually given to a male infant as a toy, and has hence become an emblem of the male sex, while the girl's plaything, a concave tile (瓦), formerly used as a weight for the spindle, has similarly become the symbol of the female. It is possible that the Joo-i may have been an emblem of ancient phallic worship.

Ceremonial Joo-i have been made of a great variety of different substances, such as rhinoceros horn, bone, gold, silver, rock-crystal, etc., but the most recent varieties are of purple sandalwood ornamented at the two ends and in the middle with jade.

AUTHORITIES.

[1] Giles: *Chinese-English Dictionary*, 5,668.
[2] Giles: *History of Chinese Pictorial Art*, 2nd Ed., p. 185.

KIDNEYS

（腎）

One of the Five Viscera (五臟), viz.: heart, liver, stomach, lungs, and kidneys, which represent the emotional feelings. They are reverenced as one of the EIGHT TREASURES (*q.v.*), or Eight Precious Organs of Buddha, and are sometimes designated as *Yü* (魚), when they symbolise the sacred FISH (*q.v.*) of the Buddhists.

The kidneys, according to the Chinese, correspond to the element water; they have the office of producing ingenuity and power. Disease is supposed to arise in consequence of the fanciful accordance between the viscera, the pulse, metals, earth, colour, sound, etc., being destroyed; the remedies given are intended to restore the natural harmony between these organs and their corresponding elements, which being accomplished the health will be recovered (*vide* MEDICINE).

KINGFISHER

（翠雀）

The kingfisher is found in many parts of China. The commonest species is *Halcyon smynensis,* and in this connection it may be interesting to note *en passant* that, according to western mythology, it was fabled by the ancients to build its nest on the surface of the sea, and to have the power of calming the troubled waves during its period of incubation; hence the phrase 'halcyon days."

Among other species of kingfishers, which have their habitat in China, may be mentioned the black-capped kingfisher, *Halcyon pileatus* (秦椒嘴), and the pied kingfisher, *Ceryle varia* (啄魚童), a native of Foochow.

The gay-coloured plumage of this bird is much appreciated by the Chinese, who employ the feathers in appliqué work on silver or copper. "Inlaid" kingfisher ware is chiefly produced in Canton and Peiping. Head-dresses, combs, brooches, etc., are fashioned by alternating azure, ultramarine and sapphire blues with filagree flowers and dragons interspersed with artificial pearls and enamel on a metal foundation, the result being somewhat similar to the plumagery of the Aztecs, the chief objection being a certain lack of durability. The bright natural colourings of the feathers are also employed in beautiful landscape and floral designs for pictures and screens.

The plumage of the kingfisher is said to vie in colour with the sky and the blue-green neutral tints of the distant hills, and is a synonym for gaudy raiment, especially that worn by the fair sex, while the bird is regarded as a popular emblem of beauty.

KUAN YIN
(觀 音)

Sanskrit, *Padma-pâni,* or "Born of the Lotus." Her Chinese title signifies, "She who always observes or pays attention to sounds," *i.e.,* she who hears prayers. "The Chinese Goddess of Mercy, sometimes represented in white clothes with a child in her arms, and worshipped by those who desire offspring, corresponds to the *Avalôkitês vara* of Buddhism, and in some respects to the *Lucina* of the Romans. Also known as 大慈大悲 'great mercy, great pity'; 救苦救難 'salvation from misery, salvation from woe'; 自在 'self-existent'; 千手千眼 'thousand arms and thousand eyes,' etc. But down to the early part of the 12th century Kuan Yin was represented as a man."[1] She is also called the Goddess of the Southern Sea—or Indian Archipelago—(南海菩薩), and has been compared to the Virgin Mary.

The image of this divinity is generally placed on a special altar at the back of the great SHÂKYAMUNI BUDDHA (*q.v.*), behind a screen, and facing the north door, in the second hall of the Buddhist monastery. Kuan Yin is also worshipped by

the Taoists, and they imitate the Buddhists in their descriptions of this deity, speaking in the same manner of her various metamorphoses, her disposition to save the lost, her purity, wisdom, and marvel-working power.

"Those who seek relief from pains and misfortunes turn to the 'Goddess of Mercy.' Her name was Miao Shan, and she was the daughter of an Indian Prince. It is related that she was a pious follower of Buddha. In order to convert her blind father, she visited him transfigured as a stranger, and informed him that were he to swallow an eyeball of one of his children, his sight would be restored. His children would not consent to the necessary sacrifice, whereupon the future goddess created an eye which her parent swallowed and he regained his sight. She then persuaded her father to join the Buddhist priesthood by pointing out the folly and vanity of a world in which children would not even sacrifice an eye for the sake of a parent. There are temples all over China dedicated to this goddess, and she is worshipped in every family." [2] This divinity is worshipped by women in South China more than in the North, on the 19th day of the 2nd, 6th, and 9th moons. Worshippers ask for sons, wealth, and protection.

The island of Pootoo (普陀山), in the Chusan Archipelago, is sacred to the Buddhists, the worship of Kuan Yin being its most prominent feature on account of the fact that the Goddess is said to have resided there for nine years. The full name of the island is *P'u t'o lo ka* (普陀洛伽), from Mount Pataloka, whence the Goddess, in her transformation as Avalokita, looks down upon mankind. There are nearly a hundred monasteries and temples on the island, with over a thousand monks.

"The most usual and popular representation of this Goddess is a beautiful and gracious woman, who holds a child in her arms and wears a rosary around her neck. She is the Chinese equivalent of India's Avalokita, and when represented in that form, she is shown with several heads, and four, eighteen, or forty hands, with which she strives to alleviate the sufferings of the unhappy." According to one legend she is said to be the daughter of a sovereign of the Chou dynasty, who "strenuously opposed her wish to be a nun, and was so irritated by her refusal to marry that he put her to humiliating tasks in the convent, no doubt that she might see the life for herself. This means of coercion failed, and her father then ordered her to be executed for disobedience to his wishes. But the executioner, who was evidently a man of tender heart and some

KUAN YIN AS PROTECTOR OF CHILDREN

forethought, probably brought it about that the sword which was to descend upon her should break into a thousand pieces. Her father thereupon ordered her to be stifled. As the story goes, she forthwith went to Hell, but on her arrival the flames were quenched and flowers burst into bloom, Yama, the presiding officer, looked on in dismay at what seemed to be the summary abolition of his post, and in order to keep his position he sent her back to life again. Carried in the fragrant heart of a lotus flower she went to the island of Potala, near Ningpo. One day her father fell ill and according to a Chinese custom, not so rare as one might suppose, she cut the flesh from her arms that it might be made into medicine. A cure was effected, and in his gratitude her father ordered her statue to be made, 'with completely-formed arms and eyes.' Owing to a misunderstanding of the orders the sculptor carved the statue with many heads and many arms, and so it remains to this day." [3]

There are said to be thousands of different incarnations or manifestations of this divinity, who is generally dressed in beautiful, white, flowing robes, with a white hood gracefully draped over the top of the head, but the Lamaistic form is often entirely naked, with or without a child in the arms. Occasionally she is depicted as a woman with small feet, sometimes as a man, and frequently as riding a mythological animal known as the *Hou* (猧), which somewhat resembles a Buddhist lion, and symbolises the divine supremacy exercised by Kuan Yin over the forces of nature (*Vide* THREE GREAT BEINGS).

AUTHORITIES.

[1] Giles: *Glossary of Reference*: KUAN YIN.
[2] *Catalogue of the Collection of Chinese Exhibits at the Louisiana Purchase Exposition*, St. Louis, 1904, p. 269.
[3] Tredwell: *Chinese Art Motives Interpreted*, 1915, pp. 83-85.

LACQUER
(漆貨)

The character *ch'i* (漆), lacquer, consists of the radical water and the phonetic *ch'i* (漆), which depicts the varnish exuding as a fluid 水 from the branches and trunk of the tree (木).

The art of preparing and applying lacquer is of great antiquity. The medium used is lac, obtained mainly from the lac tree—*Rhus vernicifera* (漆樹)—cultivated in Central and South China. It is generally applied to wooden articles, such as tables, chairs, screens, boxes, trays, etc. The manufacture of the *best* lacquerware requires more than ten years, the number of layers of lacquer being sometimes over two hundred, each layer being dried before the next is added. Sometimes the lacquer is applied to a groundwork of cloth or silk. The lacquered surface is frequently ornamented with painted designs of a conventional and symbolic nature, and is sometimes carved or inlaid with gold, silver, bronze, ivory, mother-of-pearl, egg-shell, and other substances. The art reached its zenith under the Emperor Ch'ien Lung (1736-95), and has been adopted and perfected by the Japanese. The principal places of modern production in China are Peiping and Foochow, but exportation is now very slack on account of the demand for more substantial articles of furniture.

Antique vermilion lacquer vases, cabinets, etc., are now very rare and command high prices. The coffins of high officials were formerly covered with coatings of red lacquer, while black was prescribed for those of the lower grades, and,

to the people, lacquer of any kind was forbidden. The throne of the Emperor Ch'ien Lung, in Room No. 41 of the Victoria and Albert Museum, South Kensington, was one of the products of the Imperial lacquer factory. With the exception of the seat, which is of fine flat red lacquer with floral decoration, it is executed throughout in carved lacquer of superb quality and workmanship, mainly red, but with layers also of green in two shades, brown, and yellow. The decoration is symbolical throughout of Good Fortune, Longevity, Married Felicity, and other matters of good omen, the centre panel of the back having, for its chief feature, the elephant bearing a vase of jewels—a rebus signifying 'Peace reigns in the North.' The throne is 3 ft. 11 in. in height, 4 ft. 1⅓ in. in width, and 3 ft. in depth; and the seat is still furnished with its original cushion of fine old brocade.

LAMAISM
（喇嘛教）

The word Lamaism is derived from the Tibetan *lama,* 'the superior one,' Sanskrit, *Uttara.* The religion is a debased form of Buddhism found in Tibet, Mongolia, and the smaller Himalayan states.

The head of the sect is the Dalai Lama (金剛大師), the temporal ruler of Tibet, who is supposed to be a re-incarnation of Avalokita or KUAN YIN (*q.v.*).

In addition to the usual objects of worship of the Buddhists, there are in Lamaism a large number of tutelary deities, gods of the Bön or early religion of Tibet, and various saints and sages. A lively and constant fear of evil spirits, and a dread of the hereafter, have contributed to the formation of a system of superstitious worship, consisting chiefly in the recitation of the canon, turning of the prayer-wheel, and the universal use of amulets and charms. A continual repetition of the magic formula: "Om mani padme hum" (唵嘛呢叭嘛吽)—"O, the jewel in the Lotus! Amen!"—is regarded as of great efficacy against all pernicious influences.

The Lama Temple in Peiping (雍和宮), originally built by the Emperor Yung Cheng of the Ch'ing dynasty as a palace, was presented to the Lama priests in 1740 by Emperor Ch'ien Lung. It contains a colossal image of Maitreya Buddha in sandalwood, 75 feet high.

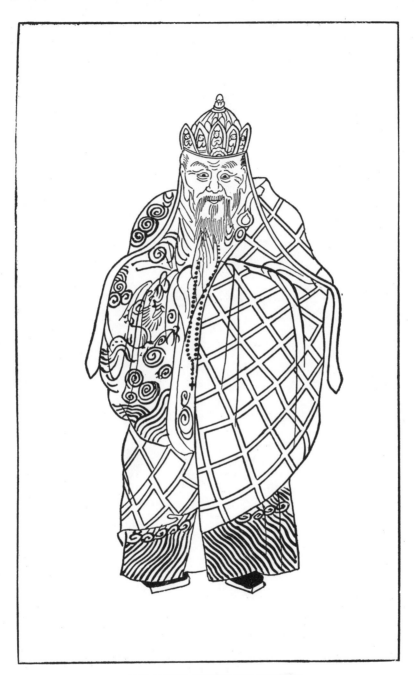

LAMA PRIEST ATTIRED FOR WORSHIP

247

INSIGNIA AND WEAPONS OF THE LAMA GODS

1, IRON GOAD; 2, HAMMER; 3, SWORD; 4, CHISEL-KNIFE; 5, THUNDERBOLT-DAGGER; 6, HAMMER; 7, CONCH-SHELL TRUMPET; 8, FLAMES; 9, THUNDER-BOLT; 10, ROSARY; 11, CROSS-THUNDERBOLT; 12, SKELETON STAFF; 13, SKULLCUP; 14, SNARE; 15, WISH-GRANTING GEM; 16, AXE; 17, SPEAR

INSIGNIA AND WEAPONS OF THE LAMA GODS

1, ALARM-STAFF; 2, PIKE; 3, HAND-DRUM; 4, WATER-POT; 5, BELL; 6,
TRIDENT; 7, MACE; 8, LOTUS-FLOWER; 9, THIGH-BONE TRUMPET; 10, DAGGER;
11, WHEEL OF THE LAW; 12, CHAIN; 13, CLUB

LAMA DEVIL-DANCERS' MASKS USED IN THE RELIGIOUS CEREMONIES
CELEBRATED ON THE 8TH OF THE FIRST MOON.
1, TIGER; 2, DRAGON; 3, HORSE-HEADED IMP OF HELL; 4, MARA THE EVIL
ONE; 5, OX-HEADED IMP OF HELL

"Fancy-dress balls and the masked carnivals of Europe find their counterpart in Tibet, where the Lamas are fond of masquerading in quaint attire; and the populace delight in these pageants, with their dramatic display and droll dances. The masked dances, however, are essentially religious in nature, as with the similar pageants still found in many primitive people, and probably once current even among the Greeks and Egyptians." [1]

AUTHORITY.
[1] Waddell: *Lamaism*, p. 515.

LAOCIUS
(老 子)

The reputed founder of Taoism was born in Honan in 604 B.C. The legend is that he was carried eighty years before birth, and was therefore born with white hair; hence the name Lao Tzu or "Old Boy"— Latinised Laocius.

THE PHILOSOPHER LAOCIUS

"It seems likely that alchemists and geomancers formulated their own devices and ascribed them to the teachings of the famous man whose name gave them added prestige. Lao Tzu seems to have taught that men should not strive, but should always pursue a course of inaction, because things will come to a successful conclusion without effort. 'Never interfere, and let things take their natural course,' was his rather aristocratic echo of Confucian doctrine. But the Taoists began to claim to make 'pills of immortality,' and painted beautiful word pictures of the 'Island of the Eastern Sea,' where the Elixir of Life might be found. One who had a full knowledge of Taoist mysteries, it was declared, might ascend bodily to heaven on the wings of a stork. The religion received an impetus from the superstitious Emperor, Shih Huang Ti, in the third

century, B.C., who actually despatched a commission to the 'Eastern Sea' in search of the mythical island and its herb of immortality. This religion was popular with many succeeding rulers, Emperor Chen Tsung of Sung having caused the building of a clossal monastery, where twenty thousand Taoist priest were gathered for the practice of weird rites. But with the coming to China of Kublai Khan the religion lost imperial favour, owing to the precedence of Lamaism, but it was later revived and remains to-day, although most of the ritual and ceremonial of the present has been borrowed from Buddhism." [1] "The priests of the sect (道 士) live in temples with their families, cultivating the ground; but many live a wandering life, supporting themselves as best they can by the sale of charms and medical nostrums. They shave the sides of the head, the rest of the hair being fastened on the top of the head in a coil by means of a pin; they may also be recognised by their slate-coloured robes." [2]

The Taoist Paradise is known as *Shou Shan* (壽 山), or the Hills of Longevity. These regions of bliss are depicted in Chinese art as mountains, with lakes and streams, rocky banks, bridges, pavilions, pine and peach trees, and all the traditional concomitants of rustic scenery. Wandering hither and thither may be seen the various Taoist deities, while occasional cranes, the coursers of the fairies, float gracefully through the air (*vide* FRONTISPIECE).

The writings of Taoism have contributed many wonderful stories and much poetical imagery to the literature of the country (*Vide* also EIGHT IMMORTALS, ELIXIR OF LIFE, GOD OF LONGEVITY, HSI WANG MU, ISLANDS OF THE BLEST, PLANT OF LONG LIFE, THREE PURE ONES, LOAD, etc.).

AUTHORITIES.

[1] Bell: *The Spell of China*, pp. 276-7.
[2] Gulland: *Chinese Porcelain*, Vol. I, p. 10.

LAPIS LAZULI
(瑠 璃)

"The blue mineral known by this name is met with in very fine specimens in China and Central Asia. It furnishes the pigment called ultramarine, and is probably one of the sources of Duhalde's azure *Lapis Armenus*, used in colouring porcelain. The Buddhists set great store upon this stone,

reckoning it as one of the seven precious things. Southern India yielded a similar mineral, called in the *Pên Ts'ao* (本 草) —or Chinese Materia Medica—*Huo Chi* (火 齊). The water in which this mineral of most variable composition is dipped, or the substance itself, is believed by the Chinese to cure fevers and inflamed eyes."[1]

AUTHORITY.

[1] Smith: *Contributions towards the Materia Medica and Natural History of China*: LAPIS LAZULI.

LEOPARD
(豹)

The panther or leopard is the emblem of bravery and martial ferocity, and was formerly embroidered on the robes of military officials of the third grade.

It is common on the hills of the northern provinces, the principal species being the Manchurian leopard, *Felis villosa*, the North China leopard, *F. fontanieri*, and the Snow Leopard, *F. uncia*.

LION
(獅)

The composition of the written symbol for the lion is intended to show that this animal is the *master* (師) of the *feline* race.

The lion is not indigenous to China, though specimens have been imported as gifts to the Emperor, etc. It does not occur in Chinese primitive art, although it was introduced later in connection with Buddhism, figuring as the defender of law and protector of sacred buildings. "Sculptured lions are frequently placed at the gates of the temples and porticos of houses, and sometimes they are seen guarding the precincts of tombs; but the trifid tail, and short thick body, prove how traditionary have been the

LION

253

models of the animal. It is also worthy of remark that in all Chinese statues of the lion, he is represented *sejant*—either with both of the fore feet on the ground, or one raised in a menacing attitude."[1] The stone lions in front of official buildings, etc., were originally set there for the purpose of demon-scaring. The conventional Chinese lion is sometimes called by curio-collectors, the "Lion of Corea" or the "Dog of Fo," the latter name being due to its being found in stone mounting guard at the threshold of Buddhist temples. The lion is sacred to Buddhism and is sometimes represented as offering flowers to Buddha, and some of the Buddhist deities are occasionally depicted mounted on this beast. It is an emblem of valour and energy, those indispensible complements of wisdom, and was formerly embroidered on the court robes of military officials of the second grade.

There is a parallel between the "lion" of the Chinese and the similar mythical figure in the Sacred Mysteries of the Mayas and Quiches, as illustrated in Le Plongeon's book on that subject. "The lion does not seem to be so highly thought of by the Chinese as the tiger, probably because it is not so well known to them; and the fact that it is generally represented as playing with a ball, or *chu*, seems to show that they considered it as belonging more to the mythical class." "The lion of the artist is by no means a formidable beast, despite its big eyes and fierce countenance. It is usually depicted with beautifully curled mane, disporting amidst peony flowers, or indulging in kitten-like gambols with a sacred gem, as harmless as its pictorial brother in European heraldry, and offering even less resemblance to the real 'monarch of the forests'."[3]

A common amusement of the Chinese is the "Game of the Lion" (耍獅子), when two men dance in the body of a coloured cloth or paper lion, and another postures in front with a large ball of gaudy hue. This ball may represent the sun, the egg symbol of the dual powers of nature, or merely a precious stone. There is an ancient legend relating that the lion produces milk from its paws, and therefore hollow balls were placed in the hills by the country people, with the result that the lions, who enjoyed sporting with the balls, would leave some of their milk in them, which the people would secure. The male lion is usually represented playing with the ball however, and the lioness is generally accompanied by its young. Two lions playing with an embroidered ball is a common design, which may have the same significance as two dragons fighting

for the pearl of supremacy. (*Vide* DRAGON and MANJUSRI).

AUTHORITIES.
1 *The Chinese Repository*, Vol. VII, March, 1839, Art. IV, p. 596.
2 Gulland: *Chinese Porcelain*, Vol. I, pp. 91-2.
3 Anderson: *Catalogue of Japanese and Chinese Paintings in the British Museum*, p. 324.

LIVER
（肝）

The liver is classed as one of the Five Viscera (五臟), *viz.*: heart, liver, stomach, lungs, and kidneys. According to the Chinese, it corresponds to the element wood, and has the office of generalissimo in the body; the soul (魂) resides in it; schemes and plans emanate from it; it is regarded as an important centre of the feelings, and is reverenced as one of the EIGHT TREASURES (*q.v.*), or Eight Precious Organs of Buddha, and is sometimes called *Hua* (花), when it symbolises the sacred LOTUS (*q.v.*) of the Buddhists.

According to a memorial to the throne, dated 2nd June, 1879, presented by Li Hung-chang (李鴻章), Governor-General of Chihli (now Hopeh), and published in the *Peking Gazette*, there were 2,900 instances of remarkable virtue and filial piety in the province of Chihli during the year, and in these cases he recommended honours to be bestowed. Amongst them were many who had carried out the principles of filial duty to the extent of cutting out part of their livers to make broth for their sick parents. The honours were accordingly granted by Imperial rescript (*vide* MEDICINE).

LOTUS
（蓮 花）

"At the head of cultivated flowers the Chinese place the *Nelumbium*, or sacred lotus, whether considered in regard to its utility or its beauty. It is often raised for mere ornament in capacious earthenware or porcelain tubs, containing gold-fish. Its tulip-like, but gigantic blossoms, tinted with pink or yellow, hang over its broad peltated leaves, which in shape only, but not in size, resemble those of the nasturtium, the stalk being inserted near the centre of the leaf. When cul-

tivated on a large scale for the sake of its seeds and root, which are articles of food, it covers lakes and marshes to a wide extent."[1]

Every part of this plant has a name and use among the Chinese. Large lakes and pools are planted with the creeping jointed stems (藕根), understood by the Chinese to be the roots; the fruits (蓮實), and leaves (荷葉) are used as food; the flower (荷花), with its red-tipped, pinkish white petals, is seldom gathered, as it is preferred in its natural position. The dried yellow stamens (蓮鬚) are used as an astringent remedy, and a cosmetic. The seeds (蓮子) are used as medicine and as an article of dessert. The kernels (蓮薏) are boiled in soup, roasted, or eaten raw. The stem, when cut across, shows a series of chambers in solid tissue, concentrically arranged and terminating at the joints, which occur about every foot. These stems are sliced and boiled as an article of diet. By grating and levigating them the native arrow-root (藕粉) is prepared. The leaves, when dried, are used by Chinese grocers to wrap up their goods, and, together with the leaf-stalks (荷鼻), and the stalks of the curious receptacle in which the carpels are embedded, resembing the broad nozzle of a watering-can, known as 蓮蓬 are used medicinally. Preparations of the *Nymphæa alba* (白蓮花), or white lotus, are said to beautify the faces of the aged.

The *Nelumbium speciosum*, or red lotus, occurs throughout China. It was formerly common in Egypt along the River Nile, and was anciently used in religious rites by the Egyptians, as shown by figures on monuments, and is still so used in various Asiatic countries. "From Egypt the lotus was carried to Assyria, and Layard found it among fir-cones and honeysuckles on the later sculptures of Nineveh. The Greeks dedicated it to the nymphs, whence the name Nymphæa."[2] The *Nelumbium speciosum*, the *Nymphæa alba*, or white Lotus, Skt., *Padma, the Nymphæa cærulea*, or blue lotus, Skt., *Utpala*, found also in Persia and India, are all sacred to the Buddhists, who declare that "the closing of the Padma flower, and the opening of the Utpala, determine the period of Day and Night in Heaven."[3]

"When Buddha attained Enlightenment under the BODHI TREE (*q.v.*), compassion for his fellow beings took possession of his mind. He saw them, as it is told, like lotus stems and buds in a lake, some immersed in the mud, others coming out of it, or just appearing above the water, and still others beginning to blossom. Seeing this he determined to bring

them all to full bloom and to the bearing of fruit. In other words he became convinced of the possibility of extending the communion of Truth-winners (*Tathagata*) to all sentient beings, which should in turn become the future Truth-winners. The lotus is a symbol of purity and perfection because it grows out of mud but is not defiled, just as Buddha is born into the world but lives above the world; and because its fruits are said to be ripe when the flower blooms, just as the truth preached by Buddha bears immediately the fruit of enlightenment." [4] "Its constant use as an emblem seems to result from the wheel-like form (*vide* WHEEL OF THE LAW) of the flower— the petals taking the place of spokes, and thus typifying the doctrine of perpetual cycles of existence." [5] Buddha is usually

LOTUS FLOWERS

represented as seated on the sacred lotus, and the Buddhist priests, in imitation of their Master, often assume what is called the "lotus posture," Skt., *Padmasana,* which is one of the cramped positions of the lower limbs thought particularly efficacious in producing bodily quietude, and hence, as is supposed, complete abstraction of soul (*vide* IDOLS). The Buddhist Heaven is said to consist of 33 stories, in the uppermost of which Buddha, enthroned upon a lotus, surveys the entire world. The lotus is classed as one of the EIGHT TREASURES (*q.v.*) or auspicious signs on the sole of Buddha's foot, and sometimes symbolically represents the sacred LIVER (*q.v.*) of that divinity.

This flower is also much esteemed by the Taoists, and is the emblem of Ho Hsien-ku (何 仙 姑), one of the EIGHT IMMORTALS (*q.v.*) of Taoism, who is represented as holding

a lotus-stem with the seed-pod, the cup of which is sometimes filled with flowers or peaches. On account of the number of seeds in the pod the lotus ranks as an emblem of offspring.

Tung-hun Hou (東 昏 侯), sixth sovereign of the Southern Ch'i dynasty, A.D. 498, had water-lilies made of gold-leaf strewn upon the ground for his concubine P'an Fei (潘 妃) to dance upon, and rapturously exclaimed, "Every step makes a lotus grow!" Hence the terms *golden lilies* (金 蓮) and *lotus hooks* (鈎 蓮) for women's bound feet—according to some authorities.

The lotus is also regarded as an emblem of summer and fruitfulness. Many beautiful lotus designs are employed in paintings, architecture, embroidery, carpets, etc. The flower is often so highly conventionalized that it frequently looks more like a peony, or some other flower. When used as a sacred symbol it is entwined with ribbons or fillets, which represent the halo, or sacred rays emanating from the mystic flower.

The Sanskrit invocation, "om mani padme hum," as used by the Lamas in their prayers, means "O God of the Jewel on the Lotus'," or more freely, "May my soul be like the gemmeaus dew-drop, which lies on the lip of the lotus leaf, before it falls into the peaceful obscurity of the lake (*i.e.*, before disappearing into Nirvana)"; but the fundamental origin of the expression is undoubledly from the Indian worship of Brahma, who is sometimes represented seated upon a lotus flower which proceeds from the navel of Vishnu, who floats on his back upon the ocean.

AUTHORITIES.
[1] Davis: *The Chinese*, p. 348.
[2] Higginson: *Outdoor Papers*, ch. II, p. 282.
[3] Beal: *Catena of Buddhist Scriptures*, p. 78.
[4] Anesaki: *Buddhist Art*, pp. 3, 4, 15, and 16.
[5] Williams: *Buddhism*, lect. XVII, p. 522.

LOZENGE

(方 勝)

A lozenge-shaped object, called *fang shêng*, apparently an open frame with a fillet draped behind it, occurs as one of the various sets of EIGHT TREASURES (*q.v.*). Sometimes it has a compartment in the upper side, and occasionally two lozenges have the ends interlocked in the form of an ancient musical instrument of jade. It is described as a head ornament, and is said to be a symbol of victory.

LUNGS

(肺)

One of the Five Viscera (五 臟), viz.: heart, liver, stomach, lungs, and kidneys, which represent the emotional feelings. The lungs are regarded as the seat of righteousness, and the repository of inward thoughts. They are reverenced as one of the EIGHT TREASURES (*q.v.*), or Eight Precious Organs of Buddha, and are sometimes called Kai (蓋), when they symbolize the sacred CANOPY (*q.v.*) of the Buddhists.

According to the Chinese, the lungs correspond to the element metal; they are said to have the office of transmission, and rule the various parts of the body (*vide* MEDICINE).

LUTE

(琴)

The *Ch'in* (琴) and the *Sê* (瑟), the large and small lutes or zithers of the Chinese, are said to have been invented by Fu Hsi (伏 羲), the first legendary Emperor, 2953 B.C. The former is an instrument of seven strings, and the latter is a variation with twenty-five strings not much used in modern times.

The harmony produced by the musical strains of the *Ch'in* and the *Sê* is emblematical of matrimonial happiness. "Besides the harmony of married life, the friendship of either sex is equally symbolized by the concord of sweet sounds proceeding from these instruments; and in another acceptation purity and moderation in official life are similarly typified." [1]

Among the stringed instruments the *Ch'in* is the most ancient and honourable. The name is said to be derived from *chin* (禁), "prohibit," because its sounds restrain and check all evil passions. The music of the *Sê* is said to represent the gentle soughing of the wind in the pine-trees, and the name of the instrument is probably onomatopoetic or corresponding to the sound. "The *ch'in*, a kind of lyre, which, when appropriated to sacred music, is accompanied with burning incense, and supported by the most ancient and venerable collection of odes, placed under one end of it, is said in the 'music classic' to represent by its length three hundred and sixty days; by its breath, the six points of the universe; by its thickness, the four seasons; by its five strings, the original elements; to

which two other strings were subsequently added, expressive of the harmony subsisting between princes and ministers; the thirteen resemblances or changes are equivalent to the 'twelve notes of music; one for each month, and then one over to the intercalary month. It was anciently made of *tung* wood, but afterwards of stones, by which its sounds, *under the influence of the wind*, resembled those of the drum.'"[2]

The lute is one of the four signs of a scholar, the other three being chess (棋), literature (書), and painting (畫), this elegant combination being often employed for decorative purposes on porcelain, etc. (*vide* MUSICAL INSTRUMENTS).

AUTHORITIES.

[1] Mayers: *Chinese Reader's Manual*, Pt. I, p. 312.
[2] Kidd: *China*, pp. 276-7.

MACE

（權杖）

The mace is one of the weapons or insignia of some of Buddhist and Taoist deities. It is an emblem of power and authority (*vide* DIAMOND MACE and Illustration under LAMAISM).

MAGNOLIA

（木蘭花）

There are said to be eight species of magnolia to be found in China, all of which are splendid flowering plants.

The *Magnolia fuscata* is known to the Chinese as *Han hsiao hua* (含笑花), or the Secretly-Smiling Flower, which suggests the loving smile of a modest girl.

The *Magnolia yulan* is called *Ying Ch'un Hua* (迎春花), or the Flower that Welcomes the Spring, on account of the fact that the large white blossoms appear before the leaves.

Other varieties are *M. hypoleuca* (厚朴), *M. rubra* (赤朴), *M. pumila* (夜合花), *M. obovata* (木蘭), and *M. purpurea* (辛夷花).

The buds, roots, and bark are employed for medicinal purposes.

The plant is an emblem of feminine sweetness and beauty.

MAGPIE

(喜 鵲)

The magpie, *Pica caudata,* is a very common bird in China. It is slightly smaller than the CROW (*q.v.*), with under parts of snowy white; as it is noisy and mischievous, it is quite a nuisance to the peasant.

The magpie is regarded as a bird of good omen. If one, while meditating on a plan about to be adopted, or while engaged in a pursuit which enlists his interest and attention suddenly hears the voice of this bird, he is prone to consider it as felicitous, its voice being springly and joyous, imparting encouragement to the hearer. There is a proverb which says of this bird, that 'its voice is good, but its heart is bad.' meaning that it is given to flattery.[1] The Chinese term for the magpie means literally "bird of joy." It is popularly believed that if a magpie builds its nest near a house the people living nearby will all have good luck. The chattering of magpies before a house is said to be an indication of the arrival of a guest in the near future. These birds figure in the legend of the Cowherd and the Spinning Maid (*vide* STARS).

The magpie was always held sacred by the Manchus on account of the connection of this bird with their early history. "According to the Chinese records the Manchu empire took its rise near the Long White Mountain, to the north of Corea, where, in a genial climate, which has ever proved productive of great spirits, between the sources of three great rivers, and in the neighbourhood of a lake, near Mount Balkhori, there formerly lived three celestial maidens. One day, while bathing in the Lake Balkhori, a sacred magpie dropped on the robe of one of the three a red fruit, eating of which she became pregnant, and bore a son, who could speak from his birth, and whose form displayed something marvellous. Demanding of the eldest of her sisters what name she should bestow upon the child, she answered: 'Heaven has sent him, in order to restore peace among the Kingdoms; therefore you must call him Aisinghioro, and give him the surname of Balkhori Yong-shon.' After his mother had been removed to the icy cave, where she died, her son entered a small boat, in which he followed the course of the river. There were at that time three chiefs engaged in mortal feuds; one of them, descending to the river for water, on perceiving the boy, greatly admired him; and his relations also going to see him, and hearing that he was born

in order to put a stop to dissension, they exclaimed: 'This man is a saint, begotten of Heaven!' They therefore chose him for their prince, upon which he adopted for his kingdom the honorary title of Manchu (*vide* MANJUSRI). At last, after several generations had passed away, the subjects revolted, and extirpated his whole family, excepting Fan Cha-chin, a lad who fled to the desert. When closely pursued by his enemies, a magpie alighted upon him, so that his pursuers, mistaking him for the withered trunk of a tree, passed by at a distance."[2]

AUTHORITIES.

[1] Doolittle: *Social Life of the Chinese*, p. 571.

[2] Gutzlaff: *History of China*, Vol. II, p. 2.

MAITREYA BUDDHA

(彌 勒 佛)

The Coming Buddha . The Sanskrit term *Maitreya*, "the Merciful One," is rendered into Chinese *Mi-li*; the name is said by some to be derived from the Syriac *Molekh*, a King (hence also *Melchi-Zedek*, King of Righteousness, Heb. 7: 1-3).

"He is always represented as very stout, with the breast and upper abdomen exposed to view. His face has a laughing expression, and he is also known as the Laughing Buddha."[1] He stands in the first hall of the Buddhist monastery.

"Maitreya (Spence Hardy, Maitri), often styled Ajita, 'the Invincible,' was a Bodhisattva, the principal one, indeed, of Sakyamuni's retinue, but is not counted among the ordinary (historical) disciples, nor is anything told of his antecedents. It was in the Tushita heaven that Sakyamuni met him and appointed him as his successor, to appear as Buddha after the lapse of 5,000 years. Maitreya is therefore the expected Messiah of the Buddhists, residing at present in Tushita, and according to the account of him in Eitel (*Handbook for the Student of Chinese Buddhism*, p. 70), 'already controlling the propagation of the Buddhist faith.' The name means 'gentleness' or 'kindness'; and this will be the character of his dispensation."[2] (*Vide* also AMIDA BUDDHA, and SHAKYAMUNI BUDDHA.)

AUTHORITIES.

[1] Edkins: *Chinese Buddhism*, p. 240.

[2] Legge: *Travels of Fa-hien*, p. 25, note 3.

MANJUSRI

(文 殊)

"The Indian Manjusri, a famous Bodhisatva, worshipped in China as the God of Wisdom, and popularly depicted as riding on a lion, the symbol of bravery."[1] He generally holds a sword in his right hand, while in his left he has a lotus, on the flower of which a book is laid. His image is often seen in the second hall of the Buddhist monastery by the side of the figure of SHAKYAMUNI BUDDHA (*q.v.*).

Manjusri, Jap. *Monju*, is called by the Indians "the Singing Buddha." M. W. E. Griffins connects the names "Manchu, Manchuria," (*vide* MAGPIE), with this God (*Corea*, p. 154). "His most common titles are *Mahâmati*, 'Great Wisdom,' and *Kumâra-raja*, 'King of teaching, with a thousand arms and a hundred alms-bowls.'"[2]

He is the presiding genius of the sacred Buddhist mountain Wu T'ai Shan (五 臺 山) in Shansi, the seat of Mongol Lamaism, where a great white pagoda is said to contain a single hair of the saint, who is supposed to have appeared there in the form of an old man.

The antecedents of the deity are a hopeless jumble of history and fable, but it is probable that his cult was originally brought from Central Asia.

"Once in a mountain cave in the 'Snowy Land' (Tibet) there lived a saint who practised austerities for fifty years in order to obtain magical powers (Sanskrit, Siddi). On the last night before he would have reached his goal, two robbers entered the cave, killed a bull which they had stolen and ate it. Afterwards they dicovered the hermit in the background of the cave absorbed in meditation, and, being afraid that he would betray them, they slew him by severing his head from his body. But as soon as the blood of the murdered man touched the ground, he came to life again and changed his body into that of a wrathful demon. He put the head of the bull on his shoulders, devoured his murderers, and became a fierce man-eating demon called Yama, the God of Hell, running amok amongst the inhabitants of the Land of Snow in blind fury and lust of blood. The Tibetans applied to their patron the Bodhisatva Manjusri for help. He, granting their request, changed his own mild appearance into the terrible one named Yamantaka, which means: the End or the Conqueror of Yama. He has 9 heads, 34 arms, and 16 feet. In this terrifying shape

MANJUSRI
265

he appeared to Yama, who retreated into the strong tower he had built for himself, which had 34 windows and 16 doors. Yamantaka closed the windows with his hands, the doors with his feet, and preached the Buddhist Law to Yama, who repenting of his cruelties, became converted, and after having taken a solemn oath to protect all believers in Buddhism he was given the rank of a Dharmaraja, 'King of the Law,' and the appointment of 'Judge of the Dead in Hell.' Such a powerful deity as Yamantaka, who was able to conquer even death must of course play an important role in worship also. So it is natural that he is invoked especially when death threatens. In those services performed to propitiate the so-called terrible deities, the 'sadhana,' or conjuring up of Yamantaka, is all-important" [3] (*vide* YAMA).

His Sanskrit name of Manjusri, Mandjusri, or Mandjunatha, means "wonderful virtue or lucky omen." He is full of benevolence and is the personification of knowledge and thought, being also associated with happiness and good fortune. He has become an object of worship in all the temples of Northern Buddhism, but more especially in Shansi. A later branch of the Mahayana School of Buddhism (一 性 宗), *lit*: "School of One Nature," claimed him as their founder. He is said to have been an Indian King (*circa* A.D. 968) who came to China, but was driven away by the intrigues of various monks. He is generally clad in a blue robe with a red collar, has long flowing whiskers, and a top-knot, holds a sword and a sacred book of the Buddhist scriptures, the latter being balanced on a blue lotus, and he rides upon a golden-haired lion, which typifies his power over the forces of life and death. Some representations of this deity have a very feminine appearance, which is explained by the fact that the gods have the power to do anything—even to the extent of changing their actual sex (*vide* THREE GREAT BEINGS).

AUTHORITIES.

[1] Giles: *Glossary of Reference*: WÊN SHU.
[2] Legge: *Travels of Fa-hien*, p. 46, note 4.
[3] Lessing: "Lamaist Pictures," in *China Arts and Handicraft*, Vol. I, No. 2, December, 1931.

MARRIAGE

(婚 姻)

"There is abundant evidence to show that, as amongst all other peoples, the first form of marriage was by capture. The

modern character *ch'ü* (娶), meaning to marry, is said to bear in its construction a reference to this old practice, made up as it is of an ear (耳), a hand (又), and a woman (女), thus commemorating the custom of bringing in captives by the ear." [1]

At the present day marriage is probably more universal in China than in any other country, owing chiefly to the strong desire to raise up male offspring to perform the burial rites and offer up the fixed periodical sacrifices at the ancestral tombs. There is no element of love in the average Chinese marriage, which is arranged by a match-maker (媒人), yet all things considered, the degree of happiness that often reigns in the family is surprising. The archaic system is to marry first and make love afterwards. The Chinese view of marriage is given in the "Book of Rites" (禮記) as follows: "Marriage is to make a union between two persons of different families, the object of which is to serve, on the one hand, the ancestors in the temple, and to perpetuate, on the other hand, the coming generation." [2] (*Vide* ANCESTRAL WORSHIP.)

The principal formalities necessary in the celebration of a marriage are the preliminary arrangements made by go-betweens, the exchange between the betrothed of the horoscopic characters (八字) pertaining to their birth, for purposes of comparison, the giving of presents, and the signing of the contract in public. Marriage is forbidden before the ages of 18 and 16 for the man and woman respectively. The parents' consent must be obtained and the marriage duly registered at the local magistrate's office. "The wedding day is celebrated by musicians who play while the bride bathes and dons her marriage clothes, the outer garments of red being embroidered with dragons. A veil completely conceals her features. A friend of the groom, bearing a formal letter, then arrives to escort the bride to her new home. This letter is sometimes regarded in the light of a marriage certificate, and is carefully preserved by the bride. She then steps, with weeping, into the red marriage chair, her mother, sisters and other relatives also weeping, while firecrackers are let off, and music is played. The chair, a heavy structure covered with red embroideries and rich carving, is borne by four men. Two men carry lanterns in the bridal procession bearing the groom's family name in red characters, followed by two other men similarly displaying the bride's family name. A red umbrella is borne in the procession, which is accompanied by musicians. The bride's brothers walk near her chair. Firecrackers are let off

WEDDING PROCESSION AT PEIPING. BY CHOU P'EI-CH'UN (周 培 春)

268

on arrival at the groom's house. The chair is carried into a reception room, and the bride is invited to descend by a little boy who holds a brass mirror towards her. A matron and bridesmaids, uttering felicitous sentences, help her out of the chair. A sieve is sometimes held over her head or placed so that she steps into it from the chair. She is then led to her room where she sits by the groom's side on the edge of the bed. Later they go separately to the reception-room, where, in front of a table spread with two sugar cocks, dried fruit and symbolical articles, they do obeisance before the gods, then to the bridegroom's ancestral tablets, then to each other. After this they drink a mixture of wine and honey out of goblets tied together by red thread, exchanging cups and drinking again. They are given pieces of the sugar cocks and a few dried fruits to eat. The bridegroom then pretends to lift the bride's veil after which she is led to her room and divested of her heavy outer garments. The couple then have dinner with their guests, the bride eating nothing. She is gazed at by friends and by the public, who criticize her appearance and make all sorts of jokes. On the third day, the couple visit the bride's family, when they worship her ancestral tablets. On the tenth day the bride often goes alone to visit her parents." [3]

Since the establishment of the Republic, however, the laws and ceremonies relating to marriage have undergone a certain amount of alteration, though the essential points remain the same. Marriages are sometimes held in a building specially hired for the purpose, and foreign clothes are often worn for the wedding. A form of marriage contract can be purchased at stationer's shops, and the signing of this document in public by the bride and bridegroom is occasionally introduced as part of the ceremony.

It is fabled that a certain bride, on leaving the house of her parents to go to that of her husband, was met and devoured by a tiger. The parents of the bridegroom, to prevent so serious a catastrophe in the present day, suspend a piece of meat at the door, as a bribe to this cruel monster. Suspending a looking-glass within the marriage-bed is thought to expel all evil spirits that may enter, for evil spirits, or demons, cannot endure to see their own forms. Arranging pans of flowers around the bed is regarded as an offering to the gods to promote the birth of children. These customs are, however, gradually passing into desuetude. At a wedding numerous red satin and paper scrolls are hung in the reception hall containing the double character *hsi* (囍), joy, in gilt lettering, and various

antithetical couplets conveying delicate compliments, veiled in classical allusions, to the wedded pair. Pictures of the various Gods of Marriage are often displayed, *i.e.* Chieh Lin (結 璘), who arranges all matrimonial affairs (*vide* COLOURS), and Shuang Hsien (雙 仙), the twin genii of mutual concord. Ho Ho (和 合), the gods of harmonious union, are especially popular, being representations of two eminent poet monks of the T'ang dynasty named Han Shan (寒 山) and Shih Tê (拾 得) (*vide* BROOM and SCROLL), who were inseparable friends, two in body but one in spirit; the term *Ho Ho* is derived from a passage in one of the Buddhist sutras, which reads *Yin yüan ho ho* (因 緣 和 合), "the general interaction of nature produces the harmony of the universe." As a pictorial enigma they sometimes carry the one a lotus, or *ho* (荷), and the other a casket, or *ho* (盒).

Polyandry, or the taking of a single wife by a number of brothers in common, is a recognised form of marriage among the Thibetans. The Chinese are polygamous, a secondary wife being taken without scandal if the first wife has no son. The women students started a movement for monogamy in 1919, but it has not yet been successful. The remarriage of a widow is regarded as most reprehensible, as it is considered that a woman should remain true to the memory of her former husband.

"The Chinese are fond of processions, and if marriages and funerals be included, have them more frequently than any other people. Livery establishments are opened in every city and town where processions are arranged and supplied with everything necessary for bridal and funeral occasions as well as religious festivals. Not only are sedans, bands of music, biers, framed and gilded stands for carrying idols, shrines, and sacrificial feasts, red boxes for holding the bride's trousseau, etc., supplied, but also banners, tables, stands, curiosities, and uniforms in great variety. The men and boys required to carry them and perform the various parts of the ceremony are hired a uniform hiding their ragged garments." [4]

AUTHORITIES.

[1] Douglas: *China*, pp. 68-9.

[2] Legge: *Li Ki*, pt. IV, pp. 264-5.

[3] Couling: *Encyclopaedia Sinica*: MARRIAGE.

[4] Williams: *Middle Kingdom*, Vol. I, p. 819.

MEDICINE

（醫 術）

The art of healing is said to have been originated by the legendary Emperor Shên Nung (神農氏), 2838 B.C., who wrested from Nature a knowledge of her opposing principles, and of the virtues of herbs and other medicinal remedies.

"Man's body is believed to be composed of the five elements: fire, water, metal, wood, and earth—all of which are mysteriously connected with the five planets, five tastes, five colours, five metals, and five viscera. To keep these five antagonistic principles in harmony is the duty of the physician, and to restore the equilibrium when any of them is in excess or deficiency, is the main object of his endeavours."[1]

"According to Chinese physiologists, the brain (A. B. in the appended chart) is the abode of the *yin* principle in its perfection, and at its base (C), where there is a reservoir of the marrow, communicates through the spine with the whole body. The larynx (D) goes through the lungs directly to the heart, expanding a little in its course, while the pharynx (E) passes over them to the stomach. The lungs (F,F,F,F,F,F) are white, and placed in the thorax; they consist of six lobes or leaves suspended from the spine, four on one side, two on the other; sound proceeds from holes in them, and they rule the various parts of the body. The centre of the thorax (or pit of the stomach) is the seat of the breath; joy and delight emanate from it, and it cannot be injured without danger. The heart (G) lies underneath the lungs, and is the prince of the body; thoughts proceed from it. The pericardium (H) comes from and envelops the heart and extends to the kidneys. There are three tubes communicating from the heart to the spleen, liver, kidneys, but no clear ideas are held as to their office. Like the pharynx, they pass through the diaphragm, which is itself connected with the spine, ribs and bowels. The liver (i,i,i,i,i,i) is on the right side and has seven lobes; the soul resides in it, and schemes emanate from it; the gall-bladder (j) is below and projects upward into it, and when the person is angry it ascends; courage dwells in it; hence the Chinese sometimes procure the gall-bladder of animals, as tigers and bears, and even of men, especially notorious bandits executed for their crimes, and eat the bile contained in them, under the idea that it will impart courage. The spleen (f) lies between the stomach and the diaphragm and assists in

271

KEY TO ANCIENT ANATOMICAL CHART.

A. 腦　*Nao*, brain.
B. 髓海至陰　*Sui hai chih yin*, reservoir of the marrow and abode of the *yin* principle.
C. 通骶　*T'ung tê*. This has communication with the sacral extremity of the vertebral column.
D. 喉通氣　*Hou t'ung ch'i*, the larynx, or passage for the breath.
E. 咽通食　*Yen t'ung shih*, the pharynx, or passage for the food.
F. 肺　*Fei*, the lungs.
G. 心　*Hsin*, the heart.
H. 心包　*Hsin pao*, pericardium.
a. 脾系　*P'i hsi*, bond of connection of the spleen.
b. 胃系　*Wei hsi*, oesophagus.
c. 肝系　*Kan hsi*, the bond of connection of the liver.
d. 腎系　*Shên hsi*, the bond of connection of the kidneys.
e. 膈膜　*Ko mou*, diaphragm.
f. 脾　*P'i*, spleen.
g. 胭膜　*Chih man*, omentum.
h. 賁門　*Fên mên*, cardiac extremity.
i. 肝　*Kan*, liver.
j. 膽　*Tan*, gall-bladder.
k. 幽門　*Yao mên*, the pylorus.
l. 胃　*Wei*, stomach.
m. 小腸　*Hsiao ch'ang*, small intestines.
n. 闌門　*Lan mên*, Caput coli.
o. 大腸　*Ta ch'ang*, large intestines.
p. 腎　*Shên*, kidneys.
q. 膀胱　*Pang kuang*, bladder.
r. 命門　*Ming mên*, gate of life.
s. 直腸　*Chih ch'ang*, rectum.
t. 溺道　*Niao tao*, urethra.
u. 精道　*Ch'ing tao*, passage of the spirit.
v. 穀道　*Ku tao*, grain passage, anus.
w. 尻　*Kao*, sacral extremity.
x. 膻中　*Shên chung*, sternal region, or centre of thorax.
y. 臍　*Chi*, navel.
z. 丹田　*Tan t'ien*, vermilion field, or public region.

ANCIENT ANATOMICAL CHART

272

digestion, and the food passes from it into the stomach (1), and hence through the pylorus (k) into the large intestines. The omentum (g) overlies the stomach, but its office is unknown, and the mesentery and pancreas are entirely omitted. The small intestines (m) are connected with the heart, and the urine passes through them into the bladder, separating from the food or faeces at the caput coli (n), where they divide from the larger intestines. The large intestines (o) are connected with the lungs and lie in the loins, having sixteen convolutions. The kidneys (p) are attached to the spinal marrow, and resemble an egg in shape, and the subtle generative fluid is eliminated by them above to the brain and below to the spermatic cord and sacral extremity; the testes, called *wai shen*, or 'outside kidneys,' communicate with them. The right kidney, or the passage from it (r), is called the 'gate of life,' and sends forth the subtle fluid to the spermatic vessels. The bladder (q) lies below the kidneys, and receives the urine from the small intestines at the iliac valve. The osteology of the frame is briefly despatched: the pelvis, skull, forearm, and leg are considered as single bones, the processes of the joints being quite dispensed with, and the whole considered merely as a kind of internal framework, on and in which the necessary fleshy parts are upheld, but with which they have not much more connection by muscles and ligaments that the post has with the pile of mud it upholds." [2] The Chinese assign three separate pulses to each wrist, which indicate the condition of various parts of the body according to whether they are lightly or heavily pressed. The Five Viscera (五臟), viz., heart, liver, stomach, lungs, and kidneys, represent the emotional feelings.

Examination of the chief Chinese medical work, the *Pên Ts'ao* (本草), or Herbal, shows that the various drugs prescribed for different ailments are selected mainly for their symbolic application rather than for their medicinal properties. Thus stalactites, stag-horns, bats, etc., are prepared as tonics for the renewal of youthful vigour; fossil bones, oyster-shells, etc., as astringents; and verdigris, bear's gall, and turtle-shell as purgatives. "Many insects are eaten in various forms as drugs. Dried centipedes, scorpions, silkworms, and beetles, the exuviæ of cicadæ, bat's dung, insect white wax, cantharides, tigers' bones, bear's galls, hedgehogs' skins, are also partaken of, and among minerals, realgar, zinc bloom, fossil teeth, brown mica, cinnabar ore, clay, and a variety of others are used." [3] The principal remedies are, however, taken from

the vegetable kingdom, and here the emblematic significance of the plant is also of primary consideration.

Of late years many Chinese students have taken foreign medical degrees, and practise their profession side by side with the quack doctors of the old school, who continue to employ the time-honoured remedial measures, which include acupuncture and cautery. (*Vide* also BAT, DEER, ELIXIR OF LIFE, FIVE ELEMENTS, HEART, KIDNEYS, LIVER, LUNGS, PEACH, PLANT OF LONG LIFE, STOMACH).

AUTHORITIES.

[1] Douglas: *China*, pp. 154-5.
[2] Williams: *Middle Kingdom*, Vol. II, pp. 119-121.
[3] Couling: *Encyclopaedia Sinica*: PHARMACOPAEIA.

MENCIUS

（孟子）

One of the premier Chinese philosophers, whose writings form the fourth of the Four Books of the Chinese classics. He was an ardent supporter of Confucianism, but he studied human nature from the point of view of political economy.

He was born in the State of Tsou (鄒), in modern Shantung, in B.C. 372. The formation of his character was chiefly due to his mother, to whose sole care he devolved upon the untimely death of his father. He held office as Minister under Prince Hsüan of Ch'i State at the age of 45, but subsequently retired into private life and devoted the remainder of his days to literary pursuits.

His tablet is placed in the Confucian temples.

MIRRORS

（鏡）

The earliest mirrors in China were circular in shape, and made of polished bronze mixed with an alloy containing a large percentage of tin, though they are now chiefly superseded by glass. The back was beautifully chased with conventional designs or inscriptions, in the centre of which was a boss or projection, perforated for a silk cord. It is probable that some of the motives of decoration were introduced from the Græco-Bactrian Kingdom in the second

THE PHILOSOPHER MENCIUS

275

century B.C. "Some of them have the curious property of reflecting from their faces in the sunlight on a wall, more or less distinctly, the raised decorations on their backs. It results from wavy irregularities of the reflecting surface produced by polishing, in consequence of uneven pressure from the back." [1]

Ancient mirrors are supposed to have magic power to

MIRROR OF THE T'ANG PERIOD, A.D. 618-905

protect their owners from evil, and are called *Hu Hsin Ching* (護心鏡). They are believed to make hidden spirits visible and to reveal the secrets of futurity. The mirror is a symbol of unbroken conjugal happiness, the death of a wife, or the absence of a husband, being often referred to as a "broken mirror." In the event of a marriage, a mirror is sometimes flashed upon the bride owing to the belief that the rays of

light are lucky influences. "Old brass mirrors, to cure mad people, are hung up by the rich in their halls." [2] "A small brass mirror, either flat or concave, but always round, is very frequently hung up on the outside of the bed-curtain, or suspended somewhere near by. Its principal use is to counteract, prevent, or dissipate devilish or unpropitious influences. It is supposed that evil spirits, on approaching to do harm, will be apt to see themselves reflected in the mirror, and, becoming frightened, will betake themselves away without delay." [3]

Ch'in Shih Huang (秦始皇), the first Emperor of the Ch'in dynasty, A.D. 255, was credited with the possession of a magic mirror, which had the power of reflecting the inward parts of those who looked upon it. Li Shih-min (李世民) A.D. 597-649, the second Emperor of the T'ang dynasty, is recorded to have remarked, "By using a mirror of brass you may see to adjust your cap; by using antiquity as a mirror, you may learn to foresee the rise and fall of Empires" (以銅 爲鑒。可整衣冠。以古爲鑒。可知興替).

In the illustration the centre is a plain circle or button representing the Great Ultimate Principle (*vide* T'AI CHI). Next are the animals of the Four Quadrants, DRAGON, PHOENIX, TIGER, and TORTOISE (*q.q.v.*). Outside these the EIGHT DIAGRAMS (*q.v.*), and next to them the Twelve Animals of the TWELVE TERRESTRIAL BRANCHES (*q.v.*), *i.e.* Dragon, Hare, Tiger, Fox, Rat, Pig, Dog, Cock, Monkey, Goat, Horse, and Snake. The outermost zodiac is composed of twenty-eight animals, each corresponding to one of the ancient constellations (*vide* STARS).

AUTHORITIES.
 [1] Bushell: *Chinese Art*, Vol. I, p. 98.
 [2] Williams: *Middle Kingdom*, Vol. II, p. 272.
 [3] Doolittle: *Social Life of the Chinese*, p. 566.

MONKEY
(猴)

The species of monkeys most common in China are the yellow monkey (黃猴), or *Macacus thibetanus*, of the Thibetan borderlands, and the golden brown monkey (金青 猴), or *Rhinopethicus roxellanæ*, of Szechuan and Kansu. "The skin of the last mentioned is much valued by the Chinese,

and it is said that at one time only members of the Imperial family were entitled to wear it." [1]

The monkey is one of the symbolical animals corresponding to or having affinity with the ninth of the TWELVE TERRESTRIAL BRANCHES (q.v.), and though worshipped to some extent by the Buddhists, is commonly regarded as the emblem of ugliness and trickery. "The monkey was first worshipped in return for some supposed services rendered the individual who went to India, by special command of an Emperor of the T'ang dynasty, to obtain the Sacred Books of the Buddhist religion—so some affirm. This Emperor deified the monkey, or at least he conferred the august title of 'the Great Sage equal to Heaven' upon that quadruped. The birthday of 'His Excellency, the Holy King,' is believed to occur on the twenty-third of the second Chinese month, when his majesty is specially worshipped by men from all classes of society. The monkey is believed to have the general control of hobgoblins, witches, elves, etc. It is also supposed to be able to bestow health, protection, and success on mankind, if not directly, indirectly, by keeping away malicious spirits or goblins. People often imagine that sickness, or want of success in study and trade, is caused by witches and hobgoblins. Hence the sick, or the unsuccessful, worship the monkey in order to obtain its kind offices in driving away or preventing the evil influences of various imaginary spirits or powers." [2]

AUTHORITIES.
[1] Couling: *Encyclopaedia Sinica*: MONKEYS.
[2] Doolittle: *Social Life of the Chinese*, p. 228.

MOON
（月）

The moon is represented as the concrete essence of the female or negative principle in nature (陰), as the male or positive principle (陽) is embodied by the sun (*vide* YIN AND YANG).

It is popularly believed that this luminary is inhabited by a hare (玉兔), said to be occupied in pounding the drugs of immortality at the foot of a cassia tree (桂) (*vide* HARE). while a toad-like batrachian with three legs known as the Chan-chu (蟾諸), the embodiment of Ch'ang O (嫦娥), who stole the Elixir of Immortality (無死之藥) from her husband Hou I (后羿), is another occupant of the moon, to which

Ch'ang O fled for safety, and where she was transformed into animal shape. Chieh Lin (結 璘), or Yüeh Lao (月老), the God of Marriage, who is supposed to connect, by an invisible red thread, such persons as are destined to marry, is also associated with the moon. Another "man in the moon" is known as Wu Kang (吳 剛). "He was skilled in all the arts of the genii, and was accustomed to play before them whenever opportunity offered or occasion required. Once it turned out that his performances were displeasing to the spirits, and for this offence he was banished to the moon, and condemned to perpetual toil in hewing down the cinnamon trees which grow there in great abundance. At every blow of the axe he made an incision, but only to see it close up when the axe was withdrawn."[1] In the writings of Huai-nan Tzŭ (淮 南 子), an expert in alchemistic research, the presiding genius of the moon is said to be named Wang Shu (望 舒) or Hsien O (纖 阿). "There is another legend which says that the moon used to be inhabited by two sisters, and that their brother lived in the sun. The sisters became very much embarrassed because people gazed at them so much, and asked their brother to exchange habitations with them. He laughed at them, and told them there were many more people about in the day time than at night, but they told him, if he would change with them, they had a plan whereby they could keep people from looking at them. So they changed, and the two sisters went to live in the sun, and no one can look at them now, because if people try to look at them, the sisters immediately prick at their eyes with their seventy-two embroidery needles which are the sun's rays."[2]

It is believed that the *T'ien kon hsing* (天狗星), or "Heavenly Dog Star," is an unlucky star which devours the moon at the time of eclipse. The temple gongs and bells are sounded and crackers exploded to prevent the evil spirit of this star from effecting his nefarious purpose. It is also called *T'ou shêng kuei* (偸生鬼), or "Child-stealing Devil," and is said to be the soul of a young girl who has died unmarried and continually seeks to adopt by force the infant of another; shooting at it with a peach-wood arrow is said to be very effective. Hou I (后 羿) (*vide supra*)—who was a famous archer in the service of the legendary Emperor K'u (嚳), 2436 B.C., "is said to have shot arrows into the sky to deliver the moon from an eclipse, and in like manner to have dispersed the false suns which suddenly appeared in the heavens and caused much mischief to the crops."[3]

TABLE OF THE CHINESE MONTHS, WITH THEIR VARIOUS NAMES AND AFFINITIES
月令全備

NUMERICAL ORDER 月數	TERRESTRIAL BRANCHES 地支	CELESTIAL STEMS 天干	CALENDARIC SIGNS 曆名	DIAGRAMIC NAMES 卦名	ARCHAIC NAMES 古名	FLORAL NAMES 花名	LEGAL NAMES 律名	LITERARY NAMES 別名
正	寅	甲	畢	泰	陬	茶	太簇	端陽;元旦;青陽;三陽;孟陽;春王
二	卯	乙	橘	大壯	如	杏	夾鐘	中和;花朝
三	辰	丙	修	夬	宿	桃	姑洗	上巳;寒食
四	巳	丁	圉	乾	余	槐	仲呂	麥秋
五	午	戊	厲	姤	皋	榴	蕤賓	蒲和;天中;蒲;端陽;蒲滿;陽
六	未	己	則	遯	且	荷	林鐘	伏日;天貺
七	申	庚	窒	否	相	桐	夷則	巧;中元;蘭
八	酉	辛	塞	觀	壯	桂	南呂	中秋
九	戌	壬	終	剝	玄	菊	無射	重陽;菊秋
十	亥	癸	極	坤	陽	梅	應鐘	陽春;小陽春;
十一	子	甲	畢	復	辜	冬	黃鐘	仲冬;長至
十二	丑	乙	橘	臨	徐	臘	除夕	嘉平;清祀

Yao Niang (窅娘) A.D. 970, a beautiful concubine of the pretender Li Yü (李煜), is said by some to have introduced the practice of foot-binding, by compressing her feet to form an arch resembling the "new moon" (*vide* also LOTUS).

The moon is a favourite motive for the Chinese poet, so much so that the celebrated versifier Li T'ai-po (李太白) was drowned in A.D. 762, from leaning one night over the edge of a boat, in a drunken effort to embrace the reflection of the moon. This luminary is often depicted in Chinese paintings as a greyish pink disk among the clouds, with curling waves covering half its base in recognition of its influence over the tides.

The influence of the moon on the tides was noticed by the Chinese in early ages, and the lunar calendar is still in use side by side with the Gregorian calendar. The Chinese year is divided into twelve ordinary months or moons (月), each of which is distinguished by various names. The first day in each month is arranged to correspond to the new moon, and the 15th day to correspond to the full moon. Some months have 30 days, others 29. As the twelve months do not equal one solar year, an intercalary month (閏月) is interposed every third year between any two of the ordinary months from the second to the eleventh, in such a manner that only one of the twenty-four solar periods (*vide* SUN), in each year will fall on the intercalary month. The thirteen months equal a Julian year. In the appended table of the months it will be seen that the first of the TWELVE TERRESTRIAL BRANCHES (*q.v.*) *Tzŭ* (子), is applied to the eleventh month. When the first moon falls under the sign (甲), it is designated (甲阪) by combining the first of the TEN CELESTIAL STEMS (*q.v.*) *Chia* (甲) with its equivalent archaic name *Tsou* (阪), and so on in recurring order.

AUTHORITIES.
1 Headland: *The Chinese Boy and Girl.*
2 Park: *Chinese Fairy Tales and Folk Lore Stories*, p. 6.
3 Giles: *Biographical Dictionary*, 667.

MOSQUITO
(蚊 蟲)

The composition of the written symbol for the mosquito denotes that it is the *lettered* (文) *insect* (虫); this is in reference to the letter-like markings on its wings, which are

specially conspicuous in the case of the "striped" or "tiger" mosquito (虎蚊).

Mosquitoes are very common in China, especially in most parts south of the Yellow River, and along the Yangtze valley. They vary in size in different localities. The male of the *Anopheles* mosquito, which stands with its head pointed downwards, is the common host of the malaria germ, while the *Stegomia*, though equally voracious, is not a disease-carrier. Mosquito nets, wire gauze windows, and the burning of a specially prepared substance put up in the form of sticks, are among the measures used to combat this pest, but the best method is to exterminate the *larvae* of the insects by means of kerosene oil applied to gutters and ponds, etc., in the neighbourhood of human habitations. The culverting of drainage creeks will also have a good effect. The range of flight of a mosquito does not generally exceed a mile. "Tincture of *Pyrethrum roseum* applied to the skin is recommended as an excellent protection against mosquito bites. The best local sedative of the irritation caused by bites is liquid ammonia, but any strong spirit is also effectual." [1]

This insect is the type of wickedness and rebellion. "A multitude of evilly-disposed people," said Chung Shan-ching Wang (中山靖王) to Wu Ti (武帝) of the Han dynasty, "will stir up strife, just as a crowd of mosquitoes can make a noise like thunder" (衆奸鼓簧。 聚蚊可以成雷).

AUTHORITY.
[1] Giles: *Glossary of Reference*: MOSQUITO.

MULBERRY

(桑 樹)

"The mulberry tree (*Morus alba*) is largely cultivated in certain provinces that rear silkworms, and in these it is heavily pruned, with a view to producing leaves and not fruit.

The mulberry, among other things, is emblematic of the comforts of home, as also of industry. Mencius, in speaking of the advantages of peace, says the mulberry trees could be attended to. It was supposed that the mulberry would flourish only in the Middle Kingdom, and was, therefore, considered to represent the native soil. In mourning for a mother, the Chinese carry a staff made from a branch of the mulberry tree; while for a father, bamboo or ash is used. Sometimes we find

drawings of bamboo and mulberry trees, symbols of filial piety." [1]

According to the "Yün Fu" (韻 府), three old men were once comparing ages; one said, "I am as old as P'AN KU (*q.v.*)"; the second observed, "During my lifetime the ocean has become changed into mulberry-fields"; the third remarked, "My teacher ate a peach of immortality, and threw away the stone, which has now grown into a tree as high as the K'un-lun Mountains!" The "transformation of the sea into mulberry orchards" (滄 海 變 桑 田) is a figure of speech metaphorically applied to the gradual changing of the times, and the advances of civilization.

Paper was formerly made of the bark of a species of mulberry (楮).

AUTHORITY.
[1] Gulland, *Chinese Porcelain*, Vol. I, p. 106.

MUSICAL INSTRUMENTS
(樂 器)

Chinese music was originally of a highly symbolic character; it was believed to exercise a strong influence over the administrative faculties of the Emperor and the government officials, and no man's education was considered complete until he had acquired an expert knowledge of harmony.

It is beyond the scope of this volume, which deals primarily with symbolism, to give a detailed treatise on the music of the Chinese, a labour already ably performed by the late Commissioner of Customs, Mr. J. A. van Aalst, and others. The following brief description, supported by illustrations of the principal instruments, will, however, be of general interest.

Chinese music, in its pure and unadulterated form, entails the study of the Five Elements, metal, wood, water, fire and earth. It is governed by the Laws of the Universe, which lay down that there are Six Adverse Occasions when certain instruments should not be played, *i.e.*, during intense cold; great heat; high wind; heavy rain; loud thunder; and a snowstorm. There are also Seven Unfavourable Conditions, namely, within sound of mourning; or of other music; when occupied with prosaic affairs; if the body has not recently been bathed or the clothing is unclean; without burning incense; and in the absence of an intelligent listener.

I. STONE INSTRUMENTS
1, SONOROUS STONE; 2, STONE CHIME
II. METAL INSTRUMENTS
3, GONG; 4, BELL; 5, CYMBALS; 6, GONG CHIMES; 7, TRUMPET

The most revered instrument was the lute, which was credited with Eight Qualities: happiness, sweetness, elegance; subtlety; sadness; softness; resonance; and strength. It had to be made of the wood of the dryandra tree, because this was the only tree on which the Phoenix, that bird of happy augury, would alight. The wood was soaked in pure water for 72 days in order to correspond with the 72 divisions of the solar terms of the year. The length represented the 361 degrees of the circle made by the sun in its course round the earth. Its upper end was eight inches wide to agree with the Eight Annual Festivals. The lower end was four inches wide to conform with the Four Seasons. It was two inches deep to connote the two divisions of the Mundane Egg. There were 12 primary notes, male and female, or positive and negative alternatively, but some of them were lost. It originally had five strings to represent the Five Elements; one string being lost in the days of the Emperors Yao and Shun, and found again by Wen Wang, whose son added another string.

Musical instruments are said to have been invented by the legendary Emperor Fu Hsi (伏羲), 2953 B.C. The Emperor Shun, 2317-2208 B.C., is said to have introduced a wind instrument known as the Shao (韶). When it was blown nine times a phoenix appeared, a phenomenon that only occurred when a virtuous sovereign was on the throne. Confucius refrained from eating meat for three months after hearing the beautiful music of this instrument. The ritual music used in the worship of Confucius was introduced from Bactria in the second century B.C., and still bears traces of Greek origin. It is of a slow and plaintive nature, and consists of singing and posturing accompanied by antique instruments of music. The impressive ceremony of the worship of the sage, as witnessed by the Author in Nanking before the close of the Manchu dynasty, and attended by the local officials in their beautifully embroidered robes, was held at night by the light of huge braziers, the proceedings being timed to terminate with the rising of the sun. The rite was carried out with animal sacrifices in the spring and autumn of each year according to the due and ancient form.

The primitive Chinese scale of notation originally consisted of five sounds, known as *kung* (宮), *shang* (商), *chiao* (角), *chi* (徵), and *yü* (羽), which were contrasted with the five planets, five points, five colours, and five elements, and represented the Emperor, minister, people, affairs of state and material objects respectively. A scale consisting of nine notes

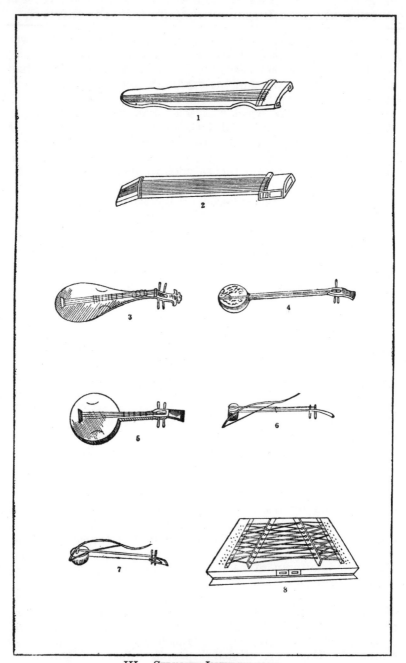

III. Stringed Instruments

1, lute (7 strings); 2, psaltery (25 strings); 3, balloon guitar;
4, 3-stringed guitar; 5, moon guitar; 6, 2-stringed violin;
7, 4-stringed violin; 8, harpsichord

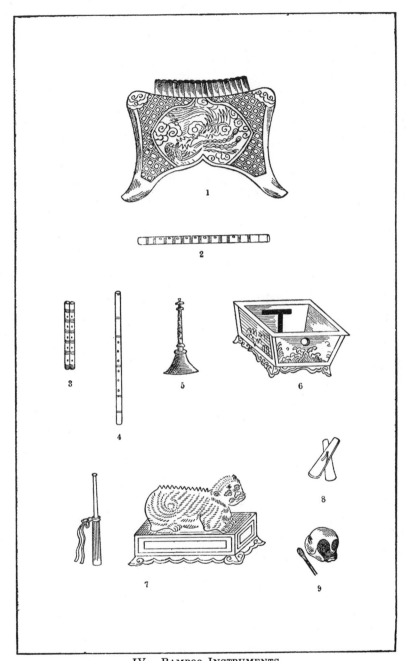

IV. BAMBOO INSTRUMENTS

1, PANDEAN PIPES; 2, COMMON FLUTE; 3, SMALL FLUTE; 4, CEREMONIAL
FLUTE; 5, CLARIONET

V. WOODEN INSTRUMENTS

6, SONOROUS BOX; 7, MUSICAL TIGER; 8, CASTANETS; 9, WOODEN FISH

(合四乙上尺工凡六五) was introduced in the Ch'ing dynasty, but has now in practice been reduced to five (合四乙上工), corresponding in Western notation to:—

C D E F A

Thus it will be seen that there is no true scale in the occidental sense. The method of writing music is by means of vertical rows of characters with occasional signs to denote the pauses or rests. The notes are often flattened or sharpened according to requirements, but the Chinese never go beyond fourteen sounds in a composition.

Vocal music is a nasal falsetto, and is usually accompanied by musical instruments, while the different attitudes and evolutions of the performers express to the eye what the voices and instruments convey at the same time to the ear.

The Chinese divide their instruments of music into eight categories, corresponding to the EIGHT DIAGRAMS (*q.v.*) : stone, metal, silk (or stringed), bamboo, wood, skin, gourd, and clay. There are said to be seventy-two different instruments in all, many of which, however, are now no longer used. Some are designed to imitate the human voice, others to reproduce the whistling of the wind through the trees, the rippling cadences of mountain torrents, or various sounds of nature, and others again to supply the necessary martial airs, festive harmony, or notes of grief and mourning. The *forms* of many are of emblematic significance; thus the *sheng* or reed organ symbolises and resembles the PHOENIX (*q.v.*), the sonorous stone typifies the carpenter's square, or the emblem of a just and upright life, being also a symbol of prosperity. The guitar resembles the moon in shape; the *ch'in* or lute is the symbol of matrimonial harmony, and suppression of lust. Some of the principal varieties of musical instruments, and their emblematic nature, have been treated under separate articles in this glossary (*vide* BELL, DRUM, FLUTE, GONG, LUTE, SHENG, STONE CHIME, etc.).

The instruments given in the accompanying diagrams are as follows :—

I. Stone Instruments—

(1) *T'ê ch'ing* (特磬), sonorous stone; (2) *pien ch'ing* (編磬), stone chime.

VI. Skin Instruments

1, LARGE BARREL-DRUM; 2, SMALL BARREL-DRUM; 3, RATTLE-DRUM;
4, FLAT-DRUM

II. Metal Instruments—
(1) *Chung* (鐘), bell; (2) *lo* (鑼), gong; (3) *yün lo* (韻鑼), gong chimes; (4) *po* (鈸), cymbals; (5) *hao t'ung* (號筒), trumpet.

III. Stringed Instruments—
(1) *ch'in* (琴), lute; (2) *sê* (瑟), psaltery; (3) *p'i p'a* (琵琶), balloon guitar; (4) *san hsien* (三絃), three-stringed guitar; (5) *yüeh ch'in* (月琴), moon guitar; (6) *hu ch'in* (胡琴), four-stringed violin; (7) *êrh hsien* (二絃), two-stringed violin; (8) *yang ch'in* (洋琴), harpsichord.

IV. Bamboo Instruments—
(1) *P'ai hsiao* (排簫), Pandean pipes; (2) *hsiao* (簫), ceremonial flute; (3) *ti* (笛), common flute; (4) *kuan* (管), small flute; (5) *so na* (鎖吶), clarionet.

V. Wooden Instruments—
(1) *Chu* (柷), sonorous box; (2) *yü* (敔), musical tiger; (3) *p'ai pan* (拍板), castanets; (4) *mu yü* (木魚), wooden fish.

VI. Skin Instruments—
(1) *Ying ku* (楹鼓), large barrel-drum; (2) *po fu* (搏拊), small barrel-drum; (3) *t'ao ku* (鞀鼓), rattle-drum; (4) *pang ku* (梆鼓), flat drum.

VII. Gourds—
(1) *Shêng* (笙), reed organ.

VIII. Clay Instruments—
(1) *Hsüan* (壎), ocarina.

"The bells give out a clanging sound as a signal. The signal is recognised by all, and that recognition produces a martial enthusiasm. When the ruler hears the sound of the bell, he thinks of his officers of war.

"The sounding-stones give out a tinkling sound, as a summons to the exercise of discrimination. That discrimination may lead to the encountering of death. When the ruler hears the sounding-stone, he thinks of his officers who die in defence of his frontiers.

"The stringed instruments give out a melancholy sound, which produces the thought of purity and fidelity, and awakens the determination of the mind. When the ruler hears the sound of the lute and cithern, he thinks of his officers who are bent on righteousness.

VII. GOURDS. REED ORGAN VIII. CLAY INSTRUMENTS: OCARINA

"The instruments of bamboo give out a sound like that of overflowing waters, which suggests the idea of an assembly, the object of which is to collect the multitudes together. When the ruler hears the sound of his organs, pipes and flutes, he thinks of his officers who gather the people together.

"The drums and tambours give out their loud volume of sound, which excites the idea of movement, and tends to the advancing of the host. When the ruler hears the sounds of his drums and tambours, he thinks of his leaders and commanders. When a superior man thus hears his musical instruments, he does not hear only the sounds which they emit. There are associated ideas which accompany these." [1]

AUTHORITY.

[1] LEGGE: *Li Ki* (禮 記), Bk. XVII, Sect., III, § 15.

MYSTIC KNOT

(腸)

This is said to be an angular knot, or the mystic sign on the breast of Vishnu, being said by some to be derived from the SWASTIKA (*q.v.*). It is also described as one of the EIGHT TREASURES (*q.v.*), or auspicious signs on the sole of Buddha's foot, and sometimes represents symbolically the sacred INTESTINES (*q.v.*) of that divinity. It is a sign of longevity, because

it is endless, like a true lover's knot, and it is also said to stand for the eight Buddhist warnings (八 師) : 1, Thou shalt not kill; 2, Thou shalt not steal; 3, Thou shalt not commit lewdness; 4, Thou shalt not bear false witness; 5, Thou shalt not drink wine; 6, Old age; 7, Infirmities; 8, Death.

NARCISSUS

(水仙花)

This flower, called by the Chinese the Water Fairy, is grown from bulbs in jars filled with pebbles and water, and is forced into blossom exactly at the new year, when it is believed to indicate good fortune for the ensuing twelve months.

NO CHA

(哪吒)

One of the most frequent-mentioned heroes in Chinese mythology. He was the son of Li Ching (李靖), who was also called Li T'ien-wang (李天王), the "Pagoda-bearer," a general under the tyrant Chou, subsequently deified, and appointed Prime Minister of Heaven. No Cha was born with a gold bracelet on his right wrist, and attired in a pair of red silk trousers, from which proceeded rays of golden light. The child was an incarnation of Ling Chu-tzu (靈珠子), 'the Intelligent Pearl,' and when he was seven years old he was already six feet in height.

NO CHA

It is related that No Cha performed many miraculous and heroic deeds with the aid of his magic bracelet, which he was able to increase in size and use as a weapon of attack upon Lung Wang (龍王), the Dragon-King, and in defence of

293

the Emperor, etc. He also bore a spear, and was provided with wheels of fire, which carried him from place to place.

The astrologer Liu Po-wen (劉伯溫) is said to have designed the building of the city of Peking (Peiping) according to the interactions of the FIVE ELEMENTS (*q.v.*), the FIVE VISCERA (*q.v.*), and other parts of the body of No Cha, figuratively disposed with his head to the south. The Emperor Yung Lo is believed to have carried out the astrologer's design with great accuracy.

NUMBERS
(數目)

The earliest method employed by the Chinese for the reckoning of numbers was by the use of pieces of wood, or tally sticks, of various lengths. The employment of these tally sticks still survives at the present day to some extent for checking the landing and shipment of cargo, etc. A mode of counting by means of notches was also anciently used. Thus *one* (一), *two* (二), and *three* (三) are simple combinations of notches or sticks; *four* (四) *now* consists of the character *pa* (八), to divide—a component of most of the even numbers—placed in a square; *five* (五) was first written ×, being four lines and centre, or five, then placed between two strokes (二), representing heaven above and earth beneath, or the dual powers YIN AND YANG (*q.v.*), begetting the FIVE ELEMENTS (*q.v.*); *six* (六) is really four (四) abbreviated and marked with a dot; *seven* (七) is two crossed sticks, one being bent; *eight* (八) is two sticks placed at an angle like the wings of a bird or the character *pa*, to divide; *nine* (九) is evidently *ten* (十) less one—indicated by the side stroke; *ten* (十) is merely two sticks crossed, and, according to the dictionary "Shuo Wên" (說文) —composed in the 2nd century A.D.—is "the most accomplished of numbers; the horizontal line represents East and West, the vertical North and South, so that together they comprise the four cardinal points as well as the centre." The character *wan* (萬), meaning 10,000, is said to be derived from the figure of a scorpion (which may have been a very common reptile in former times) showing claws, head, and tail; there is also a theory that it denotes the quantity of grass (卉) in the fields

(田). The addition of the radical *ch'ung* (虫), reptile, seems to support the former contention.

Three with the Egyptians, stands for the plural; hence when they would denote the multiplicity of an object, they repeat the word that stands for it three times. Many Chinese symbols involve the same principle; the following may be adduced as specimens: three suns to denote effulgence; three tongues, excessive talking; the symbol for hair, three times repeated, expresses the fur of animals, the down of birds, and anything delicate, soft and beautiful. Three forms of the symbol for grass constitute the generic term for plants, herbs and trees; three trees represent a forest. Many other characters might be quoted which derive an intensity of meaning from their three-fold form. "In Buddhism the three causes of demerits are, lust, anger and ignorance; the first has for its destroying agent fire; anger has water; and ignorance, wind. The three precious things are Buddha, the law, and the assembly. The sacred books consist of three great divisions. Three great obeisances are made in honour of the three precious things. The images of Buddha are only represented in three positions, viz., sitting cross-legged, as if preparing to advance, and reclining on his side with his head resting on a pillow. The *Tri-rattan* of the Hindoos is the triple-gemmed Alpha and Omega symbol of the Buddhists. The *Trikaya,* in China, means three bodies—the spiritual body, which is permanent and indestructible; the form which belongs to every Buddhist, as a reward for his merits; and the body which has the power of assuming any shape, in order to propagate the doctrines of Buddha." [1]

In conformity with the general sexual system of the universe, the numbers even have their genders; thus a unit and every odd number are male, while two and every even number are female. Certain numerical combinations are regarded as particularly felicitious, *i.e.* the Five Blessings (五福), the Three Plenties and the Nine Likes (三多九如), the Three Bonds and the Five Virtues (三綱五常), etc., etc. (*vide* the Author's *Manual of Chinese Metaphor*, Numerals). "All orientals are fond of high numbers, which have become quite a special feature of the Chinese language, in which a hundred, a thousand, or ten thousand merely serve to express many." [2]

The Chinese have three methods of writing figures in modern times: 1, the common form for ordinary use; 2, the

complicated form for security in drafts and bills; and 3, the abbreviated form for accounts, etc.

Calculations, based on the decimal system, are generally performed on the abacus, which is known as the *suan-p'an* (算 盤), *lit.*, "reckoning tray," or *ch'iu-p'an* (球 盤), "ball plate." It was introduced into China early in the Ming dynasty, and consists of an oblong frame of wood, having a bar running lengthwise, about two-thirds its width from one side. Through this transverse bar at right angles, are inserted a number of parallel wires having moveable balls on them, five on one side and two on the other of the bar. Each of the five on the first wire counts singly, but each of the two balls counts as five, and when both are drawn to the dividing line they stand for ten. The next wire to the left will similarly deal with ten and the next with hundreds. The shop-keepers have certain superstitions with regard to this instrument. "In the early morning it is very unlucky to use the abacus, or to turn up the account books; but each morning the abacus is washed to clean away the assistants' malpractices; when the shop is opened and closed, the abacus is shaken violently to drive away demons. No one entering the shop may touch the abacus, such an act would be deeply resented by many. The abacus is not generally used for business purposes before breakfast. Anyone trying to force a reckoning before breakfast will be suspected of an evil intention."[3]

The celebrated Altar of Heaven (天 壇) is situated in the southern suburbs of Peiping and is constructed with astonishing mathematical exactitude. Sacrifices were offered annually at this altar by the Emperors of China on the winter solstice. "It consists of three circular terraces with marble balustrades and triple staircases at the four cardinal points to ascend to the upper terrace, which is ninety feet wide, the base being 210 feet across. The platform is laid with marble stones in nine concentric circles and everything is arranged in multiples of the number nine. The Emperor, prostrate before heaven on the altar, surrounded first by the circles of the terraces and their railings, and then by the horizon, seems to be in the centre of the universe, as he acknowledges himself inferior to heaven, and to heaven alone. Round him on the pavement are figured the nine circles of as many heavens, widening in successive multiples till the square of nine, the favourite number of numerical philosophy, is reached in the outer circle of eighty-one stones."[4] Of the dividing supports for the balustrades, which are sculptured in cloud design,

there are 180 on the lower terrace, 108 on the one above, and 72 on the upper terrace, adding up to 360, and corresponding to the number of degrees in a geometrical circle.

AUTHORITIES.

[1] Jones: *Credulities Past and Present,* p. 262.
[2] Fork: *Lun Heng,* p. 262, note 1.
[3] Hutson: *Chinese Life in the Thibetan Foot-hills,* New China Review, Bk. VIII, Vol. II, No. 6, Dec., 1920.
[4] Bushell: *Chinese Art,* Vol. I, p. 58.

OAK

（橡 樹）

Quercus chinensis. The value of the wood and bark of the oak-tree is well understood by the Chinese. The wild silkworm feeds upon its leaves and hence produces silk of a light brown colour in contradistinction to the white silk produced by the domesticated worm which feeds on mulberry leaves. The oak-apples or nutgalls are used for making ink and dyes, and the bark is employed in tanning. The acorns serve as medicine.

The oak is the symbol of masculine strength.

OLEA FRAGRANS

（桂 花）

The *Olea fragrans* bears "minute florets of a white or yellow colour, growing in bunchy clusters, just where the leaves spring from the twigs. It flowers through a great part of the year; and in damp weather the fine odour of the blossom is perceived at some distance. It is remarkable that a branch of the fragrant olive is one of the rewards of literary merit, and an emblem of studious pursuits." [1]

It is used as an ornamental shrub, and its petals are employed in the scenting of tea.

In pictorial representations of the four seasons it figures as an emblem of autumn.

AUTHORITY.
[1] Davis: *The Chinese*, Vol. II, p. 348.

OLEANDER

(夾 枚 桃)

This beautiful evergreen shrub is much prized for its fragrant red or white flowers.

The bark of the root is used medicinally. The leaves are poisonous as they contain gallic acid.

The plant is an emblem of beauty and grace.

OPIUM

(鴉 片)

The original term *ya p'ien* (鴉 片), opium, is said to be a transliteration of the Arabic name *Afiyun,* but the various derogatory terms such as *hei t'u* (黑 土), "black dirt," etc., and the stigma which is now almost universally attached to the opium habit (which can only be carried on in secret), clearly indicate that the drug is generally regarded as symbolic of evil and dissipation.

The poppy, *Papaver somniferum,* is known by the Chinese as *ying su* (罌 粟), or "jar-seed," so called from the jar-like shape of the capsules. It was first grown in China at an early date for ornamental purposes. Its medicinal properties became known through Mohammedan merchants who entered the country through Central Asia. Opium-smoking is said to have been originally introduced from Java and Formosa. The first edict against the habit was issued in 1729, and the importation of Indian opium into China was discontinued in 1917, according to the terms of the agreement of 1907. The cultivation and sale of opium is, however, still carried on illegally in various parts of China. A National Anti-Opium Association has been formed, the policy of which is: 1, To enforce the laws prohibiting the cultivation of the poppy, the illicit use and manufacture of, and traffic in, opium and other narcotics; 2, To limit the importation of foreign narcotics to the amount required for medicinal needs; 3, To promote anti-narcotic education and the amelioration of drug addicts.

The methods of smuggling opium are many and varied, *e.g.,* concealment in false bottoms of boxes, baskets and trays, coal bunkers, coffins, carpets (woven into the fabric), stove-

pipes, water-tanks, picture-frames (between glass and black), household utensils, padded garments, bedding, fruit, bread, cake, tinned goods, saop, candles, gramophones, dressmakers' dummies, soda barrels, clothing, match-boxes, rolls of subsidiary coins, lamps, boots (between sole and upper), bamboos, stuffed animals, etc.

The head or capsule of the poppy is of the same shape and size as the official hat button of the Manchu dynasty; the poppy had to be cut and the virtue drained out of it in order to obtain the opium; hence it was regarded as a sign that the power of the House of Ch'ing was destined to pass away. This was a common saying, but kept from official ears, many years before there were any signs of decay or weakness in the imperial government.

Sir Francis Aglen, K.B.E., former Inspector General of Customs, wrote in an article published by the *Peking and Tientsin Times* on the 5th April, 1920, "There is an old Chinese saying, 'So long as there is opium there will be no revolution' (烟不死主不亂); what it says is no doubt true, but the national use of opium to the extent implied leads to a peace that spells national death and annihilation in the present age of political and economic competition."

ORANGE

（柑）

Many different species of orange are grown in China, among which may be mentioned the mandarin orange, or *Citrus nobilis* (蜜柑), a loose-jacket variety also known as the cinnabar orange (金砂桔), a name suggestive of alchemy, immortality, and good fortune; the coolie orange, or *Citrus aurantium* (橙), is found in South China; the cumquat or Golden Orange, *Citrus olivoeformis* (金橘) is made into a conserve, the Wenchow orange is a bitter variety which has a quinine-like flavour; another bitter variety is known as *Ch'ou Ch'êng* (臭橙). There are several varieties of pumelo, *Citrus decumana* (柚子), the best of which is grown at Amoy (*vide* also BUDDHA'S HAND).

The orange is most popular in China. Both the flavour of the fruit and the golden yellow of the exterior are much appreciated. Tincture of orange-peel is greatly esteemed as a sedative, carminative, stomachic, and expectorant remedy.

The peel is collected and dried by boys, women, and rag-shop keepers to sell to the druggists, who use enormous quantities of this very popular medicine. The dried fruit and pips are also employed medicinally.

This fruit was formerly used in imperial sacrifices to Heaven at the beginning of the year, and tribute of oranges was sent to Peking from Foochow annually for that purpose. The presentation of oranges at China New Year betokens the wish for abundant happiness and prosperity during the ensuing twelve months.

ORCHID
（蘭 花）

There are many varieties of orchidaceous plants indigenous to China, the commonest being the *Aglaia odorata,* a small green species of Epidendrum with an exquisite scent.

Orchids, or *Lan Hua,* are divided into two main classes, spring blooming and autumn blooming, with numerous subdivisions. The interest lies in the strangely-varied petals of this flower, and when the orchid-gatherers come in from the hills, the fancier will often buy a whole boat-load in the hope of discovering a novelty.

The *Lan Hua* is the emblem of love and beauty, and stands for fragrance and refinement, being also symbolical of numerous progeny. Confucius remarked on its exquisite characteristics, and it is therefore emblematic of the perfect or superior man.

OWL
（梟）

The Chinese name for this nocturnal marauder is a conventional picture of the bird (鳥), whose claws (﹏) are hidden in the foliage of the tree (木) on which it is perched.

Both the Screech Owl, *Strix flammea* (獅子鷹), and the Horned Owl, *Otus vulgaris* (角鴟), are found in China.

The owl is considered an evil bird, as the young are supposed to eat their mother. The saying goes, "The owl is an unfilial bird" (梟不孝之鳥), "The voice of the owl is universally heard with dread, being regarded as the harbinger

of death in the neighbourhood. Some say that its voice resembles the voice of a spirit or demon calling to its fellow. Perhaps it is on account of this notion that they so often assert having heard the voice of a spirit when they may have heard only the indistinct hooting of a distant owl. Sometimes the Chinese say that its voice sounds much like an expression of digging the grave. Hence, probably, the origin of a common saying, that when one is about to die, in the neighbourhood will be heard the voice of an owl calling out 'dig, dig.' It is frequently spoken of as the bird which calls for the soul, or which catches or takes away the soul." [1]

AUTHORITY.
[1] Doolittle: *Social Life of the Chinese*, p. 572.

OX

（牛）

The ox is the emblem of spring and agriculture and the second of the symbolical animals corresponding to the TWELVE TERRESTRIAL BRANCHES (*q.v.*).

It has a rich variety of names in the Chinese language, and a special designation in each year of growth, up to the seventh year. The characters for fish (魚) and ox (牛) are said to have been somehow exchanged, the four dots of the present symbol for fish being supposed to represent the four legs of the ox. The creature is said to be deaf in its ears, but to hear with its nose!

The flesh of the horse, mule, and donkey is sold for food in China, but, out of respect for the "yellow ox" (黃牛) and the *Bos bubalus*, or "water-buffalo" (水牛), which serve so well at the plough and the mill, beef is not much eaten, and its consumption by Buddhists and Mahomedans is, moreover, prohibited for religious reasons. Although such strong prejudices exist at the present time, beef-tea is, however, credited, in the Chinese *Materia Medica* (本草), with great strengthening powers, owing to the sturdy and muscular character of this unwieldy beast. The milk of the common cow is sweeter than that of the buffalo, though the latter is richer in cream. China is the chief market for cow hides, which are exported in large quantities from Hankow and other Yangtze ports, and to a lesser degree from Kiaochow, Canton, Kiungchow, Pakhoi, and Samshui. They are prepared for export in the rural

districts by placing them over bamboo frames and exposing them to the air to dry.

The "meeting of the spring" (迎 春) is a farmers' holiday, which occurs at the solar period known as *Li ch'un* (立 春), falling about the 5th February (*vide* SUN), and it is then that the ceremonial ploughing and the beating of the Spring Ox takes place (*vide* AGRICULTURE).

THE SPRING OX AND DRIVER

The so-called Spring Ox (春 牛) is made of clay and is beaten with sticks to stimulate the revival of spring. The details of colour both of ox and driver are carefully worked out every year according to the astrological and geomantic omens. The 1921 ox was eight feet long and four feet high, with a tail one foot two inches in length. Its head and back were white. Its abdomen and feet were green. Its horns, legs, ears, and tail were yellow. It was accompanied by a herdsman, also of clay, called Niu Mang (牛 芒), or Mang Shên (芒 神), a youth whose function is to beat the ox with a willow branch. He was three feet six inches in height, and his willow whip was two feet four inches long. He wore a green coat with a white belt. "If the ox is yellow, the people say that the year will be a fruitful one, and a bumper harvest

is expected. If it is red, fire and calamity will be rife; if white, mourning will be very plentiful. The spring will be early or late according as the tail is uplifted or downhanging. If the ox is lying down it is also an indication of a late spring. If the garments of the driver are stripped off and trousers tucked up, then an early spring is expected, but if his shoes are on and down at the heels the spring will be late. If the clothing is properly on with girdle and garters complete, then the spring will be an ordinary one. The ancient custom of making a mud ball in the shape of a drum during the winter and breaking it up at the opening of spring (擊 土 鼓) is probably the origin of the spring ox."[1] The ceremony bears some resemblance to the procession of the bull Apis in ancient Egypt, which was connected in like manner with the labours of agriculture, and the hopes of an abundant season.

A large bronze image of a water-buffalo is to be seen on the bank of the Summer Palace lake at Peiping, being placed there in the belief that the sacred and powerful animal will repress the evil spirits that disturb the lakes, rivers and seas.

AUTHORITY.
[1] Hutson: *Chinese Life on the Thibetan Foothills*, (Bk. VI).

PAGODA

(寶 塔)

The pagoda, Sanskrit, *Stûpa* (藪斗婆), is of Indian origin, and was known as *Dagoba,* or *Dhagoba,* from *Dhâtu garbha,* meaning "Relic Preserver," being used to mark the spot where sacred relics, Sanskrit *Sharira* (舍利), were interred. Pagodas have also been erected in commemoration of unusual acts of devotion, as omens of good, or merely as towers of observation. After the death and cremation of Buddha, his ashes are said to have been divided into 84,000 parts, each of which was

A TYPICAL CHINESE PAGODA

enshrined in a different part of the East, and a pagoda raised to mark the holy spot; some organs of the body are said to have been uninjured by the flames and were buried intact.

Pagodas are circular or octagonal buildings, usually of nine but sometimes of seven storeys, generally of brick, and were first erected in China in the third century. "Although Buddha is not now worshipped in India, he is at least considered as the ninth incarnation of Vishnu. It may, therefore, be conjectured that the nine stories of the pagoda have some reference to this circumstance, the real meaning of the number never having been exactly ascertained. Pagodas with only seven storeys are to be met with; and it is possible that this number may convey a mystical allusion to the seven Buddhas who are said to have existed at different periods." [1]

A pagoda is sometimes built to secure geomantic influences for the good of the surrounding district, small stone pagodas (文筆塔), in the form of the Chinese brush-pen, being frequently erected to improve the FÊNG SHUI (*q.v.*) of a locality. "In most cases the walls are double, and between the inner and outer walls winds the staircase leading to the summit, from which, by means of doorways, access is also obtained to the chambers on each flat. . . . The most celebrated and magnificent pagoda ever built in China was the well-known porcelain tower at Nanking, which was erected by the Emperor Yung Lo (1403-1425), to commemorate the virtues of his mother. Nineteen years and £200,000 were spent in building this unique structure, which, after standing for about 450 years, was destroyed by the Taiping rebels in 1856." [2]

The "pagoda-bearing god" (托塔天王) corresponds to the Indian Vajrapani, the jagged thunderbolt held in the hand of this deity being evidently mistaken by the Chinese for a pagoda, which he is generally represented as wielding (*vide* No CHA).

AUTHORITIES.
[1] Davis: *The Chinese*, Vol. II, p. 83.
[2] Douglas: *China*, pp. 188-9.

PAINTING

(畫 術)

According to historical records, the art of painting had its origin in Honan early in the Classical Period, which opened five centuries before Christ, but the Golden Age of Chinese pictorial art reached its zenith in the Sung dynasty, A.D. 960-1280.

The fine arts of poetry, painting, and writing are closely allied, and in all these it may be seen that the love of Nature is inherent in the very soul of the Chinese.

"Perspective and shading are the two points in which they appear to fail, but in spite of this, they excel in the painting of insects, birds, fruits, flowers, and ornamental patterns and borders. Their colouring is executed with great skill and accuracy. Some of their representations of abstract ideas attract notice. The symbolism of the Chinese has not attracted the notice of foreigners as much as it deserves. It meets us everywhere—on plates and crockery, on carpets, rugs, vases, wall pictures, shop signs and visiting cards. Certain animals stand for well-understood characters in the language, and convey their sense without confusion. The Chinese ornamental painting consists in water colours on silk or paper scrolls. Painting in oil is unknown, except in Canton, where foreign methods have been adopted by a few artists."[1]

A Chinese picture, which, according to the saying, is a "voiceless poem" (無聲詩), in order to be appreciated, should, owing to its perspective, be placed on the floor, leaning against the wall, and viewed from above. The fundamental difference between Eastern and Western painting is that in the former the artist uses his subject merely as a medium for expressing his thoughts in a conventional manner, while in the latter he strives to bring out the spirit of his subject in a natural way, without necessarily suggesting any other incidental ideas of his own. The one is subjective, the other objective.

Every characteristic feature of a country landscape is held by the Chinese artist to correspond to phases of the human soul; water is thus regarded as the blood of the mountains, grass and trees their hair, mist and cloud their colouring; mountains are considered to be the face of the waters, houses and fences its eyebrows and eyes, while the retired scholar represents the spirit of his rustic surroundings.

"Drawing is taught in China by the same methods as writing. Each motive in the composition is divided into a certain number of elements which the artist is made to treat separately, in the same way as the writer is taught to trace singly the eight different kinds of strokes used in the formation of the characters. . . . The grouping of the elements and the proportions of the composition are carefully arranged in accordance with certain canons."[2]

The saying goes: "When a man has read hundreds of books, studied the works of the old masters, and travelled all over the world, then and then only may he seize the brush and try his hand at painting." This is perhaps a counsel of perfection, but a study of Chinese art is certainly an aid to the proper appreciation of the evolution of the national culture, and a guide to the inner feelings of the people.

The ancient artist first saturated himself with the spirit of his subject. If he wished to depict a peaceful landscape he would ascend a high mountain, where he would sit and meditate, looking down on the world as a God from on high. Finally he would dreamily convey the conceptions of his mind to the paper or silk. Pictures of divine beings were painted by artists who had become imbued with religious feeling by living for some time in a monastery away from all mundane affairs. Thus many pictures have an underlying esoteric meaning. They are problem pictures for the most part.

The best artistic subjects, in the order of their merit, are (1) saints, gods and demons; (2) portraits and historical pictures; (3) architecture; (4) animals and flowers; (5) landscapes. The desirable criteria are: (1) vitality; (2) correctness of style; (3) fidelity; (4) harmonious colouring; (5) composition; (6) accuracy (if a copy).

The dragon used to be a popular subject with Chinese painters. Chang Seng-yao, a genius of ancient time, often specialised in this legendary monster, but he invariably left out the eyes. The Emperor obtained possession of one of his dragon studies, and commanded him to fill in the missing eyes. He obeyed the Imperial Edict, when, lo and behold, the dragon spread his wings and flew away! Another artist devoted himself to painting butterflies so realistically that they appeared to be alive. The best paintings of the tiger are said to have been produced under the influence of strong drink! T'ang Chih-ch'i, an art critic of the Ming period, mentions the picture of a cat so true to nature that it was used for driving away the rats; and a painting of the Goddess of Mercy crossing the sea—said to ensure fine weather.

Chinese works on drawing give detailed directions for representing every kind of scenery, etc., under all possible conditions. This regularised system tends to produce somewhat mechanical results, though wonderful effects are often created with only a few strokes of the brush. "Mountains and streams are described as the highest objects for the painter's skill, and the student is told how to depict their

beauties under every varying circumstance of season and weather. The ideal mountain should have a cloud encircling its 'waist,' which should hide from view a part of the stream which should pour over rocks and waterfalls down its sides.

LANDSCAPE IN THE STYLE WANG WEI

A temple or house, shaded and half concealed by a grove, should span the neighbouring torrent, over which a winding road, bordered by trees, should lead round the mountain. At intervals travellers should be seen mounting to the summit. Three sides of a rock, if possible, should be shown, and water should appear as though ruffled by wind. A ford is a fitting adjunct to a precipitous bank, and smoke and trees add to the picturesqueness of a stretch of water. A large sheet of water should always be dotted with sails. A solitary city in the distance and a market town at the foot of the mountain may be introduced with advantage. Houses should always form part of forest scenery, and an old tree with broken and twisted roots is an appropriate finish to a rocky cliff. The boughs of a tree having leaves should be supple, but if bare, should be stiff. Pine bark should be drawn as fishes' scales, and cedar bark is always, it should be remembered, entwining. The branches on the left side of a tree should be longer that those

on the right. Rocks should be heavy above and slight beneath. There should never be too much either smoke or cloud, nor should woods have too many trees. On a snowy day no cloud or smoke should be seen, and when rain is falling distant mountains should be invisible. Such are some of the directions given for landscape drawing, and a glance at Chinese pictures of scenery is enough to show how closely the rules of the textbooks are followed." [3]

Chinese paintings are to a large extent traditional, and celebrated old pictures are continually reproduced long after the original has disappeared. In judging the age of a painting it is therefore necessary to examine the nature of the material on which it is drawn. Archaic drawing alone must not be taken as any indication of age, as it may be only an imitation in the antique style.

The landscape (on page 311) after Hsia Kuei (夏珪), A.D. 1194-1224, showing the artist watching the tide, or perhaps the Bore (tidal wave) coming in at Hangchow, is well illustrated by the following lines of poetry written by the noted art critic Kuo Hsi (郭 熙), A.D. 968-976:

"Where my pathway came to an end
By the rising waters covered,
I sat me down to watch the shapes
In the mist that over it hovered."

"The human figure sitting and gazing out into a distance that is blurred with mist typifies the sage—the thinker, the philosopher—who does not blind himself to the social and political discords of his day, but can gaze on them calmly, knowing them to be, after all, just a little less ephemeral than mists or rising water. The word 'pathway' is intended to be taken in its moral sense, as the path of virtue, or less conventionally, that pathway through the world, which, in all ages, the sane, strong soul will take. This shimmering road —in the picture given—winds out through the middle distance, and is obliterated by the incoming tide of haze—perhaps of actual rising water—for floods have, at all times, been a scourge in China. The seer, gazing outward, sees that his onward progress is temporarily obscured. There is no use plunging forward into oblivion. He knows that it is a phase which must have its brief day of existence; so, instead of attempting a hopeless combat, he 'sits him down to watch the shapes in the mists that over it hover.' By 'shapes' he

LANDSCAPE AFTER HSIA KUEI

311

doubtless means those spectres of greed, oppression, and injustice that always accompany a period of unwise administration. There will be other forms and visions no less terrible. Indeed, the philosopher is able to find somthing of interest, if not of amusement, in all such forms of mist."[4]

The following list contains the names of 25 of the principal Chinese celebrities of the brush, and the periods in which they flourished. The biographies of most are given in the *History of Chinese Pictorial Art,* by Professor H. A. Giles.

NAME		PERIOD
Ku K'ai-chih	顧愷元	4th and 5th centuries
Li Ssu-hsün	李思訓	651-716
Wu Tao-tzŭ	吳道子	8th century
Wang Wei	王 維	699-759
Han Kan	韓 幹	750
Fan K'uan	范 寬	1026
Kuo Hsi	郭 熙	968-976
Li Lung-mien	李龍眠	1070-1106
Mi Fei	米 芾	1051-1107
Ma Yüan	馬 遠	1190-1224
Hsia Kuei	夏 珪	1194-1224
Mu Ch'i	牧 溪	Sung dynasty (960-1260)
Chao Mêng-fu	趙孟頫	1254-1322
Yen Hui	顏 輝	Yüan dynasty (1260-1368)
Lin Liang	林 良	Ming dynasty (1368-1644)
Shên Chou	沈 周	1427-1509
T'ang Yin	唐 寅	1470-1523
Ch'in Ying	仇 英	Ming dynasty (1368-1644)
Wu Wei	吳 偉	Ming dynasty (1368-1644)
Wên Chêng-ming	文徵明	1470-1559
Wang Shih-min	王時敏	Born 1592
Wang Shih-chien	王時監	„ 1598
Wang Hui	王 翬	„ 1632
Wang Yüan-ch'i	王原祁	„ 1670
Yün Shou-p'ing	惲壽平	„ 1633

AUTHORITIES.

[1] *Catalogue of the Collection of Chinese Exhibits at the Louisiana Purchase Exposition,* St. Louis, 1904, p. 189.

[2] Bushell: *Chinese Art,* Vol. II, pp. 109-110.

[3] Douglas: *China,* pp. 191-194.

[4] Fenellosa: *Epochs of Chinese and Japanese Art,* Vol. II, p. 44, note.

PALM-TREE

(蒲 葵)

Livistonia chinensis is the commonest form of Chinese palm, the leaves of which are made into fans. Of other species may be mentioned the Coir Palm (椶 樹), or *Trachycarpus excelsus*, the stem of which is protected by large brown bracts, or pieces of fibre, which are made into matting, cordage, rain-coats, brushes, etc.

"The Chinese think very highly of a retired life, free from the turmoil of this world, and this state of existence is generally indicated by a figure sitting under a palm tree, a cottage perched on the top of a high cliff, in the recesses of a mountain, or hidden from view by an overhanging rock. A fan made out of a palm-leaf is generally carried by retired scholars and by alchemists."[1]

AUTHORITY.
[1] Gulland: *Chinese Porcelain*, Vol. I, p. 107.

P'AN KU

(盤 古)

The Chinese Adam. "The first being brought into exist-ei ce by cosmogonical evolution. The Great Monad separated into the male Principles (the *Yin* and the *Yang*). By a similar process these were each subdivided into Great and Lesser, and then from the interaction of these four agencies P'an Ku was produced. He seems to have come into life endowed with perfect knowledge, and his function was to set the economy of the universe in order."[1] "One legend is that the dual powers were fixed when the primeval chaos separated. Chaos is bubbling turbid water, which enclosed and mingled with the dual powers, like a chick *in ovo*, but when their offspring P'an Ku appeared their distinctiveness and operations were apparent. *P'an* means a 'basin,' referring to the shell of the egg; *ku* means 'solid,' 'to secure,' intending to show how the first man P'an Ku was hatched from the chaos by the dual powers, and then settled and exhibited the arrangement of the causes which produced him."[2]

P'an Ku may be regarded as a legendary "Great Architect of the Universe," and is ordinarily represented as holding a

chisel and mallet in his hands, splitting and fashioning vast masses of granite floating confusedly in space. Behind the openings his powerful hands have made are seen the sun, moon, and stars, monuments of his stupendous labours; at his right hand, inseparable companions of his toils, stand the dragon, the phoenix, and the tortoise—divine types and progenitors with himself of the animal creation. His efforts were continued 18,000 years, and by small degrees he and his work increased; the heavens rose, the earth spread out and thickened, and P'an Ku grew in stature six feet every day, till his labours ended, and he died for the benefit of his handiwork. He gave birth in dying to the details of the existing material universe. His head was transmuted into mountains, his breath wind and clouds, and his voice thunder; his left

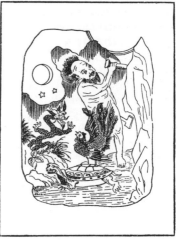

P'AN KU CHISELLING OUT
THE UNIVERSE

eye became the sun; his right eye the moon; his beard, like Berenice's hair, was transformed into stars; his four limbs and five extremities into the four quarters of the globe and the five great mountains; his blood into rivers; his veins and muscles into the strata of the earth, and his flesh into the soil; his skin and the hairs thereon into plants and trees; his teeth and bones into minerals; his marrow into pearls and precious stones; his sweat descended as rain; while the parasites which infested his body, being impregnated by the wind, were the origin of the human race (*cf.* Aristotle's belief that insects arose spontaneously from perspiration).

"The philosophical writers of the Sung dynasty are not ashamed to adopt the legend of P'an Ku, while admitting that the early historians, including Ssu-ma Ch'ien, say nothing of his existence." [3] The account is said to have been invented during the 4th century A.D. by the Taoist recluse, Ko Kung, a magistrate and author of the *Shên hsien chuan* (*Biographies of the Gods*). Other records declare that P'an Ku had the head of a dragon and the body of a snake; and that by breathing he caused the wind, by opening his eyes he created the daylight; his voice made the thunder, etc.

According to the "Chronology of the Han Dynasty" (漢曆志), a period of 2,267,000 years elapsed from creation to the capture of the *lin* in the days of Confucius (551 B.C.), though Ssŭ-ma Chên (司馬貞), A.D. 720, stated, in his "Elucidation of the Historical Records" (史記索隱), that the number of years embraced by this period extended to 3,276,000. The origin of the Chinese people is shrouded in mystery, though theories have been advanced connecting them with the ancient Egyptians, and with the Aztecs of North America, etc. (*Vide* also T'AI CHI and YIN AND YANG).

AUTHORITIES.
1 Giles: *Chinese Biographical Dictionary*, 1607.
2 Williams: *Middle Kingdom*, Vol. II, p. 138.
3 Mayers: *Chinese Reader's Manual*, Pt. I, 558.

PARROT
(鸚鵡)

The parrot is chiefly found in the southern parts of China, but various birds of the genus *Psittacus,* such as macaws, cockatoos, loris, and parrakeets, are imported from the Malay archipelago.

"In the province of Kiangsi, in which stood Chintechen, there is a legend that a pearl merchant was on the point of being ruined by the intrigues of his faithless wife when the state of affairs was made known to him by a speaking parrot. In that province, therefore, this bird is looked upon as a warning to women to be faithful to their husbands." 1

The parrot, with its vivid colouring, is occasionally used as a decoration or mark on porcelain, especially on the *famille rose* variety.

AUTHORITY.
1 Gulland: *Chinese Porcelain*, Vol. I, pp. 98-9.

PEACH
(桃)

The peach, *Amygdalus persica,* also known as the Fairy Fruit (仙果), is supposed to have really originated in China, where it bears most plentifully, as the right half of the symbol

denoting its name (which means a million) would seem to indicate.

There are various varieties, such as the Feich'êng peach (肥 桃), which comes from Feich'êng (肥 城) in Shantung, and often weighs over a pound, the flat peach (扁 桃), the yellow peach (金 桃), etc. The nectarine (油 桃) is also cultivated, though rather rare. The fruit is said to be efficacious in lung diseases, and the kernels (桃 仁) are prescribed in coughs, rheumatism and worms. The flowers are said to be laxative, the bark is given in jaundice, dropsy, hydrophobia, asthma, and many other complaints, while the sap or gum (桃 膠), exuding from incisions in the bark, is prescribed by Chinese doctors as a sedative, alterative, astringent, and demulcent remedy.

The peach has an important place in Chinese superstitions and appeals highly to the æsthetic sense of the people. It is an emblem of marriage and symbol of immortality and springtime. The peach-tree of the gods (神 桃), one of which grew in the gardens of the palace of HSI WANG MU (q.v.), was said to blossom once in 3,000 years and to yield the fruit of eternal life, which ripened for another 3,000 years. "The wood of the peach-tree is a demonifuge, and Taoist priests use it for making the seals with which they seal their talismans and amulets. Branches of the tree are also used to strike fever patients, to expel the spirit of fever. The fruit is, however, more important than the wood; it is the fruit which has given immortality to the immortals, and is a chief ingredient in the *elixir vitæ* of the Taoists. The god of longevity (壽 星) is often pictured as issuing from a peach, and peach-stones carved in the shape of locks are amulets to keep children secure from death."[1] The "peach charm" (桃 符) consists of a spray of blossom, which is placed at the doors of houses, at the new year, to prevent all manner of evil from entering.

"The most appropriate and felicitous time for marriage is considered to be in the spring, and the first moon of the Chinese new year (February) is preferred. It is in this month that the peach-tree blossoms in China, and hence there are constant allusions to it in connection with marriage. These verses from the elegant pen of Sir William Jones are the paraphrase of a literal translation which that indefatigable scholar obtained of a passage in the Chinese 'Book of Odes':

'Sweet child of spring, the garden's queen,
　　Yon peach-tree charms the roving sight;
Its fragrant leaves, how richly green,
　　Its blossoms, how divinely bright!
So softly shines the beauteous bride,
　　By love and conscious virtue led,
O'er her new mansion to preside,
　　And placid joys around her spread.'" 2

（桃之夭夭。灼灼其華。之子于歸。宜其室家。）.

AUTHORITIES.
　1 Couling: *Encyclopaedia Sinica*: PEACHES.
　2 Davis: *The Chinese*, Vol. I, p. 268.

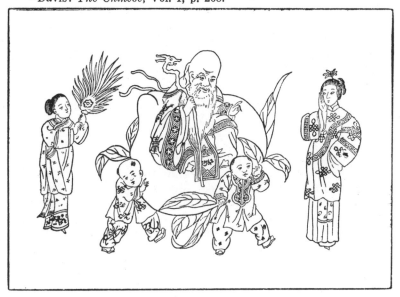

THE GOD OF LONGEVITY ISSUING FROM A PEACH

PEACOCK

（孔 雀）

Pavo muticus. This gallinaceous fowl is reared in many parts of China, and is found in a wild state in the far south. Though not originally a native of the country, having been most probably introduced from the Malay Peninsula, it has long been known to the people, who regard it with great appreciation and respect.

This bird is an emblem of beauty and dignity. The use of the handsome tail feathers to designate official rank was commenced in the Ming dynasty and ceased with the dawn of

the Republican Era (1918). The decoration of the Peacock's Feather (花翎) was granted for meritorious services, and, like many other orders, was also obtainable by purchase, or as a reward for contributing to charity. These feathers had either three, two, or a single "eye," or circular marking, according to the grade conferred. No doubt this use of the plumes caused a large annual consumption of the bird.

The beautiful daughter of Tou I (竇毅)—a military commander in A.D. 562—painted a peacock on a screen, and offered to marry the man who was able to hit the bird twice running with an arrow. The first Emperor of the T'ang dynasty put out both the eyes of the bird with his shots, and was therefore declared the successful suitor. Hence "selection by hitting the bird screen" (雀屏中選) has become a synonym for choosing a husband.

PEAR
(梨)

The pear, *Pyrus sinensis,* has long been known in China, if it be not indigenous to that country.

The character *T'ang* (棠) stands for the genus *Pyrus,* the character *Li* (梨) having been given to the fruit from the belief that it tended to cause, or to aggravate, dysentery (利 or 痢, the "sharp" malady). The White Pear (白梨), the Snowy Pear (雪梨), and the Fragrant Pear (香梨), are northern varieties. Many other kinds are kown, such as the large Horse-shoe Pear (馬蹄梨) of Manchuria, the Honey Pear (蜜梨) of Hopeh, the Oil Pear (油梨) which keeps for more than a year, and the Yellow Pear (黃梨) of Shansi. The Chefoo pear was originally imported from America, and much resembles the Bartlett.

Most of the Chinese pears are woody and tasteless, though they could no doubt be improved by scientific treatment. The flowers and bark are prescribed by Chinese physicians in fever, cholera, and dysentery, probably on the principle of "the hair of the dog." The wood of the tree was formerly much used for making printing-blocks and wood-cuts for books.

The Duke of Shao, Kiangsi (召公), 1053 B.C., is recorded to have dispensed impartial justice under a wild pear-tree which was preserved in memory of his virtue. Hence the pear is the emblem of wise and benevolent administration, or good government.

Ming Huang (明皇), the sixth Emperor of the T'ang dynasty, A.D. 685-762, founded a college of music (教坊) for young men and maidens in a pear-orchard. Thus the members of the theatrical profession are known as "brethren of the pear-orchard" (梨園子弟).

The pear-tree is very long-lived, and has been known to bear fuit when 300 years old. Hence it is one of the emblems of longevity.

PEARL
(珠)

Pearls were found in the 13th century at the mouth of the Peiho, in the Sungari river, and in some of the rivers of Shensi. They are now chiefly imported from Australia, Japan, and the Indian Archipelago. There is a sea water fishery of no great importance near Pakhoi. A process for promoting the artificial formation of pearls in the Chinese river mussels is carried on at Tê-ch'ing (德清) in Chekiang; pellets of clay and mother-of-pearl, or small images of Buddha, are introduced into the shell of the bivalve, and, in course of time, become coated with nacre. Pearl-shells were used as money in ancient times.

"The ancient fabulists are full of wonders appertaining to the nature of the pearl, which they say is the concrete essence of the moon, distilled through the secret working of the secondary principle (陰) in Nature within the shell of the mussel which produces it. Hence the pearl acts as a charm against fire, the development of the active or primary principle. The Taoist mystics have ascribed many wondrous stories to the same gem, and in their writings the *yeh ming chu* (夜明珠), or 'night-shining pearl,' is first heard of." [1]

The pearl is one of the eight ordinary symbols (八寶)— *vide* EIGHT TREASURES. The term *chu*, or pearl, seems to be generally applied to a variety of round objects, as for instance the spheroid which is a concomitant of the dragon. As a symbol of good augury it is depicted entwined with a fillet. The Wonder-working Pearl (如意珠) is also one of the Seven Treasures (七寶), Sanskrit, *Sapta Ratna*, which represent the paraphernalia of a *Chakravartti*, or universal sovereign, according to Buddhist legends, the other six being the Golden Wheel (金輪), the Gemmeous Maidens (玉女), Horses (馬), Elephants (象), Divine Guardians of the Treasury (主藏神), and Military Governors (主兵臣).

The offspring of aged parents is compared to a pearl produced by an old oyster. The pearl is also an emblem of genius in obscurity, and is figuratively employed for the expression of feminine beauty and purity. (*Vide* also DRAGON, MOON, YIN AND YANG.)

AUTHORITY.
[1] Mayers: *Chinese Reader's Manual*, Pt. I, 76.

P'ENG NIAO
（鵬 鳥）

The Chinese Rukh or Roc. A fabulous bird of enormous size, capable of flying tremendous distances. It has wings like the clouds of heaven, and at every swoop it speeds upwards for 3,000 *li*. It came into being by metamorphosis from the *Kun* (鯤), a leviathan of the ocean, and is mentioned by the philosopher Chuang Tzû (莊 子).

The flight of this mythical bird is made symbolical of rapid advancement in study, and general success in life.

"In the North, where there are neither trees nor grass, there is a dark sea, called the Pool of Heaven, in which there lives a fish. This fish is several thousand *li* in breadth, but no one knows how long it is. Its name is *Kw'en*. There is also a bird named *P'eng*, whose back is as broad as the T'ai Shan (Great Mountain). As it descends from heaven its drooping wings resemble the clouds; as it mounts on high the wind rushes violently upward in spiral gusts like the horns of a goat. When it reaches the height of ninety thousand *li*, there are no more clouds. It bears the azure sky upon its broad shoulder-blades as it flies south, and seeks the Southern Sea." [1]

AUTHORITY.
[1] Balfour: *The Divine Classic of Nan-Nua*, p. 3.

PEONY
（牡 丹 花）

The *Pæonia arborea*, or tree peony, bears the title of *Hua Wang* (花王), or King of Flowers, and *Fu Kuei Hua* (富貴花) or Flower of Riches and Honour, thus indicating

the esteem in which it is held. It is looked upon as the flower of the *Yang* (陽) principle—that of brightness and masculinity—its name, *Mou-tan*, lit: "male vermilion," suggesting the qualities attributed to the blossom. It is sometimes called *Lo Yang Hua* (洛陽花), "flower of Lo-yang," as it was originally supposed to have come from that locality. "As the petals do not vary, the names chosen depend on colour; thus the deep red blossoms are known as 'Ink,' the white as 'Jade,' and the cream as 'Bright' *Mou-tan*. Most highly prized are the 'Ink' and a variety with a yellow mark at the petal edge, known as 'Golden-border Peony.' The ordinary pink variety has no special name." [1]

This favourite flower of the Chinese gardeners, with its large, showy, and variegated blossoms, thrives best in North China and the Yangtze Valley. In the southern regions it is also reared, but rarely blossoms there more than once. More than thirty varieties are cultivated, and there is quite a literature on the subject. It is generally planted in terraces or raised beds, and protected during the hottest part of the day with mat awnings. The roughly-quilled bark of the root (丹皮) is prescribed in congestions, blood disorders, and vermes.

It is an emblem of love and affection, and a symbol of feminine beauty; it also takes its place as one of the flowers representing the four seasons: the tree-peony is a sign of spring; the lotus, summer; the chrysanthemum, autumn; and the wild plum, winter.

"The peony is also regarded as an omen of good fortune, if it becomes full of beautiful flowers and green leaves. On the other hand, if its leaves should all at once dry up, and its flowers suddenly fade or become of an unpleasant colour, such a change foreshadows poverty, or some overwhelming disaster, in the family of its owner." [2]

AUTHORITIES.
[1] Ayscough: "The Chinese Idea of a Garden." *The China Journal of Science and Arts*, Vol. I, No. 2, March 1923, p. 137.
[2] Doolittle: *Social Life of the Chinese*, p. 572.

PERSIMMON
（柿）

Diospyros kaki. Often called the "date plum" or "China fig." The fruit is like a large plum, but very harsh and

astringent, though after exposure to frost it becomes luscious and highly nutritious. It grows to a large size, and to the best advantage in North China, where it is planted in orchards at the foot of the hills. There are many varieties, such as the "large millstone" (大磨磐柿子), which sometimes reaches a pound in weight, the wild persimmon *D. lotus* (黑棗), used for grafting purposes, the sweet persimmon, fire persimmon, etc.

This fruit, owing to its bright and festive colour, is an emblem of joy. "Representations of it are to be found generally on cups and bowls of latish date, when it looks like an apple coloured light red, supported on a twig, which bends over with the weight."[1]

AUTHORITY.
[1] Gulland: *Chinese Porcelain*, Vol. I, p. 110.

PHEASANT

(野 雞)

The ornithology of China is distinguished by many splendid varieties of gallinaceous birds, amongst which the pheasant takes an important place.

The most common species is the Ring-necked Pheasant, *Phasianus torquatus*, which is found in nearly all parts of the country, and is easily known by the broad white collar, whence it has its name, as well as by the pale greyish-blue of its upper wing-coverts and rump, and the light buff of its flanks. This bird has been introduced into English preserves where it interbreeds readily with the other species. The Golden Pheasant, *P. pictus*, occurs in the southern provinces, and its prevailing colours are red and yellow, harmoniously blending with each other in different

GOLDEN PHEASANT

shades. The Silver Pheasant, *P. nycthemerus*, ranges throughout Fukien and Chekiang, and has a silvery back and tail, with breast and belly of steel blue. Reeve's Pheasant, *P. reevesi*, of the northern mountains, is remarkable for its long

tail feathers—sometimes six feet in extent, and decorated with black bars—which are used by play actors as a necessary adjunct to an ancient warrior's dress. There are also many other beautiful *Phasianidæ* in the avifauna of the country.

It is quite probable that the mythical Chinese PHOENIX (*q.v.*) is merely the Argus Pheasant, or possibly the peacock. In any case the pheasant is sometimes used in the place of the phoenix, and partakes of all its attributes, being a common emblem of beauty and good fortune.

The Golden Pheasant was formerly embroidered on the court robes of civil officers of the second grade, and the Silver Pheasant on those of the fifth. The birds were represented as standing upon a rock in the sea and looking towards the sun, the Imperial symbol of authority.

An ode in the "Canon of Poetry" (詩 經) contains the following lament of a wife on her husband's absence:

> "Away the startled pheasant flies,
> With lazy movement of his wings;
> Borne was my heart's lord from my eyes—
> What pain the separation brings!"

(雄雉于飛。泄泄其羽。我之懷矣。自詒伊阻。)

PHOENIX
(鳳 凰)

The dragon and the phoenix are the source of so many comparisons and allusions in Chinese literature that some knowledge of these mythological creatures as conceived by the Chinese is essential in appreciating the many metaphors derived therefrom, and, moreover, they take an important place in Chinese art, whether modelled or pictorial.

PHOENIX

"The *feng huang* is the phoenix of Chinese writers, and, like its counterpart in Arabian story, is adorned with everything that is beautiful among birds. The etymology of the name implies that it is the *Emperor* of all birds; and as is the unicorn among quadrupeds, so is the phoenix the most honourable among the feathered tribes. It is described by one author, 'as resembling a wild swan before, and a unicorn behind, it has the throat of a swallow, the bill of a fowl, the neck of a snake, the tail of a

fish (having twelve feathers, except in years with an inter-
calary month when there are thirteen), the forehead of a crane,
the crown of a mandarin drake, the stripes of a dragon, and
the vaulted back of a tortoise. The feathers have five colours,
which are named after the five cardinal virtues, and it is five
cubits in height; the tail is graduated like Pandean pipes, and
its song resembles the music of that instrument, having five
modulations. It appears only when reason prevails in the
country, hiding itself at other times; and two are never seen
at once; when it flies, a train of small birds always attends it.
Like the unicorn it is benevolent, and it will not peck or injure
living insects, nor tread upon living herbs; it alights only upon
the *wu t'ung* tree, or *Dryandra cordifolia*, feeds only on the
seeds of the bamboo, and quenches its thirst only at the sweet
fountains.' To this account another writer adds, 'that this
bird resides in the Vermilion Hills, where it eats and drinks
at its pleasure, waiting for the time when peace shall pervade
the country. There are four sorts which differ only in the
colour of their plumage.'

"The Arabian phoenix was described as a kind of eagle,
but the Chinese represent their bird as belonging to the
gallinaceous family; its eggs are the food of fairies. The
drawing of it does not correspond very closely with the fanciful
description given above, from which it would seem that the
artist had taken the Argus pheasant as his pattern, making
such modifications as suited its divine character and his notions
of its form. The phoenix appears from the first to have been
entirely an imaginary creature of Chinese writers, as it were
a kind of inanimate yet superbly elegant statue, which they
had full liberty to vivify and embellish with every benevolent
quality, and make it throughout perfectly beautiful and good.
It is said to have appeared about the time that Confucius was
born, and is usually represented as flying in the air, while the
unicorn ranges on the hills where the mother of Confucius
stands in the foreground. The phoenix is often seen rudely
depicted on the sterns of junks, standing on one leg and
spreading its wings." [1]

As the phoenix and the unicorn do not prey on living
creatures, they are very acceptable to the Buddhists, who
disapprove of the unnecessary taking of life. Many Chinese
beliefs have similarly become incorporated with the Buddhism
of Indian origin, which has readily adapted itself to Chinese
soil.

The *wu t'ung* (梧桐), or dryandra, famous in legendary

lore as the only tree on which the phoenix would alight, is an ornamental species, which grows to great height very rapidly, and has a bell-shaped flower, white without and reddish-brown within. The leaves are very large; they open early and commence to fall at the beginning of autumn. The seeds enter into the composition of the moon-cakes eaten by the Chinese at the autumnal festival of the eighth month.

The pheasant, as an emblem of beauty, is sometimes used in place of the phoenix. The designation *"feng"* really "includes two distinct varieties, an archaic kind like an Argus pheasant found on ancient bronzes, and a later representation which apparently combines the characteristics of pheasant and peacock." [2] The two-fold expression *"feng huang"* might perhaps better be rendered "Crested Love Pheasants." "In poetry many covert allusions to sexual pairing are intimated by reference to the inseparable fellowship of the *feng* and the *huang*." [3]

The phoenix is only supposed to appear in times of peace and prosperity. It is the second among the four supernatural creatures (四靈), the first being the DRAGON, the third, the UNICORN, and the fourth, the TORTOISE (*q.q.v.*). It presides over the southern quadrant of the heavens, and therefore symbolizes sun and warmth for summer and harvest. "This divine bird is the product of the sun or of fire, hence it is often pictured gazing on a ball of fire. The sun being the *yang* or active principle, the phoenix has great influence in the begetting of children. . . . It is six feet in height. . . . Its first recorded appearance is in the reign of Huang Ti, some 2,600 years B.C. It again showed itself in the next reign, and two phoenixes nested in Yao's palace about 2350 B.C. It is not however until the Han dynasty that we hear of worship being paid to it. Later its appearance becomes a commonplace in Chinese history, and is sure to glorify a peaceful reign or flatter a successful ruler. Its last advent was at Feng-huang-fu in Anhui, where it scratched at Hung Wu's father's grave, and the imperial power passed into Hung Wu's hands. This town now sends out enormous numbers of pictures of the phoenix to all parts of the country." [4]

The phoenix, as a decorative motive in ceremonial costume, was formerly employed to a considerable extent by the Empresses of China. A beautiful ornament for a lady's head-dress is sometimes made in the shape of the phoenix, and somewhat resembles the vulture head-dress of the women of ancient Egypt.

AUTHORITIES.

[1] *Notices of Natural History,* in the "Chinese Repository," Vol. VII, 1839, pp. 250-1.
[2] Yetts: *Symbolism in Chinese Art,* p. 24.
[3] Mayers: *Chinese Reader's Manual,* Pt. I, 134.
[4] Couling: *Encyclopaedia Sinica*: PHOENIX.

PIG

(豬)

The pig is one of the domestic and sacrificial animals, and its flesh is much esteemed by the Chinese, although, as its diet is not always carefully supervised, and it is allowed to eat offal lying in the streets, the animal is often found to be infected with trichinosis. There is a God of Swine (豬圈之神) who is, however, invoked in case of porcine diseases.

This beast is the last of the symbolical animals corresponding to the TWELVE TERRESTRIAL BRANCHES (*q.v.*). The term *Chu,* pig, is commonly used as a Chinese surname, in the belief that the evil spirits will imagine a person so named is actually an animal, and therefore not worthy of attention. Under the form *shih* (豕) it figures as the 152nd radical, while its snout, *chi* (彐), constitutes the 58th. A fancy name for the pig is "the long-nosed general" (長喙將軍). The character *chia* (家)—family or home—is made up of a pig (豕) under a roof (宀). As in the case of the Irish peasant, the same roof frequently shelters the Chinese villager and his pigs. According to a common proverb, "the coming of a pig into the house betokens poverty, and the advent of a dog riches" (豬來窮狗來富); the reason advanced for this theory is that the pig only sleeps and eats, whereas the dog protects the family.

The wild boar (野豬) is a symbol of the wealth of the forest, and has its lair in the wooded hills, whence it issues and descends to commit depredations upon the fields below. It is snared in deep pits, which are dug at the foot of the mountains, and covered over with fresh grass. Specimens over 400 lbs. in weight, with 10 inch tusks, have been shot in the Yangtze valley.

The bristles or long hairs, growing on the back of the black hog, are an important article of export from China. Each animal yields about 6 lbs. of hair, which varies from 2 to 6 inches in length. This product is used in the manufacture

of brushes, also as thread for sewing shoes and harness, and in machinery, especially spinning and tobacco machines. The intestines, or "hog casings," as they are termed in the trade, are largely exported for use as containers for sausages. They are made up in "rings" or bundles of 13½ yards, three "strings" or lengths to each ring, and packed in barrels.

The following species of the pig family, or *Suidae*, have been mentioned by naturalists as occurring in China:

Sus paludosus, in the Yangtze Valley; *S. gigas*, in Manchuria; *S. coreanus*, in Corea; *S. meles*, in Kuangsi; *S. moupinensis*, in Szechuan, Kansu, Thibet, and Shensi; *S. leucomystax*, in Kiangsu.

PIKE
(槍)

A pike, Sanskrit *Khātvānya*, is one of the weapons or insignia of the divinities of Buddhism and Taoism, and was formerly used in Chinese warfare. Imitation pikes and spears, etc., are sometimes carried in wedding and funeral processions (vide Illustration under LAMAISM).

PINE
(松)

The pine, because it is evergreen, is regarded by the Chinese as an emblem of longevity, and, together with the fir, is cultivated for ornamental and utilitarian purposes. The pine and the cypress, which, unlike most other trees, do not wither in the winter, are used metaphorically for friends who remain constant in adversity. These trees are planted around the graves on the hillsides, as they are said to be disliked by the fabulous creature known as the *Wang-hsiang* (罔象), which is supposed to devour the brains of the dead.

The sap of the pine was said to turn into amber when the tree was a thousand years old. The beautiful white pine (*Pinus bungeana*) is highly revered in China—the only country in which this variety is found. (Vide also TREES.)

PLANT OF LONG LIFE
（靈芝草）

The *Ling chih,* or Plant of Immortality, is a species of fungus, probably the *Polyporus lusidus,* which grows at the roots of trees. "When dried, it is very durable, whence it has been considered by the Chinese as an emblem of longevity or immortality. Large specimens of the fungus itself, or imitations of it in gilt wood, are preserved in the temples, and representations of it frequently occur in pictures of Lao Tzu and the immortals. It may also be seen in the mouth of deer." [1] The design of the sceptre or Joo-I (*q.v.*) is said to have been conceived from the sacred fungus of Longevity.

"In the 說文 Dictionary it is termed a 'divine plant' (神草), and it is said to be produced when virtuous monarchs are about to reign. Its seeds were reputed by the mystics of the Taoist sect as the food of the genii, and it is symbolical in general of all that is bright and good." [2]

"It was believed that 'Three Isles of the Blest' (三仙山) existed in the Eastern Sea, opposite the coast of China. In these supposed abodes of Immortals the sacred fungus grew, and wine flowed from a fountain of jade. Whoso ate and drank of them attained eternal life. . . . Later these island abodes of Immortals and the marvels they contained became a favourite theme for artists and poets, who delighted in portraying a mysterious world of fantastic palaces, set in romantic scenery and peopled with members of the Taoist mythology." [3]

Large quantities of fungi are eaten by the Chinese of every province, and are believed to possess valuable tonic or dietetic properties. Among the principle species used are the Agarics known as the Devil's Umbrellas (鬼蓋), and Earth's Umbrellas (地蓋), which are burnt and applied to sores; Earth's Ears (地耳), used as tonic; Wood Ears (木耳), which are parasitic fungi growing on trees, are used as food, together with the Stone Ears (石耳), a polyporous growing on rocks; certain Mushrooms (土菌), and Toadstools (地蕈), some of which are said to cause irrepressible laughter, are also consumed; Thunder-balls (雷丸), *Mylitta lapidescens,* are underground truffles with the reputed power of destroying worms and casting out devils.

"Fungus is actually cultivated, and not merely collected where it grows naturally, as one would suppose. The Chinese cut a large number of small oaks and remove the branches,

TAOIST PHILOSOPHER WHO HAS DISCOVERED THE SACRED FUNGUS
OF IMMORTALITY

leaving the bark intact. They are then leaned against a long trunk placed horizontally at a height of about six feet, and during the following summer the brown fungus appears on the dead trunks, to be collected as it grows. It is also collected from the decaying stumps of oak trees, where its growth is carefully watched and cultivated."[4] (*Vide* also ELIXIR OF LIFE, ISLANDS OF THE BLEST, JADE.)

AUTHORITIES.
[1] Franks: *Bethnal Green Museum Catalogue of Oriental Porcelain*, p. 246.
[2] Mayers: *Chinese Reader's Manual*, Pt. I, 57.
[3] Yetts: *Symbolism in Chinese Art*, pp. 18-19.
[4] Dingle and Pratt: *Far Eastern Products Manual*, No. 74.

PLANTAIN
（芭蕉）

The plantain, *Musa sapientum*, is popular among the Chinese for its fruit, shade and ornamental appearance. Next to the sago-palm it produces the greatest amount of wholesome food, in proportion to its size, of any cultivated plant. The fruit develops best in the southern regions, where it is a common article of diet. The tree rises to a height of fifteen or twenty feet and grows very rapidly in the warm weather.

There is a legend of a student of old who wrote on plantain-leaves for want of better material; hence the tree is the emblem of self-education. The plantain is often depicted on porcelain, the large spreading verdant leaves being very happily treated.

PLUM
（梅）

Both the wild and the domestic varieties of the *Prunus*, or plum-tree, are met with in the central provinces. The best plums are found in Shantung, where the remarkable hybrid apricot-plum （杏 李） is also cultivated. The plum is much appreciated for its flowers and fruit, though some Chinese writers have attributed injurious and even poisonous qualities to the latter. The kernels are used in the treatment of coughs, and the root-bark was formerly prescribed as an antifebrile remedy.

The genus *Prunus* is frequently denoted by the term *Li* (李), an ideogram (會意) composed of the radical *mu* (木), wood, and *tzŭ* (子), offspring, which exemplifies the prolific nature of the fruit. Pupils are sometimes referred to as peaches and plums, being unripe fruit receiving their development from the teacher. The word *Nai* (奈) also stands for some of the members of the plum family.

The plum, peony, lotus, and chrysanthemum are symbolical of the four seasons, the plum being the emblem of winter. The fruit is "equally prized for its fruit and its blossoms. The fragrance and snowy purity of the latter have been celebrated in numberless verses." [1] It is commonly regarded as a symbol of long life, owing to the fact that the flowers appear on the leafless and apparently lifeless branches of the tree until it reaches an extremely advanced age. "Though not properly an emblem of longevity, it is indirectly connected with it, as the philosopher Lao Tzŭ, the founder of the Taoist sect, is said to have been born under a plum-tree. It forms the decoration of the porcelain erroneously termed 'mayflower,' or 'hawthorn' pattern." [2] The reticulated deep azure background on which the white plum-blossoms are strikingly depicted in the blue and white chinaware is intended to represent the broken ice, which has floated down the rivers from the north in the early spring, and upon which the flowers have lightly fallen. The plum blossom has been selected by the Central Political Council (中央政治委員會) as the "National Flower" because of its five petals, which may be taken to represent the "Five Clans" (五族), *i.e.*, Chinese, Manchus, Mongolians, Mohammedans, and Thibetans—and also the "Five Power Constitution" (五權憲法) of the Chinese Republic.

A legend is recorded of a certain artist, who, in crossing a desert where he could find no spring, painted a plum so skilfully that, whenever he looked at it, it made his mouth water and thus prevented his feeling thirsty. The soldiers of the resourceful General Ts'ao Ts'ao (曹操), A.D. 155-220, were on one occasion in need of water to slake their thirst. Their commander advised them to look their fill upon a distant grove of plum-trees; the thought of the juicy fruit, it is related, made the men's mouths water, and so they obtained partial satisfaction. Hence "gazing on plums to quench thirst" (望梅止渴) has become the Chinese equivalent of "sour grapes."

The scholar Ts'ao Chih (曹植), A.D. 192-232, has enriched the language with one of its most familiar and delicious quotations:

"The Superior Man takes precautions,
And avoids giving rise to suspicion;
He does not pull up his shoes in a melon-patch,
Nor adjust his cap while passing through a plum-orchard."

（瓜田不納履。李下不整冠）.

AUTHORITIES.

[1] Mayers: *Chinese Reader's Manual*, Pt. I, 486.
[2] Franks: *Bethnal Green Catalogue of Oriental Porcelain*, 2nd Ed.

PO KU T'U

（博古圖）

A well-known work in twenty volumes, containing about 900 plates of bronze vases, tripods, bottles, mirrors, etc., used or made during the Shang, Chou and Hsia dynasties. It was from this publication that Mr. P. P. Thoms compiled his work, *A Dissertation on the Ancient Chinese Vases of the Shang Dynasty from 1743 to 1496* B.C., illustrated with 42 Chinese wood engravings, London, 1851. Mr. Thoms also wrote on this subject in the *Transactions of the Royal Asiatic Society*, Nos. 1 and 2, in 1834. Mr. Thoms remarks in his book that "in the early periods of Chinese history, a custom seems to have prevailed of interring with the dead honorary vases, which reposed with them for ages; but during the civil wars, more particularly that about A.D. 200, the graves of the ancient monarchs and eminent statesmen were dug up and their ashes dispersed; then there were many of these ancient relics discovered, and a new order of things having been established, they have been preserved to the present period. Regarding them merely on account of their symmetry and style of ornament, they cannot fail to be interesting to all who attach a value to what is ancient; while their inscriptions establish, unquestionably, the fact that the present Chinese written character is derived from hieroglyphical representations." The *Po Ku T'u* contains illustrations and much valuable information concerning the symbolic meaning of various forms of ornament. It was compiled by Wang Fu (王黼), an archaeologist and art critic of some repute.

POMEGRANATE

（石榴）

The pomegranate, *Punica grantata*, is not a native of China, Chang Ch'ien (張騫), of the Han dynasty, having

brought it from An-shih Kuo (安石國), or Cabul, in 126 B.C. Hence it was originally called An Shih Liu (安石榴). As a flowering shrub, with its handsome single and double blossoms, ranging in colour from white through pale pink to dark red, it is much cultivated in China, and many varieties are produced, but it is not very highly appreciated as a table fruit. The best varieties come from Shantung, Hupeh, and Honan. The brilliant red fruit is compared to a tumour, and, when burst open, revealing the numerous seeds, it is said to resemble a grinning mouth of teeth. The flowers are used with iron to make a hair-dye, the root is given as a tonic, and the dried pericarp or peel is regarded as an astringent and anti-rheumatic remedy and prescribed in the treatment of dysentery and diseases of the eye.

"The pomegranate is a Buddhist sign, the fruit being supposed to represent the essence of the favourable influence believed to exist in the pomegranate tree, a twig of which is sometimes used instead of willow for sprinkling water. When peaches are not obtainable, even the Taoists would make use of pomegranates in their place at temple functions." [1]

Doolittle quotes the following house-door inscription:
"The Pomegranate gleams with fiery light;
The Pear shines bright and pure, a frosty white."
（榴 紅 似 火。梨 白 如 霜。）

This would symbolise the hope of the family for numerous offspring behaving in a virtuous and filial manner and rising to fame and glory. The pomegranate, as in ancient Greece, is, owing to its numerous seeds, an emblem of posterity, while the pear is a symbol of purity and justice.

AUTHORITY.
[1] Gulland: *Chinese Porcelain*, Vol. I, p. 108.

PRAYING-MANTIS
（螳 螂）

Mantis religiosa, or the praying-mantis, is a grotesque and slender insect, with a pair of legs in front resembling a person's hands when folded in prayer. "The word 'mantis' means 'prophet,' the name having been given to this insect by the ancient Grecians, who saw in its position and gestures a resemblance to those of their priests and priestesses." [1]

It belongs to the order of *Orthoptera*, or "straight wings," which includes the locusts, grasshoppers, crickets, and cock-

roaches. Its habitat is the tops of bushes and flowering plants where it lies in wait for its prey.

"The female mantis is in the habit of devouring her mate, as is the manner of certain spiders, a thing made possible by the smaller size of the male." [2]

It is most voracious, and in its quest for food it crosses hills, rivers, and all other obstacles, and it attacks other insects, even those larger than itself, such as the CICADA (*q.v.*). The poet Lo Hung-hsien (羅鴻先), of the T'ang dynasty, wrote: "Man, by nature, is never satisfied, and resembles a snake attempting to swallow an elephant; in life, moreover, the praying-mantis pounces upon the cicada" (人 心 不 足 蛇 吞 象。 世 事 到 頭 螳 捕 蟬). The Chinese relate that it will even stretch out its feelers to stop a cart, and they regard it as a type of greed and pertinacity.

AUTHORITIES.

[1] Sowerby: *A Naturalist's Note-book in China*, p. 227.
[2] *Loc. cit.* p. 229.

P'U HSIEN

(普 賢)

Sanskrit *Samantabhadra*, the "All Gracious," a Bodhisattva who, though not very prominent in Indian Buddhism, is very popular in China.

He is the patron saint of Mount Omi (峨嵋山) in Szechuan, where there are many temples in his honour.

His Sanskrit name means "Great Activity" (大 行). He is represented with a greenish face, wears a yellow robe with a red collar, and rides upon a white elephant. This elephant could change into a man, and fought with P'u Hsien, was conquered by him, and allowed him to ride on his back. Some representations of this deity have a very feminine appearance, which is due to the fact that the gods have the power of changing their sex at will (*Vide* KUAN YIN, THREE GREAT BEINGS.)

P'U HSIEN MOUNTED ON A WHITE ELEPHANT

QUAIL

(鹌 鹑)

Coturnix vulgaris. This gallinaceous bird, so closely allied to the partridge, is met with in large quantities in China, and is greatly valued on account of its fighting qualities. The Chinese "carry them about in a bag, which hangs from their girdle, treat them with great care, and blow occasionally on a reed to rouse their fierceness. When the bird is duly washed, which is done very carefully, they put him under a sieve with his antagonist, strew a little millet on the ground, so as to stimulate the envy of the two quails; they very soon commence a fight, and the owner wins the prize." [1]

The quail is an emblem of courage on account of its pugnacious character, and, owing to its ragged appearance, is also a symbol of poverty and patched clothing.

AUTHORITY.

[1] Gutzlaff: *China Opened*, Vol. I, p. 37.

QUEEN OF HEAVEN

(天 后)

The Taoist Queen of Heaven and Holy Mother (天后 聖母), Ma Tsu P'o (媽祖婆), is the seafarer's goddess, to whom he prays or sacrifices for fine weather and safe conduct.

She is said to have been a virgin named Lin (林), who lived some centuries ago near Foochow, and is supposed to

THE TAOIST QUEEN OF HEAVEN WITH HER TWO ATTENDANTS

have control of the elements of nature. "The 'Goddess of the Sea' was the daughter of a Fukien fisherman. She was ever filial in her bearing and daily chanted long prayers calling down blessings on the heads of her parents. On one occasion she fell into a trance while her parents were out fishing. In her dream she learned that they were in danger of being swamped by the high seas. She thereupon ran to the seashore and fixedly pointed to the parental boat which, alone of the whole fishing fleet, came safely back to shore. Since her deification she is credited with having cured an Emperor of a disease which had defied the skill of the best physicians. Her attendants 'Thousand Mile Eyes' (千里眼) and 'Fair Wind Ears' (順風耳) are credited with the possession of abnormally sensitive ocular and auricular perceptions." [1]

This divinity is worshipped previous to the first trip of the fishing season on the 23rd day of the 3rd moon, when incense and candles are lighted, and an offering of chicken and roast pork made, with prayer for protection on the deep. Temples and shrines for the Holy Mother may be seen at short intervals along the lines of water communication throughout the country. When new nets are made or old ones mended, they are spread out by the owners and sacrifices offered to propitiate the goddess. Every junk is furnished with her image, before which a lamp is kept burning. Models of fishing craft are sometimes presented to the temples in her honour as a sign of appreciation of benefits anticipated or received. When a junk is about to proceed on a lengthy voyage, the goddess is taken in a procession to a temple when many offerings are placed before her. On sailing out of the harbour mock-money of paper is thrown out at the stern, and worship is also made to the compass.

This divinity is also called the "Matron of the Measure" (斗姆), and is identified with the Buddhist Goddess *Maritchi* (摩利支), while, like the Goddess of Mercy, she has also been compared with the Virgin Mary (*vide* KUAN YIN, STARS).

AUTHORITY.

[1] *Catalogue of the Collection of Chinese Exhibits at the Louisiana Purchase Exposition*, St. Louis, 1904, p. 269.

RAT

(鼠)

The written symbol for this animal is derived from the ancient pictogram of a rat, figuring the head, whiskers, feet, and tail.

The rat is one of the symbolical animals corresponding to the first of the TWELVE TERRESTRIAL BRANCHES (*q.v.*), and is an emblem of timidity and meanness. It is also regarded as the symbol of industry and prosperity on account of its ability for locating, acquiring and hoarding abundant supplies of food.

It is a recognised article of diet in Canton, where it is dried and exposed for sale, and chiefly consumed by the boat-population (蛋 家), and by persons who have a tendency to baldness, the flesh being considered an effective "hair-restorer."

These vermin are very numerous, and act as carriers of a parasite which serves as a host for the plague-germ, which causes so much devastation in North China. The marmot or tarbagan, *Aretomys bobac,* for the skins of which there is a great demand, is another rodent believed to be instrumental in the transmission of bubonic and pneumonic plague.

The rat was supposed by the ancient Chinese to turn into a quail in the spring, and quails into rats during the eighth month. The actual date of transformation was recorded in the imperial almanac.

REED-ORGAN

(笙)

The *Shêng,* or reed organ, is a musical instrument consisting of 17 bamboo tubes of 5 different lengths inserted into

the upper part of a gourd, which also contains a wooden mouthpiece in its lower end.

It is said to have been invented by Nü Kua (女媧), sister and successor of the legendary Emperor Fu Hsi (伏羲), 2953-2838 B.C., and is intended to symbolize the PHOENIX (q.v.), the reeds resembling the tail of that bird of good omen. It was formerly used at weddings, funerals, and imperial religious ceremonies, but is now only employed on rare occasions. It is played by sucking in the breath, though sounds may also be produced by blowing on it. On this account there is an old superstition that those who took up practice on the *shêng* became so enamoured of its dulcet notes that they played to excess, thus causing inflammation of the bronchial tubes and lungs, and death before the age of forty.

Kratzenstein, a Russian musician, became possessed of a *shêng*, and built an organ on the same principle with similar reeds, which led to the invention of the accordion and harmonium in Europe. (*Vide* also MUSICAL INSTRUMENTS.)

RHINOCEROS HORNS
(犀 角)

The "sworded cow," or the rhinoceros (犀牛), was formerly found in Szechuan, but the animal is now extinct. The fossil teeth are occasionally excavated, to be sold as "Dragon's Teeth," and ground up for medicinal purposes. The hide used to be made into a jelly (海犀膏).

The horns are imported from Siam, Cochin China, Sumatra, and India. "Only the horns of the rhinoceros are composed wholly of horny matter, and this is disposed in longitudinal fibres, so that the horns seem rather to consist of coarse bristles compactly matted together in the form of a more or less elongated bone."[1] They are sometimes carved in very intricate designs for ornamental purposes, and were used as drinking vessels in days of old, being said to reveal the presence of poison by sweating. They are powdered and made into medicine at the present day, the black and pointed kind being considered the most efficacious for the compounding of tonics.

A pair of rhinoceros horns symbolises happiness, and is one of the EIGHT TREASURES (q.v.).

AUTHORITY.
[1] Dingle and Pratt: *Far Eastern Products Manual*, No. 99.

RICE

(米)

Although the natives of Hopeh, Honan, Shensi, and Shantung show a preference for wheat, which is more easily grown in the dry climate of these provinces, yet rice, *Oryza sativa*, may be considered the staple food of the Chinese, and is profusely cultivated in the Yangtze Valley and the plains of Hunan, Kwangsi, and elsewhere. The annual yield is estimated at over thirty million tons a year.

There are many names for rice in its different stages and qualities, *e.g.*, *Ku* (穀), the ripe grain in the husk; *Su* (粟), paddy; *No Mi* (糯米), glutinous rice; *Tao* (稻), rice in the straw; *Mi* (米), hulled rice; *Fan* (飯), cooked rice; etc., which show the great importance it has for China.

Rice is often faced with sulphate of lime, or levigated marble, to give it whiteness and increased weight. "Glutinous rice dumplings are made at the time of the Fifth Moon Feast and consumed in large quantities. Puffed rice is eaten by persons with weak digestions, and sweetmeats are also made from this rice; it is used in diarrhoea, in the shape of a conjee, as a diuretic in fevers, and cakes of it fried in camel fat are used for hemorrhoids. The rice flowers are used as a dentifrice, the stalk is recommended for biliousness, and its ash for the treatment of wounds and discharges." [1] Rice straw (稻稈) is employed to make paper, matting, sandals, rope, thatch, and fertilizer; it also serves as a cattle-fodder.

The sweet rice-cakes, round or oval in shape, eaten at New Year, typify pleasure by their sweetness, and are suggestive by their shape of a complete family circle, and symbolise peace and harmony in general. Similar rice-cakes, but stuffed with pork, are consumed on the 15th day of the 1st month, or the first full moon of the year, and are clearly connected with the ancient worship of the moon. "The upsetting of a basin of rice on the table or elsewhere is very unlucky, and to take away any person's rice-steamer and empty it on the ground is one of the greatest insults that can be given to a family." [2]

The worship of the rice-measure is described under STARS (*vide* also GRAIN MEASURE), and the symbolic use of grains of rice for purposes of decoration is shown under TWELVE ORNAMENTS. The so-called "rice china" is stamped out in holes which are glazed over. Sheaves of rice appeared upon

the Order of the Excellent Crop (嘉禾章), on the collars, arm-bands, and belt buckles of the naval uniform, and on coins, etc. The rice-plant in fact, may undoubtedly be regarded as a national emblem (*vide* AGRICULTURE).

AUTHORITIES.
[1] Couling: *Encyclopaedia Sinica*: RICE.
[2] Hutson: *Chinese Life in the Thibetan Foot-hills.* New China Review, Vol. II, No. 6, Dec., 1920.

RING

(圈)

The circle is believed by the Chinese to be the origin of all creation; when split into two round or ovoid segments it is said to be reduced to its primary constituents, the male and female principle (*vide* T'AI CHI).

"A ring is the symbol of eternity with the Chinese, who say it has no beginning; and hence very naturally regard it as emblematical of dignity and authority. Two rings are especially worthy of regard: one perfect, the other defective; the former an emblem of the sovereign's favour, the latter, of his displeasure, as shown towards his public servants. In olden times, when officers who had been banished to the frontier for mal-administration, had completed the term of their sentence, the one or other of these rings was sent to them by the Emperor: if it were the perfect one, it denoted that he was about to restore them to their official duties, despite their temporary disgrace, without detriment to character or emolument; but if the defective ring were sent, it was a token that the offender's connection with the government was forthwith dissolved."[1]

AUTHORITY.
[1] Kidd: *China*, pp. 279-280.

ROSARY

(念珠)

The rosary, Sanskrit, *Mala,* is an essential part of the dress of the Buddhist priest, and is also worn by the people for religious reasons. It was an item of the ceremonial costume of officials of the nine grades under the late imperial form of government.

Rosaries are sometimes perfumed with musk, etc., and are composed of pearls, emeralds, rubies, sapphires, turquoise, coral, amber, crystal, jade, lapis-lazuli, bone, gold, wood, seeds, snakes' vertebrae, etc., being worn either as a necklace or as a girdle.

There is a small rosary of eighteen beads, symbolising the the EIGHTEEN LOHAN (*q.v.*), but the common article contains 108 beads of uniform size, one of the alleged reasons for this number being to ensure the repetition of the sacred name of Buddha a hundred times, the extra beads being added to make up for possible omissions through absent-mindedness during the telling process or for loss of beads by breakage. The two ends of the string of beads, before being knotted, are passed through three extra beads, the centre one being the largest. These beads keep the rosary beads in possition and indicate to the teller the completion of a cycle of beads; the triad of beads symbolises the "Three Holy Ones" of the Buddhist trinity, viz: Buddha, the Word, and the Priesthood, the large central bead representing the Master. The hidden string stands for the penetrating power of all the Buddhas, and is sometimes made of human hair.

SCROLLS

1, 2, 3, CONVENTIONAL SCROLL DESIGNS USED IN THE DECORATION OF PORCELAIN, ETC. 4, SCROLL DEPICTING THE GOD OF LONGEVITY. 5, WRITTEN SCROLL. 6, WRITTEN SCROLL. 7, SCROLL PICTURE OR SCROLL-PAINTING

SCROLL

(幅)

The Chinese are past masters in the art of making scroll
pictures and mottoes, a common form of ornamentation in
every house throughout the country. Antithetical couplets,
the wording of which is balanced with great precision, are
written on red paper, and pasted on house-doors, in the belief
that the revered character of holy and mystic origin will
ensure continual happiness and prosperity to the household.

In Buddhism the scroll is the sacred text of the scriptures,
and the store of truth. It is also the emblem of Han Shan
(寒 山), a Chinese poet of the 7th century, and implies the
unwritten book of nature. In former times books were made
in rolls (*vide* WRITTEN CHARACTERS).

SEALS

(圖 章)

"Seals, among the Chinese, are made in many shapes,
though the importance attached to them as attesting the
validity of documents is hardly so great as it is among the
Arabs or Persians. Motto seals are not uncommon, the
characters of which are written in some one of the ancient
forms, usually the *chuan tzŭ* (篆字)—from this use called
the seal character—and are generally illegible to common
readers, and even to educated men, if they have not studied
the characters. Seals containing names are more frequently

 惟吾知足

 一壺酒

 卧月

1　　　　　2　　　　　3

 時乎時乎
不再來

 人間天上

4　　　　　　　5

 樂是樂此
學是學此學
此樂

 日雲
中中

 夕陽江上樓

6　　　　8　　　　7

EXAMPLES OF CHINESE SEALS

cut in the common character, and ordinarily upon stone."
Wood, bone, ivory, crystal, china, glass, brass and other
substances are also employed, and the stamping-pad is
generally composed of moxa punk or cotton wool mixed with
bean oil and vermilion.

The examples illustrated will serve to exemplify the usual
styles of cutting, and the sentiments commonly admired. The
first three allude in their shape to the sentiments engraved
thereon. The cash (the symbol of wealth) intimates that its
possession is as good as all knowledge; the wine-cup refers to
the pleasures of the wine bibber; and the new moon to the
commencement of an affair, or the crescent-like eyebrows of a
fine lady. The fourth is written in an ancient and irregular form
cut in the style known as *yin tzŭ* (陰字), or female character,
the fifth in a very square and linear form of the seal character
cut in the style known as *yang tzŭ* (陽字), and refers to the
cosmogony of the Chinese, which teaches that heaven and
earth produced man, who is between them, and should therefore
be humble. In the sixth the characters with lines beneath
are to be repeated, in order to complete the sentence. The
characters of both the sixth and the seventh are *chuan tzŭ* of

SEAL OF THE FIRST EMPEROR OF THE CH'IN DYNASTY. FLYING FIGURES, IN
ALLUSION TO THE TAOIST FAIRIES, WITH WHOM THE EMPEROR WISHED TO
ENTER INTO RELATIONS.

different ages; the latter approaches the original ideographic forms. In the eighth, which reads: "the sun among the clouds" (日雲中), the middle character is a very contracted, running hand, while the other two are ancient forms.

Every Chinese official of any standing has had a seal of office since the establishment of the Sung dynasty, A.D. 960. The seals of the highest provincial officials were oblong and made of silver. Magistrates used square silver seals, and the lower official employed wooden seals. An official generally places his seal in the charge of his wife, as very serious consequences, entailing even dismissal from office, might result from its accidental loss. As the official seal denotes the power of authority, it has also come to be considered by the people as possessing potency for the cure of diseases, and impressions of such seals are sometimes torn from proclamations and other documents, and applied to sore places, ulcers, etc.

AUTHORITY.
[1] *The Chinese Repository*, Vol. XVII, Nov., 1848, Art. IV, p. 592.

SECRET SOCIETIES
(私 會)

The numerous secret societies which have existed in China at various times have been formed chiefly for political, but sometimes also for religious, or personal reasons.

The chief of these organisations was the Triad Society (三合會), besides which may be mentioned the Vegetarians (喫素教), Elder Brothers (哥老會), Red Eyebrows (赤眉), Golden Orchid Sect (金蘭會), and the Boxers (義和拳).

The Triad Society was originally formed for the purpose of overthrowing the Manchus and restoring the Ming or Tartar dynasty. In its complicated ceremonies of initiation many Buddhist and Taoist emblems are employed (*vide* Stanton: *The Triad Society or Heaven and Earth Association*, pp. 38 *seq*).

The members of the Vegetarian Sect abstain from meat and put their hope in the Pure Land of the West (*vide* SHAKYAMUNI BUDDHA).

The Elder Brothers base their society on the friendship of Liu Pei (劉備), Chang Fei (張飛), and Kuan Yü (關羽), the three sworn brothers and heroes of the period of the Three Kingdoms.

The Red Eyebrows existed about the beginning of the Christian era and were originally a body of rebels who painted their eyebrows red.

The Emperor Asoka placed a great monolith called "The Pillar of Asoka" on the exact spot where the Gâutama Buddha was born, with the inscription "Here the Blessed One was born", and, in 1895, Dr. Führer—a noted archeologist—discovered the pillar, when, by permission of the Maharajah of Nepaul, he was allowed to visit there.

The Golden Orchid Society is an association of girls sworn never to marry.

The Boxers were originally a society of women and youths who practised incantations and hypnotism and subsequently developed into an anti-foreign organisation.

There is said to be a considerable resemblance to Freemasonry in the ritual of many of the Chinese secret societies, which have always been under the ban of the law on account of their political or otherwise objectionable tendencies.

SEVEN APPEARANCES
(七 相)

The various emblematic and auspicious signs on the FOOT-PRINTS OF BUDDHA (q.v.). They are the SWASTIKA, FISH, DIAMOND MACE, CONCH-SHELL, FLOWER-VASE, WHEEL OF THE LAW, and CROWN OF BRAHMA (q.q.v.).

SHÂKYAMUNI BUDDHA
(釋 迦 牟 尼)

"From Shâkya (one who is) mighty in charity, and muni (one who dwells in) seclusion and silence. The favourite name among the Chinese for the great founder of Buddhism." [1]

"Prince Siddartha, known as Shâkyamuni Gâutama Buddha, was born 624 B.C. at Kapilavastu (迦 維 羅 衛)—'the city of beautiful virtue '—on the borders of Nepaul (lat. 26° 46' N. and long. 83° 19' E.), and died in his 80th year. He was the son of a king; but renounced the pomps and vanities of this wicked world to devote himself to the great task of overthrowing Brahmanism, the religion of caste." [2] His birthday is celebrated as a religious festival in China on the 8th day of the 4th moon. The traditional father of Buddha was the Brahman King Suddhodana (白 淨 王). His mother Maya (摩 耶), or Maha-maya déva, was a daughter of Anjana or Anusâkya, King of the country of Koli, and Yasodharâ, an aunt of Suddhodana. There seem to have been various intermarriages

between the royal houses of Kapila and Koli. At the age of fifteen the young Prince was made heir-apparent; at seventeen he was married to Yashodara, a Brahmin maiden of the Shakya clan, and his son Râhula was born in the following year.

According to the *Lalita-Vistara*, Shâkyamuni had "a large skull, broad forehead, and dark eyes; his forty teeth were equal and beautifully white, his skin fine and of the colour of gold; his limbs were like those of Ainaya, the king of the gazelles; his head was well shaped; his hair black and curly." "The type of head conforms to fixed tradition regarding marks of identity (*lakshanas*)—e.g., eyebrows joined together; a bump of wisdom on the top of the head (*ushnisha*), covered in the case of the Bodhisattva by the high-peaked tiara; three lucky lines on the neck; the lobes of the ears split and elongated in a fashion still prevalent in Southern India; a mark in the centre of the forehead (*urnā*) symbolising the third eye of spiritual wisdom."[3] Representations of Buddha, though possessing these marks of identity, vary slightly according to the country in which they have been made, and show unmistakeable signs of national character. The deity is in fact an ideal racial type rather than an individuality.

There are numerous legendary incidents connected with the Buddha who gave up kingdom, city, wife, and son to devote himself to the inculcation of his doctrines. He is said, on one occasion, to have plucked out his eyes to give to another; he cut off a piece of his flesh to ransom the life of a dove pursued by a hawk; he gave his body to feed a starving tigress; he flung an elephant over a wall, etc. (*vide* Spence Hardy: *Manual of Buddhism*). He appeared six times in the form of an elephant; ten times as a deer; and four times as a horse (*vide* also BODHI TREE, ELEPHANT, FOOTPRINTS OF BUDDHA).

The relics of his body after his death and cremation at Kusinara (180 miles N.W. from Patna, near Kusiah, about 120 miles N.N.R. of Benares, and 80 miles due east of Kapilavastu) were divided among the eight kings of Kusinara, Pâvâ, Vaisîlî, and other kingdoms, who erected topes, pagodas, stupas, and temples in which they were enshrined; many of the relics subsequently passed into China and Japan, and great virtue was ascribed to them.

"The Chinese language, although extremely rich in symbols to convey all sorts of ideas, did not contain a character or symbol that would convey their highest ideals of the Founder of the Higher Buddhism—the Mahayana. They therefore invented one composed of two symbols, 弗 *not*, and 亻 which

means man. They wrote the symbol for their ideal Founder thus 佛, pronounced *Fo,* meaning that he is not human but Divine." [4]

Buddha is generally represented as enthroned on the Lotus, the three right hand fingers being lifted in blessing; "the head is 'snail-crowned,' *i.e.,* with the characteristic spiral curls, an allusion to the beautiful legend current in India that one day when, lost in thought as to how to assuage the world's woes, Buddha was oblivious of the Sun's fierce rays beating on his head, the snails in gratitude to Him who loved and shed his blood for all living things, crept up and formed a helmet of their own cool bodies." [5] He is sometimes figured holding a weaver's shuttle in his hand, symbolical of his passing backwards and forwards from life to life, as the shuttle is guided by the weaver's hand. He is also sometimes shown in feminine form as the Goddess of Fertility, holding a pot of earth in his left hand, and a germinating grain of rice in the left. He is occasionally depicted with the symbols of learning (book) and courage (spear-head) emanating from his closed fists. On the temple altars the golden Buddha is seated in the centre; on his right is usually Anânda, the writer of the sacred books of the religion, and on his left Kas'yapa, the keeper of its esoteric traditions. But sometimes the place of these two disciples is occupied by two other representations of Buddha, *viz.,* Buddha Past and Buddha Future.

Shâkyamuni Buddha was not the only Buddha or enlightened one; other Buddhas, some of whom may have been adopted from the legends or beliefs of the many races with which the faith had come in contact outside India, also receive the prayers of the devout, for example, AMITÂBHA, MAITREYA BUDDHA (*q.q.v.*), etc. Every intelligent being who has thrown off the bondage of sense, perception, and self, and knows the utter unreality of all phenomena, is qualified to become a Buddha. Râhula (羅 喉 羅), the eldest son of Shâkyamuni, is to be reborn as the eldest son of every future Buddha.

Buddhism was introduced into China in A.D. 67. The fundamentals and basis of the religion may be summed up briefly as follows:

1. Misery invariably accompanies existence.

2. Every type of existence, whether of man or of animals, results from passion or desire.

3. There is no freedom from existence but by the annihilation of desire.

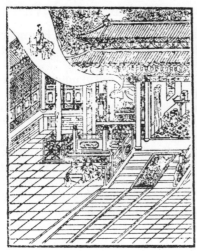

TOP LEFT: DREAM OF BUDDHA'S MOTHER OF HIS INCARNATION. TOP RIGHT:
THE NEW-BORN BUDDHA WASHED BY THE NINE DRAGONS. BOTTOM LEFT:
BUDDHA, MAHAYANISTIC TYPE. BOTTOM RIGHT: DEATH OF BUDDHA

4. Desire may be destroyed by following the eight paths to Nirvâna.

5. The "eight paths" are attained by correctness in one's views, feelings, words, behaviour, exertions, obedience, memory, and meditations.

The Buddhist scriptures are chiefly written in Sanskrit or Pâli, but printed explanations in colloquial Chinese are also obtainable. The Three-fold Canon (三 藏), Sanskrit: *Tripitaka,* or "three baskets," consists of the *Sûtras* (修 多 羅) or doctrinal records, the *Vinaya* (毗 尼), or writings on discipline, and the *Abhidharma* (阿 毗 曇), or writings on metaphysics.

The Five Precepts of Buddhism, Sanskrit: *Pancha Veramani,* (五 戒) are:

1. Slay not that which hath life (不 殺 生).
2. Steal not (不 偷 盜).
3. Be not lustful (不 欲 邪 行).
4. Be not light in conversation (不 妄 欲).
5. Drink not wine (不 飲 諸 酒).

"Buddhism not only introduced a whole world of alien mythology, which for centuries provided a favourite theme for Chinese painters, sculptors, and designers in every branch of Art, but it also directed the very expression of these new ideas along the lines of Western tradition. To the present day Græco-Indian and Persian elements are found mingled with the purely native decoration." [6]

There are many Buddhist monasteries in China, and also numerous nunneries, the latter being more common in the South. The monastery consists of a number of buildings and courtyards facing south with living-rooms, etc., on each side. There is something truly majestic in the apprearance of the broad and massive temples, with the grand upward sweep of their heavily-tiled, roofs and deep-shaded eaves, with an intricate maze of supports and carvings beneath; the whole sustained on colossal round posts locked and tied together by equally massive timbers (*vide* ARCHITECTURE). The first temple is called the Hall of the Four Great Kings (*vide* FOUR HEAVENLY KINGS), containing the images of those worthies, and also of MAITREYA BUDDHA, WEI T'O and GOD OF WAR (*q.q.v.*). The second is the Precious Hall of the Great Hero (大 雄 寶 殿) containing figures of SHAKYAMUNI BUDDHA, sometimes accompanied by AMITABHA and MANJUSRI (*q.q.v.*)

or some other. KUAN YIN (*q.v.*) has a shrine at the back of the altar facing north, and TI TSANG (*q.v.*) is also accommodated, while the EIGHTEEN LOHAN (*q.v.*) are seated along the sides. The third temple is the Fa T'ang (法堂), and is used for religious services.

The number of monks (和尚) in a monastery varies from 30 to 300 according to the size of the establishment. There are three ceremonies of initiation, the first being the admission as novice, the second the reception of the robes and bowl and pledge of obedience to the rules of the *Pratimokoksha,* and the third is the acceptance of the Bodhisatva's commandments (受菩薩戒), or the 58 precepts of Brahma's Classic (梵王經), when the candidate's head is branded by lighting pieces of charcoal placed on the shaven pate.

BUDDHIST MONKS WITH ROSARIES

OF 18 AND 108 BEADS

The primitive form of Buddhist doctrine is known as Hînayâna or *Hsiao Ch'êng* (小乘), *lit:* "Small Conveyance," also styled Theravada, or "School of Elders." It is characterised by the presence of much moral asceticism and the absence of speculative mysticism. It was succeeded by an advanced phase of dogma called Mahâyâna, or *Ta Ch'êng* (大乘), "Great Vehicle," with a less important link, Madhymâyanâ. While both sects claimed their doctrines to be the "vehicles" or means of arriving at Nirvâna (涅槃) or Salvation, the Mahâyânist creed is more emotional, ornate, and fanciful than the practical asceticism of the Hinayâna, and it advocates the power of human beings to actually become Bodhisattvas or divine beings by faith in Buddha. The two schools are sometimes spoken of as the Northern and Southern Buddhism.

With the introduction of the Mahâyâna system, the mysterious Nirvâna had, as a reward for virtue, been supplemented by a "Pure Land in the West" (西方淨土), Sanskrit, *Sukhavati,* where there is fulness of life, and no pain nor sorrow, no need to be born again, no Nirvâna even. This happy land is surrounded with a sevenfold row of railings, a

sevenfold row of silk nets, and a sevenfold row of trees. "In the midst of it there are seven precious ponds, the water of which possesses all the eight qualities which the best water can have, *viz.*, it is still, it is pure and cold, it is sweet and agreeable, it is light and soft, it is fresh and rich, it traquilises, it removes hunger and thirst, and finally it nourishes all roots. The bottom of these ponds is covered with golden sands, and round about there are pavements constructed of precious stones and metals, and many two-storied pavilions built of richly-coloured transparent jewels. On the surface of the water there are beautiful lotus-flowers floating, each as large as a carriage-wheel, displaying the most dazzling colours, and dispersing the most fragrant aroma. There are also beautiful birds there, which make delicious, enchanting music, and at every breath of wind the very trees on which those birds are resting join in the chorus, shaking their leaves in trembling accords of sweetest harmony." [7] This abode of bliss was naturally more attractive than the abstract and uninteresting Nirvâna of the Hînayânists, which is described as "the state of a blown-out flame."

It is a well-known fact that the principal religions of the world have borrowed largely from primitive beliefs and observances for the formulation of their ritual worship. Buddhism has much in common with Roman Catholic Christianity, having its purgatory, its Goddess of Mercy, and its elaborate machinery for delivering the dead from pain and misery through the good offices of the priests. Among other similarities may be mentioned celibacy, fasting, use of candles and flowers on the altar, incense, holy water, rosaries, priestly garments, worship of relics, canonization of saints, use of a dead language for the liturgy and ceremonials generally. The trinity of Buddhas, past, present, and future, is compared by some to the Father, Son, and Holy Ghost. The immaculate mother of Shakyamuni, whose name Maya is strikingly similar to that of Mary, the mother of Jesus, is also to be noticed, while Buddha's temptation on Vulture Peak by Mara the Evil One, may also be contrasted with the similar temptation of our Lord. The eighteen Lohan (formerly less in number), or followers of Buddha, have also been compared with the twelve disciples of Christ, who was born 600 years later than Buddha. The worship of ancestors is in some measure akin to the saying of masses for the dead, and at one time the Jesuits considered it a harmless observance and tolerated it in their converts. Finally the Dalai Lama is a spiritual sovereign closely resembling the Pope.

AUTHORITIES.

[1] Giles: *Glossary of Reference*: SHAKYAMUNI.
[2] *Loc. cit.*: BUDDHA.
[3] Havell: *A Handbook of Indian Art*, p. 153.
[4] Richard: *New Testament of Higher Buddhism*.
[5] Gordon: *The Lotus Gospel*, p. 290.
[6] Yetts: *Symbolism in Chinese Art*, p. 17.
[7] Eitel: *Lectures on Buddhism*.

SHEEP

(羊)

The written symbol representing the sheep is a conventional picture, or birds'-eye view, of a ram, showing horns, feet, and tail.

The sheep or goat (called the hill-sheep) is the eighth symbolic animal of the TWELVE TERRESTRIAL BRANCHES (*q.v.*), and the emblem of a retired life. The lamb is the symbol of filial piety, as it is said to kneel respectfully when taking its mother's milk. The goat is one of the six sacrificial animals and was undoubtedly known in China long before the sheep, which was a later importation called the "Hun-goat" (胡羊). according to an ancient legend, five venerable magicians, clothed in garments of five different colours, and riding on rams of five colours, met at Canton; each of the rams bore in his mouth a stalk of grain having six ears, and presented them to the people of the district, to whom the magicians said: "May famine and dearth never visit your markets." Having said these words they immediately disappeared, and the rams were changed into stone. Canton has therefore come to be known from this legend as the City of Rams (羊 城).

The domestic sheep (綿羊) is the broad-tailed species, and is not so common as the goat (山 羊) in the northern provinces. The long wool is shorn in some parts of China. The animals are chiefly fed on cut fodder owing to the scarcity of good grazing. The mutton is of good quality, and is consumed by Mohammedans, being only occasionally introduced at Chinese tables. The wild sheep (盤羊) has a ram's head with long spiral horns, and a deer-like body. There are various species, *e.g.*, *Ovis argale*, ranging over the Altai and Daurian Mountains; *O. jubata*, found in Mongolia, Shansi, and Hopeh; and *O. nahura*, a small animal which occurs in Kansu.

SHOP-SIGNS

(幌 子)

The variety and effectiveness of Chinese sign-boards is well known, but the symbols and emblems which accompany them are also worthy of attention. Shop-signs are usually images or pictures of the articles sold and generally have a red pennon attached to them. They are of all shapes and sizes, fixed in stone sockets on the ground, hanging from the eaves of the roofs, painted on the walls, lintels and door-posts, or suspended from a pole protruding over the street. The sign-board sometimes sets forth the name and birth-place of the proprietor as well as his trade or profession. "The sign-boards are often board planks fixed in stone bases on each side of the shop-front and reaching to the eaves, or above them; the characters are large and of different colours, and in order to attract more notice, the signs are often hung with various coloured flags bearing inscriptions setting forth the excellence of the goods."[1] "Some of them are ten or fifteen feet high, and being gaily painted and gilded on both sides with picturesque characters, a succession of them seen down a street produces a gay effect. The inscriptions merely mention the kind of goods sold, and without half the puffing seen in Western cities."[2]

PAWNSHOP SIGN

The practice of persons keeping small tables, where money can be changed, is very common in China. "Those who are itinerant, usually provide themselves with a small table, about three feet long by fifteen inches wide, and establish it on the way-side, at the corners of the streets, before the temples, and in the markets; in short, wherever there is a thoroughfare, the money-changer is not far off. The strings of copper cash are piled on one side, often secured to the table by a chain, and the silver is kept in drawers, with the small ivory yard with which it is weighed, which is more peculiarly the implement of this profession. Their sign is a wooden figure

THE EMPEROR SHUN

358

carved in the form of a cylinder to represent a string of cash." [3]

AUTHORITIES.
[1] Williams: *Middle Kingdom*, Vol. I, p. 83.
[2] *Loc. cit.*, Vol. I, p. 738.
[3] The *Chinese Repository*, Vol. VII, April, 1840, Art. V. pp. 643-4.

SHUN

(舜)

2317-2208 B.C.　A native of Yü-mu (虞幕) in Honan. His father Ku Sou (瞽瞍), said to be a descendant of the Emperor Ch'uan Hsü (顓頊), having a favourite son by a second marriage, took a dislike to Shun, and, assisted by his wife, made several attempts to kill him.

By his exemplary conduct towards his parents in spite of their ill-feeling, Shun has since been included in the twenty-four historic examples of filial piety.

At the age of twenty he attracted the notice of the Emperor YAO (*q.v.*), who made him his heir, setting aside his own unworthy son, and giving Shun his own two daughters Nü Ying (女英) and O Huang (娥皇) in marriage.

He was gifted with extraordinary mental and physical qualities, and was said to have had double pupils in his eyes, which no doubt added to his quick perception and ready grasp of the principles of good government.　He received the title of Ch'ung Hua (重華), implying that he rivalled his predecessor Yao in virtue.　At his death he was canonised as Yü Ti Shun (虞帝舜).

SILK

(絲)

The written symbol in use to express the word "silk"—derived from the Chinese *ssŭ* through the Latin *sericum*—is composed of the form *ssŭ* (糸) in duplicate, consisting of *ssŭ* (厶) repeated, derived from the figure of a silkworm coiled up in its cocoon, with three twisted filaments issuing therefrom.

The silkworm is an emblem of industry and its product is symbolic of delicate purity and virtue.　The art of sericulture

originated in China, and Lei Tsu (嫘祖), or the Lady of Hsi-ling (西陵氏), Consort of the Yellow Emperor, 2698 B.C., is said to have introduced the rearing of silkworms and the use of the loom.

"The name China is derived from Ssu which is the Chinese word for silk. All the names by which China was known to the ancients were also derived from that of the precious fibre. Seres, Tsin, Sinem, Sereca, and others all signify the land of silk. China is said to have an uninterrupted literary history which goes back to between two and three thousand years B.C., and in it there are many references to the silkworm, sericulture, silk weaving, and silk embroidery." [1]

During the reign of the Yellow Emperor the annual festivals of agriculture and sericulture were first instituted. In these festivals, among other ceremonies, the reigning emperor ploughed a furrow, and the empress made an offering, at the altar of her deified predecessor, of cocoons and mulberry leaves.

Chinese designs on silk are characterized by a natural treatment of flowers and other objects, and also of many frequently-repeated symbolic forms.

"The sericultural industry is pursued universally among the Chinese, but with the exception of main silk centres, the work is not attended to with any considerable zeal. Again, outside of Kwangtung and Kwangsi, the industry is pursued as a side business of farmers, and consequently run on a small scale." [2]

White silk is spun by the cultivated caterpillar *Bombyx mori,* which feeds on mulberry-leaves, wild silk of a brownish colour is reeled from the cocoons of the *Tussah* or *Antheræa mylitta,* which feeds on Manchurian oak-leaves, and a yellow variety is produced in Szechuan. The mulberry trees are planted round the edges of fields devoted to grain and other crops, or are grown on the raised embankments which separate the paddy-fields. Heavy damage is inflicted upon the silkworms by the *Merococcus,* causing a disease which develops in the worms just before they begin to cocoon. If diseased worms were discarded, and the eggs scientifically developed, a larger yield of better quality silk would undoubtedly result. The Yangtze valley is certainly capable of five times its present production. The International Sericultural Association, however, renders valuable assistance by the distribution of healthy selected stock-worms. Dr. Vartan

Osiglan's super-size worm, which—according to the *Illustrated Review*, Atascadero, California, January, 1921—spins a cocoon containing 1,800 yards of silk in any of eighteen different natural colours graduated by its diet, might with some advantage be introduced into China.

Silk is the premier article among the exports of the country. With the adoption of modern methods and steam filatures in all the leading centres, the quantity and quality of this important product would be very greatly improved.

"China was, no doubt, the first country to ornament its silken web with a pattern; the figured Chinese silks brought to Constantinople were there named 'diapers,' but after the 12th century, when Damascus became celebrated for its looms, the name of damask was applied to all silken fabrics richly wrought and curiously designed, and Chinese figured silks were included under this class. The designs used in weaving and embroidery are of varied character and can be traced back to very ancient times—the silk weaver is the most conservative of artisans and continues to use all the old patterns."[3]

AUTHORITIES.
 [1] Hooper: *Pitman's Common Commodities of Commerce*: SILK, p. 19.
 [2] Dingle and Pratt: *Far Eastern Products Manual*, No. 199.
 [3] Couling: *Encyclopaedia Sinica*, SILK.

SILVER

（銀）

The written symbol for this metal, which is an emblem of brightness and purity, is described as consisting of the form *kên* (艮), obstinate, and *chin* (金), metal, because it is so difficult to find in China. Argentiferous galena occurs, however, to some extent in Yunnan, Kuangsi, Kueichow, and Szechuan. Importations are made from India.

The use of silver as a measure of value became common under the Ming dynasty in the form of shoe-shaped ingots (元寶) or sycee (細絲). Dollars and subsidiary coinage are produced in the various mints. Before a silver ingot has solidified in the mould it is lightly tapped, when fine silk-like lines appear on the surface of the metal. The higher the "touch" (色) or purity of the sycee, the more like fine silk are the markings on its surface. Those ingots may be of any weight from 1 to 100 ounces.

A silver locket is sometimes suspended from a child's neck to protect it from evil influences. The milky way is poetically styled the "silver river" (銀 河), the moon, the "silver sickle" (銀 鈎), or "silver candle" (銀 燭), and the human eye, the "silver sea" (銀 海).

SKELETON STAFF

(骸 骨 棒)

A staff of wood or bone in the form of a conventional skeleton, and used by the Lama priests in their devil worshipping ceremonies (*vide* Illustration under LAMAISM).

SKULL-CUP

(顱 杯)

A libation cup fashioned from a human skull, Sanskrit, *Kapāla*. Used in Lamaism on the altars of the fiercer deities. It is usually mounted on a brass stand and filled with samshu, or rice-spirit (*vide* Illustration under LAMAISM).

SNAKE

(蛇)

The written symbol representing the snake is compounded of the form *ch'ung* (虫), reptile or worm, and *t'o* (它), hump-backed, which is derived from the figure of a cobra rising on its tail with dilated neck and darting tongue.

The serpent is one of the symbolic creatures corresponding to the sixth of the TWELVE TERRESTRIAL BRANCHES (*q.v.*), and is the emblem of sycophancy, cunning, and evil, while at the same time it is regarded with feelings of awe and veneration owing to its supposed supernatural powers and its kinship with the benevolent dragon. It is said to be very unlucky to injure a snake which has made its domicile below the floor of one's house; while to purchase a snake that has been captured, and liberate it, is considered a good deed that will not go un-

362

rewarded. The Chinese believe that elfs, demons, and fairies often transform themselves into snakes. The Buddhist priests occasionally harbour snakes around their temples.

According to one of the fables in the *Shan Hai Ching* (山海經), there was once a snake in Szechuan which devoured elephants and took three years to disgorge their bones. Pythons measuring upwards of 20 feet in length are, however, found in the far south of China. The most common snake is the harmless Columbrine, which is chiefly found under the floors of Chinese houses. Dilapidated graves afford seclusion for many of these reptiles. There are not many poisonous varieties, though the cobra is occasionally seen in the south, and certain species of vipers occur in various parts. Snakes are offered for sale as food in many cities and the poisonous kinds are sold to the druggists for the manufacture of medicines. The Chinese have various herbal remedies for snake-bite. and the mashed head of the reptile is sometimes applied to the wound as a poultice, on the principle of "the hair of the dog."

SNARE

(絆 脚 鎖)

Sanskrit *Pāsa*. A symbol of Siva, Varuna, and Lakshmi, employed in Lamaism. Its purpose is to rescue the lost or bind the opponents. It consists of a cord or chain with knots or metal knobs at each end (*vide* Illustration under LAMAISM).

SPEAR

(矛)

Many different varieties of long pointed weapons were employed by the Chinese until comparatively recent times in warfare and hunting. The long spear, curved lance, tiger-head hook, moon-shaped sickle, javelin, long shuttle, toothed spike, and halberd were commonly used in ancient times.

A spear or lance is one of the weapons or insignia of some of the Buddhist and Taoist divinities. It sometimes has a red pennon or tassel attached to it near the point (*vide* TRIDENT).

SPIRITUALISM

（招 魂 術 ）

Communication with the souls of the departed has been practised by the Chinese from remote ages, both by means of automatic writing and with the aid of a psychic medium. The methods adopted are similar in many cases to those employed in other countries, and the science is, as in the western world, generally connected with religious observances. Spiritualistic seances, during which darkness seems to be indispensable, are frequently held in temples under the auspices of the priests, who are often gifted with pronounced psychic powers. Women, owing to their temperamental and emotional nature, are also often found to possess skill in this respect, and there are certain varieties of spiritualistic medium known as *ma chiao* (馬 脚), *kuo yin* (過 陰), *ling ku* (靈 姑), etc., who work themselves into frenzies or fall into trances, under the influence of which they profess to be able to communicate with the spirit world.

It is only natural that, since ANCESTRAL WORSHIP (*q.v.*) is so firmly established in China, there should be a strong desire on the part of the living to profit by the counsels of the dead. Divination has been practised for centuries by means of the system known as *fu chi* (扶 乩) or planchette, when a forked stick, with a projecting style or point, is grasped by two men standing back to back, and characters are traced legibly on a table covered with sand, placed before the shrine of a god, forming an appropriate response to any question that may have been put to the oracle. A brush pen suspended by a hair, and resting on a piece of paper, is also employed for the same purpose.

A number of inscribed bones unearthed in Honan are said to have been used for purposes of divination (*vide* illustration under WRITTEN CHARACTERS). In ancient times the shell of the tortoise was heated and the future divined from the fissures thus created (占 卜), while fortune-telling by the casting of lots (抽 籤), and the working out of horoscopes (算 卦) is common at the present day.

"The belief in spirits and in a future state generally has prevailed in China from the earliest ages, though not in any way recognised by Confucianism which preserves an agnostic attitude towards all spiritual questions. A heaven and a hell were introduced by the Buddhists, and borrowed by the

Taoists as a defensive measure against their more attractive rival. The popular belief now is that there is a world of shades, an exact model of the present life, with penalties and rewards for wicked and deserving persons." [1] An exhaustive account of Chinese demonalatry is given in de Groot's *Religious System of China*. For descriptions of Heaven and Hell (*vide* LAOCIUS, SHÂKYAMUNI BUDDHA, and YAMA).

There is a Chinese theory that the *animus* (魂) can issue from the body during the state of trance or coma, leaving the body sustained by the *anima* (魄). Clairvoyantism (神視力), mesmerism (罡符), and palmistry (相手法) are commonly practised to discover that which is beyond the reach of human ken. Auto-hypnosis (工夫), or a system of exercises for the production in oneself of abnormal psychic conditions (ecstacy, etc.), is practised by the Taoists. The original organisation of the Boxers employed hypnotic methods to produce enthusiasm and insensibility to pain. "We read how the Emperor Wu Ti of the 2nd century B.C., when he lost a favourite concubine whose beauty was such that 'one glance would overthrow a city, two glances a State,' engaged a magician to put him in communication with her departed spirit." [2]

AUTHORITIES.
 [1] Giles: *Glossary of Reference*: FUTURE STATE.
 [2] *Loc. cit.*, SPIRITUALISM.

SPLEEN
(脾)

The spleen is regarded by the Chinese as one of the emotional centres of the body, and a man's disposition is said to be regulated by it. It is reverenced as one of the EIGHT TREASURES (*q.v.*) or Eight Precious Organs of Buddha, and is sometimes called *San* (傘), when it symbolises the sacred UMBRELLA (*q.v.*) of the Buddhists.

This organ is said to correspond to the element earth, and with the stomach has the office of storing up; the five tastes emanate from the spleen and the stomach.

STARS
(星)

The Chinese records show remarkable acquaintance with stars, and many curious theories are based thereon. That

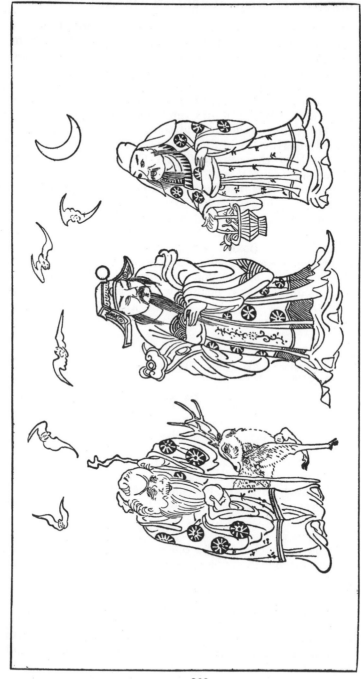

THE THREE STAR GODS OF HAPPINESS, AFFLUENCE AND LONGEVITY, WITH AUSPICIOUS EMBLEMS

the mysteries of human life, the differences between people and their fates should be connected with the equally inexplicable but regular movements of the beautiful orbs in the sky, cannot be wondered at.

"The division of the celestial sphere into twenty-eight constellations was conceived more than 3,000 years ago, for it is mentioned in the *Chou Ritual*. The character 宿 used for these constellations is taken to mean the 'mansions' or 'resting-places' of the sun and moon in their revolutions. Seven of these stellar 'mansions' were allotted to each of the four quadrants of the vault of heaven. The quadrants were associated with four animals, often called the 'Four Supernatural Creatures' (四神), which maintain their importance and exert an influence over national life to the present day, especially in the domain of geomancy. . . . The 'Azure Dragon' (青龍) presides over the eastern quarter, the 'Vermillion Bird' (朱鳥)—*i.e.*, the Chinese phoenix—over the southern, the 'White Tiger' (白虎) over the western, and the 'Black Warrior' (玄武)—*i.e.* the tortoise—over the northern. From an analogy between a day and year, it can be understood how these animals further symbolised the four seasons. The morning sun is in the east, which hence corresponds to Spring; at noon it is south, which suggests Summer. By similar parallelism the west corresponds to Autumn, and the north to Winter." [1]

The stars are grouped under the twenty-eight constellations or **asterisms**, also known as *Kung* (宮), as follows:

1. 角. Chiao, the Horn, consisting of four stars, in the form of a cross, viz., Spica, Zeta, Theta, and Iota, about the skirts of Virgo. Represented by the Earth Dragon. Element, Wood.

2. 亢. Kang, the Neck, four stars in the shape of a bent bow, viz., Iota, Kappa, Lambda, and Rho in the feet of Virgo. Represented by the Sky Dragon. Element, Metal.

3. 氏. Ti, the Bottom, four stars in the shape of a measure, viz., Alpha, Beta, Gamma, and Iota, in the bottom of Libra. Represented by the Badger. Element Earth.

4. 房. Fang, the Room, four stars nearly in a straight line, viz., Beta, Delta, Pi, and Nun, in the head of Scorpio. Represented by the Hare. Element, Sun.

5. 心. Hsin, the Heart, three stars, viz. Antares, Sigma, and Tau, in the heart of Scorpio. Represented by the Fox. Element, Moon.

6. 尾. Wei, the Tail, nine stars in the shape of a hook,

viz., Epsilon, Mim, Zeta, Eta, Theta, Iota, Kappa, Lambda, and Nun, in the tail of Scorpio. Represented by the Tiger. Element, Fire.

7. 箕. Chi, the Sieve, four stars in the form of a sieve, viz., Gamma, Delta, Epsilon, and Beta, in the hand of Sagittarius. Represented by the Leopard. Element, Water.

8. 斗. Tou, the Measure, six stars in the shape of a ladle, viz., Mim, Lambda, Rho, Sigma, Tau, and Zeta, in the shoulder and bow of Sagittarius. Represented by the Griffon. Element, Wood.

9. 牛. Niu, the ox, six stars, viz., Alpha, Beta, and Pi, in the head of Aries, and Omega, with A and B in the hinder part of Sagittarius. Represented by the Ox. Element, Metal.

10. 女. Nü, the Girl, four stars in the shape of a sieve, viz., Epsilon, Mim, Nin, and 9, in the left hand of Aquarius. Represented by the Bat. Element, Earth.

11. 虛. Hsü, Emptiness, two stars in a straight line, viz., Beta in the left shoulder of Aquarius, and Alpha in the forehead of Equleus. Represented by the Rat. Element Sun.

12. 危. Wei, Danger, three stars in the shape of an obtuse-angled triangle, viz., Alpha in the right shoulder of Aquarius, and Epsilon or Enif, and Theta in the head of Pegasus. Represented by the Swallow. Element, Moon.

13. 室. Shih, the House, two stars in a straight line, viz., Alpha or Markab, in the head of the wing, and Beta or Sheat, in the leg of Pegasus. Represented by the Bear. Element, Fire.

14. 壁. Pi, the Wall, two stars in a straight line, viz., Gamma, or Algenib, in the tip of the wing of Pegasus, and Alpha in the head of Andromeda. Represented by the Porcupine. Element, Water.

15. 奎. Kuei, Astride, sixteen stars, said to be like a person striding, viz., Beta, or Mirac, Delta, Epsilon, Zeta, Eta, Nim, Nun, Pi in Andromeda, two Sigmas, Tau, Nun, Pi, Chi, and Psi, in Pisces. Represented by the Wolf. Element, Wood.

16. 婁. Lou, a Mound, three stars in the shape of an isosceles triangle, viz., Alpha, Beta, and Gamma, in the head of Aries. Represented by the Dog. Element, Metal.

17. 胃. Wei, the Stomach, three principal stars in Musca Borealis. Represented by the Pheasant. Element, Earth.

18. 昴. Mao, seven stars in Pleides. Represented by the Cock. Element, Sun.

19. 畢. Pi, the End, six stars in Hyades, with Nim and Nun of Taurus. Represented by the Raven. Element, Moon.

20. 觜. Tzŭ, to Bristle up, three stars, viz., Lambda and two Phi, in the head of Orion. Represented by the Monkey. Element, Fire.

21. 參. Shên, to Mix seven stars, viz., Alpha, or Betelgeux, Beta or Rigel, Gamma, Delta, Epsilon, Zeta, Eta, and Kappa, in the shoulders, belt, and legs of Orion. Represented by the Ape. Element, Water.

22. 井. Ching, the Well, eight stars, viz., four in the

MIRROR OF THE T'ANG PERIOD, A.D. 618-905, SHOWING THE "FOUR SUPER-NATURAL CREATURES" REPRESENTING THE FOUR QUADRANTS OF THE HEAVENS. FROM THE *Hsi Ch'ing Ku Chien*

TOU MU (斗母), THE MOTHER OF THE BUSHEL, ACCOMPANIED BY TWO
ATTENDANTS YU PI (右弼), AND TSO FU (左輔), AND ENTHRONED ON A
LOTUS SUPPORTED BY THE NORTHERN DIPPER (北斗), AND THE SOUTHERN
DIPPER (南斗), OR THE STAR-GODS OF LONGEVITY AND AFFLUENCE

feet and four in the knees of Gemini. Represented by the Tapir. Element, Wood.

23. 鬼. Kuei, the Imp, four stars, viz., Gamma, Delta, Eta, and Theta, in Cancer. Represented by the Sheep. Element, Metal.

24. 柳. Liu, the Willow, eight stars, viz., Delta, Epsilon, Zeta, Eta, Theta, Rho, Sigma, and Omega in Hydra. Represented by the Muntjak. Element, Earth.

25. 星. Hsing, the Star, seven stars, viz., Alpha, Iota, two Taus, Kappa, and two Nuns, in the heart of Hydra. Represented by the Horse. Element, Sun.

26. 張. Chang, to Draw a Bow, five stars in the form of a drawn bow, viz., Kappa, Lambda, Mim, Nun, and Phi, in the second coil of Hydra. Represented by the Deer. Element, Moon.

27. 翼. I, the Wing, twenty-two stars, in the shape of a wing, all in Crater and the third coil of Hydra. Represented by the Snake. Element, Fire.

28. 軫. Chên, the Cross-bar of a carriage, four stars, viz., Beta, Gamma, Delta, and Epsilon, in Corvus. Represented by the Worm. Element, Water.

The above characters are applied in regular order to the days of the lunar month. Four of them, viz., 房 (No. 4), 虛 (No. 11), 昴 (No. 18), and 星 (No. 25) always mark the Christian Sabbath, and are denoted by the character 密, the days of the sun or "the ruler of joyful events" traced to the Persian *mitra,* while the others designate the week days respectively. It may be noted that the Chinese term *hsing ch'i* (星期), or "star period," is applied to a lucky day appointed for a wedding, and is also used in the sense of "week" or "Sunday." The constellations are further divided into four quadrants (四宿) *vide supra*—of which the Azure Dragon comprises Nos. 1 to 7, the Black Warrior 8 to 14, the White Tiger 15 to 21, and the Vermilion Bird 22 to 28 (*vide* also Giles: *Chinese English Dictionary,* Pt. I. pp. 26-27).

The Great Bear occupies a prominent position in the Taoist heavens as the aerial throne of their supreme deity, Shang Ti, around whom all the other star-gods circulate in homage. The Northern Dipper (北斗), a group of stars in Ursa Major, is frequently worshipped by the Chinese on the fourteenth or fifteenth day of the eighth month, together with the Southern Dipper (南斗) in the southern heavens. They are also styled *Shou Hsing* (壽星) and *Lu Hsing* (祿星) respectively, and represent the Gods of Longevity and Wealth.

THE MEETING OF THE COW-HERD AND THE SPINNING-MAID ON THE BORDERS
OF THE MILKY WAY

In this ceremony a rice-measure (斗), half filled with rice and decorated on the exterior with stars, is placed in a perpendicular position, and at each of the four corners is placed some utensil, e.g., a pair of scales, a foot measure, a pair of shears, and a mirror, an oil lamp standing in the centre of the rice-measure. The table also bears candles and sticks of incense. The object of the worship (拜斗) is to ensure longevity and affluence. The "Mother of the Measure" (斗姥), or the Queen of Heaven (天后), the Buddhist Goddess *Maritchi* (摩利支)—sometimes represented with eight arms, which are holding various weapons and religious insignia—who dwells among the stars that form the Dipper in the Constellation of the Great Bear, is also worshipped, chiefly by sailors (*vide* QUEEN OF HEAVEN). Taoist priests are called upon to officiate, which they do by ringing bells, reciting formulas, walking slowly round the table, and bowing towards it. Various dishes of food are also offered up on the table or altar. The Chinese say "rice is the staff of life, so the rice measure is the measure of life." The Chinese word for "measure' has the same sound as a constellation, which probably accounts for the connection between the two." [2]

A remarkable legend is related by the philosopher Huai Nan Tzŭ (淮南子) in connection with the stars *Vega* in the constellation *Lyra,* and *Altair* in *Aquila.* In this story Ch'ien Niu (牽牛), the Cow-herd (Altair), has an affinity for Chih Nü (織女), the Spinning-maid (*Vega*), and at one time when they were visiting the earth they were married. Afterwards they returned to heaven, but they were so happy with each other that they refused to work. The King and Queen of Heaven were angry at this, and decided to separate the two; so the Queen "with a single stroke of her great silver hair-pin, drew a line across the heavens, and from that time the Heavenly River has flowed between them, and they are destined to dwell forever on the two sides of the Milky Way. Their evident affection and unhappy condition moved the heart of His Majesty, and caused him to allow them to visit each other once each revolving year, on the seventh day of the seventh moon. But permission was not enough, for as they looked upon the foaming waters of the turbulent stream they could but weep for their wretched condition, for no bridge united its two banks, nor was it allowed that any structure be built which would mar the contour of the shining dome. In their helplessness the magpies came to their rescue. At early morn

on the seventh day of the seventh moon, these beautiful birds gathered in great flocks about the home of the maiden, and hovering wing to wing above the river, made a bridge across which her dainty feet might carry her in safety. But when the time for separation came, the two wept bitterly, and their tears falling in copious showers are the cause of the heavy rains which fall at that season of the year."[3] It is said that there are no magpies to be seen on the seventh day of the seventh moon, as if any refuse to go to Heaven to help build the bridge they are afflicted with scabies. The two small stars close to *Vega* are twins, the children of the Spinning-maid and the Cow-herd, and from time immemorial it has been known that the Yellow River is a prolongation of the Milky Way, the waters of which are soiled by earthly contact and contamination. The Spinning-maid is revered as the patroness of embroidery and weaving.

A comet is a very unlucky omen; and the appearance of Halley's comet in 1910-11 brought with it a great deal of unrest and fear. The people believe that it indicates calamity such as war, fire, and pestilence (*vide* also ASTROLOGY).

AUTHORITIES.
[1] Yetts: *Symbolism in Chinese Art*, pp. 13-14.
[2] Gulland: *Chinese Porcelain*, Vol. I, p. 60.
[3] Headland: *The Chinese Boy and Girl*.

STOMACH

(胃)

One of the Five Viscera (五藏), viz.: heart, liver, stomach, lungs, and kidneys. The stomach is regarded by the Chinese as the seat of learning and repository of truth, and is reverenced as one of the EIGHT TREASURES (*q.v.*) or Eight Precious Organs of Buddha, and is sometimes called Kuan (礶), when it symbolises the sacred JAR (*q.v.*) of the Buddhists.

STONE

(石)

The written symbol for the word stone, which represents radical 112, comprises the character *k'ou* (口), depicting a fragment of rock detached or fallen from a cliff (厂). It is the emblem of reliability and hardness.

Stone abounds in southern and western China, and marble, granite, sandstone, and limestone are all used for building purposes in a rough as well as in a dressed state, while pulverized stone is used for making toothpowder and cosmetics. Stone monuments, archways, artificial rockwork, and architectural reliefs are sculptured with great skill by the Chinese, who thus display their artistic and symbolic designs with striking effect. "Ornamental walls are frequently formed of large slabs set in ports, like panels, the outer faces of which are beautifully carved with figures representing a landscape or a procession." [1] The stone-cutter produces large numbers of monuments and statues for public and private use, and for placing at the grave.

The carving and cutting of semi-precious stoneware is carried out with great accuracy and artistic finish. Jade, agate, cornelian, lapis-lazuli, malachite, coral, fluorspar, and crystal are cut into figures, while Shansi amethyst and turquoise matrix are made into beads and pendants. Juvenile workers are largely employed as apprentices, and can be seen at their rough lathes, hollowing out agates, etc., in preparation for the external working of the piece. Natural markings in the stone are invariably adapted for the cutting of leaves and floral sprays, etc., in order to enhance the beauty of the article, and no effort is spared in utilising the grain and markings to the best effect. A design may often take several months to work out satisfactorily. A rough-shaped stone might suggest, for example, a dragon, on account of its peculiar shape; it may have an awkward shaped top, which, however, must not be cut away or wasted; the part at the top may suggest a hill, so the dragon is carved coming round a hill, and any natural markings in the hill can be cut in relief as dwarf shrubs, rocks, or any other motives which will appear to be suitable to the engraver. The designer's motto might well be "Artistry, but Economy."

The practice of burying figures of stone, clay, metal, etc., with the dead is of great antiquity. They were generally in the shape of servants, concubines, horses, etc., and were interred with the dead primarily for superstitious reasons relating to the invisible powers of evil and the means of controlling them, in fact with fetish worship, and secondarily in connection with the honours paid to deceased celebrities by the sacrifice of human beings and domestic animals to attend them in the land of shadows (*vide* DEATH). Stone statues (石象) of men and animals were erected before the tombs of Chinese Emperors

and high officials for the same reasons as the figures were placed with the corpse; effigies made of coloured paper are now also burnt at the graveside. Sacrifices of animals at the grave have been carried out from time immemorial, but living sacrifices were not introduced until life-size images of human beings had first been erected before the grave and their miniature counterparts interred with the body. Some of the ancient stone figures and bas-reliefs found in China reveal traces of Indian or Grecian origin, while others are purely Chinese in conception. If extensive excavation was not impeded for reasons of FENG SHUI (*q.v.*), no doubt many interesting sculptures would be unearthed, which would be highly important from an archaeological standpoint (*vide* also JADE).

Mount T'ai (泰山), in Shantung, has the epithet of "eminent" attached to it as it is the most famous of all the mountains of China. A stone from this sacred mountain is believed to have the power to ward off demons, though any local stone may be employed. The following inscription is cut upon it: "This stone from Mount T'ai dares to oppose" (泰山石敢當), and it is sometimes erected at sharp turnings of the road where evil influences are considered likely to strike against it. No doubt the origin of the motto is partly due to the security offered by Mount T'ai in times of flood and Yellow River disaster in Shantung, and to its former use in the worship of the sun.

AUTHORITY.
1 Williams: *Middle Kingdom*, Vol. I, pp. 307-9.

STONE CHIME
（磬）

The stone chime is a musical instrument of percussion, consisting of a plate in the form of an angle or T-square, made of jade or other stone and sometimes of bronze.

It is employed in the hymnal service in honour of Confucius, which takes place in Spring and Autumn. It is one of the EIGHT TREASURES (*q.v.*), and is sometimes carved on the ends of rafters, etc., when it represents the word of the same sound, *ch'ing* (慶), meaning felicity (*vide* MUSICAL INSTRUMENTS).

THE POET SU TUNG-P'O

SU SHIH
(蘇 軾)

Commonly known as Su Tung-p'o (蘇東坡). A cele-brated poet and statesman of the Sung dynasty, who lived from A.D. 1036-1101. He filled various official positions including that of President of the Board of Ceremonies. His poems and essays are of considerable merit, and are published to this day under the title of 東坡全集.

SUN
(日)

"The Sun, defined by the 說 文 as corresponding to 實 that which is solid or complete, and hence the symbol of the sovereign upon earth. The great luminary is represented as the concreted essence of the masculine principle in nature 陽 and the source of all brightness. From it emanate five colours. It is 1,000 *li* in diameter, 3,000 *li* in circumference, and suspended 7,000 *li* below the arch of the firmanent. The 山 海 經 asserts that the Sun is the offspring of a female named Hsi Ho (羲 和)."[1] There is a legend to the effect that the chariot of the Sun is harnessed to six dragons driven by the Goddess Hsi Ho.

A fabulous being known as Yü Hua (鬱華) is said to dwell in the Sun, and in the language of Taoist mysticism the name of the Sun is Yü I (鬱 儀). According to ancient Chinese philosophy Heaven is round and Earth is square. The sun, moon, and stars, which were worshipped in former times, are known as the Three Luminaries (三 光), or the Three Regu-lators of Time (三 辰). A common colloquial term for the sun is T'*ai-yang* (太 陽), or Great Male Principle, and the term *Jih* (日), derived from an archaic figure depicting a dot within a circle, is not only applied to the sun, but also in the sense of one revolution of that body, or a day.

"The red crow with three feet is the tenant of the solar disc, and is the origin of the *triquetra* symbol of ancient bronzes. Huai Nan Tzu, who died 122 B.C., grandson of the founder of the Han dynasty and an ancient Taoist votary, says that the red crow has three feet because three is the emblem of the masculine principle of which the sun is the essence; the bird often flies down to Earth to feed on the plant of immortality."[2]

The self-styled First Emperor (始皇帝), 259 B.C., offered sacrifices to the following Eight Gods (八神); 1, Lord of Heaven (天主); 2, Lord of Earth (地主); 3, Lord of War (兵主); 4, Lord of the Yang Principle (陽主); 5, Lord of the Yin Principle (陰主); 6, Lord of the Moon (月主); 7, Lord of the Sun (日主); 8, Lord of the Four Seasons (四時主). The ceremonial worship of the firmament was last carried out by President Yüan Shih-k'ai (袁世凱), who unsuccessfully attempted to restore the Imperial form of government in 1916.

It is believed that the *Lo hou hsing* (羅睺星) is an unlucky star which tries to devour the sun at the time of the eclipse. The evil spirit of this star is said to have retarded the birth of SHAKYAMUNI BUDDHA (*q.v.*) for six years. The temple drums and gongs are loudly beaten and crackers exploded to prevent this demon from devouring the sun. An eclipse of the sun (日食) was believed to bring about a loss of virtue on the part of the Emperor, of whom that luminary was the emblem.

Sometimes an enormous red sun is depicted on the "shadow wall" (影壁), placed before the gate of an official building as a bar to all noxious influences. Being typical of the pure and bright principle *Yang*, it daily suggests to the inmates of the establishment the desirability of pure and just administration (*vide* BEAST OF GREED, YIN AND YANG).

The Chinese year is divided into twenty-four solar terms or periods (氣), corresponding to the day on which the sun enters the first and fifteenth degree of one of the zodiacal signs. To each of these an appropriate name is given, as shown in the following table. Their places in the lunar calendar will change every year, but in the solar year they fall nearly on the same day in successive years. When an intercalary month occurs, they are still recorded as usual; but the intercalation is made so that only one period shall fall in it. The equinoxes and solstices, and some of the festivals, are regulated by the solar periods, some of which contain fourteen, and others sixteen days, their average length being fifteen days.

The sundial is symbolic of virtuous government. It is useless when obscured by clouds, so the ruling power is without effect if evil counsel intervenes. As the sun shines on high and low alike, the people should, similarly, be impartially treated.

AUTHORITIES.
 [1] Mayers: *Chinese Reader's Manual*, Pt. I, 235.
 [2] Bushell: *Chinese Art*. Vol. I, pp. 40-41.

TWENTY-FOUR SOLAR TERMS
二十四氣

5	February	Li ch'un	立	春	Spring begins	Aquarius
19	"	Yü shui	雨	水	Rain water	Pisces
5	March	Ching shih	驚	蟄	Excited insects	
20	"	Ch'un fên	春	分	Vernal equinox	Aries
5	April	Ch'ing ming	清	明	Clear and bright	
20	"	Ku Yü	穀	雨	Grain rains	Taurus
5	May	Li hsia	立	夏	Summer begins	
20	"	Hsiao man	小	満	Grain fills	Gemini
6	June	Mang chung	芒	種	Grain in ear	
21	"	Hsia chih	夏	至	Summer solstice	Cancer
7	July	Hsiao shu	小	暑	Slight heat	
23	"	Ta shu	大	暑	Great heat	Leo
7	August	Li ch'iu	立	秋	Autumn begins	
23	"	Ch'u shu	處	暑	Limit of heat	Virgo
8	September	Pai lu	白	露	White dew	
23	"	Ch'iu fên	秋	分	Autumnal equinox	Libra
8	October	Han lu	寒	露	Cold dew	
23	"	Shuang chiang	霜	降	Frost descends	Scorpio
7	November	Li tung	立	冬	Winter begins	
22	"	Hsiao hsüeh	小	雪	Little snow	Sagittarius
7	December	Ta hsüeh	大	雪	Heavy snow	
22	"	Tung chih	冬	至	Winter solstice	Capricorn
6	January	Hsiao han	小	寒	Little cold	
21	"	Ta han	大	寒	Severe cold	Aquarius

SWALLOW
（燕）

The Chinese term for the swallow is a pictogram, or conventional representation of the bird, showing head, body, wings, and tail (*vide* Illustration: The Evolution of Chinese Writing, under WRITTEN CHARACTERS).

Hirundo gutturalis is the common house swallow so numerous in central and northern China. The Striped Swallow (花燕) or *H. nipolensis* and the Reed Swallow (蘆 燕) are also found, but the celebrated birds' nest soup is made from the gelatinous nests of the Sea Swallow (海燕), or *H. esculenta* from the Malay Archipelago.

Peking (Peiping) is known as the City of Swallows (燕京) on account of the numbers of these birds which nest in the ancient buildings of the capital. "The coming of swallows and their making their nests in a new place, whether dwelling-house or store, are hailed as an omen of approaching success, or a prosperous change in the affairs of the owner or

occupier of the premises." [1] Women's voices are compared to the twittering of swallows, while the fragile nest of the bird (燕窩) is metaphorically applied to positions of insecurity and danger.

AUTHORITY.
[1] Doolittle: *Social Life of the Chinese*, p. 572.

SWASTIKA
(卍字)

The fylfot, or swastika, is of great antiquity and is common to many countries. It was the monogram of Vishnu and Siva in India, the battle-axe of Thor in Scandinavian inscriptions, and a favourite symbol with the Peruvians. In China and Japan it would appear to be a Buddhist importation, though it may possibly be a variation of the meander (*vide* DIAPER PATTERNS). This emblem is to be seen on the wrappers of parcels, on the stomach or chest of idols, on the eaves of houses, on embroidery, and many other objects.

It has its crampons directed towards the right, but another form 卐, called Sauvastika, is directed to the left. The former is said to be the first of the 65 auspicious signs on the footprint of Buddha, and the latter the fourth. It is said by some authorities to have been impressed by each toe of the Buddha. Sometimes these toe impressions are represented by flowers or flames (*vide* FOOTPRINTS OF BUDDHA).

The term Swastika, or Svastika, is derived from the Sanskrit *su* "well" and *as* "to be," meaning "so be it," and denoting resignation of spirit. It is styled the "ten thousand character sign," *Wan Tzŭ* (萬字), and is said to have come from Heaven. It is described as "the accumulation of lucky signs possessing ten thousand efficacies." 'It is also regarded as the symbol or seal of Buddha's heart (佛心印), and is usually placed on the heart of SHAKYAMUNI BUDDHA (*q.v.*) in images or pictures of that divinity, as it is believed to contain within it the whole mind of Buddha (*vide* HEART). It appears as an ornament on the crowns of the Bonpa and Lama deities of Thibet. It may, after all, be nothing more or less than a variety of the MYSTIC KNOT (*q.v.*).

"According to Burnouf, Schliemann, and others, the Swastika represents the 'fire's cradle,' *i.e.*, the pith of the wood, from which in oldest times in the point of intersection of the

two arms the fire was produced by whirling round an inserted stick. On the other hand, according to the view most widespread at the present day, it simply symbolises the twirling

SAUVASTIKA
WITH CRAMPONS TO THE LEFT

SWASTIKA OR SVASTIKA
WITH CRAMPONS TO THE RIGHT

movement when making the fire, and on this, too, rests its application as symbol of the sun's course." [1] The Latin cross, ╪; the Greek *Tau*, ᚦ; the St. Andrew's cross, ×; the "Mirror of Venus," ♀; the "Key of the Nile," ♀; etc.; are also said to have been borrowed from the same source, *i.e.*, the Aryan or Vedic sun and fire worship. The Swastika is sometimes represented in a circle, and this circle undoubtedly symbolises the sun, while the crossing lines are also emblematic of the rays of that luminary. It is frequently employed in ornamental border designs, in carpets, silk embroideries, carved woodwork, etc.

A number of bronze and brass crosses about the size of belt buckles have been unearthed in the Ordos district of North China. These tokens are nearly all different, and chiefly take the form of the Christian cross, though the swastika is also in evidence in many of them. It is possible that they may have had a religious significance, or that they were used as military medals, secret society emblems, or merely as amulets of good fortune.

AUTHORITY.
[1] Drews: *The Christ Myth*, pp. 153-4.

SWORD
（劍）

In ancient times there were many celebrated swordsmiths in China, the best known being Chê Yen (蚩尤), 2600 B.C., and Kan Chiang (干將), who lived in the State of Wu in the 3rd century B.C., and is said to have forged various "magic" swords of steel, which were regarded as supernatural because they were so much sharper than the bronze weapons previously

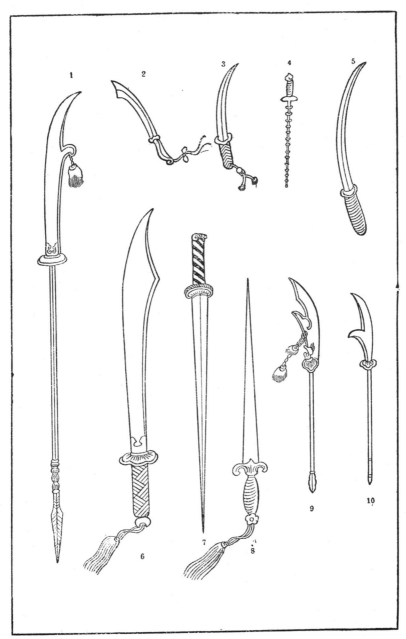

1, 9, 10, LONG-HANDLED BROAD-SWORDS; 2, SWORD OF EMPEROR'S BODY-GUARD;
3, 5, 8, SHORT SWORDS; 4, ANCIENT MAGIC SWORD; 6, EXECUTIONER'S SWORD;
7, TWO-HANDED SWORD

used in warfare. There is a rock in Kashing (嘉興) apparently divided into two sections, concerning which tradition says that Kan Chiang there tried the metal of his blade by splitting the stone asunder.

In Buddhism, the sword, Sanskrit *Adi*, is emblematic of wisdom and penetrating insight, and its purpose, in the hands of the deities, is to cut away all doubts and perplexities and clear the way for knowledge of the truth. In Taoism it is symbolic of victory over evil, and is the emblem of Lü Tung-pin (呂洞賓), one of the EIGHT IMMORTALS (*q.v.*), who, armed with his magic sword, traversed the earth subduing the powers of darkness.

TA YÜ

(大 禹)

The Great Yü. A semi-mythological hero and native of Shih-niu (石 紐), in modern Szechuan, appointed by the Emperor SHUN (*q.v.*) to drain the empire from a great flood, which has been identified by some with the Biblical Deluge, a labour which he accomplished after nine years of unremitting toil.

When he rested from his task of draining off the waters, he is said to have recorded the event upon a stone tablet, which he erected on the Kou-lou Peak (岣 嶁 峰) of Mount Hêng (衡 山) in the modern province of Hupeh. This tablet is no longer in existence, but doubtful reproductions of it are to be seen, engraved in the tadpole character, at Changsha, Wuchang, and Shaoshing.

He became the first Emperor of the Hsia dynasty in 2205 B.C.

T'AI CHI

(太 極)

"Chinese philosophers speak of the origin of all created things under the name of *T'ai-chi*. This is represented in their books by a figure, which is thus formed: On the semi-diameter of a given circle describe a semi-circle, and on the remaining semi-diameter, but on the other side, describe another semi-circle. The whole figure represents the *T'ai-chi*, and the

THE GREAT YÜ, FIRST EMPEROR OF THE HSIA DYNASTY, 2205 B.C.

two divided portions, formed by the curved line, typify what are called the *Yin* (陰) and the *Yang* (陽), in respect to which, this Chinese mystery bears a singular parallel to that extraordinary fiction of Egyptian mythology, the supposed intervention of a masculo-feminine principle in the development of the mundane egg. The *T'ai-chi* is said to have produced the *Yang* and the *Yin*, the active and passive, or male and female principle, and these last to have produced all things."[1] The circle represents the origin of all created things, and when split up into two segments, it is said to be reduced to its primary constituents, the male and female principles.

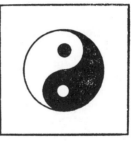

THE T'AI CHI OR ULTIMATE PRINCIPLE OF ALL THINGS

The *T'ai-chi* is said to be essence of extreme virtue and perfection in heaven and earth, men and things. Speaking figuratively it is like the ridge-pole of a house, or the central pillar of a granary, being always in the middle of the building, and the whole structure on every side depends upon it for support

From the *T'ai-chi*, which may be called the Great Extreme or Ultimate Principle, composed of the YIN AND YANG (*q.v.*), springs the FIVE ELEMENTS (*q.v.*), which are the source of all things, and man, having been evolved from the union of the male and female principles, is enriched at his birth by the possession of the Five Virtues (五 常), viz: Benevolence (仁); Purity (義); Propriety (禮); Wisdom (智); and Truth (信).

The *T'ai-chi* surrounded by the EIGHT DIAGRAMS (*q.v.*), is a common design of good omen, and is frequently painted above the doors of Chinese houses as a charm against evil influences (*vide* EIGHT DIAGRAMS, YIN AND YANG).

AUTHORITY.
[1] Davis: *The Chinese*, Vol. II, p. 62.

TEA
（茶）

The tea-plant, which is chiefly grown in Fukien, Chekiang and Kuangtung, is not indigenous to China, and is said to have been imported in A.D. 543 by an ascetic from northern India, and in the ninth century it was in general use as a national

beverage. Tea was first introduced into Europe towards the close of the sixteenth century by the Dutch.

Bodhiharma, or Ta Mo (達 摩), the Blue-eyed Brahmin, was an Indian Buddhist missionary of royal descent, who reached China in A.D. 526, and is regarded as the chief of the Six Patriarchs (六祖) of the Buddhist religion. He is identified by some with St. Thomas the Apostle. His doctrine was that perfection must be sought in the inward meditations of the heart rather than in outward deeds and observances, and his miraculous crossing of the Yangtze on a reed has formed the theme of many painters and sculptors. It is recorded that once when he sat in meditation, sleep overcame him; and on waking, that it might never happen again, he cut off his eyelids. But they fell on the earth, took root, and sprouted; and the plant that grew from them was the first of all tea-plants—the symbol (and cause!) of eternal wakefulness.

The word "tea" is said to be derived from the Fukienese pronunciation *ta*, and "that excellent, and by all Physitians approved, China Drink, called by the Chineans *Tcha*, by other Nations *Tay* alias *Tee*," was advertised for sale three centuries ago (in the Weekeley Newes, 31 January, 1606) at the Sultaness Head, a coffee house in Sweetings Rents, near the Royal Exchange, London. The Chinese term *ch'a* (茶), "tea," is said to be indentical with *k'u t'u* (苦搽), or *t'u* (荼), "chicory," often referred to in the Classics, but during the reign of a prince of the Han dynasty the latter name for tea was interdicted, and is now chiefly used to signify "poison." The classical term *ming* (茗) was introduced during the T'ang dynasty, and is still employed in literary composition; it originally denoted the late pickings of the tea-plant. *Shê* (蔎) and *ch'uan* (荈) are other names for coarse teas. Lu Yü (陸 羽), who died in A.D. 804, was the author of the "Tea Classic" (茶 經), a famous work on Tea, and is worshipped by the tea-planters as their tutelary deity.

The time for sowing tea seeds is about the month of September. Holes are dug, each hole being about three feet square, and nine or ten seeds are planted in each hole. When the seedling has grown to the height of a few inches the planter clears away any grass that may be growing round it. . . . The best tea generally grows on high mountain peaks, where fogs and snow prevail, which gives a better flovour to the leaves." [1] "The tea-plant yields its first crop at the end of the third year, and thereafter three to four crops are taken

BODHIDHARMA, THE BLUE-EYED BRAHMIN, THE REPUTED
DISCOVERER OF THE TEA-PLANT
389

annually. The first picking takes place while the leaf is still unfolded." [2]

The tea-shrub of Central China is the *Thea chinensis,* or *Thea viridis* of the botanists, and the leaves are perhaps more lanceolate than those of the *Thea Cantoniensis,* or *Thea assamica,* of the southern regions. "As a result of long cultivation and promiscuous planting, there is hardly a tea garden but is mainly filled with hybrids between these two species." [3] "Both the green and the black, or reddish, varieties of tea-leaf may be produced from either plant. The leaves are picked at three or more occasions in the year, the first picking, which is the best, taking place in April. The leaves are slightly dried in the sun, crushed by the feet of coolies in tubs, in order to get rid of the useless watery juices, and to give a twist to the leaf. The leaf undergoes a series of heatings at a low temperature, is winnowed, picked and packed in lead-lined chests which are arranged in 'chops' of from four hundred to six hundred and fifty chests." [4]

"The adulterants of tea are extremely numerous, and the Chinese show great skill in this direction. Among adulterants that are used are the leaves of the ash, plum, dog-rose, *Rhamus spp., Rhododendron ssp.,* and *Chrysanthemum ssp.,* as well as tea stalks and paddy husks. The scented flowers of the *Olea fragrans, Chloranthus inconspicuus, Aglaia odorata, Camellia Susanqua, Gardenia florida, Jasminum Sambac* and other species, are used to give fragrance to inferior qualities. Sometimes the true tea is almost replaced by a factitious compound known as 'lie tea' which is composed of a little tea dust blended with foreign leaves, sand and magnetic iron by means of a solution of starch, and coloured with graphite, turmeric, indigo, Prussian blue or China clay, according to the kind of tea it is desired to simulate." [5] The leaves of the *Sageretia theezans* (檟), together with those of the willow, poplar, and spiroea, provide the poor with passable substitutes for tea.

Brick tea (磚茶) is made of tea dust steamed and pressed into hard cakes. The *Camellia oleifera* (山茶) also belongs to the genus *Thea* (order *Ternstroemiaceæ*), and yields the so-called tea-oil (茶油), which is expressed from the seeds.

"Tea is described in the *Pên Ts'ao* (本草), or Herbal, as cooling, peptic, exhilarating, rousing, both laxative and astringent, diuretic, emmenagogue, and, in large concentrated doses, emetic. Taken in large quantities for a long time it is believed to make people thin and anæmic. Weak tea is a

favourite wash for bad eyes and sore places.　Tea-seeds (茶子) are said to benefit coughs, dyspnœa, and singing in the head."[6]

AUTHORITIES.

[1] *Catalogue of the Collection of Chinese Exhibits at the Louisiana Purchase Exposition*, St. Louis, 1904, p. 267.
[2] Dingle and Pratt: *Far Eastern Products Manual*, No. 219.
[3] *Loc. cit.*, No. 219.
[4] Smith: *Contributions towards the Materia Medica and Natural History of China*: TEA.
[5] Dingle and Pratt: *Far Eastern Products Manual*, No. 219.
[6] Smith: *Contributions towards the Materia Medica and Natural History of China*: TEA.

TEN CELESTIAL STEMS

(十 天 干)

The Ten Celestial Stems, *Shih t'ien kan,* are the ten primary signs which, when used in combination with the TWELVE TERRESTRIAL BRANCHES (*q.v.*), form the CYCLE OF SIXTY (*q.v.*) ; they form the masculine or primary, *i.e.,* left hand column of the cycle.　The following table shows their names, affinities, and corresponding elements (*vide* also FIVE ELEMENTS) :

	Celestial Stems		Affinities	Corresponding Elements		
1	Chia	甲	Trees	Mu	木	Wood
2	Yi	乙	Hewn Timber	,,	,,	,,
3	Ping	丙	Lightning	Huo	火	Fire
4	Ting	丁	Burning Incense	,,	,,	,,
5	Wu	戊	Hills	T'u	土	Earth
6	Chi	己	Earthenware	,,	,,	,,
7	Kêng	庚	Metallic Ore	Chin	金	Metal
8	Hsin	辛	Kettles	,,	,,	,,
9	Jên	壬	Salt Water	Shui	水	Water
10	Kuei	癸	Fresh　,,	,,	,,	,,

The first of the Twelve Terrestial Branches is joined to the first of the Ten Celestial Stems until the last or tenth of the latter is reached, when a fresh commencement is made, the eleventh of the series of twelve branches (戌) being next appended to the first stem (甲).　This system is applied to the numbering of hours, days, months, and years (*vide* also SUN and MOON).　The application of the method to the successive days has been traced to Ta Nao (大 撓), 27th century B.C.,

and the similar numbering of years is attributed to Wang Mang (王莽), 33 B.C., but signs of its employment at a somewhat earlier date have been discovered.

"The cyclical signs play a great part in Chinese divinations, owing to their supposed connection with the elements or essences which are believed to exercise influence over them in accordance with the order of succession represented above."[1]

AUTHORITY.
[1] Mayers: *Chinese Reader's Manual*, Pt. II, 296.

THIGH-BONE TRUMPET
(腿骨喇叭)

A trumpet made from a human thigh-bone, and used by the priests of Lamaism for the purpose of summoning the spirits.

In the preparation of these thigh-bone trumpets the bones of criminals or those who have died by violence are preferred. (*Vide* also SKELETON STAFF.)

THREE GREAT BEINGS
(三大士)

A well-known set of images is called San Ta Shih, or the Three Great Beings. These are three Bodhisattvas (Skt.), or P'u Sa (Chinese), namely Manjusri (Skt.) or Wên Shu, Samantabhadra (Skt.) or P'u Hsien, and Avalokitesvara (Skt.) or Kuan Yin.

The 83rd chapter of the popular work *Hsiu hsiang fêng shên yen i* (繡僑封神演義) refers to this category of deities, and also to their power over the animal kingdom, or the forces of nature. (*Vide* separate articles under MANJUSRI, P'U HSIEN, and KUAN YIN.)

THREE PURE ONES
(三清)

The Three Pure Ones are the deities of the Taoist trinity, and live in separate heavens. The supreme Master of the Gods is the Jade Ruler, or the Pearly Emperor, Yü Huang 玉皇), who has been identified with Brahma and Indra, though the Buddhists claim that the Taoists have simply stolen their god Yü Ti. The second Pure One is Tao Chün (道君),

THE THREE PURE ONES OF THE TAOIST TRINITY

of whom little is known beyond that he controls the relations of the YIN AND YANG (*q.v.*), or principles of nature, and dwells beyond the North Pole, where he has existed from the beginning of the world. The third is LAOCIUS (*q.v.*). Wayside shrines in honour of this trinity are perhaps more common than any others.

Yü Huang is said to have been the son of an Emperor called Ch'ing Ti (清帝), whose consort Pao Yüeh-kuang (寶月光) implored the gods to grant them a child. Her prayers were accepted and "when the birth took place a resplendent light poured forth from the child's body, which filled the country with brilliant glare. His entire countenance was super-eminently beautiful, so that none became weary in beholding him. When in childhood he possessed the clearest intelligence and compassion, and taking the possessions of the country and the funds of the treasury, he distributed them to the poor and afflicted, the widowers and widows, orphans and childless, the houseless and sick, halt, deaf, blind and lame. Not long after this the demise of his father took place, and he succeeded to the government; but reflecting on the instability of life, he resigned his throne and its cares to his ministers, and repaired to the hills of Pu-ming, where he gave himself up to meditation, and being perfected in merit ascended to heaven to enjoy eternal life. He however descended to earth again eight hundred times, and became the companion of the common people to instruct them in his doctrines. After that he made eight hundred more journeys, engaging in medical practice and successfully curing the people; and then another similar series, in which he exercised universal benevolence in hades and earth, expounded all abstract doctrines, elucidated the spiritual literature, magnanimously promulgated the renovating ethics, gave glory to the widely-spread merits of the gods, assisted the nation, and saved the people. During another eight hundred descents he exhibited patient suffering; though men took his life, yet he parted with his flesh and blood. After this he became the first of the verified golden genii, and was denominated the pure and immaculate one, self-existing, of highest intelligence." [1]

Yü Huang has also been taken to be the subject of a nature myth, on account of the meaning of the names of his parents (*vide supra*), viz., "Brilliance" and "Moon-light," or the sun and the moon, whose union symbolizes the revival of spring.

AUTHORITY.
 [1] *Chinese Repository*, Vol. X, p. 306.

THE PEARLY EMPEROR YÜ HUANG SEATED IN HIS COURT OF JUSTICE

THUNDERBOLT

(箭 石)

Sanskrit *Vajra*. The Thunderbolt is the emblem of the divine force of Buddha's doctrine which shatters all false beliefs and mundane wickedness (*vide* DIAMOND MACE). The emblem representing the Thunderbolt is often grasped in the hand of Buddhist images (*vide* Illustration under LAMAISM).

GOD OF THUNDER

Thunder occurring in unusual and unseasonable times is considered by the Chinese as ominous of some political change, such as a revolution, etc. Wicked persons are said to be killed by the God of Thunder (雷 公), and the Goddess of Lightning (電 母) flashes light on the intended victim to enable her colleague the God of Thunder, to launch his deadly bolt with accuracy (*vide* also GOD OF FIRE). The God of Thunder is "almost the only Chinese mythological deity who is drawn with wings. The cock's head and claws, the hammer and chisel, representing the splitting peal attending a flash, the circlet of fire encompassing a number of drums to typify the reverberating thunder and the ravages of the irresistible lightning, present a grotesque ensemble which is quite unique even among the *bizarrerie* of oriental figures." [1] He was originally represented, in the 1st century B.C., according to Wang Ch'ung (王 充) in his

TIEN MU, THE GODDESS OF LIGHTNING

Lun Hêng (論 衡), as a strong man, not a bird, with one hand dragging a cluster of drums, and brandishing a hammer with the other. His present birdlike form would appear to

have been evolved, through the medium of Buddhism, from the Indian Garuda, a divine being, half man and half bird, having the head, wings, beak and talons of an eagle, and human body

LEI KUNG, THE GOD OF THUNDER, ASSISTED BY TIEN MU, THE GODDESS OF LIGHTNING

and limbs, its face being white, its wings red, and its body golden. The Garuda served as an aerial courser for the Hindu God Vishnu. The "Thunderer" also bears some resemblance to the Indian God Vajrapâni who in one form appears with Garuda wings.

AUTHORITY.
1 Williams: *Middle Kingdom*, Vol. II, p. 109.

THUNDERBOLT-DAGGER

(雷 電 刀)

Sanskrit, *Phurbu*. A dagger of wood or metal to stab the demons. The central portion is in the form of a *vajra*—

thunderbolt (*vide* DIAMOND MACE, THUNDERBOLT), which is the part held in the hand, and the hilt-end is terminated either by a fiend's head, or by the same surmounted by a horse's head, representing the horse-headed tutelary devil of Lamaism, Tamdin, Sanskrit *Hayagriva*. This emblem of authority is seen in the hands of Buddhist and Lama deities (*vide* Illustration under LAMAISM).

TIGER

（虎）

Tigers were very common in ancient times, and are still to be found in Kuangtung, Kuangsi, Fukien, Kiangsi, and Manchuria. The largest variety runs to twelve feet in length.

The written symbol for this animal consists of the radical *hu* (虎), which is the representation of the tiger's stripes, while the form *jên* (儿), man, below, implies that the beast rears up on its hind legs like a human being erect.

THE MEETING OF THE DRAGON AND THE TIGER, THE TWO GREAT FORCES OF THE UNIVERSE

"The tiger is called by the Chinese the king of the wild beasts, and its real or imaginary qualities afford them matter for more metaphors than any other wild animal. It is taken as the emblem of magisterial dignity and sternness, as the model for the courage and fierceness which should characterize a soldier, and its presence or roar is synonymous with danger and terror. Its present scarceness has tended to magnify its prowess, until it has by degrees become invested with so many savage attributes that nothing can exceed it. Its head was formerly painted on the shields of soldiers, on the wooden covers of the port-holes of forts to terrify the enemy, on the bows of revenue cutters, and embroidered upon court robes as the insignia of some grades of military officers. The character *hu* has been numbered as one of the radicals of the language, and the words comprised

under it are nearly all descriptive of some quality appertaining to the tiger. . . . Virtues are ascribed to the ashes of the bones, to the fat, skin, claws, liver, blood, and other parts of a tiger, in many diseases; the whiskers are said to be good for toothache. . . . In the days of Marco Polo, the multitude of tigers in the northern parts of the empire rendered travelling alone dangerous." [1]

"Just as the dragon is chief of all aquatic creatures, so is the tiger lord of all land animals. These two share the position of prime importance in the mysterious pseudo-science called FÊNG SHUI (q.v.). The tiger is figured on many of the most ancient bronzes, and its head is still reproduced as an ornament on the sides of bronze and porcelain vessels, often with a ring in its mouth. It frequently appears in a grotesque form which native archaeologists designate a 'quadruped' (獸). The tiger symbolises military prowess. It is an object of special terror to demons, and is therefore painted on walls to scare malignant spirits away from the neighbourhood of houses and temples." [2] The shoes of small children are often embroidered with tiger's heads for the same reason. The God of Wealth is sometimes represented as a tiger, and tiger gods are also to be found, chiefly in Hanoi and Manchuria, where the animals are most plentiful. In former times Chinese soldiers were occasionally dressed in imitation tiger-skins, with tails and all complete. They advanced to battle shouting loudly, in the hope that their cries would strike terror into the enemy as if they were the actual roars of the tiger.

"According to the astrologers, the star 樞 (a. of Ursa Major) gave birth by metamorphosis to the first beast of this kind. He is the greatest of four-footed creatures, representing the masculine principle of nature, and is the lord of all wild animals (山獸之君). He is also called the King of Beasts (獸中王), and the character 王 (King) is believed to be traceable upon his brow. He is seven feet in length, because seven is the number appertaining to Yang, the masculine principle, and for the same reason his gestation endures for seven months. He lives to the age of one thousand years. When five hundred years old, his colour changes to white. His claws are a powerful talisman, and ashes prepared from his skin worn about the person act as a charm against sickness. Pai Hu (白虎), the White Tiger, is the name given to the western quadrant of the Uranosphere and metaphorically to the West in general." [3] The title of White Tiger was bestowed on the canonized Yin Chêng-hsiu, a general of the last Emperor

of the Yin dynasty. His image may be seen at the door of Taoist temples.

The tiger represents the third of the TWELVE TERRESTRIAL BRANCHES (*q.v.*). This animal is said by Chinese writers "to eat its victims by the Chinese calendar, and to have the power of planning out the country round its lair, to be visited according to a fixed system. If it leaps up three times at its prey, and fails, it withdraws. Its victims become devils after digestion, but the flesh of the dog is said to intoxicate this cat-like creature. Bad smells, such as burnt horn, are said to scare it away, and the hedgehog, or tenroc, is said to be able to get the better of it." [4]

According to the Chinese belief, the spirit of a person eaten by a tiger urges the beast to devour others; those who have met a violent death may return to the world, if fortunate enough to secure a substitute. According to K'ang Hsi's dictionary, when a tiger bites a man in such a way that death ensues, the man's soul has no courage to go elsewhere, but regularly serves the tiger as a slave, and is called a *ch'ang* (虎齧人人死。魂不敢他適。輒隸事虎。名曰倀。). The same idea of seeking a substitute (討替) is the explanation of the objection by superstitious persons to save a drowning man, lest they themselves should be dragged down as a substitute by the spirit of one previously drowned there, who, it is supposed, is endeavouring to secure a substitute and thereby effect his own escape.

AUTHORITIES.

[1] *The Chinese Repository*, Vol. VII, March, 1839, Art. IV, pp. 596-7.
[2] Yetts: *Symbolism in Chinese Art*, p. 25.
[3] Mayers: *Chinese Reader's Manual*, Pt. I, p. 65.
[4] Smith: *Contributions towards the Materia Medica and Natural History of China*, pp. 40-41.

TI TSANG

(地 藏)

The Bodhisatva *Ksitigarbha* (Sanskrit), worshipped as a ruler of the nether world, and also as the protector of little

chidren. He opens the gates of purgatory and rescues the suffering souls.

"As to his origin, he is known in Indian Buddhism, but is not prominent there. He was early known in Central Asia, but whether his cult became important there first or in China is doubtful." [1]

He is the patron saint of Chiu-hua Shan (九華山), a mountain in Anhui, one of the chief places of pilgrimage of the Chinese Buddhists. His image is found in the second or chief hall of the Buddhist monasteries, and the last day of the seventh moon is set apart for his worship and propitiation.

TI-TSANG WANG
RULER OF HADES

AUTHORITY.
[1] Couling: *Encyclopaedia Sinica*: TI TSANG.

TOAD
(蝦 蟆)

Frogs and toads are very common in China, especially in the irrigated paddy-fields where they combine to produce a vociferous chorus during the breeding season in the early summer.

The Chinese do not appear to distinguish very clearly between the frog and the toad. The spawn of the frog is believed to fall from heaven with the dew, and hence the frog is called the "heavenly chicken" (天 鷄). It is used as an article of diet. A kind of medicine, said to be similar in its physiological action to digitalis, is obtained from the Chinese toad, *Bufo asiaticus,* in the following manner. The toad is held firmly in one hand, while the biggest wart-like swelling just behind the eye is touched lightly with a hot iron, whereupon a whitish juice is exuded by the toad. This is scraped off and put on to a glass plate, and another toad is taken and the operation repeated, till there is a good supply of the white juice. This is then allowed to evaporate slowly to a powder, which is used to make up into pills and solutions as a heart remedy.

As in the other countries, many stories and superstitions have been connected with the toad, owing no doubt to its weird and warty appearance, and the length of its life, which may

LIU HAI, THE IMMORTAL, SPORTING WITH THE THREE-LEGGED TOAD

extend to thirty or forty years. The three-legged toad of Chinese mythology is said to exist only in the moon, which it swallows during the eclipse. It has therefore come to be the emblem of the unattainable. The legendary Chieftain Hou I (后羿), *circa* 2500 B.C., obtained the Elixir of Immortality (無死之藥) from Hsi Wang Mu (西王母); Ch'ang O (嫦娥), his wife, stole it and fled to the moon, where she was changed by the gods into a toad (蟾蜍), whose outline is traced by the Chinese on the moon's surface. Liu Hai (劉海), a Minister of State of the 10th century A.D., was a proficient student of Taoist magic. He was said to possess a specimen of the mystical three-legged toad, which would convey him, like Bucephalus, to any place he wished to go. Occasionally the creature would escape down the nearest well, but Liu Hai had no difficulty in fishing it out by means of a line baited with gold coins. He is popularly represented with one foot resting on the toad, and holding in his hand a waving fillet or ribbon upon which five gold cash are strung. This design is known as "Liu Hai sporting with the Toad" (劉海戲蟾), and is regarded as most auspicious and conducive to good fortune, the three-legged toad being also considered to be the symbol of money-making. Another version of the story is that this toad lived in a deep pool and exuded a poisonous vapour which injured the people. Liu Hai is said to have hooked the ugly and venomous creature with a gold cash and destroyed it. Hence this legend points the moral that money is the fatal attraction which lures men to their ruin.

Chang Kuo-Lao (張果老), one of the EIGHT IMMORTALS (*q.v.*) of Taoism, is sometimes depicted riding on a colossal batrachian. An ancient form of Chinese script is known as the Tadpole Character (蝌蚪字), so called from its resemblance to tadpoles swimming about in water.

TORTOISE
(龜)

The written symbol for this reptile is a pictogram showing the snake-like head above, the claws on the left, the shell on the right, and the tail below (*vide* Illustration: "The Evolution of Chinese Writing," under WRITTEN CHARACTERS).

"Tortoises are kept in tanks in Buddhist temples, and it

is considered very meritorious to feed them, or to add to their number by purchasing them alive from the stalls of the street, where they are constantly exposed for sale as food. When a tortoise is thus purchased, a hole is made in the shell, and a creature with several such holes, often filled with rings, is much prized for medicinal purposes. Jelly made from the plastron, or the powdered shell made into pills or mixed up in cakes, is reputed to be tonic, cordial, astringent, and arthritic, and very useful in diseases of the kidneys."[1] Tortoiseshell (玳瑁) is chiefly obtained from the hawk's bill turtle (*Chelonia imbricata*), which is found in the Malay Archipelago and the Indian Ocean, and imported for carving and inlaying purposes at Canton. The soft-shelled fresh water turtle, *Trionyx sinensis,* is a common article of diet. The Large-headed Tortoise, *Platysternum megacephaluf,* is found in South China. The Chinese employ the tortoise to open up gutters and drains, as it is fond of burrowing in the earth. The tortoise is "vulgarly known (1) as *Wang Pa* (王八), from a nickname given by the people of the village to Wang Chien, who after a youth spent in violence and rascality, became the founder of the Earlier Shu State, dying A.D. 918; or (2) as *Wang-po* (忘八), 'the creature that forgets the eight rules of right and wrong—viz., politeness, decorum, integrity, sense of shame, filial piety, fraternal duty, loyality and fidelity (禮義廉恥孝悌忠信)—from a superstitious belief in the unchastity of the female. Hence, *wang-pa* is a common term of abuse, equivalent to cuckold."[2]

According to the "Book of Rites" (禮記), the unicorn, phoenix, tortoise, and dragon are "the four spiritually endowed creatures" (四靈). The tortoise is sacred to China, and is an emblem of longevity, strength, and endurance. It was said to be an attendant of P'AN KU (*q.v.*) when he chiselled out the world. Under the name of the "Black Warrior" (玄武) it presides over the Northern Quadrant of the uranoscope and symbolises winter. "The tortoise symbolises the universe to the Chinese as well as the Hindus. Its dome-shaped back represents the vault of the sky, its belly the earth, which moves upon the waters; and its fabulous longevity leads to its being considered imperishable."[3] "The *kuei* or tortoise is the chief of all shelly animals, 'because its nature is spiritual.' The upper vaulted part of its shell (蔡), says the *Pên Ts'ao* (本草), has various markings corresponding to the constellations in the heavens, and is the *yang;* the lower even shell has lines answering to the earth, and is the *yin*

(*vide* YIN AND YANG). The divine tortoise has a snake's head, and a dragon's neck; the bones are on the outside of the body, and flesh within; the intestines are joined to the head. It has broad shoulders and a large waist; the sexes are known by examining the lower shell. The male comes out in spring, when it changes its shell, and returns to its torpid state in the winter, which is the reason that the tortoise is very long-lived. Chinese authors describe ten sorts of tortoise; one of them is said to become hairy in its old age, after long domestication. Another has its shell marked with various lines resembling characters, and it is the opinion among some of the Chinese that their writing was first suggested by the lines on the tortoise shell (*vide* EIGHT DIAGRAMS), and the constellations of the sky. The shell was employed in divination and fortune-telling." [4]

"Divers marvellous tales are narrated with regard to its fabulous longevity and its faculty of transformation. It is said to conceive by thought alone, and hence the 'progeny of the tortoise,' knowing no father, is vulgarly taken as a synonym for the bastard-born. A species of the tortoise kind is called *pieh* (鱉), the largest form of which is the *yüan* (黿), in whose nature the qualities of the tortoise and the dragon are combined. This creature is the attendant of the god of the waters (河伯使者), and it has the power of assuming divers transformations. In the shape of the tortoise is also depicted the *pi-hsi* (贔屭), a god of the rivers (河神), to whom enormous strength is attributed; and this supernatural monster is frequently sculptured in stone as the support of huge monumental tablets planted immovably as it were, upon its steadfast back. The conception is probably derived from the same source with that of the Hindoo legend of the tortoise supporting an elephant, on whose back the existing world reposes." [5]

The "Record of Science" (格物志) puts the age limit of the tortoise at 1,000 years. Wang Ch'ung (王充), however, states in his "Lun Hêng" (論衡), "When the tortoise has lived 300 years, it is no bigger than a coin, and may still walk on a lotus leaf; when 3,000 years old, its colour is blue with green rims, and it is then only one foot two inches in size" (龜生三百歲大如錢。游於蓮葉之上。三千歲色青邊綠。巨尺二寸)

It is said that the wooden columns of the Temple of Heaven at Peking were originally set on live tortoises, under the belief that as these animals are supposed to live for more than 3,000 years without food and air, they are gifted with miraculous power to preserve the wood from decay.

AUTHORITIES.

1 Smith: *Contributions towards the Materia Medica and Natural History of China*: TERRAPIN.
2 Giles: *Glossary of Reference*: TORTOISE.
3 Waddell: *Lamaism*, p. 395.
4 *The Chinese Repository*, Notices of Natural History, Vol. VII, Sept., 1838, Art. II, p. 255.
5 Mayers: *Chinese Reader's Manual*, Pt. I, No. 299.

TREES

（樹）

Although a poetic appreciation of the beauty of trees and the luxuriance of their flowers and foliage has always been a characteristic of the Chinese people, yet, on account of the necessity for the provision of abundant fuel, and the high cost of wood as a building material, a continual process of deforestation has greatly reduced the timber supply of the country. The Philosopher Mencius said, "The trees of the Ox Hill were once beautiful. Being situated, however, on the borders of a large State, they were hewn down with axes and bills; and could they retain their beauty? . . . It looks barren now, and people think it was never finely wooded, but is this the natural state of the hill?" （孟子曰。牛山之木嘗美矣。以其郊於大國斧斤伐之。可以爲美乎。人見其濯濯也。以爲未嘗有林焉。此豈山之性也哉). The "Book of Poetry" （詩經） contains an ode referring to the period of Wên Wang (a contemporary of Saul), and the sentiment expressed is reminiscent of Morris' lines beginning "Woodman, spare that tree!":

> "O fell not that sweet pear-tree!
> See how its branches spread;
> Spoil not its shade,
> For Shao's chief laid
> Beneath it his weary head."

（蔽芾甘棠。勿剪勿代。召伯所茇。）

In spite of this injunction the tree has completely vanished, not even leaving a legend as to where it may once have stood. Lord Shao dispensed justice out in the open beneath the tree, which was held sacred for some time after his death.

The general destruction of forests bears fruit in the train of calamities due to flood, or drought, consequent on the removal of Nature's covering of the earth. Of recent years, however,

the Chinese government has recognised that forestry is of prime importance, and has taken steps to check the wholesale demolition of the trees of the country.

Tree-worship was widely spread throughout China in ancient times, as is evidenced by the reluctance of the people to cut down trees in the neighbourhood of temples and graves, and the fact that a shrine to some local god is often placed at the roots or in the fork of a tree remarkable for its size and beauty. It is believed that the soul of the god resides in the tree, which is therefore held to be sacred, and if dug up or cut down, the person doing so is liable to die. "Orthodox Buddhism decided against the tree-souls, and consequently against the scruple to harm, declaring trees to have no mind nor sentient principle, though admitting that certain devas or spirits do reside in the body of trees and speak from within them."[1] Binding trees with garlands, and decorating their branches with lanterns, is part of the old tree-worship, the tree being also a phallic emblem. Reference to trees that bleed, and utter cries of pain or indignation when hewed down, occur very often in Chinese literature. China is not unique, however, in superstition regarding trees; in England the elder trees of Sussex, which used to be sacred to Pan in pre-Christian times, must never be cut down, and the result is that they grow in many inconvenient spots. Tamarisks, which flourish along the southern coast, are never brought into the house, and tamarisk hedges are left untrimmed, a relic of the ancient Egyptian belief that tamarisks grew over the grave of Osiris. Many forms of tree worship survive, the decoration of houses with holly at the Christmas season being one of them, and in many parts of England there is a strong superstition that hawthorn blossoms will cause death if brought indoors.

Magic virtues are ascribed to certain trees and plants. The leaves of the *Chung K'uei* (終 葵), a kind of mallow, were reputed to have the power of warding off demons. A bunch of Artemisia (艾), a handful of the sword-shaped sweet flag— *Acorus calamus* (水菖蒲)—or a spray of willow leaves, is hung over the doors of houses to disperse evil influences on the 5th day of the 5th moon, the anniversary of the day when the rebel Huang Ch'ao (黃 巢), who captured Ch'ang-an in A.D. 880, gave orders to his soldiers to slay all the inhabitants except certain favoured ones who exhibited a bunch of leaves at the door.

There are said to be eight trees called Ch'ien (騫) or *Yao Wang* (藥王)—the King of Drugs—in the moon, the

leaves of which confer immortality on those who eat them. According to the Buddhist sutras a similar tree (藥王之樹) grows in the Himalayas, and possesses the virtue of healing all diseases. A cassia-tree (桂) is also said to grow in the moon, and a man named Wu Kang (吳剛), having committed an offence against the gods, was banished to the moon and condemned to the endless task of hewing down the tree. As fast as he dealt blows with his axe, the incisions in the trunk closed up again. Immortality is also the reward of these who eat of this tree (*vide* MOON).

The Chinese believe that if the Ailantus (臭椿) grows too high, the family living in the same courtyard will have bad luck. A mulberry should not be planted in front of a dwelling-house, nor a willow at the back, because *sang* (桑), mulberry, has the same sound as *sang* (喪), sorrow, and the willow, being symbolic of frailty and lust, may exercise an unhealthy influence on the ladies who generally occupy the rear apartments. The lilac, or *ting hsiang shu* (丁香樹), should not be grown in a private residence, because *ting* (釘) is also a nail, which implies family strife, friction, etc., amongst the womenfolk of the household. The *Tz'ŭ mei* (刺梅) or wild rose, owing to its thorny nature, is also under a ban, because it may be a thorn of dissension in the family. Flogging is said to be necessary for a date-tree to keep it in order, and if the root of a grape-vine happens to shoot beneath the house it is said to be an omen of death. The cactus, *Hsien jên chang* (仙人掌), literally the "fairy's hand," is considered unlucky to women who are about to bear children. A strip of red cloth or paper is often attached to a tree in order to prevent it from injury by the spirits of evil, who always avoid that particular colour of happiness and good fortune.

A conventional leaf resting on a fillet constitutes one of the EIGHT TREASURES (*q.v.*), used for ornamental purposes on porcelain, etc., and as an emblem of felicity. The cotyledon, or opening seed, is also a symbol of the germ of life. "All flesh is grass," which, when found in abundance as a decorative motive, is supposed to represent the people.

The principal species of Chinese trees are treated separately in this book, and their respective emblematic significances have also been fully dealt with.

AUTHORITY.
[1] Tylor: *Primitive Culture*, Vol. I, p. 475.

TRIDENT
（三 股 杈）

Three-pronged spears were formerly used by the Chinese in war and hunting. They are still used in processions, and may be seen in the hands of the Taoist idols. The Indian form of trident, Sanskrit, *Trisula,* is sometimes decorated with a miniature carved skull, or various religious emblems, and, when held in the grasp of the Buddhist deities, is regarded as the insignia of power and authority (*vide* SPEAR and Illustration under LAMAISM).

TWELVE ORNAMENTS
（十 二 章）

Many of the designs employed in the decoration of textile fabrics are undoubtedly of great antiquity. Among the earliest is a group of symbols known as the Twelve Ornaments, which signified authority and power, and were embroidered on vestments of state. They are as follows:

TWELVE ORNAMENTS

ON THE UPPER ROBE

1. 日　The SUN (*q.v.*) with a three-legged raven in it.
2. 月　The MOON (*q.v.*) with a hare in it, pounding the drug of immortality.
3. 星辰　The STARS (*q.v.*). Similar groups of three stars occur in Orion, Musca, Draco, etc.
4. 山　The MOUNTAINS—regarded with great appreciation by the Chinese, who hold some of them as sacred.
5. 龍　The examples of the DRAGON (*q.v.*).
6. 華蟲　The PHEASANT (*q.v.*).

ON THE LOWER ROBE

7. 宗彝　Two GOBLETS, with an animal on each.
8. 　　A spray of PONDWEED.
9. 火　Flames of FIRE (*q.v.*)—one of the FIVE ELEMENTS (*q.v.*).

409

10. 粉米　Grains of RICE (*q.v.*).
11. 黼　An AXE (*q.v.*).
12. 黻　The figure YA亞, said to be two 巳 *chi* (self) back to back. Also described as the upper garment, which is cut square and hangs down back and front.

According to the *Shu Ching* (書經), the Twelve Ornaments were referred to by the Emperor Shun (舜) as being ancient even at that distant date—more than 2,000 years B.C. "I wish," said the Emperor, "to see the emblematic figures of the ancients: the moon, the stars, the mountain, the dragon, and the flowery fowl, which are depicted on the upper garment; the temple-cup, the aquatic grass, the flames, the grains of rice, the hatchet, and the symbol of distinction, which are embroidered on the lower garment; I wish to see all these displayed with the five colours, so as to form the official robes; it is yours to adjust them clearly." [1] "Considering his ministers as his feet and hands, he was particularly anxious that the executors of his commands should be trustworthy and zealous. To remind them of their duty he pointed out to them symbols in their robes of state. Some had a sun, moon, and stars embroidered upon them. This, he said, points out the knowledge of which we ought to be possessed in order to rule well. The mountains indicate the constancy and firmness of which we stand in need; the dragon denotes that we ought to use every means to inspire the people with virtue; the beauty and variety of the colours of the pheasant remind us of the good example we ought to give, by practising the various virtues. In the upper robe, we behold six different kinds of embroidery, which are to remind us of the virtues to be engraved on our breast. The vase, which we are used to see in the hall of the ancestors, is a symbol of purity and disinterestedness; the fire, of zeal and love for virtue; the rice, of the plenty which we ought to procure for people; the hatchet is a symbol of justice in the punishment of vice; and the dresses, Fo and Fuh, are symbols of the discernment which we ought to have of good and evil." [2]

Only the Emperor had the right to wear the complete set of twelve emblems painted or embroidered on his robes of ceremony. "The hereditary nobles of the first rank were restricted from the sun, moon, and stars; those of the next two degrees were further restricted from mountains and dragons; and by a continually decreasing restriction five sets of official robes were made to indicate the rank of the wearers." [3]

These archaic figures are often found on porcelain and other works of art. "The two *fu* are among the commonest. The axe (黼) may be taken as the emblem of a warrior, but the original meaning of the other 黻 is doubtful. It is used at the present day to signify 'embroidered.'"[4]

AUTHORITIES.
[1] Legge: *Chinese Classics*, Vol. III, Pt. I, p. 80.
[2] Gutzlaff: *Sketch of Chinese History*, Vol. I, p. 136.
[3] Bushell; *Chinese Art*, Vol. II, pp. 59-6.
[4] Yetts: *Symbolism in Chinese Art*, pp. 12-13.

TWELVE TERRESTRIAL BRANCHES
（十 二 地 支）

CHARM DEPICTING THE YIN AND YANG (q.v.), THE EIGHT DIAGRAMS (q.v.), AND THE SYMBOLIC ANIMALS OR TWELVE TERRESTRIAL BRANCHES

The Twelve Cyclical Signs, or Duodenary Cycle of Symbols, forming the feminine or secondary, *i.e.* right hand column of the CYCLE OF SIXTY (*q.v.*).

They are employed for chronological purposes and used to designate the hours, days, months, and years, being usually symbolised by twelve different animals （十二獸） or affinities （相屬）, each of which is supposed to exercise some influence over the period of time denoted by the special character which the animal represents, as will be seen in the following table:

TWELVE BRANCHES	SYMBOLICAL ANIMALS	ZODIACAL SIGNS	CORRESPONDING HOURS		POINTS OF THE COMPASS
子 T'zŭ	鼠 Rat	Aries	11-1 a.m.	三更 3rd watch	North
丑 Ch'ou	牛 Ox	Taurus	1-3	四更 4th „	NNE¾E
寅 Yin	虎 Tiger	Gemini	3-5	五更 5th „	ENE¾N
卯 Mao	兔 Hare	Cancer	5-7		East
辰 Ch'ên	龍 Dragon	Leo	7-9		ESE¾S
巳 Ssŭ	蛇 Serpent	Virgo	9-11	上午 Forenoon	SSE¾E
午 Wu	馬 Horse	Libra	11-1 p.m	正午 Noon	South
未 Wei	羊 Goat	Scorpio	1-3	下午 After-	SSW¾W
申 Shên	猴 Monkey	Sagitiarius	3-5	noon	WSW¾S
酉 Yu	雞 Cock	Capricornus	5-7		West
戌 Hsü	犬 Dog	Aquarius	7-9	初更 1st watch	WNW¾W
亥 Hai	豕 Boar	Pisces	9-11	二更 2nd „	NNW¾W

411

"The first explicit mention of the practice of denoting years by the names of animals as above is found in the history of the T'ang dynasty, where it is recorded that an envoy from the nation of the 黠 戛 斯 (Kirghis?) spoke of events occurring in the year of the hare, or of the horse. It was probably not until the era of Mongol ascendancy in China that the usage became popular; but, according to Chao I (趙 翼)—A.D. 1727— traces of a knowledge of this method of computation may be detected in literature at different intervals as far back as the period of the Han dynasty, or second century A.D. The same writer is of opinion that the system was introduced at that time by the Tartar immigration." [1] Professor Chavannes has written a learned article to prove that the group known as the Twelve Animals was borrowed from the Turks, and was used in China as early as the first century of the Christian era (*vide* *T'oung-Pao*, Vol. VII, 1906).

The zodiac of twelve is common to many nations of the East. "Every Chinese knows well under which animal he was born. It is essential that he should do so, for no important step throughout life is taken unless under the auspices of his particular animal. Indeed, this mysterious influence extends even beyond his life, and is taken into consideration in the disposal of his corpse." [2]

AUTHORITIES.
[1] Mayers: *Chinese Reader's Manual*, Pt. II, 302.
[2] Yetts: *Symbolism in Chinese Art*, p. 21.

UMBRELLA

(傘)

In the China trade the common umbrella, made of bamboo and oiled paper, and found in every part of the country, is called a "kittysol," a corruption of the Portuguese and Spanish term *quitasol*. This article, which is now chiefly manufactured in Wenchow, was introduced in the 4th century A.D., though silk umbrellas such as the *Lo-san* (羅 傘), or the *Jih-chao* (日 照), carried in processions, have been in use from earlier times. Factories for the making of umbrellas in foreign style have recently been established in certain localities.

An umbrella called the Umbrella of Ten Thousand People (萬 民 傘) is sometimes presented to a popular official when he leaves his district. It is a token of respect and purity and a symbol of dignity and high rank, being made of red silk or satin and inscribed with the names of the donors in gilt characters.

An elaborate umbrella is one of the EIGHT TREASURES (*q.v.*) or auspicious signs on the sole of Buddha's foot, and sometimes symbolically represents the sacred SPLEEN (*q.v.*) of that divinity.

UNICORN

(麒 麟)

The Ch'i-lin (Jap. *Kirin*) or Unicorn, whose prototype may have been some rare species of quadruped now extinct, or pos-

sibly the giraffe, is a fabulous
creature of good omen, and the
symbol of longevity, grandeur,
felicity, illustrious offspring, and
wise administration.

UNICORN

It is reputed to be able to
walk on water as well as on
land, and is said to have last
appeared just before the death
of Confucius. It is sometimes
called the Dragon Horse (龍 馬), and is one of the four great
mythical animals of China, the others being the DRAGON,
PHOENIX, and TORTOISE (q.q.v.). It is represented by
Buddhists as carrying on its back the civilizing Book of the
Law. A Dragon Horse is recorded to have come up out of the
Yellow River and appeared to Fu Hsi (伏 羲), the first legend-
ary Emperor, bearing on its back a mystic map from which
the written language of China is said to have been evolved.

The predominant characteristic of the *Lin* is its perfect
goodwill, gentleness, and benevolence to all living creatures.
"The unicorn is supposed to combine and possess all the good
qualities which are to be found among all hairy animals: it is
invested with a skin of the gayest colours, endowed with a
disposition of the kindest feelings; and a discriminating mind,
that enables it to know when benevolent kings or wise sages
are to appear in the world, is attributed to it. The male is
called *ch'i,* and the female *lin*; it resembles a large stag in its
general form; but combines the body of the musk deer with the
tail of an ox, the forehead of a wolf, and the hoofs of a horse.
Its skin is of five colours, red, yellow, blue, white, and black;
and it is yellow under the belly; it is twelve cubits high. Its
voice is like the sound of bells and other musical instruments.
It has a horn proceeding out of the forehead, the tip of which
is fleshy, and this peculiarity pointed it out as an animal unfit
for war. The male has a horn, but the female is without this
defence. It carefully avoids treading upon any living insect,
or destroying the grass under its feet, and its gait is regulated
according to propriety. It never eats contrary to right (mean-
ing that it does not eat carrion or what other animals have left),
nor will it drink muddy water; and so well known is its dis-
position that other animals are not afraid to see its footsteps.
It is always seen solitary, and appears to mankind only when
a king of the highest benevolence sits upon the throne, or when
a sage is about to be born. The unicorn envelopes itself with

benevolence, and crowns itself with rectitude. Chinese writers say that it appeared in the halcyon days of the Emperors Yao and Shun, and was also seen at the time when Confucius was born; but so degenerate have mankind since become, that it has never since shown itself. Some of them go so far as to affirm that the mother of Confucius became pregnant of him by stepping into the footsteps of a unicorn when she went to the hills to worship. This representation of the *ch'i lin* combines most of the external characteristics, as described by the Chinese; it is sometimes drawn surrounded with fire, and other times with clouds."[1] Some writers state that it has the body of a horse, is covered with scales like a fish, and has two horns bent backwards. The celebrated scholar Ts'ai Yung (蔡邕), A.D. 133-192, asserts that it is the incarnate essence of the FIVE ELEMENTS (*q.v.*). "It is said to attain the age of one thousand years, and to be the noblest form of animal creation, the emblem of perfect good."[2] It is regarded as a happy portent, on its alleged appearance, of the advent of good government or the birth of virtuous rulers.

Pictures of the Goddess of Fecundity (注生娘娘) riding on a unicorn, and holding a child in her arms, may often be seen in the nuptial chamber. The unicorn was formerly embroidered on the court robes of the military officials of the first grade.

AUTHORITIES.
[1] *The Chinese Repository*, Notices of Natural History, Vol. VII, 1838-9, pp. 212-3.
[2] Mayers: *Chinese Reader's Manual*, Pt. I, 389.

VASE

(花 瓶)

Vases are made of porcelain, bronze, etc., in many different styles, the principle of construction being derived from the curves of the female form. They are fashioned in special shapes for particular flowers; bottle-shaped vases are said to be suitable for holding peonies and orchids, as they have narrow necks so that the warm water with which they are filled may not emit a bad odour; vases are occasionally seen with several mouths for flowers of different varieties.

Many emblematic devices are employed in the decoration of vases. The gift of a "rare vase," *pao p'ing* (寶 瓶), suggests the idea of "the maintenance of peace," *pao p'ing* (保 平), on account of the similarity in the sound of the Chinese terms, and is equivalent to the greeting "Peace be with you." The vase is therefore regarded as an emblem of perpetual harmony.

Buddha is said to have been fond of flowers, and vases are always placed on the Buddhist altars. The vase is one of the auspicious signs on the FOOTPRINTS OF BUDDHA (*q.v.*), symbolizing the idea of "not leaking," and signifying that condition of supreme intelligence triumphant over birth and death. (*Vide* also CHINAWARE.)

VERMICELLI

(粉 絲)

Vermicelli is one of the staple foods of north China, where rice is not plentiful. It is made of wheat and beans, especially

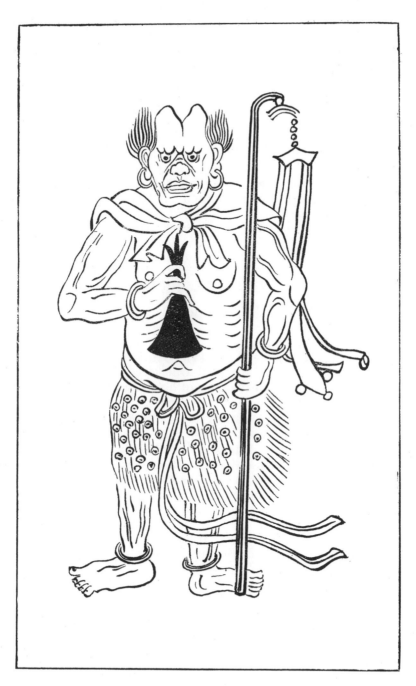

MARA THE TEMPTER, ARCH FIEND OF THE BUDDHISTS

417

the green bean (綠荳), *Phaseolus mungo L*, large quantities being exported, principally from Chefoo and Newchwang. Both the solid vermicelli and the tubular macaroni are made of the same materials, the best qualities being produced in Shantung. A coarse variety of vermicelli is made from rice flour. Fine vermicelli (銀絲) is made from flour dough, drawn out on a frame and dried in the sun.

Vermicelli is always eaten on the first and fifteenth days of each month, or when the moon is at the full, and, owing to its length, is regarded as an emblem of longevity. It is generally served at weddings and birthday festivities, when the guests are expected to partake of it to intimate their wish that those in whose honour the celebrations are held will be blessed with long life.

VULTURE PEAK

(耆 闍 崛 山)

Translated into Japanese as Mount Reishu, "The Mountain of the Spiritual Eagle," Sanskrit *Gridhra-krita*. So called because Mâra (魔王) the Evil One, according to Buddhist tradition, once assumed the form of a vulture on it to interrupt the meditation of Ânanda, the disciple of Buddha. It is also called "the Hill of the Vulture Cavern" (雕鷲窟山), because Buddha, by his supernatural power, made a cleft in the rock, introduced his hand, and stroked Ânanda's shoulder, so that his fear of the evil bird passed away. Some say that the name is merely due to the fact that vultures abound on the mountain.

It was situated near Râjagriha, the earlier capital of Asoka. On this mountain Buddha preached the Law, and the Monk Fa Hsien (法顯) spent a night there in worship and in great peril from wild beasts. It abounded in caverns and was famous as a resort of ascetics. (*Vide* also SHÂKYAMUNI BUDDHA.)

WATER

（水）

The symbol for water is a pictogram (像形), showing a cascade in the centre, and the spray dashing out on both sides. It figures as the 85th radical of the language. The character for rain (雨) is a conventional picture of a cloud floating under Heaven, from which drops of moisture are falling to the earth below.

China was originally believed to be bounded by four seas, east, west, south, and north, while beyond were only barbarian tribes. According to Chinese records, the Great Flood occurred four thousand two hundred years ago, and Ta Yü (大禹), the founder of the Hsia dynasty, saved the country by opening up channels into which he directed the overflowing waters. The Yellow River frequently causes great devastation by over-flowing its banks, and, in former times, the river-god was annually propitiated with the sacrifice by drowning of a young girl in bridal attire. Hsi-mên Pao (西門豹), Governor of Yeh, *circa* 424 B.C., put an end to this sinister practice by casting the officiating priests and their associates into the river at the time set apart for the ceremony. Water-ways, *i.e.*, lakes, rivers, and canals, are greatly relied upon in China for purposes of communication. The Grand Canal is a wonderful piece of engineering, being about 650 miles in length, and extending from Tientsin to Hangchow. A famous tidal wave or bore is to be seen at Hangchow, on the Ch'ien-t'ang River.

According to the "Book of Rites" (禮記), jewels and brocade were offered on the altars, and bells and drums were sounded, at the ancient summer sacrifices for the rain so necessary to the crops. During an exceptionally dry season

雨師

THE LORD OF THE RAIN. THE PARJANYA OF THE VEDAS
420

proclamations are sometimes issued by the officials forbidding the slaughter of animals (禁 止 屠 宰) to propitiate the gods of the Buddhist religion. "In times of drought an altar is put up at the Lung Wang Miao (龍 王 廟), the temple of the Dragon King. In times of flood it is erected at Huo Shên Miao (火 神 廟), the temple of the God of Fire. At this altar the district magistrate makes obeisance morning and night. When fasting for fine weather, the north gate of the city is closed; when fasting for rain, the south gate; because it is said in the eight diagrams the North belongs to water and the South to fire." [1]

Water is the first of the FIVE ELEMENTS (q.v.). The Chinese Pharmacopœa (本 草) places it in the forefront of all medical agents and discusses very elaborately all its conditions and uses. It is said to be the first of the sixteen great classes of all known substances, and is divided into the celestial and terrestrial orders, which are subdivided into thirteen and thirty varieties respectively. The hydropathic system seems to have been in vogue in the time of the celebrated surgeon Hua T'o (華 佗), who flourished towards the close of the 2nd century, and practised the cold douche in a regular form. Hot water is often taken medicinally by the Chinese, and "water of the five metals" (五 寶 湯), in which gold, silver, copper, iron, and tin articles have been boiled together, is a popular remedy for faintness and shock. The complexion of women (水 色) is said to depend on the water of the locality, and for this reason it is customary to clean out the wells at the summer solstice.

A fancy name for water is "essence of jade" (玉 液), vide ELIXIR OF LIFE. "Sweet dew" (甘 露), Sanskrit Amrita, is the nectar of the gods, the holy or miraculous water of immortality, believed to have descended from heaven upon the flowers of the earth. The "flagon of sweet dew," Sanskrit Amrita karka, is symbolic of the sacred doctrine of Buddha. A bronze vessel with a spout is sometimes used by Buddhist priests for anointing the worshippers with holy water. Rainwater and dew are believed to possess remarkable medicinal and alchemistic value. "Pure dew collected without contamination with earthly things is superstitiously supposed to confer the enviable blessing of immortality on the fortunate being who is successful in quenching his thirst at dawn of day with a precious draught." [2] The PHOENIX (q.v.) is said to be the essence of water, which is the emblem of purity in the abstract. The rainbow is supposed to be the result of a meeting between the impure vapours of the sun and the earth. Rock crystal

THE SPIRIT OF THE YELLOW RIVER

was believed by the ancient Chinese to be petrified ice. The term *shan shui* (山 水)—hills and water—is a euphemism for scenery, while *fêng shui* (風 水)—wind and water—is the name applied to the art of selection of propitious locations for houses, graves, etc., in harmony with the forces of nature (*vide* FÊNG SHUI). The rippling of the mountain streams and the deep reverberation of the waterfalls are employed by the Chinese as motives for the music of the flute.

AUTHORITIES.
[1] Hutson: *Life on the Thibetan Foothills*, New China Review, Vol. II, No. 5, Oct., 1920.
[2] Mesny: *Chinese Miscellany*, 10 June, 1899, Vol. III, No. 12, p. 225.

WATER-POT
(水 壺)

A bronze vessel, Sanskrit *Kalasa*, for holding liquids, and used on the Buddhist altars, is commonly seen. The small round water-pot, generally of china, is one of the appurtenances of the writing-table, and holds the water for mixing with the ink. (*Vide* also FOUR TREASURES, WATER.)

WEI CH'I
(圍 棋)

The game of Wei Ch'i, or "surrounding checkers," is apparently the Chinese original (some five thousand years old) of the Japanese game of Go.

It is played with black and white counters on a square board, with nineteen horizontal and nineteen vertical lines, the pieces being placed at their points of intersection and not in the resulting 324 squares. In principle it is a war game, the object of the player being to detach, surround and capture his adversary's men, according to certain rather complicated but easily intelligible rules.

Experts of the game require to show considerable initiative and ready wit, and are held in high honour.

There is a legend of a wood-cutter watching two venerable sages playing Wei Ch'i in a mountain cave, and looking down eventually to find that his axe helve had rotted in its socket and

his beard grown to his toes, so masterly was the strategy and so grim the determination of the opposing generals.

A clearly written and well illustrated explanation is to be found in *The Game of Wei-ch'i*, by Mr. Tong Shu and Count Daniele Pecorini (formerly of the Chinese Maritime Customs Service). (*Vide* AMUSEMENTS.)

WEI T'O
(韋 陀)

A military Bodhisatva (菩 薩), styled the "Deva who protects the Buddhist religion" (護 法 韋 陀), sometimes identified with Indra. His image is placed in the first hall of the Buddhist monastery. He is represented in complete armour and holding a sceptre-shaped weapon of assault.

WHEEL OF THE LAW
(法 輪)

Sanskrit *Dharmachakra*. One of the auspicious signs on the FOOTPRINTS OF BUDDHA (*q.v.*), though sometimes replaced by the representation of a large bell. Also called the Wheel of Life, Wheel of Truth, the Holy Wheel, the Wheel of a Thousand Spokes, or the

THE SACRED WHEEL OF BUDDHISM

Indestructible Wheel of the Cosmos. This emblem exemplifies the crushing effect of Buddha's preaching upon all delusions and superstitions, just as a wheel crushes anything it passes over. Symbolic of Buddha's person. Buddha is recorded to have originated the design of the Wheel of the Law by drawing it in diagrammatic fashion with grains of rice, drawn from a stalk which he had plucked while teaching his disciples in a rice-field. The manifold spokes of the Wheel correspond to the many rules of conduct stipulated by Buddha's teaching, and also symbolise the rays of sacred light emanationg from the Master. The turning of the Buddhist prayer-wheel, either by

hand or by the power of wind or water, is supposed is be tantamount to repeating the doctrines of Buddha, which are sometimes written out and attached to the Wheel.

The chariot-wheel is regarded as the symbol of sovereign rule and authority, for, says Dr. Bühler, "The unopposed progress of a king's chariot shows the wide extent of his power." The Sacred Wheel may have been derived by the Buddhists from the ancient Aryan sun emblem, and "turning the Wheel of the Law" is probably connected with the Vedic sun-worshipping ceremonies in which a chariot-wheel was fastened to a post and turned towards the right, *i.e.* following the path of the Universal Law which directed the Sun in its orbit. It is a recognised fact that many religions owe much of their symbolism to other beliefs of more ancient origin (*vide* also CHAIN, EIGHT TREASURES, SHAKYAMUNI BUDDHA).

The Wheel of Life is described as follows by the Lamas:

In the inside centre are what is known as the "Three Poisons." The Snake depicts hatred; the Bird depicts lust; the Pig depicts ignorance.

The middle division has six departments, known as the "Six Species." This middle circle is divided into an upper and lower section: the lower is called the "Three States of the Lost" and the upper is termed the "Three States of the Blest."

The lowest division is Hades; this is divided again into 18 departments, one half of which are very cold and the other half exceedingly warm. In each division there is a dreadful Overseer and a friendly Protector.

The division to the left of Hades is called by the Tibetans the "Yi-dag" and is represented by beings with huge bodies, large bellies, and narrow necks. In this division there are three separate sections.

To the right of Hades is the "Brute Division" and this again is divided into three sections.

The upper half: the three heavens or the three states of the blest: to the right, below the gods is the "Man Division." In this division is depicted birth, old age, sickness, and death. To the left, below the gods, is the "Division of the Demigods." "And there was war in heaven": this division is given up to perpetual warfare with the gods for possession of the "fabulous tree, which grants every wish."

On the extreme top of the picture, immediately above Hades and above the "Three Poisons" is the division occupied by the gods. Here warfare is also the order of the day; the object being simply to retain possession of the "fabulous tree." Im-

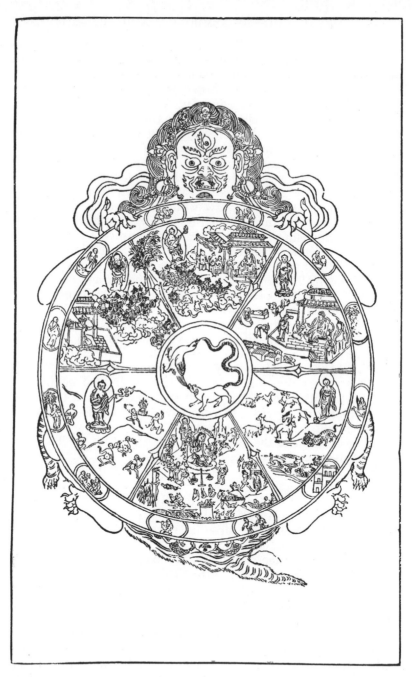

LAMA WHEEL OF LIFE

426

mediately below the Protector may be seen the warriors engaged in fighting the demigods. Below the warriors is an elephant pouring forth the maddening drink and turning the wheel with its trunk. On the right sits the Overseer of the gods.

The outside narrow rim is called "the Twelve Deeds" or the "Continuous Connection" and is supposed to give the idea of the Wheel of Life. This outside rim shows the enactment of twelve different phases in daily life and represents, as said above, the Wheel of Life, or the "Continuous Connection" from birth to death, or as it is here, from old age to death. Scene number one is an old blind man being led; scene number two is the potter and his wheel; scene number three is the yellow monkey climbing a tree; scene number four is the man in the boat; scene number five is the house with the six windows; scene number six is marriage; scene number seven is an arrow piercing the eye; scene number eight is two men having a drink of wine; scene number nine is grasping the fruit of the tree of life; scene number ten—maternity; scene number eleven—birth; and lastly scene number twelve—death.

WILLOW
（柳）

The willow is found in all parts of China, and is much esteemed for its shade. The slender osiers are used for making baskets and ropes, while the leaves, owing to their large proportion of tannin, provide the poorer classes with a passable substitute for tea. The leaves and bark of certain species are prescribed as remedies for goitre, dysentery, rheumatism, and bruises.

The genera of *Populus*, *Salix*, and *Tamarix* are much confused by the Chinese, who class them all together as *Yang liu* (楊柳). Thus *Mu yang* (木楊) indicates the *Salix pentandra*; *Ch'ih yang* (赤楊), the Red Willow or Tamarisk, also called the Willow of the Goddess of Mercy (觀音柳); *Pai yang* (白楊), the *Populus alba*; and *Chü liu* (欂柳), the *Pterocarya stenoptera*.

The willow is the Buddhist symbol of meekness. It is regarded as a sign of spring, and has provided the famous poets of the T'ang and painters of the Sung dynasties with a never-failing *motif*, for owing to its beauty, suppleness, and

frailty, it has become the emblem of the fair sex. The female waist is compared to the willow. Hsiao Man (小蠻), one of the beautiful concubines of the celebrated poet Po Chü-i (白居易), was noted for her willow-like waist (楊柳小蠻腰). The tree is believed, moreover, to possess power over demons, and can expel them as occasion demands. Bunches of willow branches are used to sweep out the tombs at the Ch'ing Ming festival (*vide* ANCESTRAL WORSHIP). The spiritualistic medium makes use of images carved of willow wood to communicate with the spirit world. The Buddhists consider that water, sprinkled by means of a willow branch, has a purifying effect. A willow-branch is sometimes suspended over the front door of a Chinese dwelling as an omen of good to the family (*vide* LEAF). Women wear sprigs of willow in their hair because they believe that, by so doing, they will keep their eyes clear and ward off blindness. The 24th constellation of the zodiac is named after the willow (*vide* STARS).

The design of the well-known willow-pattern chinaware was originally obtained from Chinese sources and engraved on copper by the celebrated English potter Minton in 1780, for use in Thomas Turner's porcelain factory, and a certain amount of this willow ware has been subsequently produced in Canton (*vide* Gulland: *Chinese Porcelain*, Vol. I, pp. 157-8). The Willow Pattern Tea-house in the Shanghai Chinese city is said to have provided part of the scheme of decoration, which, however, may be derived from the legend of the Cow-herd and the Spinning-maid (*vide* STARS). More commonly the story "has been explained as portraying the secret love of a young lady for her father's secretary, discovery, flight, pursuit of relentless parent, and finally transformation of the lovers into two turtle-doves. The name is further said to have been adopted because the flight took place at the time when the willow sheds its leaves."[1]

On the right-hand side is seen a Chinese house of unusual extent and magnificence. The wealth and resources of the owner are indicated by its being of two stories in height—a most rare thing in China—by the existence of out-buildings at the back (to the right), and by the large and rare trees which are growing upon all sides of the main building. This house belonged to a mandarin of great power and influence, who had amassed considerable wealth in serving the emperor in the excise department. The work, as is the case in other places besides China, was performed by an active secretary, named Chang, while the business of the master consisted in receiving

bribes from the merchants, at whose smuggling and illegal traffic he winked, in exact proportion as he was paid for it. The wife of the mandarin having, however, died suddenly, he requested the emperor to allow him to retire from his arduous duties, and was particularly urgent in his suit, because the merchants had began to talk loudly of the unfairness and dishonesty of the Chinese manager of the customs.

The death of his wife was a fortunate excuse for the old mandarin, and in accordance with his petition, an order signed by the vermilion pencil of his Imperial Majesty the Emperor, was issued to a merchant who had paid a handsome douceur to his predecessor.

To the house represented on the plate did the mandarin retire, taking with him his only daughter, Koong-see, and his secretary Chang, whose services he had retained for a few months in order to put his accounts in such array as to bear a scrutiny, if from any unforeseen circumstances, he should be called to produce them. When the faithful Chang had completed this duty, he was discharged. Too late, however! The youth had seen and loved the mandarin's daughter. At sunset, Koong-see was observed to linger with her maid on the steps which led to the banquet-room, and as the twilight came on, she stole away down the path to a distant part of the grounds; and there the young lovers, on the last evening of Chang's engagement, vowed mutual promises of love and constancy. And on many an evening afterwards, when Chang was supposed to be miles away, lovers' voices in that place might have been heard amongst the orange trees; and as darkness came on, the huge peonies which grew upon the fantastic wall had their gorgeous petals shaken off as Chang scrambled through their crimson blossoms. By the assistance of the lady's handmaid, these interviews were obtained without the knowledge of the old mandarin; for the lovers well knew the harsh fashion of the country, and that their stations in life being unequal, the father would never consent to the union. Chang's merit, however, was known, and the affectionate wishes of the young people pictured a time when such an obstacle would be removed by his success. They believed as they hoped, and the year of their fancy had only two seasons—spring-time and summer.

By some means, at last, the knowledge of one of these interviews came to the old man, who, from that time, forbade his daughter to go beyond the walls of the house; the youth was commanded to discontinue his visits upon pain of death, and to prevent his chivalrous courage any chance of gratifica-

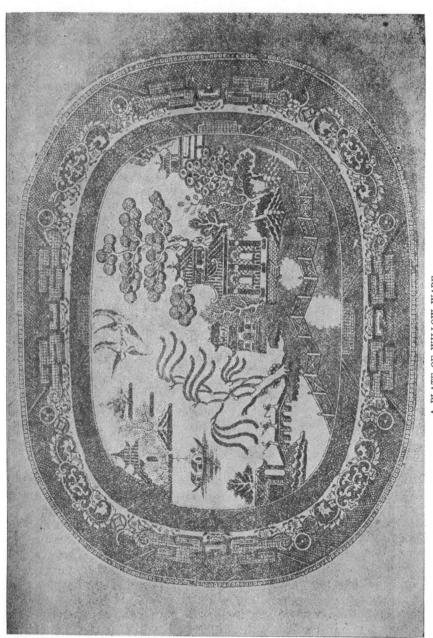

A PLATE OF WILLOW WARE

430

tion, he ordered a high wall of wood to be built across the pathway from the extremity of the wall to the water's edge (*see plate*). The lady's handmaid, too, was dismissed, and her place supplied by an old domestic, whose heart was as withered as her shrivelled face.

To provide for his daughter's imprisonment, and to enable her to take exercise in the fresh air, he also built a suite of apartments adjoining his banquet room, and jutting out over the water's edge, with terraces upon which the young lady might walk in security. These appartments having no exit but through the banquet-hall, in which the mandarin spent the greatest part of his time, and being completely surrounded by water, the father rested content that he should have no further trouble from clandestine meetings. As also the windows of his sitting-room looked out upon the waters—any attempt at communication by means of a boat would be at once seen and frustrated by him. To complete the disappointment of the lovers, he went still further—he betrothed his daughter to a wealthy friend, a Ta-jen, or duke of high degree, whom she had never seen. The Ta-jen was her equal in wealth and in every respect but age, which greatly preponderated on the gentleman's side. The nuptials were, as usual, determined upon without any consultation of the lady; and the wedding was to take place "at the fortunate age of the moon, when the peach-tree should blossom in the spring." The willow-tree was in blossom then, the peach-tree had scarcely formed its buds. Poor Koong-see shuddered at what she called her doom, and feared and trembled as she watched the buds of the peach-tree, whose branches grew close to the walls of her prison (*see plate*). But her heart was cheered by a happy omen—a bird came and built its nest in the corner above her window.

One day, when she had sat on the narrow terrace for several hours, watching the little architect carrying straws and feathers to its future home, the shades of evening came upon her, and her thoughts reverting to interviews that were associated with the hour, she did not retire as usual, but disconsolately gazed upon the waters. Her abstraction was disturbed by a half cocoa-nut shell, which was fitted up with a miniature sail, and which floated gently close to her feet. By the aid of her parasol she reached it from the water. Her delighted surprise at its contents caused her to exclaim aloud in such a manner as to bring the old servant to her side, and nearly to lead to a discovery; but Koong-see was ready with a plausible

excuse, and dismissed the woman. As soon as she was gone, she anxiously examined the little boat. In it she found a bead she had given to her lover—a sufficient evidence from whose hands the little boat had come; Chang had launched it on the other side of the water. There was also a piece of bamboo paper, and in light characters were written some Chinese verses. [2]

> "The nest yon winged artist builds,
> Some robber-bird shall tear away;
> So yields her hopes the affianced bride,
> The wealthy lord's reluctant prey."

"He must have been near me," she murmured, "for he must have seen my bird's nest by the peach-tree." She read on:

> "The fluttering bird prepares a home,
> In which the spoiler soon shall dwell,
> Forth goes the weeping bride, constrain'd;
> A hundred ears the triumph swell."
> "Mourn for the tiny architect,
> A stronger bird hath ta'en its nest;
> Mourn for the hapless stolen bride,
> How vain the hope to soothe her breast!"

Koong-see burst into tears, but hearing her father approaching, she hid the little boat in the folds of her loose flowering robe. When he was gone, she read the verses again; and wept over them. Upon further examination she found upon the back these words, in the peculiar metaphorical style of oriental poetry: "As this boat sails to you, so all my thoughts tend to the same centre; but when the willow blossom droops from the bough, and the peach-tree unfolds its buds, your faithful Chang will sink with the lotus-blooms beneath the deep waters. There will he see the circles on the smooth river, when the willow blossom falls upon it from the bough—broken away like his love from its parent stem." As a sort of postscript was added, "Cast your thoughts upon the waters as I have done, and I shall hear your words."

Koong-see well understood such metaphorical language, and trembled as she thought of Chang's threat of self-destruction. Having no other writing materials, she sought her ivory tablets, and with the needle she had been using in embroidery, she scratched her answer in the same strain in which her lover had addressed her. This was her reply: "Do not wise husbandmen gather the fruits they fear will be stolen? The sunshine lengthens, and the vineyard is threatened to be spoiled by the hands of strangers. The fruit you most prize

will be gathered, when the willow blossom droops upon the bough." Much doubting, she placed her tablets in the little boat, and after the manner of her country-women, she placed therein a stick of frankincense. When it became dark she lighted the frankincense and launched the little boat upon the stream. The current gradually drew it away, and it floated safely till she could trace it no longer in the distance. That no accident should have overturned the boat or extinguished the light, she had been taught to believe was a promise of good fortune and success, so with a lighter heart she closed her casements and retired to rest.

Days and weeks passed on, but no more little boats appeared; all intercourse seemed to have been cut off, and Koong-see began to doubt the truth of the infallible omen. The blossom upon the willow-tree—for she watched it many an hour—seemed about to wither, when a circumstance occurred which gave her additional grounds for this distrust.

The old mandarin entered his daughter's apartment one morning in high good humour. In his hands he bore a large box full of rare jewels, which he said were a present from the Ta-jen, or duke, to whom he had betrothed her. He congratulated her upon her good fortune, and left her, saying "that the wealthy man was coming that day to perform some of the preliminaries of the wedding, by taking food and wine in her father's house. Koongs-see's hopes all vanished, and she found her only relief in tears. Like the netted bird, she saw the snare drawing closer and closer, but possessed no power to escape the toils.

The duke came, his servants beating gongs before him, and shouting out his achievements in war. The number of his titles was great, and the lanterns on which they were inscribed were magnificent. Owing to his rank, he was borne in a sedan, to which were attached eight bearers, showing his rank to be that of a viceroy. The old mandarin gave him a suitable reception, and dismissed his followers. The gentlemen then sat down to the introduction feast according to custom, and many were the "cups of salutation" which were drank between them, till at last they became boisterous in their merriment. The noise of revelry and the shoutings of the military duke seemed to have attracted a stranger to the house, who sought alms at the door of the banquet-room. His tale being unnoticed, he took from the porch an outer garment which had been left there by one of the servants, and thus disguised, he spread the screen across the lower part of the banquet hall; passing

forward, he came to Koong-see's apartment, and in another moment the lovers were locked in each other's arms. It was Chang who had crossed the banquet-room. He besought Koong-see to fly with him, "for," said he, "the willow blossom already droops upon the bough." She gave him into his hands the box of jewels which the duke had that day presented to her, and finding that the elders were growing sleepy over their cups, and that the servants were taking the opportunity to get intoxicated elsewhere, Koong-see and Chang stole behind the screen—passed the door— descended the steps, and gained the foot of the bridge, beside the willow-tree. Not till then did the old mandarin become sensible of what was going on—but he caught a glimpse of his daughter in the garden, and raising the hue and cry, staggered out after them himself.

To represent this part of the story are the three figures upon the bridge (*see plate*). The first is the lady Koong-see, carrying a distaff, the emblem of virginity; the second is Chang, the lover, bearing off the box of jewels; and the third is the old mandarin, the lady's father, whose paternal authority and rage are supposed to be indicated by the whip which he bears in his hand. As the Chinese artist knows little or nothing of perspective, he could not place the old gentleman—to be seen— in any other situation than in the unnatural proximity in which we find him. The sketch simply indicates the flight and the pursuit, and is graphic enough for the purpose.

The old mandarin, tipsy as he was, had some difficulty in keeping up the pursuit, and Chang and Koong-see eluded him without much effort. The Ta-jen fell into an impotent rage on hearing what had occurred, and so great was his fury, that he frothed at the mouth, and well-nigh was smothered in his drunken passion. Those few of the servants, indeed, who were sober enough to have successfully pursued the fugitives, were detained to attend upon the duke, who was supposed to be in a fit, until the lovers had made good their escape.

Every suggested plan was adopted during the following days, to discover whither the undutiful daughter had fled; but when the servants returned, evening after evening, and brought no intelligence which afforded any hope of detecting her place of retirement, the old mandarin gave himself up to despair, and became a prey to low spirits and ill-humour. The duke, however, was more active and persevering, and employed spies in every village for miles round. He made a solemn vow of vengeance against Chang, and congratulated himself that, by his power as magistrate of the district, when Chang could be

discovered, he would exercise his plenary authority, and put him to death for the theft of the jewels. The lady, too, he said, should die, unless she fulfilled the wishes of her parent, not for his own gratification, but for the sake of public justice.

In the meantime, the lovers had retired to an humble tenement at no great distance from the mandarin's establishment, and had found safety in the concealment afforded to them by the handmaid of Koong-see, who had been discharged in consequence of affording Chang an opportunity of clandestinely meeting his love in the gardens of her former home. The husband of this handmaid, who worked for the mandarin as a gardener, and Chang's sister, were witnesses of the betrothal and the simple marriage of the fugitives, who passed their time in close concealment, and never appeared abroad, except after nightfall, when they wandered across the rice grounds, or, from the terrace gardens on the mountain sides, breathed the rich perfume of the olea fragrans, or the more delicate scent of the flowers of the orange or the citron groves. From the gardener they learned the steps taken by their pursuers, and were prepared to elude them for a considerable time. But at last, the mandarin having issued a proclamation, that if his daughter would forsake Chang, and return to her old home, he would forgive her, the young man expressed himself so exceedingly joyful at the signs of his master's relenting, that suspicion was attached to him, and the poor house in which he resided was ordered to be watched.

The reader will find this house significantly represented (*see plate*) at the foot of the bridge. It is only of one storey in height, and of the most simple style of architecture. The ground about it is uncultivated, the tree that grows thereby is of an unproductive species, being a common fir, and the whole place has a sad air of poverty and dullness, which become more striking when the richly ornate and sheltered mansion on the other side of the bridge is compared with it.

It having been agreed, that, in case any suspicion fell upon the house, the young gardener should not return at the usual hour, Chang and his wife suspected that all was not right when he did not enter at the customary time in the evening. The gardener's wife also saw strange people loitering about, and in great sorrow communicated her fears to the newly-married pair. Later in the evening, a soldier entered the house, and after having read the proclamation of the mandarin, he pointed out the great advantages which would arise to all parties who assisted in restoring Koong-see, and bringing Chang to justice.

He told her, moreover, that the house was guarded at the front, and reminded her that there could be no escape, as the river surrounded it in every other direction.

The attachment of the gardener's wife for her old mistress was, however, sufficient to enable her to retain her presence of mind; and after appearing exceedingly curious as to what reward she would obtain if she was successful in discovering Chang, she led him to suppose that he was not there, but in a friend's house, to which she would conduct him if he would first obtain a distinct promise of reward for her, in the handwriting of the mandarin and the duke. The soldier promised to obtain the writing, but told her, to her great disappointment, that he must leave the guard about the house. She dared not object to this, for she felt she would be convicted, but she talked as loudly as possible of the impropriety of rough soldiers being left without their commanding officer, and thus gave the trembling lovers the opportunity of overhearing what was passing, and of learning the dreadful extremity in which they were placed.

As soon as the officer had gone, a brief conference was held between the lovers and their protector. A few minutes—an hour at most—was all they could call their own. A score of plans were suggested, examined, cast aside. There was the suspicious guard, who were ordered to let no person under any circumstances pass, in front; and behind was the broad, rapid river. Escape seemed impossible, and, for Chang at least, detection and arrest was death. To attempt to fight through the guard was madness in a man unarmed—and what would become of Koong-see? What was to be done?

In was almost impossible to swim the roaring river when it was most quiet; but now it was swollen with the early rains —but the river was the only chance.

"But you will be seen, and be butchered in the water before you climb the other bank," suggested the gardener's wife.

"It is my only chance," said Chang, thoughtful, as he stripped off the *p'ao kua*, or loose outer garment commonly worn by the higher classes, or by those who seek for literary honours.

Koong-see clung to him, but his resolution was firm, and bidding her be of good cheer—that he would get across, and come again to her, he jumped from the window into the stream below, with Koong-see's promise of eternal constancy ringing in his ears.

The struggle was frightful, and long before Chang had reached the middle of the torrent, Koong-see's eyelids quivered,

and closed: she fainted, and saw no more. Her faithful attendant laid her upon a rude couch, and seeing the colour returning to her lips, gazed out of the window on the river. Nothing of Chang was to be seen: the rapid torrent had carried him away. Where?

Time passed on, every moment seeming an age, and darkness began to come down upon the earth. The poor gardener's wife hung over her pallid mistress, and dreaded her questions when consciousness would be restored. The officer had been absent sufficiently long to visit the duke and mandarin: hark! —he was even now knocking at the door.

The soldier knocked again before the gardener's wife could bring herself to leave Koong-see, but no other course was left to her: and scarcely knowing why, she securely closed the door of the apartment behind her, and drew the screen across to conceal it. The soldier rudely questioned her as to her delay in opening the door, and showed her the document which he had obtained, in which large sums of money and the emperor's favour were promised to any person who should give up Chang, and restore Koong-see to her father. She made pretence that she could not read the writing, and having given the soldier some spirit made from rice, she managed to pass a very considerable time in irrelevant matters. When the officer became impatient, she told him that she thought it would be useless to attempt to catch Chang till it was quite dark, when he would be walking in a neighbouring rice ground. Two hours were thus whiled away, when the officer was called out by one of the men under him, who told him that a messenger had arrived from the Ta-jen, inquiring why the villain Chang had not been brought before him, and requiring an answer from the commanding officer himself. This gave the gardener's wife time to see what had become of Koong-see. She had fancied she heard some noise in the apartment, and with intense curiosity she pushed the screen aside, opened the door, and peeped into the room: Koong-see was not there. There were marks of wet feet and dripping garments upon the floor, and upon the narrow ledge of the window, to which she rushed. A boat had just that instant been pushed off from the shore into the river, and in it, there was no doubt, were her mistress and her husband, the brave Chang. The darkness concealed them from the eyes of friends or enemies, as the rushing river carried them rapidly away.

The gardener's wife gently closed the window, and hastily removed all traces of what had happened; she then cheerfully

returned to the other part of the house, and waited for the officer. He came, stimulated his soldiers to search the house, which they did most willingly, as upon such occasions they were accustomed to possess themselves of every thing which could be considered valuable. Their search was in vain, however, for they neither found traces of the fugitives, nor anything worth stealing. The jewels were with Chang upon the river, and the gardener was but a poor man. They then visited the rice ground, but were equally unsuccessful there. They suspected that the woman had played them a trick, but she looked quite unconscious, and in a very innocent manner persuaded the officer that she had been imposed upon, and that she was sorry she had given him so much trouble.

The boat with its precious cargo floated down the river all that night, requiring no exertion from Chang, who sat silently watching at the prow, while his young wife slept in the cabin. When the grey of early morning peeped over the distant mountains, Chang still sat there, and the boat was still rapidly buoyed onwards by the current. Soon after daylight they entered the main river, the Yangsi-keang, and their passage then became more dangerous, requiring considerable management and exertion from the boatman. Before the sun was well up, they had joined crowds of boats, and had ceased to be singular, for they were in company with persons who lived wholly upon the rivers, but who had been engaged in taking westward the usual tribute of salt and rice to his imperial majesty's treasury. To one of the boatmen he sold a jewel, and from another he purchased some food with the coin.

Thus they floated onwards for several days towards the sea, but having at length approached a place where the mandarins were accustomed to examine all boats outward-bound, Chang moored his floating home beside an island in the broad river. It was but a small piece of ground, covered with reeds—but here the young pair resolved to settle down, and to spend the rest of their days in peace. The jewels were sold in the neighbouring towns, in such a manner as not to excite suspicion, and with the funds thus procured, the persevering Chang was enabled to obtain all that was necessary, and to purchase a free right to the little island. It is related of Koong-see, that with her own hands she assisted in building the house; while her husband, applying himself to agricultural pursuits, brought the island into a high state of cultivation.

On referring again to the plate, the reader will find the history of the island significantly recorded by the simple

artist. The ground is broken up into lumps, indicating recent cultivation, and the trees around it are smaller in size, indicating their youth. The diligence of Chang is sufficiently evidenced by the manner in which every scrap of ground which could be added to the island, is reclaimed from the water. To illustrate this, narrow reefs of land are seen jutting out into the stream.

The remainder of the story is soon told. Chang having achieved a competence by his cultivation of the land, returned to his literary pursuits, and wrote a book upon agriculture, which gained him great reputation in the province where he then resided, and was the means of securing the patronage of the wealthy literary men of the neighbourhood for his children —one of whom became a great sage—after the death of his father and mother, which occurred in the manner now to be related.

The reputation of Chang's book, if it gained him friends, revealed his whereabouts to his greatest enemy, the Ta-jen, or duke, whose passion for revenge was unabated. Nor did the duke long delay the accomplishment of his object. Having waited upon the military mandarin of the river station, and having sworn, by cutting a live cock's head off, that Chang was the person who had stolen his jewels, he obtained an escort of soldiers to arrest Chang—and with these the Ta-jen attacked the island, having given secret instructions to seize Koong-see, and kill Chang without mercy.

The peaceful inhabitants of the island were quite unprepared; but Chang, having refused the party admittance, was run through the body, and mortally wounded. His servants, who were much attached to him, fought bravely to defend their master; but when they saw him fall, they threw down their weapons and fled. Koong-see, in despair, rushed to her apartments, which she set on fire, and perished in the flames.

The gods—(so runs the tale)—cursed the duke for his cruelty with a foul disease, with which he went down to his grave unbefriended and unpitied. No children scattered scented paper over his grave, but in pity to Koong-see and her lover, they were transformed into two immortal doves (*see plate*), emblems of the constancy which had rendered them beautiful in life, and in death undivided.

AUTHORITIES.
[1] Giles: *Glossary of Reference*: WILLOW PATTERN.
[2] Translated by Sir William Jones, in the *Asiatic Transactions*.

WISH-GRANTING GEM

(如 意 寶)

Sanskrit *Ratna* or *Mani*. In Buddhism the emblem of richness and benefaction. The possession of the inexhaustible jewel grants every wish. It is symbolic of the Buddhist Trinity, *i.e.* Buddha, his Word (Sanskrit *Darma*), and the priesthood (Sanskrit *Senga*), and is usually in a three-fold or five-fold form. Mani (摩尼珠) is explained as meaning "free from stain," "bright and growing purer." The most valuable rosaries are made of manis.

FIVE-FOLD (CINTA) MANI, OR
WISH-GRANTING GEM

WOLF

(狼)

The wolf, *Lupus tschiliensis,* is very common in the northern hill districts. The Chinese distinguish two varieties, the *Ch'ai* (豺) and the *Lang* (狼); the former refers to the small tawny species, and the latter to the more dangerous large grey animal, the fur of which fetches a good price.

This animal does a great deal of damage in the sheep-fold and the farmyard, and is regarded as the emblem of cupidity and rapaciousness, being compared to an official who exacts money unfairly from the people in the shape of unauthorised taxation. In the vicinity of Peking, it was customary to draw large white rings on the plastered walls of the houses, in order to terrify the wolves, as these beasts are supposed to run away at the sight of such traps.

WOOD

(木)

The written symbol for wood, which is the 75th radical of the language, is a pictogram (像形) representing the roots,

trunk, and spreading branches of a tree. This material is the second of the FIVE ELEMENTS (*q.v.*), and corresponds to the first and second of the TEN CELESTIAL STEMS (*q.v.*).

Wood is a very important article in Chinese life, and enters largely into the composition of houses, being also universally employed as fuel (*vide* TREES).

"There is no essential difference between the elements of design for decorative woodwork and any other Chinese decorative art. The bronzes, embroideries and porcelains all show many similar designs and patterns, modified to suit the material. . . . Chinese design in art woodwork shows great fertility in invention of ornament. One rarely sees a vulgar riot of unshapely forms. A due appreciation is shown of the value of plain surfaces. Great use is made of the written characters and of symbols having mythical or religious meaning. . . . It is, perhaps, in perforated carving that Chinese work most excels. In the infinite variety and intricacy of repeated frets and wave and cloud motives the infinite patience and manual dexterity of the oriental finds its special field in a land where time is scarcely considered." [1]

AUTHORITY.
[1] Couling: *Encyclopædia Sinica*: WOOD CARVING.

WRITTEN CHARACTERS
（文 字）

The origin of the written language of China is of great antiquity. After events had been recorded by knotted cords (not unlike the Peruvian *quipos*), and notched sticks, a writing proper began, like the Egyptian, with *wên* (文). images, forms of visible objects, or ornaments; the first legendary Emperor Fu Hsi (伏羲), 2953 B.C., the third Emperor Huang Ti (黃帝), 2698 B.C., and the Statesman Ts'ang Chieh (倉頡), 2700 B.C., are the traditional inventors of the *k'o t'ou tzŭ* (蝌蚪字), or "tadpole characters," and the *niao chi wên* (鳥跡文), or "bird-tract script," consisting of undulating marks. The historic *ku wên* (古文), or ancient writings, imitative of natural forms, are found on stones and metallic vases, and are the prototypes of the subsequent sinograms.

"History relates that, at the moment Fu Hsi was seeking

Modern Form	Gradual Evolution	Earliest Form	Meaning
象	𧰼 𧰼 𧰼 𧰼 𧰼 𧰼 𧰼	𧰼	Elephant
虎	虎 虎 虎 虎 虎 虎	虎	Tiger
鹿	鹿 鹿 鹿 鹿 鹿	鹿	Deer
馬	馬 馬 馬 馬 馬	馬	Horse
牛	牛 牛 牛	牛	Ox
羊	羊 羊 羊	羊	Sheep
狗	狗 狗 狗 狗 狗 狗 狗	狗	Dog
魚	魚 魚 魚 魚 魚 魚	魚	Fish
黽	黽 黽 黽 黽 黽 黽	黽	Toad
龜	龜 龜 龜 龜 龜 龜	龜	Tortoise
蛇	蛇 蛇 蛇 蛇 蛇	蛇	Snake
鳥	鳥 鳥 鳥 鳥	鳥	Bird
雀	雀 雀 雀 雀 雀 雀	雀	Sparrow
燕	燕 燕 燕 燕	燕	Swallow

THE EVOLUTION OF CHINESE WRITING FROM ANCIENT TO MODERN FORM

to combine the characters proper to express the various forms of matter, and the relation between things physical and intellectual, a wonderful horse (龍馬) came out of the river, bearing on his back certain signs, of which the philosophic legislator formed the eight diagrams which have preserved his name."[1] While the Great Emperor Yü (大禹), B.C. 2205, was engaged in drawing off the floods, a "divine tortoise" (神龜) is said to have presented to his gaze a scroll of writing upon its back, whence he deciphered the basis of his moral teaching and the secrets of the unseen.

From the period of the Chou dynasty, the graphic symbols of China have been divided into Six Scripts or Categories, *Liu Shu* (六書), as follows:

1. *Hsiang Hsing* (象形), Pictograms, Conventional pictures of objects as *jih* (日), sun; *yüeh* (月), moon; *mu* (木), tree; *shan* (山), hill.

2. *Chih Shih* (指事), Indicators. Shapeless things, as *shang* (上), above; *hsia* (下), below; *chung* (中), central.

3. *Hui I* (會意), Ideograms. Combined images such as *ming* (明), sun-moon, or bright; *wên* (聞), door-ear, or to hear; *hsien* (仙), man-hill, or hermit; *fu* (婦), woman-broom, or wife.

4. *Hsieh Shêng* (諧聲), Phonograms. Formed of a pictogram and a phonetic, the former supplying a guide to the meaning and the latter to the sound. Thus the phonetic *chu* (主), firm, imparts its sound to the following: in combination with *shou* (扌), hand, it forms the character *chu* (拄), to lean upon; with *jên* (亻), man, it forms *chu* (住), to dwell; with *mu* (木), tree, it forms *chu* (柱), a pillar.

5. *Chuan chu* (轉注), Deflectives. Antithetic signs such as *shan* (山), mountain, which when turned round on its side, becomes *fou* (阜), a mound; *ch'ia* (卡), barrier, a combination of *shang* (上), up, and *hsia* (下), down, originally used to denote a guard-house controlling the route above and below it, where soldiers collected a toll on goods.

6. *Chia Chieh* (假借), Borrowed Characters. Metaphoric or symbolic forms produced by association of ideas, which originally without a counterpart, have borrowed the symbols of others, as *tzŭ* (字), written character, composed of *tzŭ* (子), child, and *mien* (宀), roof; *wai* (歪), aslant composed of *pu* (不), not, and *chêng* (正), straight.

Some of these classes, however, overlap into others, and the second, fifth, and sixth are manifestly subordinate groups, and may well be included in the first, third, and fourth.

ABOVE: INSCRIBED BONE FRAGMENTS OF GREAT ANTIQUITY UNEARTHED IN
HONAN; BELOW; FACSIMILE OF INSCRIPTION ON ANCIENT STONE DRUMS IN
CONFUCIAN TEMPLE AT PEKING

In 1899 some three thousand bone and tortoise-shell fragments inscribed with old characters were said to have been dug up in Honan. Some of the inscriptions on these fragments are crudely pictorial, and others are in the seal character, as may be seen from the specimens displayed in the Museum of the Royal Asiatic Society, N.C.B., Shanghai. They all bear symbolic designs of great antiquity, and are supposed to be divination responses.

There are ten stone drums in the Confucian temple in Peking inscribed with what are held to be old seal characters. The inscriptions on these drums are generally believed to be a poetical record of a royal hunt in the time of King Hsüan of the Chou dynasty, who began his reign in 827 B.C. The illustration given has been copied from a rubbing taken from one of these drums, and Professor G. Owen observed of this inscription in his lecture at King's College of 4th October, 1910, that:

1. The pictorial element, though much subdued, is still marked in a good many characters, while in a few it is nearly, if not quite, lost.

2. The inscription is largely composed of pictograms and ideograms, the phonograms being comparatively few.

3. There is a considerable number of archaic characters now rare or obsolete.

The general style of writing is much more compact and much more like writing than the old pictorial style.

There are many symbols in the Chinese and Egyptian languages which resemble each other. This indicates either that these tongues had a common origin, or that the various resemblances are merely pictographic coincidences due to incidental similarities of manners and customs. But there is no palpable evidence that the Egyptian borrowed from the Chinese or *vice versa*. The Chinese compound their primitives or roots, allowing one of the two (the phonetic) to preserve its sound, while the other (the radical) is silenced. K'ang Hsi's lexicon gives 214 radicals, and Soothill's dictionary records 888 phonetics. The Egyptians rarely compounded their roots with reference to their sense as well as their sound, but used them singly for sense or for sound, or grouped them into sets as sounds only, or in other terms employed them as letters in the spelling of words. The theory of the supposed affinity between Chinese and Egyptian has been treated by de Guines in his *Memoire dans lequel on prouve que les Chinois sont une colonie Egyptienne,* 1758, and by Pauthier in his

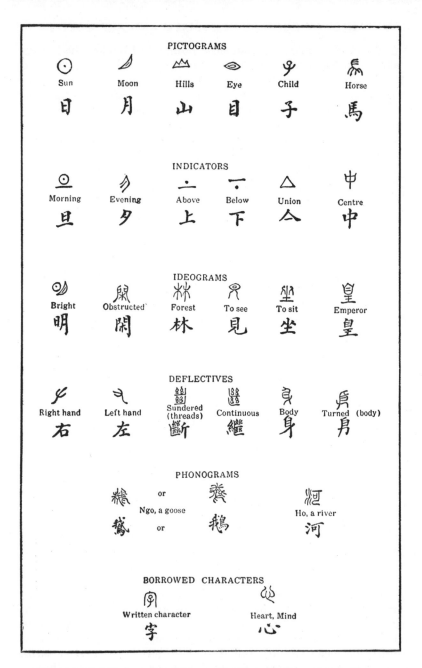

THE SIX SCRIPTS OR CATEGORIES OF WRITTEN SYMBOLS (ANCIENT AND
MODERN STYLE)

Essai sur l'origine et la formation similaires des écritures figuratives Chinoise et Egyptienne, 1842.

Chinese characters may be written in six different ways, known as the Six Forms, *Liu T'i* (六體), as follows:

1. 篆.—The *Chuan* or Antique, called the "Seal" character, consisting of (a) the *Ta Chuan* (大篆), the greater seal character, invented about 800 B.C. by the historiographer Shih Chou (史籀), of the Chou dynasty, to take the place of the simple pictographs; and (b) the *Hsiao Chuan* (小篆), or lesser seal character introduced in the 3rd century B.C. by the Minister Li Ssŭ (李斯) of the Ch'in dynasty. They are now only used for ornamental purposes, and upon public and private seals. There is an older form of seal character to be found on ancient bronzes, drums, etc.

2. 隸.—The *Li*, known as the square character or ancient official text, introduced about 200 B.C. by the official Ch'êng Miao (程邈), of the Ch'in dynasty, to replace the more cumbrous lesser seal character. This style has been in current use until about A.D. 350, and is now used for writing on scrolls, fans, stone tablets, etc.

3. 楷.—The *Ch'iai*, known as the clerical style, the pattern or plain character, so called in Chinese from the name of a tree which grows at the grave of Confucius. This handwriting was invented, to replace the less handy square text, by the Brigade General and student Wang Hsi-chih (王羲之), A.D. 312-379, of the Chin dynasty; his penmanship being said to be "light as floating clouds and vigorous as a startled dragon." This form has been used ever since for official documents.

4. 行.—The *Hsing*, called the Cursive or Running Hand, introduced under the T'ang dynasty, A.D. 618-906, and, being easier and quicker than the clerical style, has been in common use continuously for the writing of private letters, bookkeeping, etc.

5. 草.—The *Ts'ao*, named the Grass Text or Rapid Style, is said to be so called from the draft (槁) of a document, which was formerly written on straw paper, and also because of the irregular plant-like appearance of the characters. This style was introduced under the Chin Dynasty, about A.D. 350. This grass hand has never been used in official or ceremonious writings, the square characters, and afterwards the clerical style, being the proper form of writing. It was only on account of its being of easier and quicker writing that the

宋 Sung	草 Grass	行 Cursive	楷 Pattern	隸 Ancient	篆 Seal
書有六體日篆隸楷行草宋	玉書六諤口篆隸抖ㄇ了寄	畫有六體四篆絲楷行草宋	書有六體日篆隸楷行草宋	書有六骵日篆絲楷行卅用	壽而宊體日蕭隸楷尜卅宋

THE SIX FORMS OF WRITING

grass hand had been adopted for private use. It is now used only for writing on scrolls.

6. 宋.—The Sung dynasty text, or printer's style, used in books.

An attempt is now being made to introduce a Chinese phonetic script to displace the classical form. With the publication of books and periodicals in this simplified language, the illiteracy in China, due to the difficulties associated with the written character, should be overcome to a considerable degree. This phonetic script has been adapted to the linotype: K'ang Hsi's dictionary contains more than 40,000 different characters, but a working knowledge of 5,000 is adequate for ordinary purposes.

To the fact that Chinese characters were originally pictures representing objects, conditions, and abstract ideas may be ascribed the ancient regard for painting and writing as correlated arts of equal importance, both of them executed with the same breadth and flexibility of line, and by means of the same implement. The ancient and mysterious origin of written symbols, and the respect accorded to a literary scholar, are also factors in the production of a spirit of veneration for the written character, which is regarded as sacred. A box is sometimes affixed to the outer wall of a house, with the inscription, "Respect written paper and treat it with care" (敬惜字紙); in this receptacle scraps of printed or written paper are deposited and subsequently burnt in a special brick furnace.

Writing or painting for other people is "the usual occupation of poor scholars who are ashamed to go into trade and who have not enterprise enough to start as doctors or fortune-tellers. Besides painting pictures and fans, and illustrating books, these men write fancy scrolls in the various ornamental styles so much prized by the Chinese; they keep accounts for people, and write or read business and private letters for the illiterate masses." [2]

The graphic beauty of Chinese calligraphy is greatly employed for ornamental purposes, i.e., on porcelain, stone tablets, inscriptions on doorways, etc. The almost infinite variety of forms which the symbolic character is capable of receiving, is certainly favourable to the picturesque effect. The characters *fu* (福), felicity; *lu* (祿), emolument; *shou* (壽), longevity; and *hsi* (喜), joy; are regarded as emblems of particularly good augury. They are painted or embroidered in many different styles. "The character for 'joy,'

written twice, side by side, as though the whole constituted one word or letter, is regarded as a very auspicious combination. It may mean double joy, or joy repeated, and indicates a desire that occasions for joy (such as the birth of a son) may be repeated or numerous."[3] The phrase *Wu fu lin mên* (五福臨門), "May the five blessings approach the door," is frequently written on red paper, and pasted on the lintel of the main door of a Chinese dwelling at New Year. These five blessings are: old age (康寧), wealth (富), health (壽), love of virtue (攸好德), and a natural death (老終命), and are sometimes pictorially represented on chinaware, etc., by five bats, *wu fu* (五福), fluttering round the ornamental symbol *shou* (壽), longevity—usually written in the seal character (*vide* BAT). Antithetical couplets are also pasted up on each side of the door; they are generally of a poetic or classical nature, and are believed to possess the power of repulsing evil influences. A common design is known as the *san to* (三多), or the three most desirable objects, namely sons, money, and long life, represented by a child, an official, and an old man accompanied by a stork. These designs are often adapted for advertising purposes, especially in the case of medicinal specifics for anæmia and debility. The pictorial rebus is very common in combination with the linguistic pun. (*Vide* also BOOKS, EIGHT DIAGRAMS, FU HSI, SCROLL, TA YÜ.)

AUTHORITIES.
[1] Jacquemart: *History of the Ceramic Art*, p. 29.
[2] Werner: *Myths and Legends of China*, p. 376, note.
[3] Doolittle: *Social Life of the Chinese*, p. 571.

YAMA
（閻 羅）

Sanskrit *Yama*, a twin. The judge and ruler of the departed; the Hindu Pluto, or king of the infernal regions; originally conceived of as one of the first pair from whom the human race is descended, and the beneficent sovereign of his descendants in the abodes of the blest; later a terrible deity, the tormentor of the wicked. He is represented of a green colour with red garments, having a crown on his head, his eye inflamed, and sitting on a buffalo, with a club in one hand." [1]

"Yama was originally the Aryan god of the dead, living in a heaven above the world, the regent of the south; but Brahmanism transferred his abode to hell. Both views have been retained by Buddhism." [2] "He has a sister who controls all the female culprits, as he exclusively deals with the male sex. Three times, however, in every twenty-four hours, a demon pours boiling copper into his mouth, and squeezes it down his throat, causing him unspeakable pain. Such, however, is the wonderful 'transrotation of births,' that when his sins have been expiated, he is to be reborn as a Buddha, under the name of 'The Universal King.'" [3]

The Buddhist-Taoist purgatory consists of Ten Courts of Justice situated in different positions at the bottom of a vast ocean, which lies down in the depths of the earth. These are subdivided into special wards, different forms of torture being inflicted in each. Taoist temples often contain graphic representations of the torments of the nether world, of which

451

THE SOULS OF THE DEAD ARRAIGNED BEFORE YAMA, THE GOD OF HELL, AND
PLACED BEFORE THE MIRROR, WHICH SHOWS THE FORMS UNDER WHICH
THEY WILL BE REINCARNATED

TORTURES OF THE BUDDHIST HELL

(a) TORTURE OF LYING ON A BOARD FULL OF NAILS FOR THOSE WHO BUY
GRAIN FOR A RISE IN PRICE, ETC. (b) TORTURE OF CUTTING OUT THE TONGUE
FOR THOSE WHO SCRAPE GOLD LEAF FROM THE OUTSIDE OF IDOLS AND EXTRACT
THEIR SOUL OR INTESTINES. (c) TORTURE OF FLAYING ALIVE FOR THOSE
WHO STEAL GOOD BOOKS OR DEFACE AND TEAR FINE LITERATURE. (d)
TORTURE OF CUTTING IN HALVES. RESENTED IN HEAVEN AND HATED ON
EARTH. GAZE ON THIS, THOSE WHO DISRESPECT THE GODS. (e) TORTURE
OF KNEELING ON IRON FILINGS FOR THIEVES

a full description is given in the Taoist work "Yü Li Ch'ao Chuan" (玉 歷 鈔 傳), which dates from the Sung dynasty.

"The journey of the departed spirit to Hades is described with a wealth of illustration and elaboration, and is divided into seven periods of seven days, or 'weeks,' which correspond with the various stages of the spirit's wanderings in the infernal regions. The first 'week,' when the traveller reaches the 'Demon Gate Barrier' (鬼 門 關) and is assailed by demons who demand his money, on the excuse that at his last trans-migration he borrowed so much from the infernal treasury and must now return it. If he has money to pay he is let pass, but if not he is beaten, stripped, and suffers many indignities. The second 'week' he comes to a place where he is weighed: the good man proves to be as light as air, but the evil are borne down by their ill deeds and are punished by being sawn asunder, ground to powder, etc. Nirvana, how-ever, is still very far off, a wave of the 'two-sided fan' restores him to his former condition and he is sent forward on his journey. The third 'week' he arrives at the 'Bad Dog Village' (惡 狗 村), where, if good, he is recognised joyfully by the fierce beasts, but, if evil he is torn until his blood flows in rivers. At the fourth 'week,' a gigantic mirror, called the 'Mirror of Retribution' (業 鏡), is exhibited: the good man on looking into it sees himself as he is, in all the beauty of innocence, but the sinner sees only the presentiment of the doom which awaits him; is he to be turned into an animal? then an animal form is reflected before his horrified vision. The fifth 'week' he begs to be allowed to return to life, but the God replies that he is no longer fit to take his place with uncorrupted mortals; he thereupon begs at least to be per-mitted to take a last look at his old home, and is allowed to ascend a high platform from whence he may obtain a view. He sees his loved ones at home, occupied with their various duties, and his heart is all the more sorrowful as he realises that he himself has no longer a place in mundane affairs. In the sixth 'week' he reaches the bridge which spans the 'Inevitable River' (奈 河 橋). This bridge is very high and narrow, and the water rushes underneath like a whirlpool, showing enormous snakes lifting their heads high out of the water on the look-out for human flesh. At the foot of the bridge stand lictors who, with iron maces and other weapons, force the unwilling travellers to ascend the bridge and essay the crossing which inevitably ends in destruction. The bridge is 100,000 feet high and 1 inch and 3/10ths wide, and the

TORTURES OF THE BUDDHIST HELL

(a) TORTURE OF IMPALEMENT ON SPIKES FOR THOSE WHO RAISE SUBSCRIP-
TIONS FOR REPAIRING TEMPLES, ETC., AND KEEP THE MONEY, AND FOR ALL
THOSE WHO MAKE EXCESS PROFITS IN THE PRINTING OF GOOD LITERATURE.
(b) TORTURE FOR CATCHING FROGS, EELS, POISONING FISH, KILLING BIRDS,
AND EATING COWS AND HORSES. (c) TORTURE OF SPEARING FOR THOSE WHO
ARE THE CAUSE OF BROKEN ENGAGEMENTS OF MARRIAGE. (d) TORTURES OF
GNAWING BY DOGS AND PIGS FOR STIRRING UP ENMITY BETWEEN RELATIVES,
DRAWING LICENTIOUS PICTURES, ETC. (e) TORTURE OF PECKING BY BIRDS
FOR THOSE WHO KILL ANIMALS AND INNOCENT CREATURES. (f) TORTURE
OF SNAKEBITE FOR THOSE WHO KILL TORTOISES AND SNAKES

only possible way of crossing is by 'riding' straddle-legged as on a horse. The good are not forced to attempt the passage, but are led by the 'Golden Youth' and his companion on to the 'Fairy Bridges,' the gold and silver bridges which cross the river at the side of this demon 'Bridge of Sighs.' In the seventh 'week' the abode of the 'Rajah of the Wheel' (轉 輪 王) is reached, and he is petitioned by the traveller to expedite the process of transmigration. The petitioner is handed over to a 'Runner,' who takes him off to the place of the wheel; and on the way a rest-house is visited, where old Mrs. Mêng (孟 婆) gives tea 'free gratis' to passers-by, they being already thirsty after all their experiences. When the good man has imbibed the tea he enjoys a comfortable sensa- tion, and a sense of coolness takes possession of him, but the moment the evil-doer tastes the liquid, he forgets all the past, both good and bad. The victim is then driven on towards the great 'Wheel of the Law' (法 輪) and takes his place between the revolving spokes. If he is permitted to escape at the top right-hand corner he finds himself, on re-incarna- tion, admitted into the ranks of the nobility; if by the top left-hand corner he is relegated to the status of widower or widow, orphan or childless, the lame, the halt, and the blind; if he emerges on the right-hand, lower down, he is classed among viviparous animals; if on the left-hand, among ovipar- ous animals. The right-hand, still lower, is the place of creatures with shells or scales; the left-hand corresponding is the sphere of insects."[4]

"The Pratas (of the Hindoo mythology)—in Chinese *kuei* (鬼), 'demons'—are the inhabitants of the *narakas* or 'subterranean' and other 'prisons' called *ti-yü* (地 獄), 'hell.' Many of them formerly belonged to the world of men. Some are condemned by Yama (the Prince of Hell) to certain prisons. Others haunt the graves where their former bodies are interred. The Pretas hunger for food, and hence the custom is prevalent in China of feeding the hungry ghosts both of relatives and of others."[5] (*Vide* also ANCESTRAL WORSHIP, MANJUSRI, TI TSANG, WHEEL OF THE LAW).

AUTHORITIES.
[1] Webster: *Dictionary of the English Language*, 1884: YAMA.
[2] Eitel: *Handbook for the Student of Chinese Buddhism*, p. 173.
[3] Legge: *Travels of Fa-hien*, pp. 90191, note 4.
[4] Walshe: *Some Chinese Funeral Customs*, Journal Royal Asiatic Society, N.C.B., Vol. XXXV, 1903-4, pp. 49-51.
[5] Edkins: *Chinese Buddhism*, pp. 217-8.

TORTURES OF THE BUDDHIST HELL

(a) TORTURE OF BEING THROWN ON A HILL OF FIRE FOR THOSE WHO STEAL
CLOTHES AND ORNAMENTS FROM COFFINS, AND MAKE MEDICINE FOR IN-
DUCING MISCARRIAGE. (b) TORTURE FOR THOSE WHO STEAL OR KILL
CHILDREN. (c) TORTURE OF THE CANGUE FOR AVARICIOUS PERSONS. (d)
TORTURE OF BOILING IN OIL FOR THOSE WHO STEAL DEAD BODIES OR BONES

YAO

(堯)

The famous legendary Emperor of China's Golden Age. He is said to have been born with eyebrows of eight different colours. He came to the throne in 2357 B.C., and, after a glorious reign of 70 years or more, he abdicated in favour of SHUN (*q.v.*).

YIN AND YANG

(陰 陽)

Chinese cosmogony is based upon the principle of dualism, which has its parallel in the Ormuz and Ahriman of the Persians, the masculo-feminine principle of the ancient Egyptians, the subdivision of the Hindoo God Brahma into male and female elements for the creation of the world, and Plato's theory of universal dualism, etc.

The *Yin* (陰) and *Yang* (陽) are the negative and positive principles of universal life, and are pictorially represented by the symbol ☯, which is the diagram of an egg showing the yolk and the white strongly differentiated, the dark and light colours distinguishing the two principles. *Yang* signifies Heaven, Sun, Light, Vigour, Male, Penetration, the Monad. "It is symbolized by the Dragon and is associated with azure colour and oddness in numbers. In *Fêng Shui*, or the geomantic system of orientation, raised land forms (mountains) are *Yang*. Similarly *Yin* stands for Earth (the antithesis of Heaven), Moon, Darkness, Quiescence, Female, Absorption, the Duad. It is symbolized by the Tiger and is associated with orange colour and even numbers. Valleys and streams possess the Yin quality." [1]

The celestial principle (or soul of the universe), *Tien Li* (天 理) first existed, combined with the immaterial principle *Ch'i* (氣), or vapour, and then came primary matter (器), which accumulated and constituted substance (or the qualities of matter) *Chih* (質), from which all creation evolved. The Great Monad or Extreme—the first cause—T'AI CHI (太 極) (*q.v.*) being contained in the immaterial principle, moved and produced the *Yang*, the superior or male principle of native. When it had moved to the utmost it rested; and having rested,

EMPEROR YAO

459

it produced the *Yin*, the inferior or female principle of nature. When the pure male principle was diluted, it formed the heavens; while the dark and heavy *Yin* coagulated and formed the earth. The *Yin* and the *Yang* together constitute the Tao (道), the eternal reason or principle of heaven and earth, the origin of all things human and divine, and thence was finally produced the *Chi* 繼 or Succession.

The following diagram of the Chinese cosmology illustrates the process of change and evolution out of the Unknown and the ultimate return into it, and is quoted from a paper on "The Chinese Idea of the Second Self," read at a meeting of the Things Chinese Society, on the 26th May, 1931, at Peiping, China, by Mr. E. T. C. Werner.

<div align="center">

From all Eternity

was

|

道 *Tao*,

</div>

the Cause, the Reason, the Principle, the Way that Cannot be Walked, the Name that Cannot be Named, the Unknownable.

<div align="center">

In the beginning

was

|

無 *Wu*,

</div>

Nothing (nothing in which *Tao* was not), or *Wu-wu* 無 無 Non-existing Non-existence, or *Wu-chi* 無極, No Limit (which reason can find).

<div align="center">

From this emanated

|

渾 沌 *Hun-tun*,

</div>

Chaos, which is synonymous with

<div align="center">

|

太 極 *T'ai-chi*,

</div>

the Great Ultimate, the Grand Ridge-pole, the Primal Monad (a mingled potentiality of Form, Breath, and Substance).

<div align="center">

In this there took place a great change called

|

太 易 *T'ai-i*,

</div>

the Great Change, and there was

<div align="center">

|

太 初 *T'ai-ch'u*,

</div>

460

the Great Starting (the beginning of 形 *Hsing*, Form) which caused

|

太始 *T'ai-shih*,

the Great Beginning (the inception of 氣 *Ch'i*, Breath), which was followed by

|

太素 *T'ai-su*,

the Great Blank (the first formation of 質 *Chih*, Substance), which originated

|

兩儀 *Liang I*,

the two primary symbols representing

陰 *Yin*,
(formerly called 坤 *K'un*)
the negative principle or
modality,

陽 *Yang*,
(formerly called 乾 *Ch'ien*),
the positive principle or
modality,

which, by their interaction, produced

|

五行 *Wu Hsing*,

the Five Forces (水 *shui*, water, 火 *huo*, fire, 木 *mu*, wood, 金 *chin*, metal, 土 *t'u*, earth), from which, through this interaction and the coming together of the *kuei* and the *shên* elements permeating the *yin* and the *yang*, resulted

|

萬物 *Wan Wu*,

all things that are, including

|

人 *Jen*

Man, who is composed of

|

陰 *Yin*,
from which he derives

陽 *Yang*,
from which he derives

During life.

七 魄 *Ch'i P'o* the Seven Emotions (喜 *hsi*, joy, 怒 *nu*, anger, 哀 *ai*, grief, 懼 *chü*, fear, 愛 *ai*, love, 惡 *ê*, hatred, 慾 *yü*, desire),

三 魂 *San Hun*, the Three Spiritual Energies (氣 *ch'i* breath, that in which the 神 *Shên* is, manifests itself on high as 明 *ming*, bright spirit; 精 *ching*, energy or essence— 心 神 也 *hsin shên yeh*, the spiritousness of the heart, whose actual observable manifestation is 靈 *ling;* and 神 *shên* spiritousness or spiritual energy: to be distinguished from 神 *shên, infra*).

After death.

which on his death (*i.e.* when his 魂 *hun* and 魄 *p'o* separate) descend to the earth and become

魁 *Kuei,*
a dependant, preta, ghoul, goblin, vampire, or devil,

which on his death, *i.e.* when his 魂 *hun* and 魄 *p'o* separate, ascend to heaven and become

神 *Shên,*
a spirit, fairy, ghost, genie, angel, or god,

Second death.

which (post-Classically only) dies comparatively soon and becomes

Chi,
a dead devil.

which dies eventually, though much later than the *kuei* and generally only after a very long period of time (though popularly regarded as immortal). There is, apparently, no special name for a dead *shên* .

AUTHORITY.
[1] Couling: *Encyclopædia*: YIN AND YANG.

INDEX

Charles Alfred Speed Williams was a distinguished British scholar who spent most of his active life in China. He served as Acting Commissioner in Charge of Maritime Customs in Peking, Examiner in Mandarin for Hong Kong University, and Lecturer at Chiaotung University.